Kelva

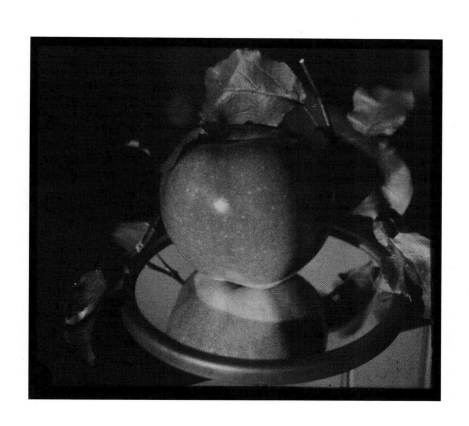

ANDRE
DEUTSCH

For Mum & Dad and Mum R

THIS IS AN ANDRE DEUTSCH BOOK

Design copyright © André Deutsch 2007
Text copyright © Pamela Roberts 2007

This edition published in 2007
by André Deutsch, an imprint of the
Carlton Publishing Group
20 Mortimer Street
London
W1T 3JW

A CIP catalogue for this book is available from the
British Library.

ISBN 978 1 0 233 00220 0

Editor: Penny Craig
Art editor: Zoë Dissell
Design: Vicky Rankin
Picture research: Pamela Roberts and Jenny Lord
Production: Lisa Moore

Printed in Italy

PREVIOUS PAGE Charles Zoller from Rochester,
USA, was visiting Paris in June 1907 when the
Lumière brothers first demonstrated the autochrome
process to the public and seems to have mastered
its difficulties instantly if the 1907 date of this
autochrome is correct. Its composition appears
simple but shows Zoller's ease with the process,
using foreground lighting, reflection and background
shadow to place all the emphasis on the red apple.

RIGHT Initially, William Eggleston's stunning green
column strung around with red and blue lights,
superimposed against a deep blue sky seems to be
all about celebrating glorious rich colour and full
form. Then we notice the little snippets of everyday
banality creeping in around the edges: the parking lot
and the ugly, thoughtlessly designed shopping centre,
that ever-present man-altered landscape.

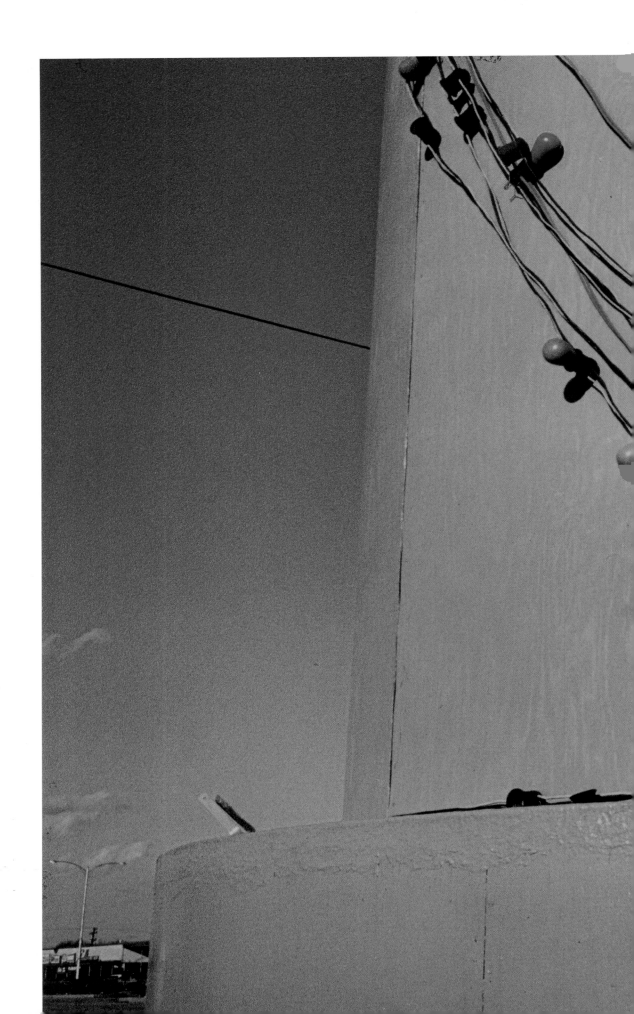

A CENTURY OF COLOUR
PHOTOGRAPHY

FROM THE AUTOCHROME TO THE DIGITAL AGE

PAMELA ROBERTS

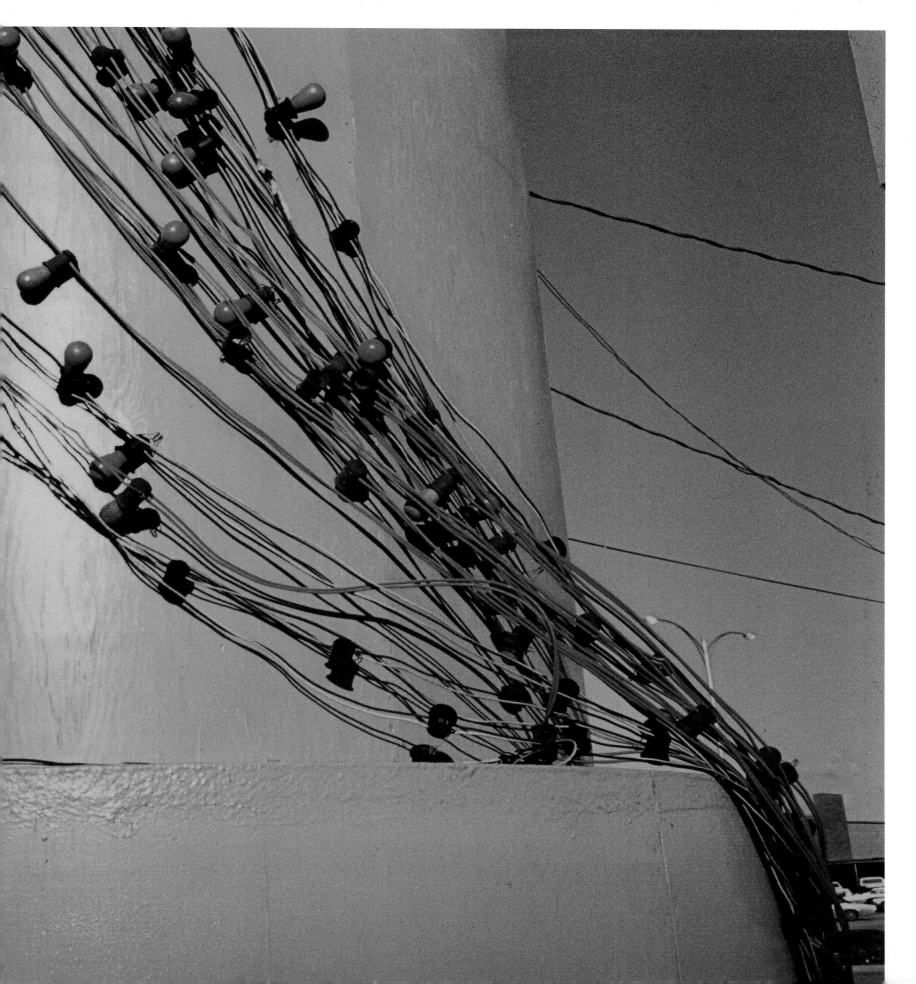

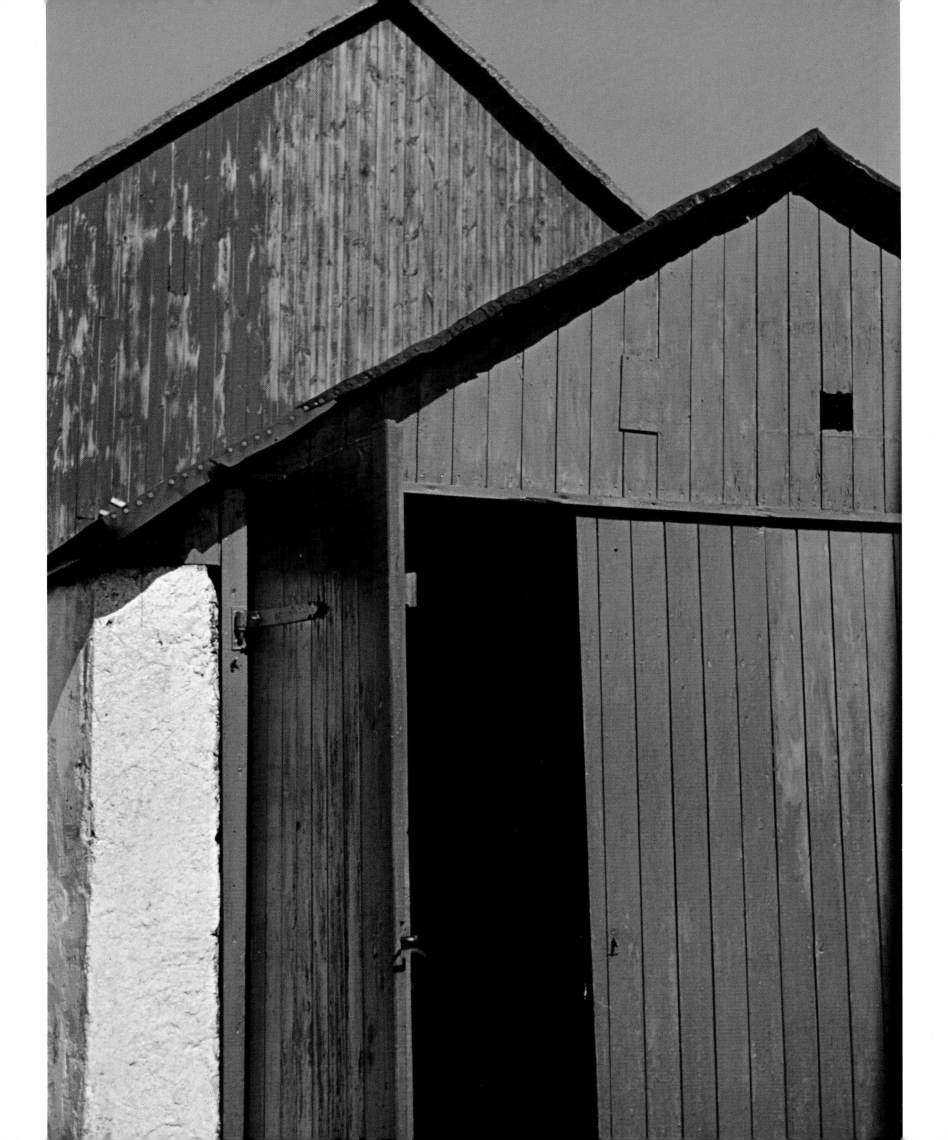

CONTENTS

LEFT Danish photographer Keld Helmer-Petersen had begun to photograph in colour during World War II. His 1948 book *122 Farvefotografier* (*122 Colour Photographs*) was one of the first to emphasize that photographing the mundane and everyday in colour with aesthetic intent, as with this image of two sheds, took it out of the realms of the ordinary and into the territory of abstract art and graphic urban still life.

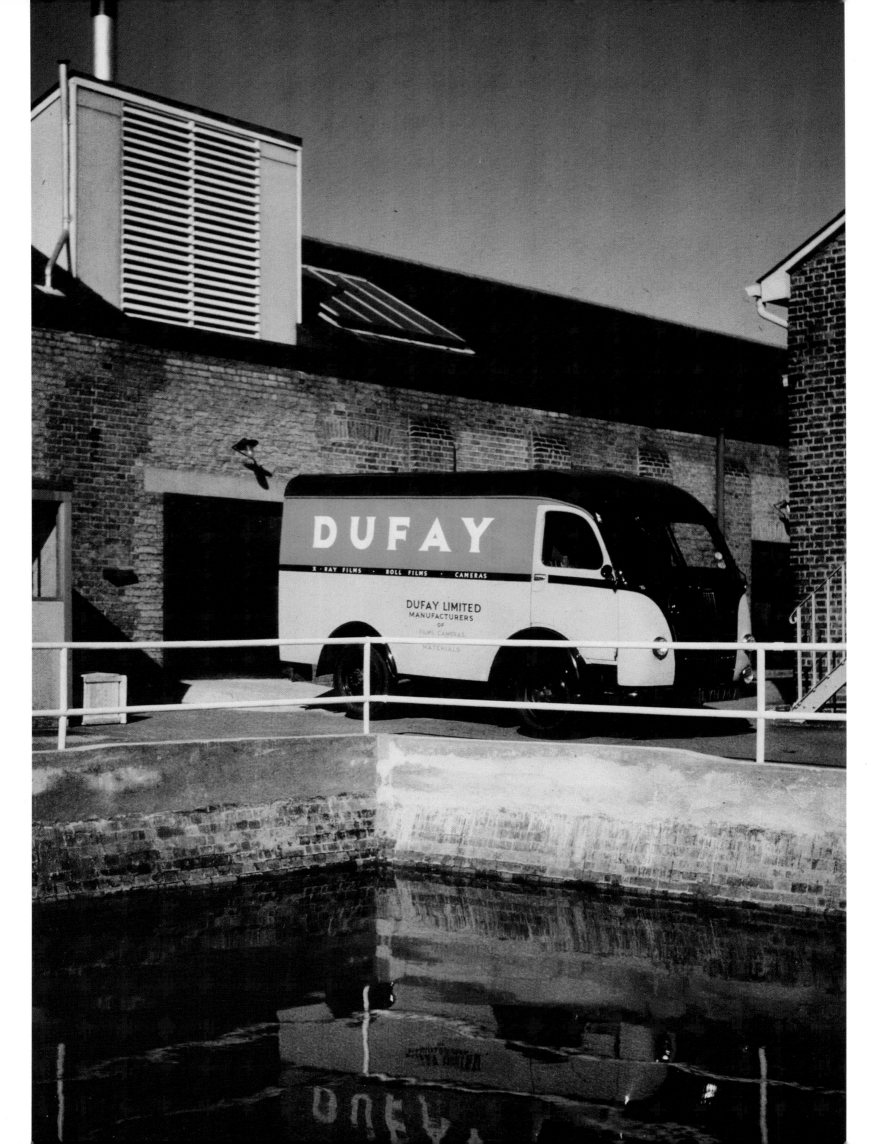

PREFACE

In 1940 the American photographer Paul Outerbridge, who knew more about colour than most, explained colour theory thus: "When you look at a colored object, remember that the color you see is the color of colors it reflects, for all the other colors that it might have been have been absorbed by it".[1] When we look at a colour photograph – a recorded visual interpretation of Outerbridge's colour-reflecting object – we have moved even further away from his definition of the object's intrinsic reality, imposing several extra levels of interpretation.

The particular chemical composition of the photographic process used is one level; the colour film (or digital camera) itself automatically reacts to and records colour in the way it has been chemically (or electronically) profiled (or programmed) to do. Then there is the subjectivity of the colour awareness, vision and creativity of the photographer, the eye behind the camera. Photographers have to experiment with what is available and discern a way of representing colour that suits their particular visual aesthetic. Then the viewer imposes yet another level of interpretation, bringing his or her own colour appreciation to the existing photograph. If photographs are printed, copied, scanned, viewed on a screen or reproduced on the pages of a book as here, then we are several generations and several further levels of interpretation away from that original colour-reflecting object. Is it any wonder that colour photography is maddeningly difficult to describe accurately – and that reactions to it are so diverse – given its wonderful subjective variations?

The dyes and pigments available in any particular period in which a specific colour photographic process was invented, manufactured and used have profound effects on the quality of colour that defines both a style and a particular historical period. Predictable chemical colour reactions were already embedded in specific colour processes, like the Lumière autochrome plate, Kodachrome and Polaroid film, which were designed to perform in specific ways and advance the future proliferation of colour photography, as well as richly reward their respective companies financially. But it depended on the creativity and resourcefulness of photographers to experiment, to bend and shape and tweak that predictable product and get it to behave in an unpredictable fashion by emphasizing, reducing or otherwise changing the expected colour balance; to discover something within its standardized chemical package that agreed with their own colour sense, their own vision and to produce something unique and distinctive to them.

LEFT This anonymous *c.*1950 Dufaycolor colour transparency of a Dufay Limited Austin K8 25cwt (1,250kg) delivery van in its jaunty red, yellow and black livery was possibly taken at the Dufay factory in Elstree, Hertfordshire. The Dufay company closed in 1955 after over two decades of successful cine and roll film production.

This is a personal book and the image selection will doubtless raise queries about the criteria for inclusion and exclusion of particular photographers. Some photographers (or their agents) chose not to be involved. Some were not included for a variety of reasons. There are some classic images, some hopefully very new. The image choices, and any of the book's faults, are the author's own.

During my 25 years involvement with photography, I have loved colour more than monochrome – I am told that colour appeals more to the senses than the intellect – and have always been keen to write a book and curate an exhibition on its evolution. It is a huge theme and this book can only be a tantalizing taster of a much under-researched subject.

I am fascinated by nineteenth- and early twentieth-century experimentation, which strove to introduce colour into photography and have included cyanotypes and hand-coloured photographs as well as various alternative nonsilver processes like gum and carbon printing. These are not standard three-colour photographs of course, yet they are coloured and brought a different interpretation and vision to photography and these processes are still used. The range of colours in this book are amazingly diverse through the Pointillist autochromes, the balmy pastels of the 1920s, the pistachio-green, carmine reds and metallic tints of the Art Deco 1930s; the vibrant primary blues, reds and yellows of the 1940s and 1950s, the lurid acid tones of the 1960s, and on to the infinitely variable colour combinations of the digital twenty-first century.

Roland Barthes believed that colour damaged photography's basic (perceived) truthfulness and that it was just a sham, "a coating applied later on to the original truth of the black and white photograph. For me, colour is an artifice, a cosmetic (like the kind used to paint corpses)."[2]

Barthes' "corpse-painting" technique received a major fillip as recently as 2006. The most expensive photograph in the world, Edward Steichen's *The Pond—Moonlight, 1904*, which sold at Sotheby's New York on February 14, 2006 for $2,928,000, is a print with colour. This glorious platinum print with a multiple blue/green/yellow/brown gum overlay proves that our fascination with colour in photography is a past, present and future obsession.

RIGHT Auguste and Louis Lumière used the autochrome to photograph their own large extended family, in this case a son or daughter dressed in Pierrot costume.

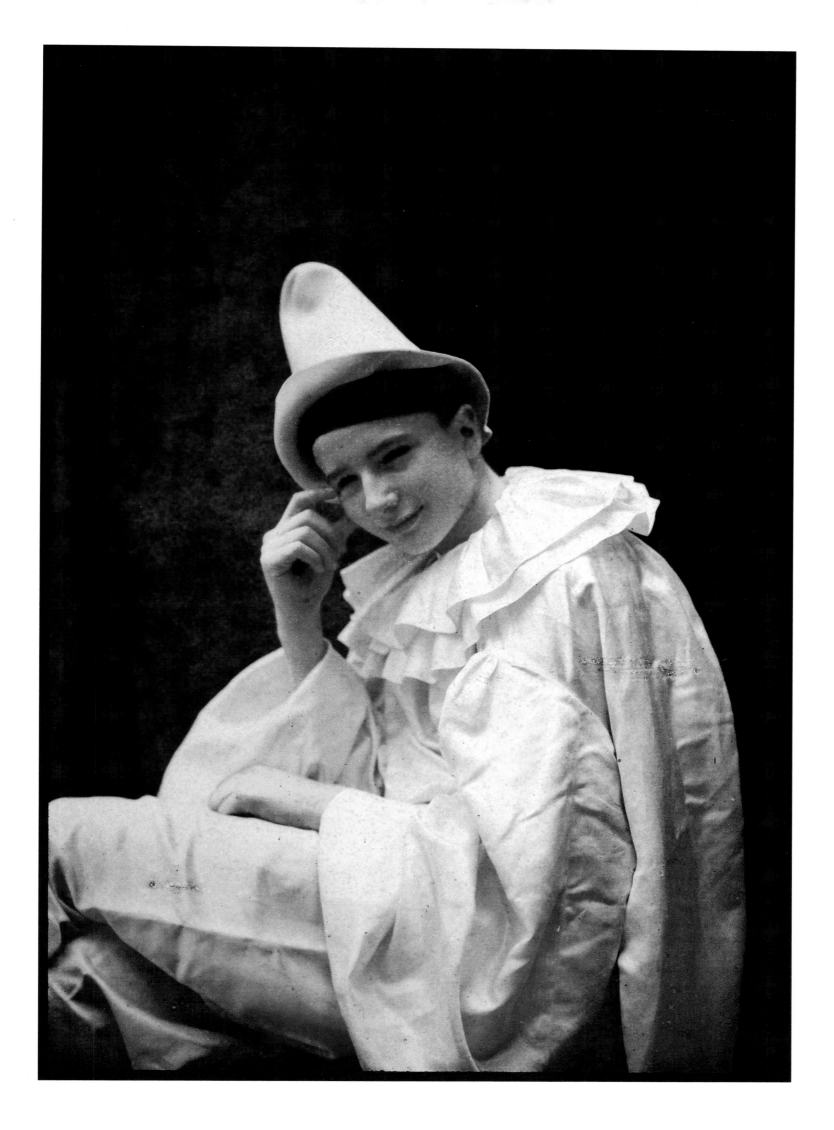

1 WHAT CAME BEFORE

1839–1907

S ir Isaac Newton (1642–1727) was a busy man. When not avoiding plummeting apples and laying the foundations of modern mathematics, optics and physics, he was proving that white light was not a single entity. Instead, it was composed of a spectrum of rainbow colours which combined to make white. From this finding – that light is the source of all colour – comes our basis for understanding the concept of colour and thus colour photography.

Prior to 1666, it was thought that the spectrum produced when pure white light passed through a glass prism was due to some corruption of the light as it travelled through. In Newton's experiments, he passed a thin beam of sunlight through a prism to produce the expected spectrum of colours – red, orange, yellow, green, blue, indigo, violet. By placing an inverted prism in the path of these coloured beams of split white light, he recombined the colours to produce pure white light once more. If the previous corruption theory was correct then the white light, having travelled through two prisms, should be twice as corrupted and twice as colourful. Plainly it was not: it was as pure as before.

After Newton, science continued to advance our understanding of the perception of colour. In lectures published in 1807, Thomas Young (1773–1829) established various important principles. Employing a theory first proposed by Robert Hooke (1635–1703) and Christiaan Huygens (1629–1695), he stated that light moved in waves and that light of different colours had different wavelengths, red being the longest and violet the shortest. In addition, he explained that our perception of colour depended on three different kinds of nerve fibres in the retina of the human eye responding respectively to the three wavelengths of red, green and blue light. The brain then blended these three colours to make every other colour, and thus the perception of colour was a psycho-physiological process. Young's work was further progressed in 1851 by Hermann Ludwig Ferdinand von Helmholtz (1821–94).

Despite these general natural principles, perception of colour is still subjective. We all see colour differently: my bluey-green may be your greeny-blue, my pinky-purple your mauve. Even two eyes in the same head may produce a different "reading", while some people are colour blind and do not perceive certain colours at all. But of course none of us sees in black and white. This is why it was so disappointing to those who saw the first photographs on paper and metal in 1839 that, astonishing as these captured images were, they were in sober monochrome tones rather than in natural colours – shades of brown or silvery grey rather than the true colours of the natural world.

RIGHT Hand-colouring of albumen prints with paint was initially the only way to introduce full colour into a photograph. Felice Beato ran a photographic studio in Yokohama, Japan from 1863 to 1877 and employed Japanese watercolourists and *ukiyo-e* woodblock printmakers to delicately tint his photographs. This Japanese girl with parasol is from a series of 100 portraits of "Native Types" which he produced from 1864 to 1867.

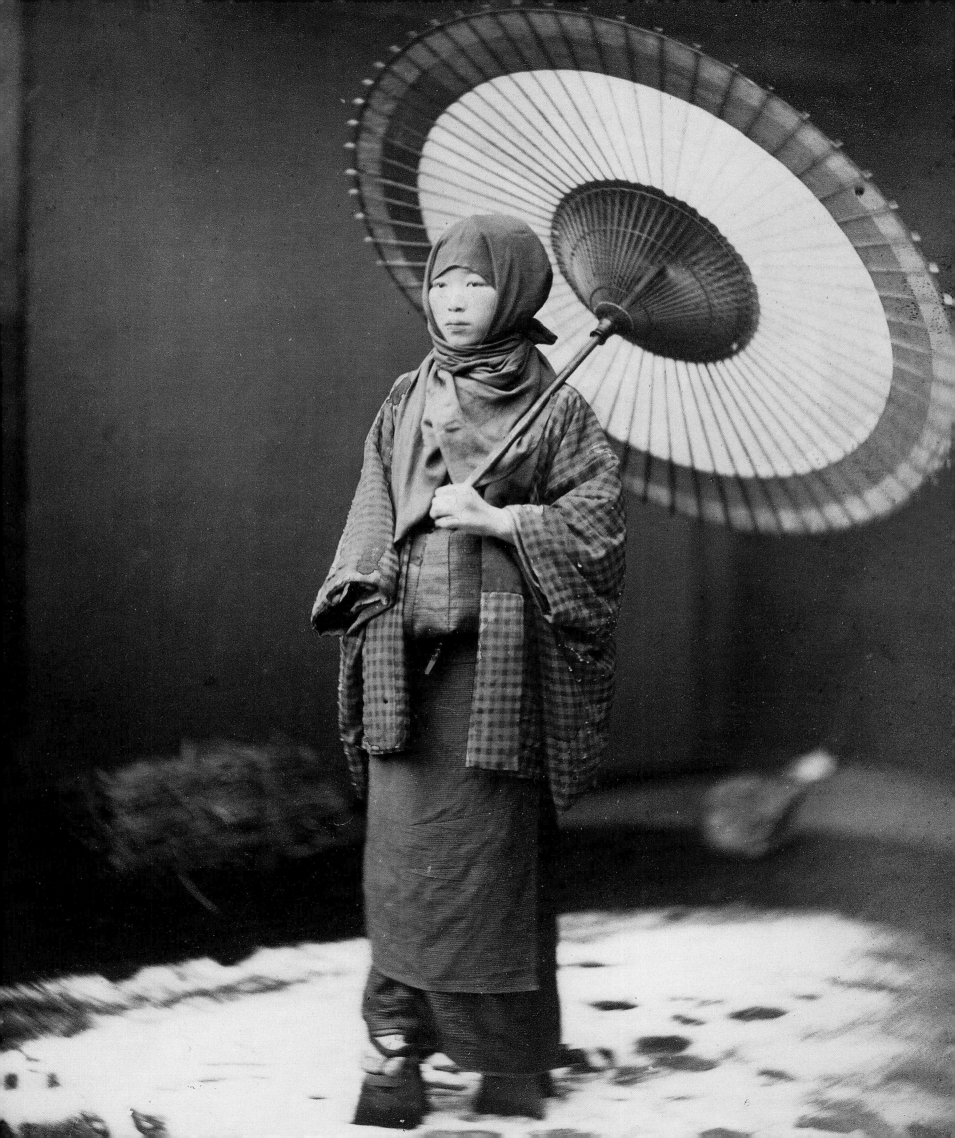

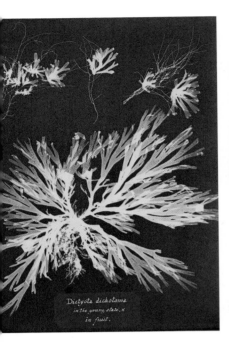

Dictyota dichotoma
in the young state, &
in fruit.

LEFT Hippolyte Bayard (1801–87) crammed his 1842 cyanotype *Arrangement of Specimens* with a variety of objects that would let light through to register on paper coated in light-sensitive chemicals. An uncomplicated process, the cyanotype also had the benefit of being permanent as well as a glorious colour.

FAR LEFT Anna Atkins (1799–1871) produced the first photographically illustrated book, *Photographs of British Algae: Cyanotype Impressions*, in parts from 1843–53. This print of *Dictyota dichotoma* [doubling weed] *in the young state, & in fruit* from part XI was made in 1849/50 and is from the album that Atkins presented to Sir John Herschel, the process's inventor, in October 1843.

Practically as soon as photography was invented, the race was on for colour. In 1840 Sir John Frederick William Herschel (1792–1871) registered colours on paper coated with light-sensitive silver chloride but was unable to fix and retain them. Even if viewed in very dim light, they eventually darkened. Herschel's cyanotype (or ferro-prussiate) process of 1842 was based on Prussian blue, a bright blue pigment used by painters. Although not a colour process in the accepted sense, the cyanotype brought a different, brighter colour into photography, could be toned to produce violet, green or red and, because it involved no silver, was cheap, relatively easy and did not fade. However, it could only be used for making contact prints (a print made directly from a same-size negative) or photograms in which objects – usually botanical specimens – were laid on sensitized paper, exposed to light and then fixed. During the nineteenth century, the cyanotype became widely used as the first reprographic process (better known as the blueprint) and was rediscovered by American pictorial photographers in the early twentieth century (see Chapter 3, pp.61, 64–66).

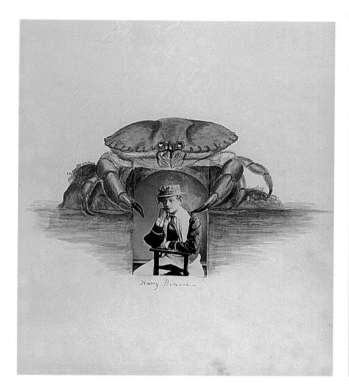

By far the most popular solution to remedy photography's colour deficiency was to add colour by means of a brush, using oil and watercolour paints or ground powdered pigments. Hand-colouring of monochrome photographs has endured ever since, ebbing and flowing as colour photography became more practicable, and is currently enjoying a minor renaissance among those who wish to invest their digital and monochrome prints with an enhanced naturalism or a more "hand-crafted" effect (see Chapter 10, pp.220–21, 233).

Artists who specialized in painting miniature colour portraits found portrait photography a serious threat to their business. In order to survive, they rapidly adapted their meticulous skills to stippling powdered pigment mixed with gum arabic on to daguerreotypes with a fine camel-hair brush, the colour then being "set" by heat and moisture in the breath as they breathed on them. A daguerreotype was an early form of photograph in which an image was directly exposed on to an iodine-sensitized silvered plate, and hence had a cold grey metallic sheen. Many surviving daguerreotypes show hand-colouring used to varying effect. Often, only minute dabs of gold leaf were added to highlight proudly displayed jewellery, with perhaps a crude smattering of pink on the subject's face to alleviate the daguerreotype's silvery-greyness. However, an expert colourist could give the sitter subtle and warm natural flesh tones.

Adding colour to prints on paper was an altogether easier affair and one which was employed on both an amateur and a professional level. Family albums of *cartes-de-visite* (visiting cards) were often skilfully hand-painted by the artistic ladies of the household to suggest pertinent aspects of the sitter's character that their studio portrait might not reveal. Felice Beato (1834–c.1907), who ran a studio in Yokohama, Japan from 1863, used local artists of immense skill and subtlety to hand-colour his albumen prints which hark back to the woodcuts of the eighteenth- and early nineteenth-century Japanese printmakers Hiroshige and Hokusai.

The search for inherent rather than applied colour went on. On May 17, 1861 James Clerk Maxwell (1831–79) demonstrated to the Royal Institution in London his findings on colour vision, derived and developed from the work of Young and Helmholtz, and previously addressed in his 1855 paper, "Experiments in Colour". For his demonstration, Clerk Maxwell made three

ABOVE LEFT Ready decorated albums, into which one could paste family photographs such as *cartes-de-visite*, were widely sold, but artistic family members, usually female, could add colour and variety to an undecorated album with watercolour paint. Here Catherine Mary Wood uses her creative skills to surround a *carte-de-visite* of the oblivious Harry Benson with a giant painted crab, *c.*1868.

ABOVE RIGHT Whether taken as a jokey reminder of a trip to the dentist or for a serious scientific purpose as a record of a man with deformed teeth and diseased gums, this anonymous French daguerreotype of 1852 has been exquisitely hand-coloured to give subtle flesh tones and hair colour. The orange and blue borders around the edges show the tarnishing of the image's silver base as it has reacted, over the past 150 years, with sulphurs in the air.

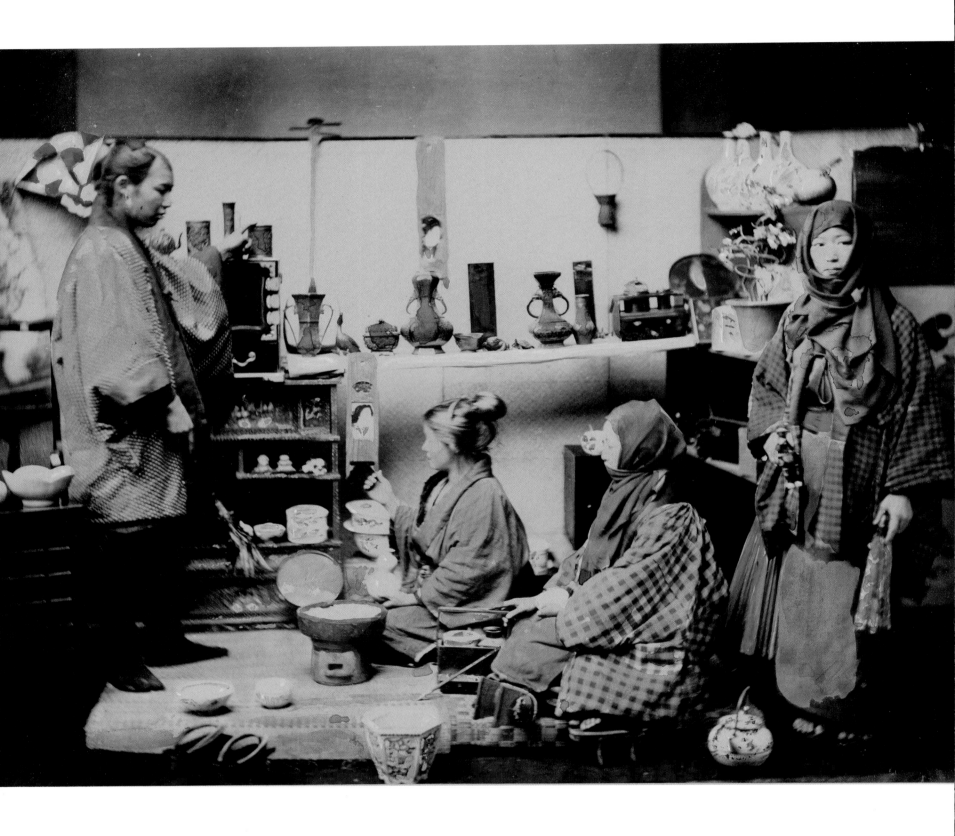

LEFT Beato's hand-coloured recreations of Japanese scenes were hugely popular and sold well, but a skilled hand-colourist could take 12 hours to produce only two to three meticulous prints. By setting up a production line, whereby one colourist concentrated on faces, another on clothes and so forth, output could be increased to 20 or 30 less perfect prints a day. This scene inside a culinary utensil shop, recreated in the studio, displays a rather overenthusiastic application of red paint.

ABOVE RIGHT James Clerk Maxwell had the photographer Thomas Sutton, a fellow lecturer at King's College London, make the negatives for his 1861 experiment, but even the accomplished Sutton was unable to make a print. It was only 70 years later, in around 1937, that a print was finally made from the original projected positive plates by Dr D. A. Spencer, using his own Vivex carbro process.

ABOVE FAR RIGHT Ducos du Hauron's earliest surviving colour experiment is this lovely 1869 tricolour *Diaphanie*, a study of leaves, petals and grasses made using *photocollographie*, a kind of collotype process producing prints in ink from a photographic image made of dichromated gelatine. Du Hauron married technical expertise with aesthetic awareness.

black and white glass negatives of a tartan ribbon and rosette, shot through three separate red, green and blue filters. He then projected three black and white glass positives made from these negatives through three magic lantern projectors fitted with the corresponding red, green and blue filters used to make the original negatives. When these three images were superimposed on the screen, a recognizable full-colour image was achieved. This was the basis of "additive" colour photography whereby the addition of red, blue and green made a full colour range. The most successful commercial realizations of this colour principle were the autochrome (see Chapter 2, pp.20–55) and, many years later, colour television.

Over the next few decades, many other processes using projected additive photography on glass were also popular, including those developed by the astoundingly prolific inventor Frederic Eugene Ives (1856–1937), Professor Adolf Miethe (1862–1927) and Sergei Mikhailovich Prokudin-Gorskii (1863–1944). With a great deal of difficulty, some were even registered on paper (see Chapter 3). But the difficulties of achieving the much-desired colour on paper by the additive process – a colour print was only finally made from Clerk Maxwell's negatives in the 1930s by the Vivex process (see Chapter 4, pp.86–87) – meant that a different method was required. Still based on Young's colour theory, "subtractive" colour photography was the principle from which all future twentieth-century colour photography was derived. Rather than add the three colours together to make all colours, the subtractive process subtracts some colours from white light while allowing others to remain – in other words, it uses the selective removal of wavelengths from light to produce a colour.

As with all great visionary ideas, the theoretical basis is often understood way before the practical application can be realized, because areas of the technology necessary to convert theory into practice have not yet been invented. This was just as true of colour photography as of any other innovation: in the nineteenth century many pieces needed to complete the colour photography jigsaw were still missing. From 1859, Louis Ducos du Hauron

(1837–1920) anticipated, described and occasionally was able to demonstrate practically every future development in colour photography over the coming 80 years. Amongst his propositions was a filter colour line screen process (realized by Joly and McDonough – see p.19); a mosaic screen-plate additive process (invented by the Lumière brothers as the autochrome – see Chapter 2); a one-shot colour camera using triple negatives (a technique which he named Heliochromy and which was the mainstay for producing subtractive colour photography on paper for more than 50 years – see Chapters 3 and 4); and a tripack film system (finally achieved by Kodachrome in 1935).

On May 7, 1869, Ducos du Hauron first publicly demonstrated his subtractive colour photographs on paper at the Société Française de Photographie (SFP) in Paris, having patented his research on tricolour photography on November 23, 1868. (His 17-page British patent was granted in 1876, the first on any aspect of colour photography in the UK). Because the more sensitive panchromatic emulsions he needed had not yet been invented,[1] the relative insensitivity of the materials he had at his disposal meant that the colour balance of his photographs was flawed. That same year, he published his ideas in a book entitled *Les Couleurs en Photographie: Solution du problème*[2] (*Colour in Photography: the solution to the problem*) and he continued to patent and publish although his discoveries made negligible impact. Despite his brilliance, he gained little economic profit from any of his inventions and lived much of his life in relative poverty. Only belatedly were his achievements recognized by the French government when he was made a Chevalier of the Légion d'Honneur in 1912 and awarded a small pension. Since that date, twentieth-century research and practice has established his contributions.

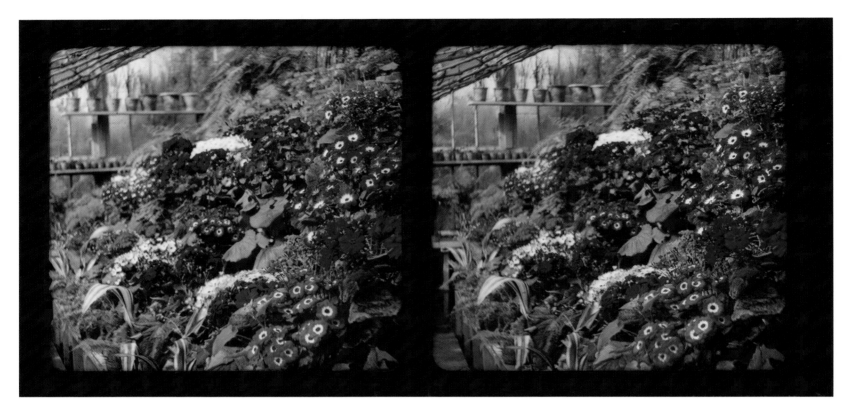

Coincidentally, Charles Cros (1842–1888) presented a paper on colour synthesis at the same meeting of the SFP as Ducos du Hauron in 1869. Arriving at many of the same conclusions, he also anticipated the 1940s dye transfer process. Again, he was unable to put many of his theories into practice or capitalize on them and he died before he saw them realized.

The early colour inventor who profited most from his various inventions and who, over the next 50 years, continued to be obsessed by colour photography was the combative American Frederic Eugene Ives. Ives had registered several patents and enjoyed a successful career in halftone printing and photogravure before he concentrated his formidable energies on colour. He had been working on his Photochromoscope single-plate camera since 1888. This exposed three separate black and white negatives on a single plate through blue-violet, green and red filters. Three glass positives were then made by contact printing and subsequently cut to separate them and viewed through Ives's Chromoscope viewer: this had the same colour filters as the camera and three mirrors which optically superimposed the three positive colour separations, creating a full colour image. Like Clerk Maxwell's demonstration 30 years previously, a colour image only existed when viewed or projected and, like Prokudin-Gorskii's process 15 years later, it could only be printed on paper with a great deal of labour on the part of the inventor.

Ives named his various additive colour systems Kromskop and the resulting images Kromograms. There was a Kromskop stereoscopic viewer which retailed for £5 in 1895. Through this could also be viewed ready-made stereo Kromograms, taken with a Kromskop camera, on a wide variety of subjects which Ives also supplied at the cost of 5 shillings each. Eventually, a whole family of Kromskops was on the market including a Junior and a Lantern Kromskop. Ives's promotional literature modestly described this invention as "invaluable for Evening Parties, At Homes, Conversaziones, Garden Parties &c, &c, and is the most beautiful invention of the nineteenth century".

In 1891, a very different colour process was announced which initially appeared to have great potential. Professor Gabriel Jonas Lippmann's (1845–1921) direct interference

ABOVE The aesthetic content of F. E. Ives's images did not always live up to the brilliance of his ever inventive mind, but this 1899 stereo Kromogram of the interior of a greenhouse is beautifully composed, with the rows of terracotta pots and panes of glass in the background balancing the riot of floral exuberance in the foreground. Viewed in 3D through an Ives Kromskop viewer, the image would be breathtaking.

RIGHT Dr Richard Neuhauss's parrot (1899), like Ducos du Hauron's rooster and budgerigar, was a product of the taxidermist's studio. A 10- to 20-minute exposure time would suggest that the poor stuffed creature was, indeed, nailed to its perch. Unfortunately for exotic birds, the radiance of their plumage made them natural subject matter for experimentation in colour photography.

FAR RIGHT John Joly, who in 1897 became Professor of Geology and Mineralogy at Trinity College Dublin, was just a few years ahead of his time with his screen process which, to work successfully, needed a more colour-sensitive emulsion than was currently available in 1895. His surviving photographs have a pleasing simplicity and elegance, the products of a sharp and lively mind. Joly later went on to estimate the age of the earth, work out how sap rose in plants and develop radiotherapy for the treatment of cancer.

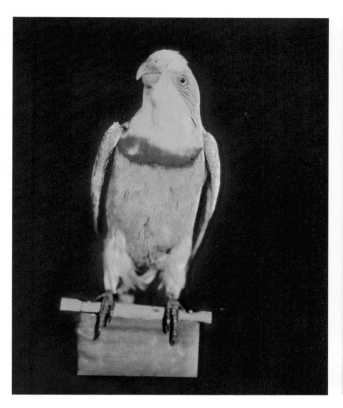

process, presented on February 2, 1891 to the Académie des Sciences in Paris, used neither dyes nor pigments and was neither additive nor subtractive; instead, it created colours through the creation of interference patterns between light waves. Using mercury to reflect light into the photographic emulsion, the resulting image looked like a brightly coloured daguerreotype or an early hologram (and holography later developed from these same principles). However, the process required a long exposure, the technique was complex and the end result had to be viewed held at a suitable angle in reflected light. While it never entered the mainstream, the Lippmann process was taken up with alacrity by a select audience including, briefly, the Lumière brothers and Dr Richard Neuhauss, who produced 2,500 Lippmann process photographs between 1894 and 1904. In 1908 Lippmann was awarded the Nobel Prize for Physics for the demonstration of undulatory theory in his colour photographic work.

As the nineteenth century drew to a close, it finally seemed that Professor John Joly (1857–1933) had achieved a viable working colour process when he launched the Joly Colour Process in 1895. A fine screen of lines less than 0.1mm wide of red, green and blue-violet dyes mixed with gum was precision-ruled on to a glass plate coated with gelatin. When exposed against a sensitive emulsion, developed, printed and registered, a full-colour lined image was produced. Although rather beautiful, it was expensive and the colour range was limited. Extant plates tend to have a pinkish cast.

Like the similar research of Ducos du Hauron and Cros in 1869, Joly was not alone in his inspirational thinking and a similar process was patented by James William McDonough in the USA in 1896. In 1892, McDonough had patented a random-patterned mosaic screen process made up of powdered grains of shellac, resin or gelatin dyed red, green and blue, dusted on to a plate and then coated with a light-sensitive emulsion. However, he had not manufactured it. Just a few years later, in 1907, the Lumière brothers' autochrome, based on a very similar mosaic screen technology, but using dyed starch grains derived from potatoes as the powdered base, became the most successful colour process then invented, both aesthetically and commercially.

2 THE AUTOCHROME

1907–1932

On June 10, 1907 in Paris, France, Louis Jean Lumière (1864–1948) and Auguste Marie Nicolas Lumière (1862–1954) began a revolution in colour photography when they demonstrated the autochrome, the first commercially available colour process, to a specially selected audience of 600, including the movers and shakers of the day – artists, writers, politicians, the press and, of course, photographers. Unlike previous nineteenth-century experiments with colour, the autochrome was the first colour process that was simple enough to be mastered by all competent photographers, not just by its inventors.

The Lumière brothers, especially Louis, had a seemingly inexhaustible genius for photographic invention (Auguste was eventually more interested in medical research, but all their photographic research, patents and publications were attributed to both). Born in Besançon in eastern France, the Lumière boys moved with their family to Lyon in 1870 where their father, Antoine (1840–1911), opened a photographic studio. After a scientific education at La Martinière, one of Lyon's top technical schools, the 17-year-old Louis perfected the chemistry of the gelatin-bromide emulsion invented by Richard Leach Maddox (1816–1902) to increase the speed of dry-plate negatives. The family opened a factory to manufacture these "Etiquette Bleue" plates in Monplaisir, a Lyon suburb, in 1883, and Lumière Co. was in business. The company rapidly became the largest photographic manufacturer in Europe as it expanded into other photographic areas, eventually producing film for the fledgling American motion picture industry.

In 1895 the Lumières patented their invention of the Cinematograph. In December of that year, at the Grand Café in Paris, they showed a selection of 10 of their motion pictures including the first that they had made, of their workforce of 900 leaving the factory. Having dealt with moving photography, Louis was now able to turn all his attention to colour, his true passion. Familiar with Ducos du Hauron's body of work and using the principles the former had established 30 years previously, he experimented ceaselessly and researched many different permutations of producing images in colour.

Over the next few years the Lumières published several articles on their colour research and, on December 17, 1903, they registered their "autochrome" process as French patent no. 339,223. After a successful presentation to the Académie des Sciences in Paris on May 30, 1904, they built a new plant to manufacture the plates involved in the process, and

RIGHT Taken at St Paul de Varax, 45km (28 miles) from Lyon, and attributed to France Lumière, the Lumière brothers' younger sister, this autochrome of *c.*1909 shows Louis Lumière, watched by his brother Auguste, concentrating intently on crocheting an intricate ladies' collar in pink cotton, demonstrating both the autochrome process and his own rather surprising expertise with a crochet hook.

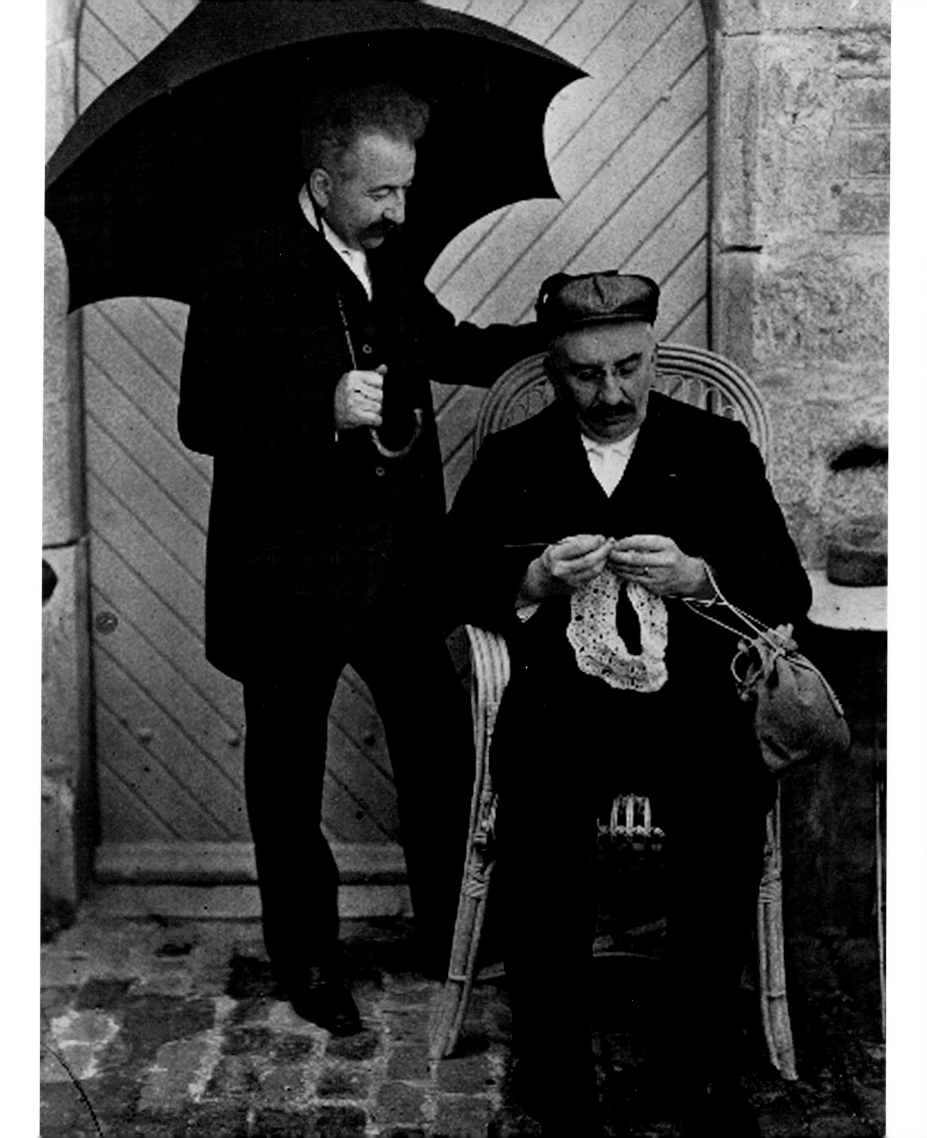

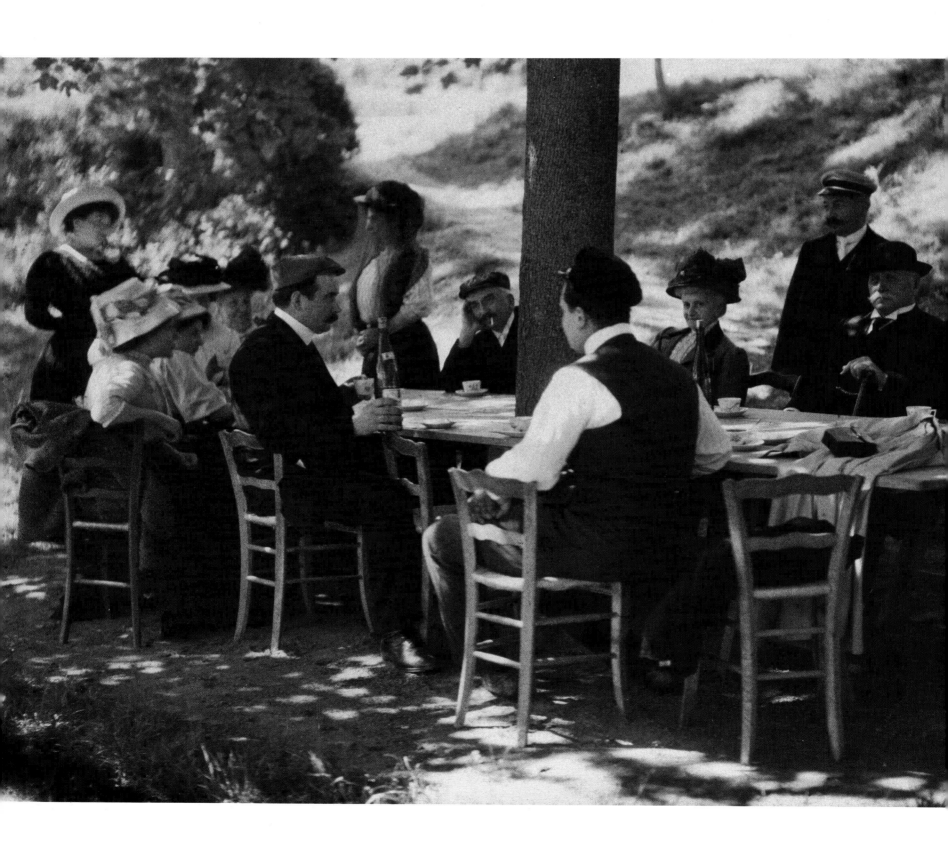

improve them over the next couple of years. By the date of the public demonstration of the autochrome, held at the Photo-Club de Paris in the offices of *L'Illustration* (France's first illustrated magazine, founded in 1843), the success of the new technique, 14 years in the researching, was practically guaranteed. The expectation was palpable.

The process employed to produce an autochrome involved microscopic grains of potato starch,[1] measuring between 0.01 and 0.02mm in diameter (although measurements of extant plates reveal an actual grain size range of 0.006–0.025mm). There were 7,000 grains to a square millimetre, 140 million grains on an average-sized glass plate (5 x 7in/13 x 18cm) dyed orange-red, green and blue-violet, which acted as tiny colour filters. These were mixed in roughly equal proportions, dusted on to a glass plate coated with latex-based sticky varnish, with carbon black (crushed charcoal) filling the interstices between the grains of colour. The whole plate was then covered with the new and more sensitive fine-grained panchromatic silver bromide emulsion. On exposure in a camera, with the emulsion furthest away from the lens, light would pass through the colour filters before striking the emulsion and registering an image. The autochrome's great advantage was that it could be used in any plate camera and did not require special equipment, apart from a yellow/orange filter to cover the lens to correct the excessive sensitivity of the emulsion to blue and ultra-violet light.

The processing and developing of the plate after exposure could also be quickly learnt by any photographer used to processing his or her own black and white negatives. Although the minute coloured grains tended to form clumps visible to the naked eye, this Pointillist effect became one of the autochrome's greatest attractions. The main disadvantage was a very slow exposure speed, at least 20 times longer than that of a black and white negative exposed in similar light conditions. One to two seconds at an aperture of f8 in very bright midday sunlight was not unusual, while several times that was the norm on a cloudy day. Ironically, the price of twentieth-century colour was a return to nineteenth-century immobility while the exposure was made – and this was especially paradoxical given that the Lumières' other

iconic invention was movie film. However, by September 1908 practised photographers such
as Alvin Langdon Coburn (1882–1966) were soon achieving "snapshot" autochromes of a
tenth of a second exposure with an f3 lens.

Widely regarded as the most beautiful photographic process ever invented, the autochrome
was luminous and lush, and put an Impressionist palette at the photographer's disposal. Its
distinctive colour quality encapsulates both a style and a particular historical period, while
its romantic appeal is no doubt enhanced by the fact that, during its first seven years, the
autochrome captured an era which abruptly ceased to exist in 1914 when World War I began,
almost as if it had never been. And yet the medium captures nothing so well as it captures
reality, albeit with an unreal shimmering Impressionist colour cast and an atmospheric depth.
In the world depicted in these early autochromes, it seems to be always golden summer, the
skies always blue, the gardens bursting with perfect red, orange and blue flowers (the process
was not so successful at registering yellow accurately). With its emphasis on the domestic
and the familiar – children happy, content and trembling with unrealized potential, women
beautiful and languorous, flamboyantly and artistically dressed in their most colourful clothes
– the autochrome presents a world of nostalgia where there is still excitement about the
possibilities of the new century, long before that century's horrors kicked in.

The simplicity of the autochrome process was a key factor in its appeal to the photographer.
Although underexposure is the most frequent problem, it is rare ever to see a truly awful
autochrome, however ungifted or inexperienced the photographer (the worst ones were probably

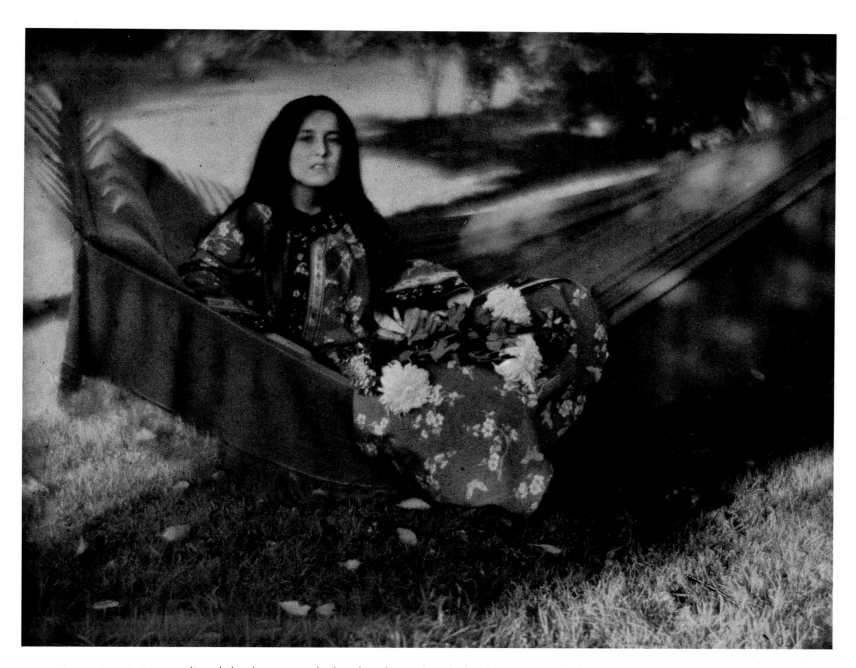

ABOVE The autochrome's ability to capture red so effectively has been fully utilized by Alvin Langdon Coburn here in his 1908 portrait of Elsie "Toodles" Thomas wearing a red Chinese robe and seated on a red hammock. The Chinese theme is further invoked by the addition of yellow chrysanthemums.

discarded and many may also have been lost or destroyed in the past century). The technology was all built into the autochrome plate itself and worked automatically if the instructions were followed to the letter. At first, there was little possibility of manipulation or of improvement – dodging, burning and tweaking – to be done in the darkroom. But the autochrome did require a colour vision which many photographers did not initially have. A knowledge of which tones and colours, highlights and shadows, foregrounds and backgrounds worked best together in monochrome on paper did not transfer to this new process of colour on glass, which required a whole new visual vocabulary and a new understanding of the rules of chromatic relationships.

But the artist-photographers of the various Secession and Pictorial movements that were widespread in Europe and the USA at the time, who espoused a naturalistic style and sought to emulate fine art, initially seized on the autochrome as if it were the Holy Grail. Edward Jean Steichen (1879–1973) was in the Paris audience for the initial demonstration, as was Marcel Meys (1885–1972), both of whom were to become superb practitioners of the autochrome over the next few years. Although it is not known if he attended the demonstration, Charles C. Zoller (1854–1934) was also in Paris at the time and most likely

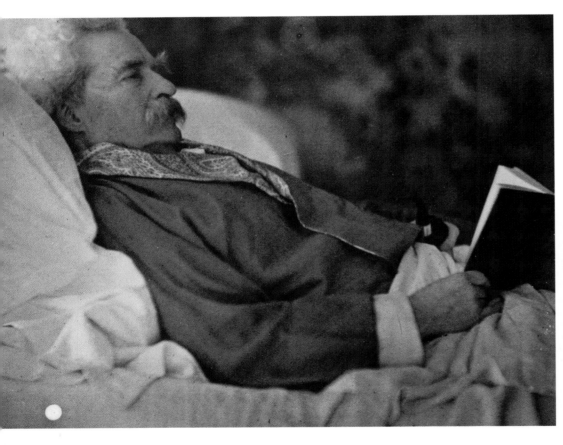

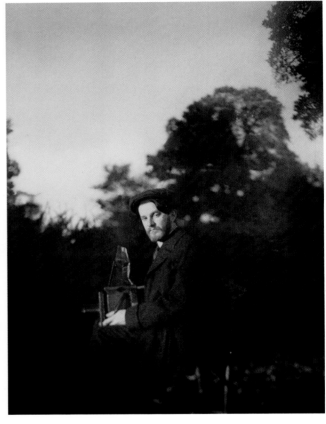

bought plates to take back to the USA. Steichen, although disappointed with the image content and quality of the plates that the Lumières showed, immediately bought plates, experimented for a week and achieved results which were thought, by his immediate circle, to surpass anything the mere inventors of the process could produce! However, this was perhaps an unfair judgement as the Lumières' own autochromes of their family life have great relaxed charm and are shot through with the warmth, love and humour of a happy domestic record. Steichen then quickly taught Alfred Stieglitz (1864–1946), who was also in Paris on that eventful day but unable to attend the demonstration because of illness.

In a positive whirlwind of autochrome activity over the next few months, Steichen met up with Stieglitz, Frank Eugene (1865–1936) and Heinrich Kühn (1866–1944) in Tutzing near Munich, where all four practised their "autochromery", Steichen and Stieglitz having stocked up on plates in Paris. Between them, the photographers discovered "quite some elasticity" in what could be achieved on the plates. Steichen then autochromed George Bernard Shaw (1856–1950) and others in London, and subsequently taught Alvin Langdon Coburn the process in Paris when the latter went over there to buy plates, as yet unavailable outside France. The Lumière factory could not meet the excessive demand and by July 1907 it was doubling its production every three weeks, despite the fact that one autochrome plate cost the same as 12 dry plate black and white negatives of the same size.

The first autochromes for sale outside France did not reach London until September 1907, New York until October 1907, and then were at least twice the French price.[2] Coburn autochromed Shaw and Shaw autochromed Coburn. The press was full of articles on colour and a Society of Colour Photographers was speedily formed in London. In September 1907,

ABOVE LEFT Coburn and Archibald Henderson (Professor of Mathematics at the University of North Carolina but also Twain's biographer) visited Twain's new home "Stormfield", in Redding, Connecticut on December 21, 1908. Coburn, who had photographed Twain in New York in March 1905 in monochrome, made 30–40 exposures including several autochromes. This image, utilizing the contrast between Twain's snowy white hair and rich red dressing gown, was used as the frontispiece in Henderson's subsequent biography.

ABOVE George Bernard Shaw, a keen if only passable photographer, was taught the autochrome process by Coburn. Shaw's portrait of Coburn holding his autochrome camera was most likely taken on October 21, 1907 when Coburn and Shaw had an autochrome session at the latter's home in Ayot St Lawrence, Hertfordshire. The original autochrome was subsequently shattered into more than 20 pieces and some shards were lost. This image comes from an early digital reconstruction of 1993.

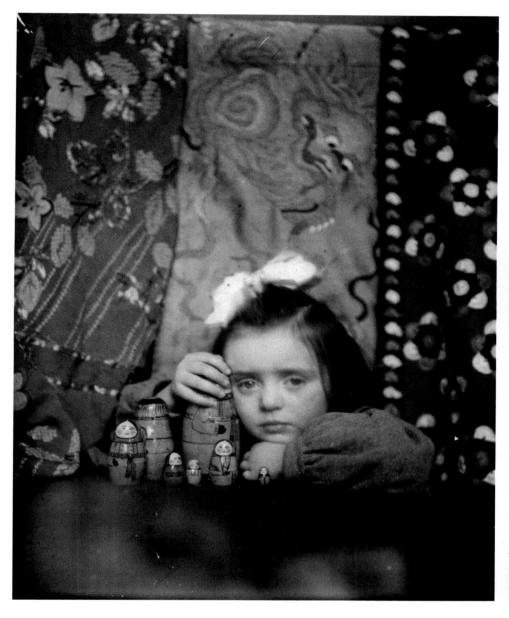

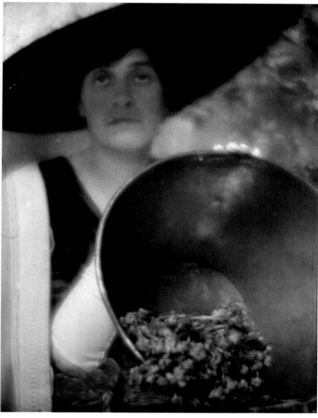

Houghtons Ltd of London rushed out a guide entitled *Colour Photography with the Lumière "Autochrome" Plates* written by George E. Brown and C. Welborne Piper who had been experimenting with the plate since July 1 of that year. Stieglitz wrote of the world going "color mad".

In these first few heady months, those who produced the best autochromes were those who already had a background in colour vision through art. In the hands of experts like Kühn, Steichen, Coburn or John Cimon Warburg (1867–1931), the results are breathtakingly glorious and startlingly emotional, the subject matter often being their children and friends – but seemingly more beautiful children and more photogenic friends than those of other photographers.

Steichen, a painter as well as a photographer, moved in artistic circles and had already experimented with various ways of adding colour to his photography – using coloured gum layers and inventing his own colour processes as well as using those of Dr Adolf Miethe and others (see Chapter 3, pp.58–60, 65–66). Over the next 60 years, Steichen would successfully and exhaustively experiment with every colour process that each new decade discovered and become something of a colour barometer. Most of his autochromes (and early tricolour negatives) were damaged or destroyed when he was forced to abandon his home in France during World War I, but those few that remain show his easy mastery of the process and his adoption of a distinctively harmonious but vibrant colour palette.

Coburn trained his "colour eye" through painting lessons with Arthur Wesley Dow (1857–1922) at the latter's summer school in Ipswich, Massachusetts, in 1903 and with the artist Frank Brangwyn (1867–1956) in London from 1905. He put his colour knowledge to

ABOVE LEFT Edward Steichen's first daughter Mary was born in 1904 and fulfils the dictum that the autochrome process was especially successful for photographing children. Against a background of three busy strips of woven and embroidered textiles, silks and wools, and clutching her brightly coloured wooden dolls, Mary herself appears oddly colourless but yet, with her unblinking gaze, is the heart of this loving image, taken *c.*1908.

ABOVE RIGHT Steichen gives Alfred Stieglitz's first wife Emmeline the full Pictorial treatment here *c.*1910, having her clutch the requisite aesthetic prop – the copper bowl – and stare vacantly into the middle distance. The image's strength and appeal comes from the balance between this formal structural composition, the curve of the hat echoing the curve of the bowl, and the intense blue of the tumbling bunch of flowers. Unusually, Steichen signed this autochrome just underneath the flowers.

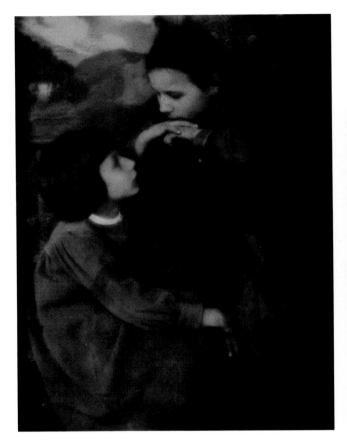

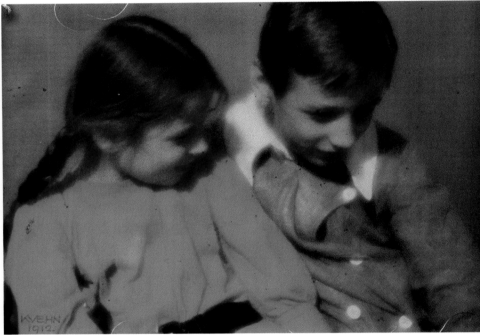

glorious use in both his early coloured gum-over-platinum prints and his autochromes. But while being distracted by the autochrome, he was simultaneously learning the photogravure printing process. Eventually, his urge to produce multiple copies of books illustrated with monochrome photogravures – such as *London* (1909), *New York* (1910) and *The Door in the Wall* (1911) – triumphed over his desire to continue to use the autochrome, which was proving impossible to reproduce reliably on paper.

Kühn moved in artistic Viennese Secessionist circles, was a friend of the painter Gustav Klimt (1862–1918) and, like Steichen, had been working with colour for several years, using, perfecting and exhibiting his complex multicoloured gum prints since 1897. He seems to have mastered the autochrome instantly and instinctively, using his personal domestic life as subject matter. He created his own distinctive, and very pure, colour palette of reds, greens, blues and whites – colours achieved by none of his contemporaries, which made his autochromes immediately recognizable. Writing in 1907, Kühn warned, "Only somebody who possesses a delicate sense of colours should work with the autochrome process, the palette is somewhat dangerously colourful."[3] Despite the autochrome's supposed inability to be manipulated, he managed to find a way to use an intensifying solution locally on the plate.

Kühn's exposures are also suffused with a huge emotional charge. His wife had died two years previously in October 1905, leaving him a widower with four young children: Walter, (Edel)Trude, Hans and (Char)Lotte, all under the care of a Scottish nurse, Mary Warner. One wonders if the very dashing and photogenic Miss Warner was employed as the children's nurse, helpmeet and surrogate mother because of her gloriously autochromable red hair? To hold Kühn's autochromes in one's hands is to feel, at a jolt, the palpable love and grief with which he invested his work and with which his sad-eyed children posed.

ABOVE LEFT Heinrich Kühn used the autochrome process for longer than his fellow art photographers, from 1907 to 1912, and was expert at capturing jewel-bright colours. In this *c.*1908 autochrome, his children Hans and Trude, dressed in identical blue smocks, pose in front of a landscape painting (or perhaps one of Kühn's large multicoloured gum prints?) in a room hung with Arthur Silver's 1887 peacock-feather patterned wallpaper designed for Liberty of London.

ABOVE RIGHT Lotte and Hans Kühn in 1912. To avoid blinking, Kühn's children rarely look at the camera and they were obviously expert, after several years of practice, at remaining immobile during the lengthy exposure time.

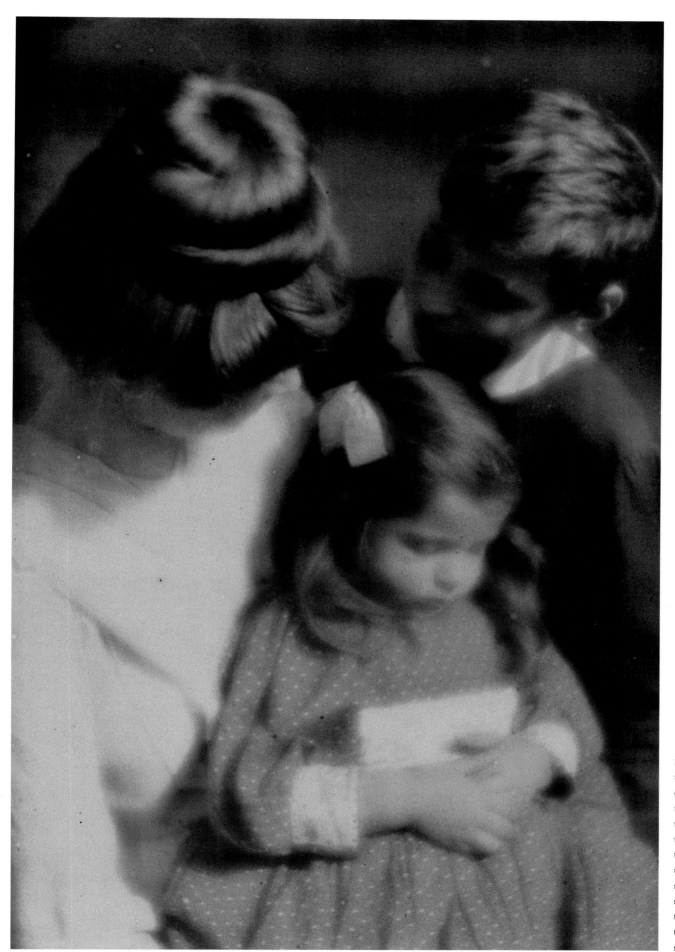

LEFT A prime contender for being the most beautiful autochrome ever taken, the strength of this image by Kühn lies in the triangular composition of the three bent heads, emphasizing the close and supportive family unit. But it is the coiled shining spiral of governess Mary Warner's spectacular auburn hair that pulls the eye into the image and down to the loosely clasped hands of the seemingly sleeping Lotte.

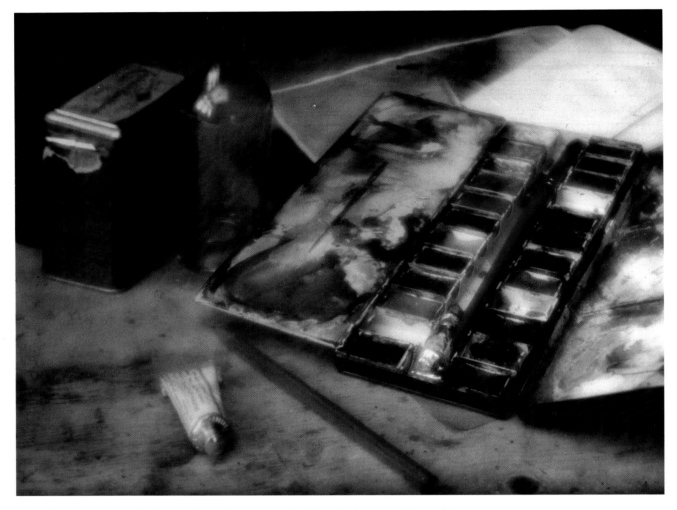

Warburg was a British photographer who practised and excelled in every form of late nineteenth- and early twentieth-century photography from the brown-toned albumen print, through platinum, gum and his own invented processes. He spent several years utterly dedicated to the autochrome, achieving his own distinctive colour palette best demonstrated in his wistful, Whistleresque hazy watery landscapes and seascapes in washed-out, almost bleached, pastels, occasionally punctuated by startling splashes of primary red, blue and green. The independently wealthy Warburg had the time and the expertise to practise and achieve the very particular results he desired. He wrote extensively and informatively about his colour work in the British photographic press and, while his autochromes are not so well known as those of his American and European contemporaries, they are equally distinctive in an unshowy, understated way.

The autochrome's great attractions – its uniqueness, its relative ease of use, its transparency, luminosity and fragility – also became, for most of the artist-photographers, its major problems. Like the daguerreotype 70 years before, the autochrome was a single one-off image from which it was impossible to make multiple copies. As a transparency on glass, with a glass cover to protect the image layer, that was then bound with paper tape around the edges to hold the whole thing together, it had to be viewed against a backlight or in a diascope, a special reflecting hand-held viewer – or, for lecture purposes, as a projected image with very strong rear illumination owing to its density. Because of the need for a light

ABOVE Kühn's statement of his artistic credentials – *Der Tisch des Malers* (*The Painter's Table*) – is another complex composition drawing the eye into the image via the well-used paintbox and the reflections on the bottle to the top left-hand corner, where the tin of W. D. and H O. Wills leaf tobacco punctuates the image.

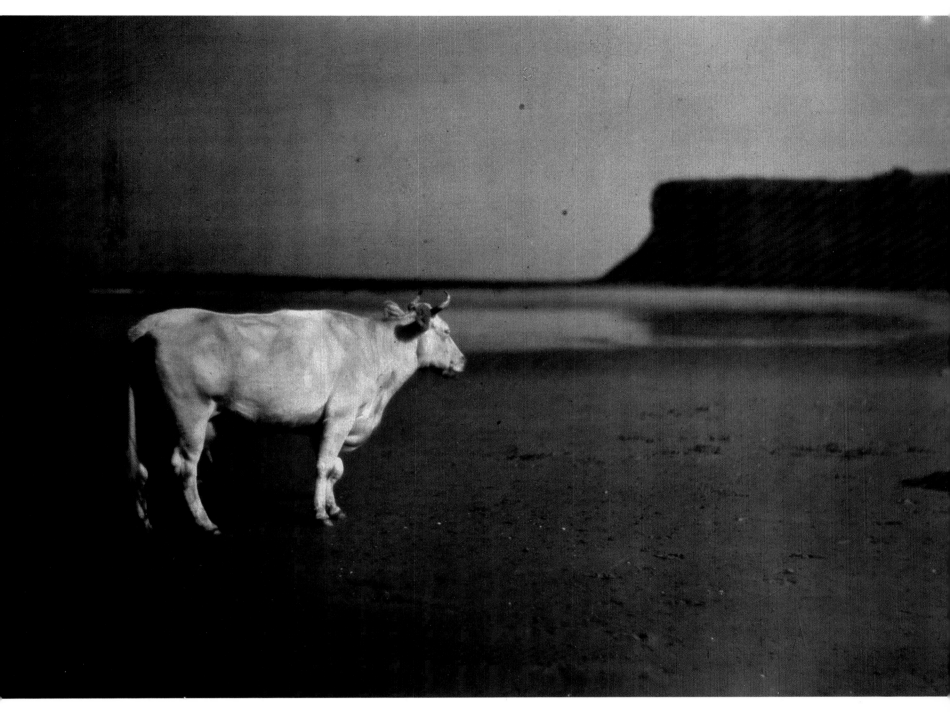

source, the best way therefore to look at both an autochrome and a daguerreotype was to hold it in the hands as a one-on-one experience. Consequently they were almost impossible to display in an exhibition and could never be a shared viewing experience for a gallery audience in the same way as a framed print hanging on a wall.

For the Secessionist artist-photographers like Coburn, Steichen, Stieglitz, Clarence Hudson White (1871–1925) and Baron Adolf de Meyer (1868–1946) – all of whom initially embraced and exhibited the autochrome with huge enthusiasm but for whom exhibition display was a raison d'être – the autochrome's inability to be hung on a wall alongside their beautifully printed, mounted, signed and framed photographs on paper presented a problematic aesthetic and design conundrum. The perfect negative, followed by exquisite and time-consuming printing on paper, using all their art and soul, skill and sensitivity, was their métier: so where did the almost "ready-made" autochrome fit into this aesthetic?

The secondary purpose of exhibiting work in a gallery was to sell it, but the buying public were unconvinced by the high prices that photographers had to put on their autochromes which, by definition, were all unique originals. Nor was there a market for commissioned autochrome portraits for the same reasons. The average portrait sitting required six to eight negatives from which the best was chosen, not an economically viable proposition with the more expensive autochrome. Although Stieglitz showed six separate autochrome exhibitions in his 291 Gallery in New York between September 1907 and February 1910, the jarring

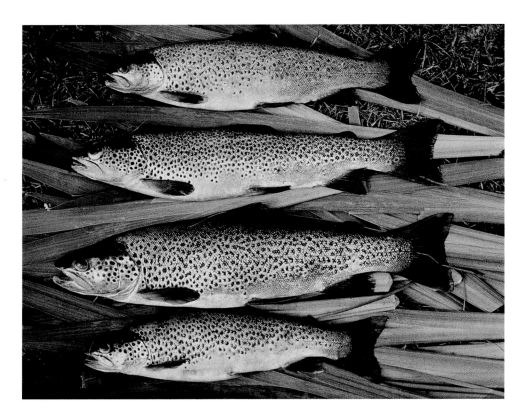

display styles of colour and monochrome obviously jangled his artistic nerves and the initial passionate love affair with colour was soon remembered only as a brief dalliance.

Autochromes were also initially problematic, and costly, to reproduce well in books and magazines, at a time when photographically illustrated books and magazines were rapidly becoming a huge growth market and, for photographers, a vital form of both visual and textual communication and thus publicity. In 1908, Stieglitz reproduced autochromes in *Camera Work* 22, the American *Century* magazine used two of Steichen's autochromes and the British *Studio* magazine had a special colour issue organized by Coburn. But autochrome reproduction was complex, expensive, and the colour often flat and dull compared with the translucent originals, even when printed in four-colour half-tone. Nonetheless, the magazine *L'Illustration* featured four autochromes by Léon Gimpel (1878–1948) in its issue of June 15, 1907 and frequently afterwards, until it folded in 1944.

The publications edited by Dr Fritz Schmidt (active 1907–1914?), *Meesterwerken der Kleuren-Photographie. Eene verzameling van opnamen in de natuurlijke kleuren door middel van Lumieres autochroomplatten*[4] (*Masterworks of Colour Photography. A collection of photographs in natural colours using Lumière's autochrome plates*) and a similar series entitled, *Farbenphotographie: Eine Sammlung von Aufnahmen in natuerlichen Farben*[5] (*Colour Photography: A collection of photographs in natural colours*) were published as separate issues from 1912 to 1913. Of course, reproduction improved over the years and *National Geographic* magazine published over 2,000 autochromes and later Finlaycolors (2,355 in all) between 1914 and 1938 but, again, once an autochrome was reproduced on a matt paper base, it lost all the glowing, glassy translucency and personal intimacy of the original, which somewhat defeated the purpose.

The glass support that gave autochromes their beauty and unique shimmering appeal was also prone to breakage if handled badly, exposing the fragile image layer to dirt, damp and mould or to physical abrasion, leading to emulsion and therefore image loss. As unique items, they were irreplaceable once broken or damaged. In contrast, if a paper print, however beautiful, was damaged, another copy could always be printed from the negative.

LEFT Baron Adolf de Meyer's flirtation with the autochrome process was fleeting and he mainly used it to photograph simple still lifes. Here four freshly caught brown trout have been simply laid on the ground, but the tight composition in the camera renders the image elegant and graphic.

RIGHT Intriguingly, the spots of damage or mould on the surface of Wladimir Nikolaiovich Schohin's 1910 autochrome of breakfast eggs only add to its appeal, suggesting the sort of speckled egg that is most visually nostalgic. It is hard to believe that an image of such modern simplicity, its lighting emphasizing colour and form, was taken almost a century ago.

BELOW Both Emmanuel Sougez and Schohin capture the elusive and difficult to achieve bright yellow in their autochromes. Sougez, a photographer, writer and critic, more generally worked with a large-format camera in monochrome. He established the photography department of *L'Illustration* magazine in 1926 and later became editor of *Photographie*.

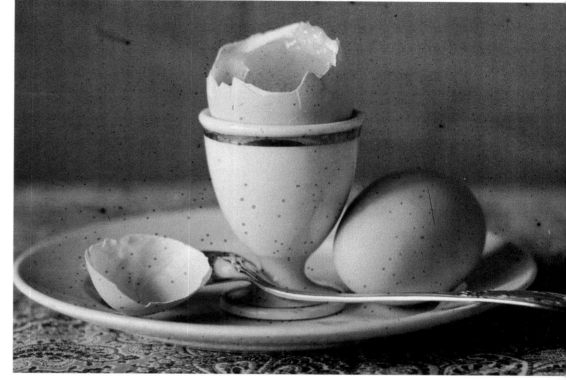

But perhaps what really sounded the death knell of the autochrome for the artist-photographers was that they could not control the process or have much variety of artistic input into the end product, despite the "elasticity" that Kühn, Steichen, Warburg and others were eventually able to find and exploit. Initially, the plates were unreliable, the emulsion quality varying unpredictably from batch to batch, making consistent results unachievable and leading to high and expensive plate wastage. (In the USA in 1910, a dozen 3¼ x 4in plates cost $4.50; a dozen 4 x 5in cost $6.00; a dozen 5 x 7in $7.50; and a dozen 6½ x 8½in $12.00.) Subject matter, too, was necessarily limited to inanimate objects, such as still lifes, buildings, garden flowers or collaboratively non-moving humans, clothed or unclothed, owing to the long exposure times, which could be as much as a minute in low light. And this was at a time when moving picture technology was revealing a speedier new reality and when standard monochrome negative/positive photography was getting faster and enabling intriguing possibilities.

To some, the autochrome eventually seemed to be little more than a return to the long "posed" exposures of the nineteenth century, even in the brightest light – albeit with the glory of colour. Gradually, and certainly by 1913, most of the artist-photographers had moved away from the warm, translucent embrace of the autochrome and returned to the familiar cold paper of the monochrome print. This was often by necessity since, once current stocks were depleted, World War I made long-distance supply of autochromes outside France problematic and disjointed.

But despite these constraints, some glorious images were made between 1907 and 1932, epitomizing how most photographers' colour work reflected a different or expanded vision from their previous monochrome work and perhaps signposting an artistic direction they did not wish to pursue. De Meyer's few autochromes of flowers and fish are the sharpest and most realistic images he ever produced, showing a totally different, almost brash eye compared with the rest of his delicate soft-focus output. The still lifes of Wladimir Nikolaiovich Schohin (1862–1934) and Emmanuel Sougez (1889–1972) exude a sense of calm

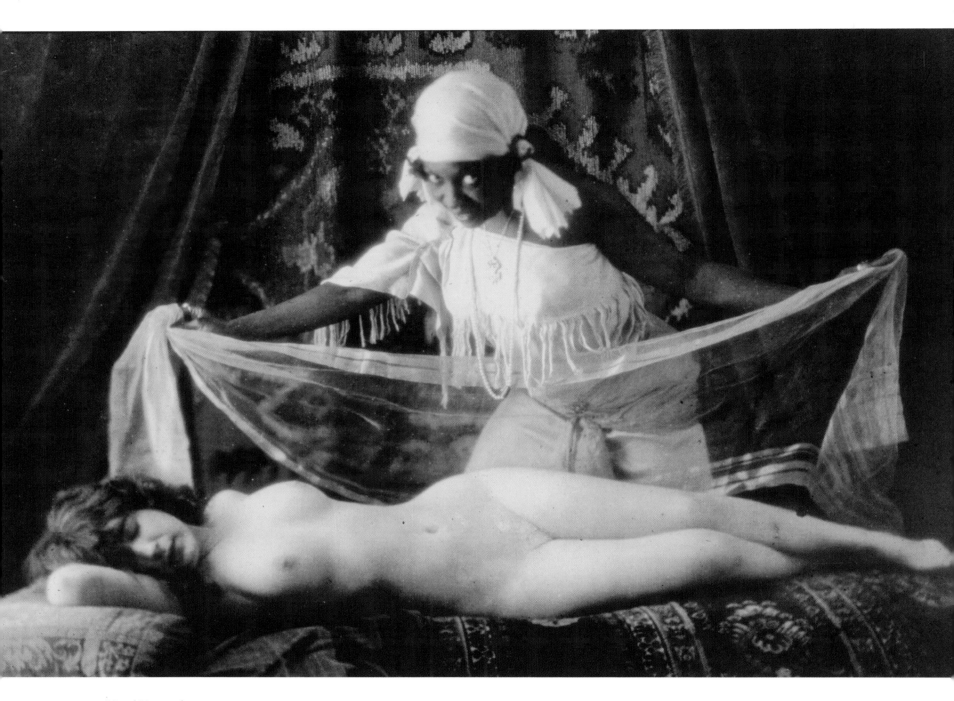

ABOVE Marcel Meys made many
nude studies in his colour and
black and white photography, also
working in stereo. When he was a
14-year-old schoolboy, his exercise
book full of nude drawings was
confiscated, but he continued
to pursue this direction in his
subsequent successful career in
photography and painting. Meys
created exotic tableau such as this
Olympia, *c.*1910, in his studio on
rue Blanche in Paris.

and perfection. Schohin's mastery of the process is such that he can manipulate the shadows and tones to give a simple everyday image a powerful emotional charge – a boiled breakfast egg has never looked so good, or so minimally modern. Sougez's work, almost two decades later, uses colour boldly and has a stark Modernist simplicity shared by the advertising work of the American photographer Paul Outerbridge (1896–1958; see Chapters 4 and 6).

The autochrome had a natural affinity with skin tones and was used extensively for portraits but, surprisingly, rather less often for nude studies or pornography. (Although examples of both exist, they do not seem to be as prolific as either genre, especially pornography, is in other photographic formats – or perhaps this is a part of the autochrome's history still waiting to be discovered?) Marcel Meys, an artist and photographer from a family of artists, produced both palely beautiful and amusingly coy nudes. Léon Gimpel, an early photojournalist and, like Meys, a photographic correspondent for *L'Illustration*, was perhaps more skilled in using the autochrome than any other photographer. Having been in regular

ABOVE LEFT Meys also worked outside the studio photographing nudes *en plein air*, where he was able to adopt a more naturalistic and simplistic vision as in this charming *La néréide et le miroir d'eau*, c.1910.

ABOVE Léon Gimpel was an experimental and innovative autochromist whose work is too little known. His images contain much fascinating and informative detail but yet have a classical austerity. He effortlessly combines the eye of an instinctive artist with that of a perceptive photojournalist. His familiarity with the autochrome process enabled him to compose adroitly for both colour and content.

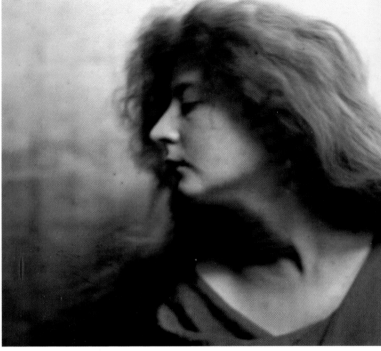

LEFT Taken in the New York studio of fellow photographer Clarence White in 1909, Paul Burty Haviland's series of autochromes and cyanotypes (see Chapter 3) of Florence Peterson is his best work. The grandson of the prominent art critic Philippe Burty who coined the term *Japonisme* to describe the West's fascination with Japanese art in the late nineteenth century, Burty Haviland composes his images with that innate sense of Oriental spareness and balance.

RIGHT Leonid Andreyev preferred to use stereo autochromes (of which this is one half) and the power of this image of his son Vadim, when seen in 3D in a stereo viewer, can easily be imagined. Although estranged from his father, Vadim held on to his family photographs after Andreyev's death and during the family's relocation to Paris. The autochromes are now in the holdings of the Leeds Russian Archive at Leeds University.

ABOVE Arnold Genthe moved from Germany to San Francisco in 1895 and began to photograph the city's teeming Chinatown. Despite the destruction of his studio and most of his negatives in the city's 1906 earthquake and fire, he remained a successful portrait photographer for many years. The Library of Congress in Washington acquired 20,000 photographic items by him after his death.

contact with the Lumières since 1904, he was certainly more experienced and experimented with the autochrome prior to its public inauguration at his magazine's offices on June 10, 1907, an event which he also instigated. He then provided the four autochrome images, the first ever published, for the June 15 issue of *L'Illustration*. While best known for his documentary war work, Gimpel was a photographer of rare distinction and virtuosity whose compositions, often including some slight element of movement, hide their complexity in an apparent simplicity.

Like the Pre-Raphaelite artists half a century earlier, autochromists preferred redheads. The series of platinum prints, autochromes and cyanotypes by Paul Burty Haviland (1880–1950) showing his favourite model (and maybe more), Florence Peterson, emphasize her cascading red-gold hair and pale skin. Arnold Genthe (1869–1942) had Miss S. G. pose dramatically for her portrait like a Rossetti painting.

In many autochrome portraits, no direct eye-contact is made owing to the possibility of blinking and blurring occurring during the lengthy exposure. This may be why one of the most powerful autochrome portraits ever taken reveals the miserable confrontational stare of Vadim Andreyev, the sulky, unhappy and badly neglected eldest son of the dynamic pre-Revolutionary Russian novelist and playwright Leonid Nikolayevich Andreyev (1871–1919), whose cache of autochromes was unknown beyond his immediate descendants until 1978.

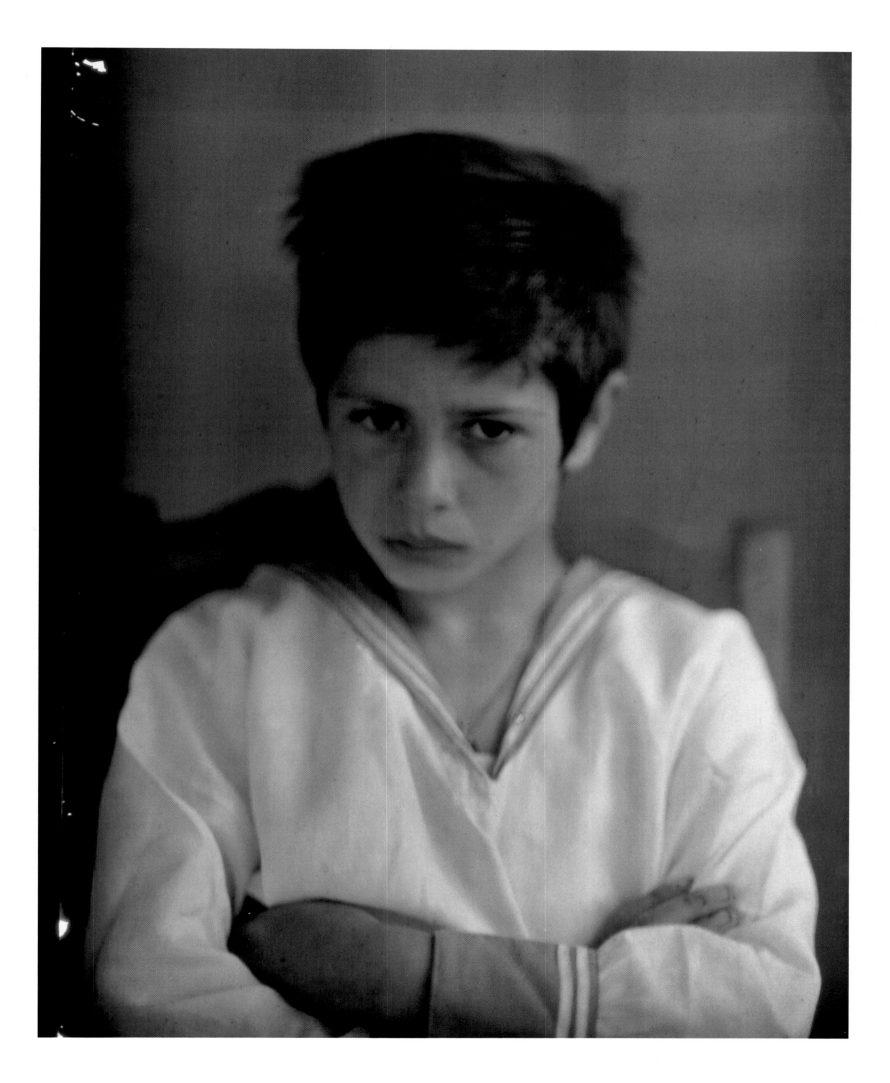

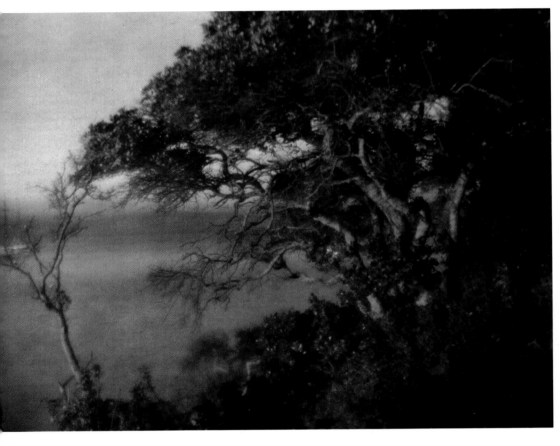

LEFT The year-long Panama Pacific International Exposition was held in San Francisco in 1915 to commemorate the opening of the Panama Canal in August 1914 and the new linking of East and West. The city also celebrated the 401st anniversary of the discovery of the Pacific by Balboa in 1513 and its own rapid rejuvenation after the devastating earthquake in 1906. This beautiful, atmospheric image by Francis Bruguière of the Golden Gate strait taken in the same year was once owned by the photographer Imogen Cunningham.

BELOW Karl F. Struss's square autochrome is cinematic in construction and made up of a series of slanting planes. Dissected by four diagonal lines – a partial one of blurred promenaders in the foreground, then boardwalk railings and people, windbreaks and umbrellas, shoreline and paddlers, it ends with the sea, horizon and sky, which make up almost half the image.

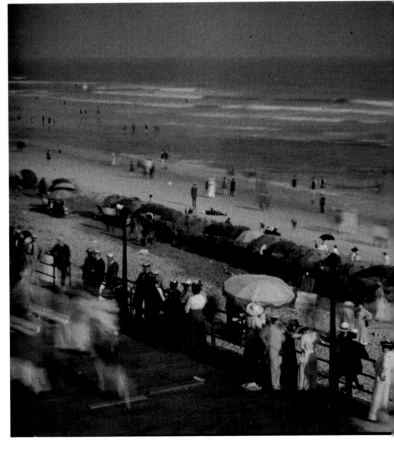

Like the Kühn children, Vadim had been motherless for a few years when this was taken. There is very little in this image, apart from the obligatory early 1900s sailor suit, to suggest that it was made almost a century ago. Vadim's picture has an immediacy, rapport and reality because it is in colour and the pose seems very modern.

When the small band of artist-photographers who had used the autochrome returned to their more manipulative fine-art monochrome printing processes, they were in a definite minority and their turning away from colour did nothing to dent the enthusiasm of the majority. By 1913, the Lumière factory was producing 6,000 plates a day. An estimated 20 million were made and sold between 1907 and the mid-1930s, with a falling-off during the war years. These figures would suggest that almost every photographer with a camera and a modicum of skill tried the autochrome at some stage, although the numbers of autochromes currently known to be surviving in collections worldwide are probably less than 1 per cent of this total.

For many amateur photographers, the autochrome was a one-hit wonder, tried and discarded for reasons of personal incompetence, overlong exposure times, inability to be mounted into family albums or difficulty, and expense, of supply. For others, it became the photographic medium of choice and was so loved by many that they continued to use it until its demise in 1932 and beyond, having hoarded supplies against that fateful day. Amongst

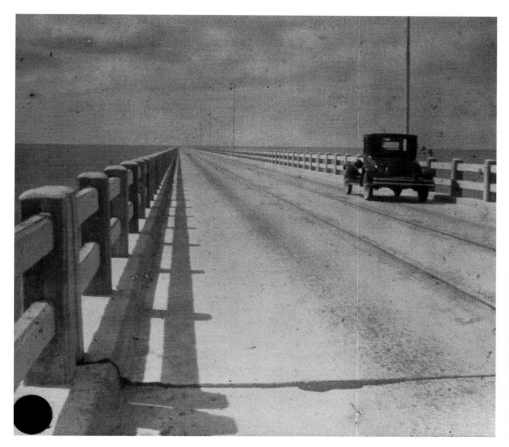

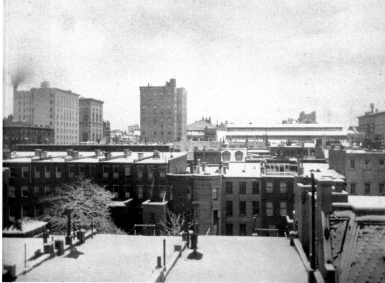

those, as yet, lesser-known photographers whose large bodies of autochromes have survived are Americans Helen Messinger Murdoch (1862–1956), Fred Payne Clatworthy (1875–1953), Charles C. Zoller (1854–1934) and European photographers such as Friedrich Adolf Paneth (1887–1958), Sarah Angelina Acland (1849–1930) and Lionel Nathan de Rothschild (1882–1942). Although all these photographers, and many others – including the great "Anonymous" – also photographed the uncommon and unusual, it is their more everyday records and snapshots – the extraordinariness of ordinary reality – that remain in the memory.

Anonymous French roadside images reveal as much about French life as the San Francisco landscapes of Francis Bruguière (1879–1945), and the blurred-motion Long Island boardwalk of Karl F. Struss (1886–1981) do of American life. On the strength of these images, it is hardly surprising to learn that Struss became a fêted Hollywood cameraman from 1919, initially working for Cecil B. de Mille (1881–1959) and Bruguière an abstract photographer, artist and sculptor. Harry T. Shriver (1831–1928) owned the J. E. Shriver Company, now part of the aluminium producer Alcoa. He and his friend George Eastman (1854–1932) were avid amateur photographers; Eastman went on to found Kodak.

Charles C. Zoller left behind a magnificent and extraordinary archive of more than 4,000 images, mostly depicting the everyday. They were largely taken in his hometown of Rochester, New York, although he also travelled extensively throughout the USA.[6]

ABOVE LEFT Charles C. Zoller's November 1924 autochrome celebrates the opening of the Gandy Bridge which spanned Tampa Bay in Florida. At 2½ miles (4km) long, it was the longest automobile toll bridge in the world at that time and knocked over 25 miles (40km) off the previous journey. With his low-level viewpoint, Zoller emphasizes the bridge's length as it stretches off into infinity and creates a Modernist image.

ABOVE The industrialist Harry T. Shriver was almost 80 years old, and 40 years a photographer, when he made this study of New York rooftops after a snowfall, using the particular qualities of the autochrome to capture an everyday scene of the kind that many of his Secessionist peers preferred to capture in monochrome.

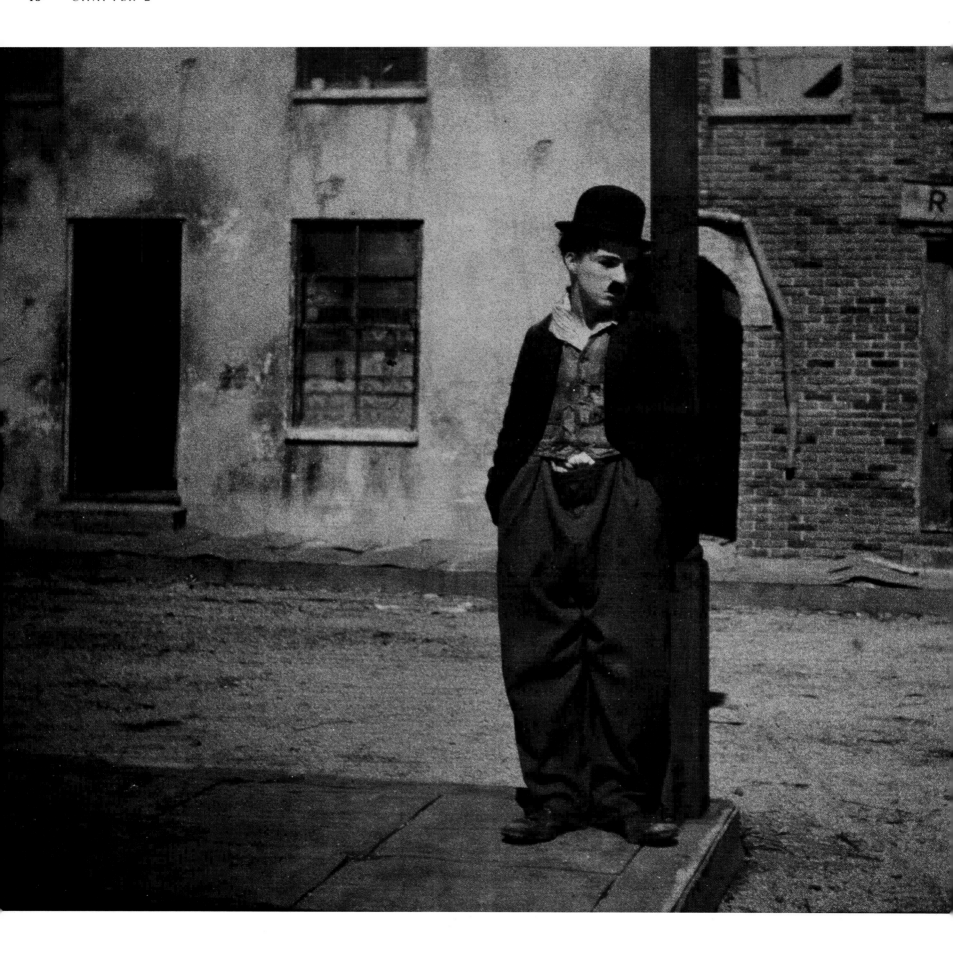

ABOVE RIGHT This autochrome of a politically incorrect (to our twenty-first-century eyes) *Affiches Gaillard* roadside advertising poster for spark plugs and motor oil obviously appealed to the photographer, who made his two companions go and pose underneath it. The stereotypical grinning black face seems a strange choice to sell car accessories, but certainly grabs the attention.

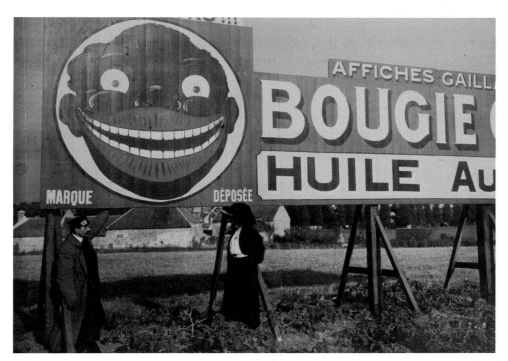

RIGHT This very late autochrome entitled *La Route – Borne, 19 July 1936* may have been taken during the 30th Tour de France, which ran from July 7 to August 2 that year. Or it may just be a cyclist's memory of a summer day's cycling taken by a dedicated autochrome hoarder.

OPPOSITE Zoller photographed Charlie Chaplin on the set of his film *A Dog's Life* (1918), the first film that Chaplin wrote, produced and directed for First National Films, and which co-starred "Scraps" the dog. Chaplin's films were still shot in black and white of course and the unexpectedness of seeing his "Little Tramp" persona and the backlot set in colour somehow makes the image more unreal, and less believable, than monochrome.

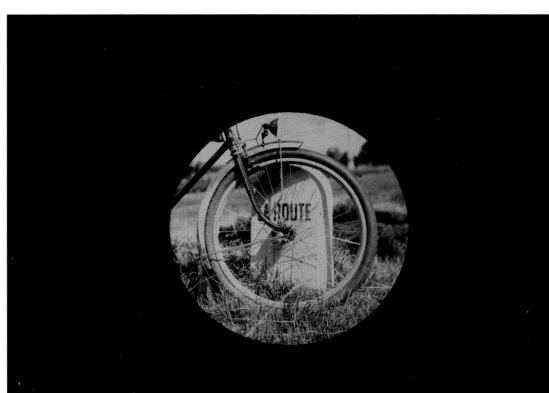

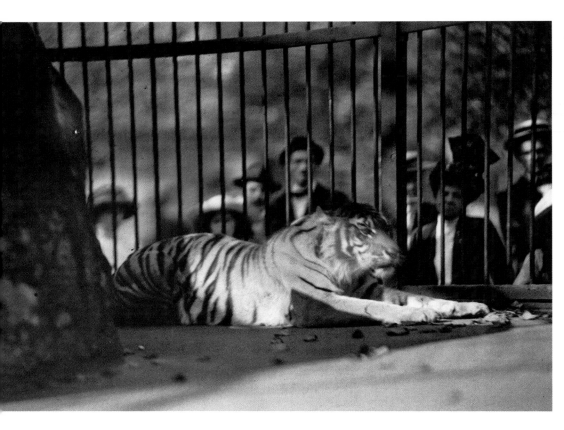

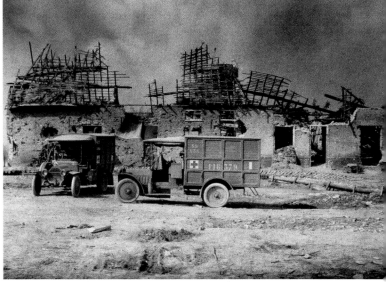

LEFT Lionel de Rothschild was no dilettante photographer: he left a black and white archive as well as a body of 700 autochromes, including this wonderful image of a tiger in the Lion House in 1910, the first photograph in colour of the Zoological Gardens in Regent's Park, London. Rothschild has photographed as if inside the cage with the tiger, who stretches at ease, while the zoo visitors are shown as the distressed incarcerated species behind the bars. Rothschild's later autochromes concentrated on the beautiful gardens he created at his Exbury estate in Hampshire.

ABOVE The town of Boesinghe (now Boezinge) in Flanders, near Ypres on the Yser canal, was almost completely destroyed during World War I. In Paul Castelnau's September 10, 1917 autochrome of Red Cross ambulances and ruins, he has managed to get the red cross – the most colourful thing in the image – almost exactly central.

Through Zoller's eyes the everyday is heightened and within such a large archive of work, spanning almost 30 years, it is possible to glimpse elements of Modernism, Abstraction and Surrealism – as well as images of one more local garden fête that was perhaps just one fête too many.

Although Lionel de Rothschild's archive of photographs and autochromes generally depicts a rather more privileged and private world – a very different reality from Zoller's and yet reality as Rothschild knew it – his caged tiger in Regent's Park Zoo in London is a true Everyman image. He had a passion for the autochrome, keeping his in meticulous detailed order, and his autochrome camera in remarkably good shape.[7] It seems he only gave up this type of photography during World War I when he necessarily had to spend more time in the family banking business, with his brothers all serving at the Front. Sadly he seems never to have taken it up again.

World War I ruined many lives and improved few but, thanks to the autochrome, we have a better understanding of the physical and mental devastation it caused. Although there is little original German or British colour photography of the war surviving other than as images on postcards, in 1915 the French Army set up the Photographic and Cinematographic Service reporting to the Ministry of War. By 1918, this was under the command of Jean-Baptiste Tournassoud ((1866–1951), a committed photographer who was born near Lyon. He first met the Lumières in 1900 and worked extensively with the autochrome. Among the photographers who documented World War I were some who had already worked for the

RIGHT Senegalese soldiers (Senegal was a French colony and a third of Africa was under French rule in 1914) hole up in a shack near the frontline at Saint-Ulrich, Haut-Rhin, Northern France on June 16, 1917. The coarseness of the autochrome grain here – the soldier's white shirt is made up of obvious clumps of colour – is doubtless a result of Castelnau's hasty processing under battlefield conditions.

BELOW Fernand Cuville's autochrome of a Nieuport biplane fighter, its Vickers machine gun mounted on top of the cowling in front of the cockpit, was made on an improvised airfield in Soissons, Aisne, northern France in 1917. Designed by Gustave Delage of the Nieuport Co. in 1914, the various models of Nieuports eventually helped turn the tide of the war.

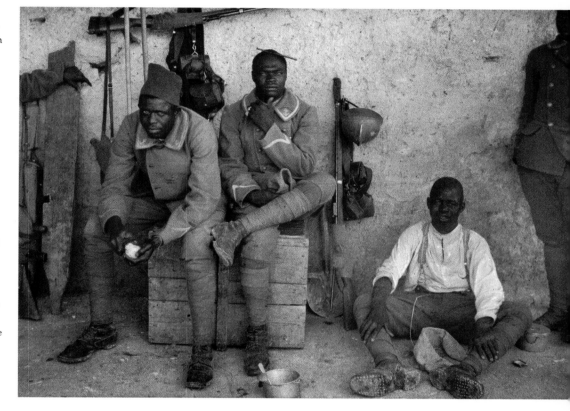

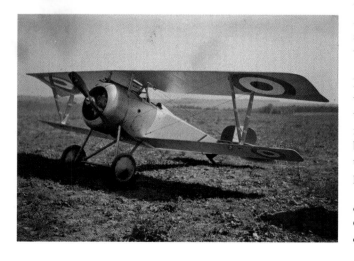

brothers and/or Albert Kahn (see below) such as Léon Gimpel, Jules Gervais-Courtellement (1863–1931), Paul Castelnau (1880–1944), Fernand Cuville (1887–1927), Albert Samama-Chikli (1872–1933) and L. Aubert (dates unknown).

Because of the long exposure times required, real-time photography with the autochrome was impossible so the photographers necessarily depicted a static war. Group shots of soldiers and prisoners have a posed, theatrical quality which often gives them the bizarrely comic appearance of a tableau vivant. But the autochrome faithfully documented the colour of mud, the chaotic graphics of destruction and the blank desperation in men's eyes.

There was as yet no cheap and efficient way for a publication to reproduce autochromes as halftones in print unless it had a large budget and could afford such an extravagance, so *L'Illustration* was taking a financial risk once it began to cover the war using this photographic form. But under the inspired directorship of René Baschet (active 1900–44), it was a risk that quickly paid off as the magazine's pre-war weekly circulation of 80,000 rose to 300,000 between 1914 and 1918, dropping back to 50,000 after that. Once the war ended in 1918 another series of autochromes was made by the American Committee for Devastated France, an organization which sponsored reconstruction projects, and recorded the previous devastation and subsequent reconstruction.

After the war, many of the photographers went to work for Albert Kahn and his Archives de la Planète (see below), taking their weary war-honed vision to all parts of the world. Gervais-Courtellement, who had been giving wildly popular illustrated autochrome lectures of his Oriental travels since 1908, had opened a 250-seat Palais de l'Autochromie in Paris in

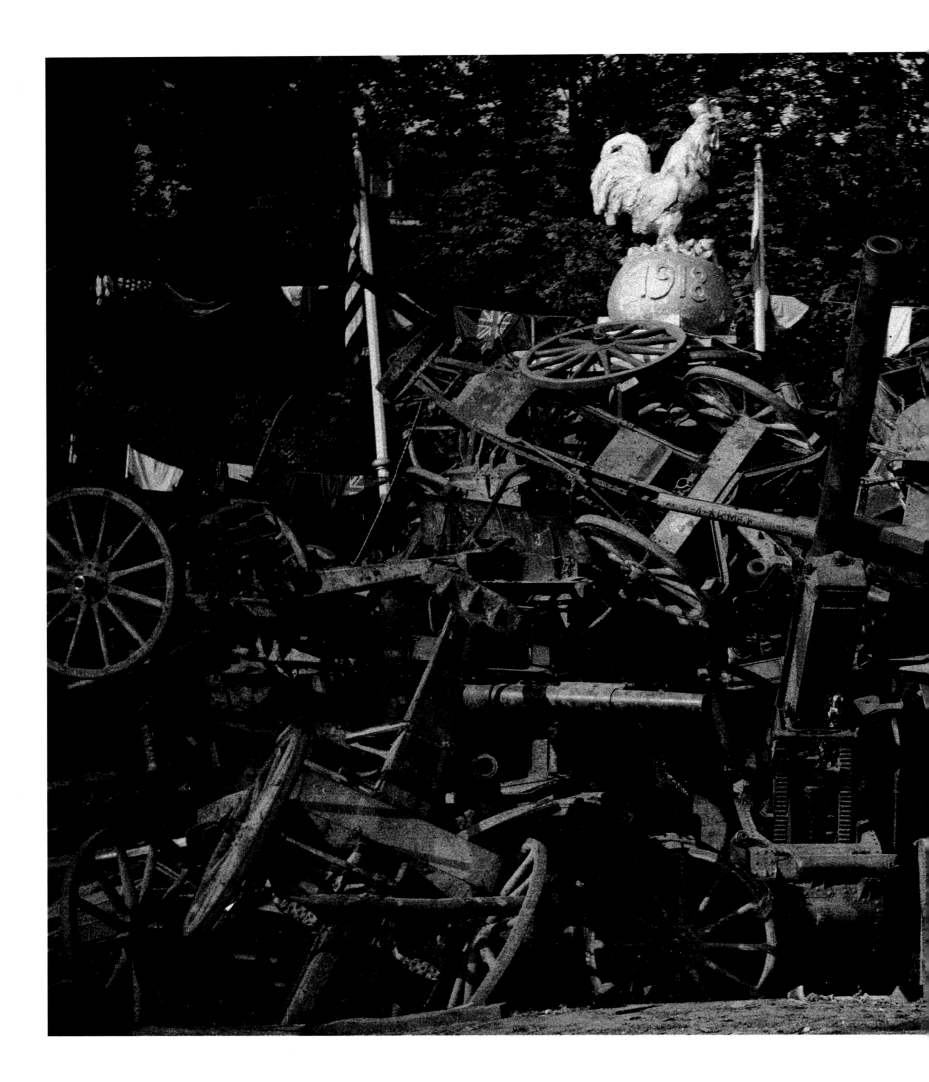

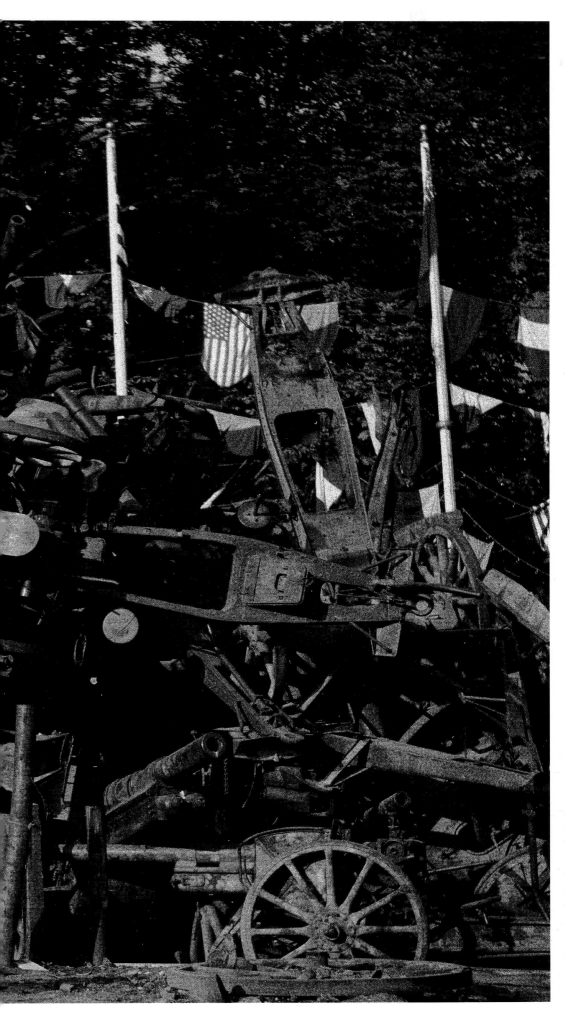

LEFT Gimpel's astonishing image of the cacophonous piled spoils of war in the Champs-Elysées in July 1919 brings a sense of static order to total mayhem. The armaments, mostly field guns, were piled at the side of the avenue down which soldiers from Allied nations, led by wounded Frenchmen, would later march in a victory parade. The majority of Gimpel's work is now in the archives of the Société Française de Photographie.

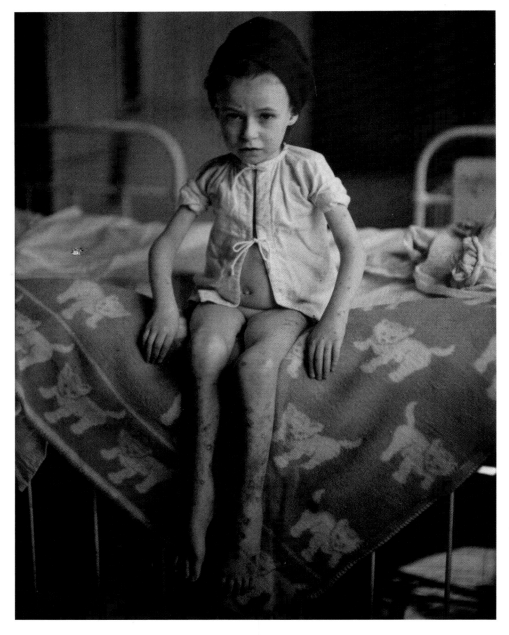

rue Montmartre in 1911 and, until the 1920s, showed his war autochromes there to great acclaim, with his previous colleagues Gimpel and Meys as guest lecturers. He also published a series of partworks on the Battles of Verdun and Marne.

One of his colleagues, Aubert, photographed perhaps the most poignant and shocking autochromes of the war while he worked in hospitals. His images of dead bodies, post mortems, diseased organs and survivors with a whole gamut of appalling injuries are still, even to twenty-first-century eyes, starkly horrific. There is a bizarre incongruity to be found in the delicate beauty of these photographs and the grisly subject matter they were depicting.

Many excellent publications have been written on medical photography, but seemingly little research has yet been done on the degree of relevance and usefulness of early colour photography as a didactic teaching and identification aid to the medical profession. Many

RIGHT Fritz Paneth photographed
the chart of the periodic table
of elements and may perhaps
have projected this image in his
travelling lectures if a wall chart
was not available. More likely it is
a portrait of one of his assistants,
C. Reimann, in situ. Paneth also
turned the camera on his audience
on occasions, leaving a valuable
record of the student population
of the time.

FAR RIGHT Paneth has laterally
reversed and enlarged, or
rephotographed, a section of the
same autochrome of Reimann
to emphasize the grain structure
and the clumping of the colours,
probably for use in lectures.

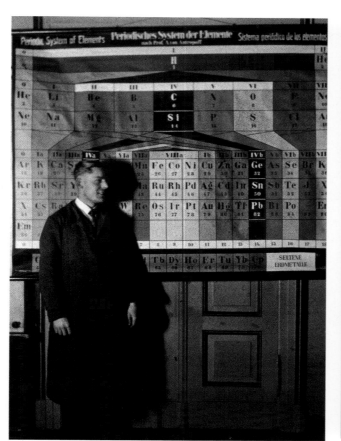

autochromes exist, often as stereoscopic images to give full three-dimensional effect
when seen in a viewer, of carcinomas and various other diseases, wounds, malformations,
etc. These were sometimes much enlarged for emphasis and elucidation, and most are
rather too gruesome to illustrate in a book of this nature, and are beyond its immediate
scope. Nevertheless, the advent of photography in natural colour, in the initial form of the
autochrome, introduced various options that had not been previously available to the world
of medicine. Once the photograph had been taken, a plate could be used as a projected image
for lectures or as a visual identification tool for medical staff. An unusual case peculiar to one
hospital or area could be photographed and shared with others in the medical services. Thus,
colour photography must initially have made a radical difference to diagnosis and continued
to do so throughout the next century. Its uses were rapidly appreciated not only in medicine
but in all instructive professions.

Dr Friedrich Adolf (Fritz) Paneth taught chemistry in several German universities before
leaving the country for England in 1933 after Adolf Hitler's rise to power. By 1938 he was
guest lecturer and reader in atomic chemistry at Imperial College and University College,
London. During World War II, he worked as head of the chemistry division of the joint
British-Canadian atomic energy team in Montreal and became the greatest authority of his
time on volatile hydrides (a compound of hydrogen with more electropositive elements). In
1953 he returned to Germany to take up the position of director of the Max Planck Institute
for Chemistry in Mainz.

Despite this illustrious career, Paneth also found the time to be an ardent photographer
who was committed to the autochrome for more than 25 years; subsequently, when all his
stockpile was depleted, he switched to Kodachrome. His daughter Eva could not remember

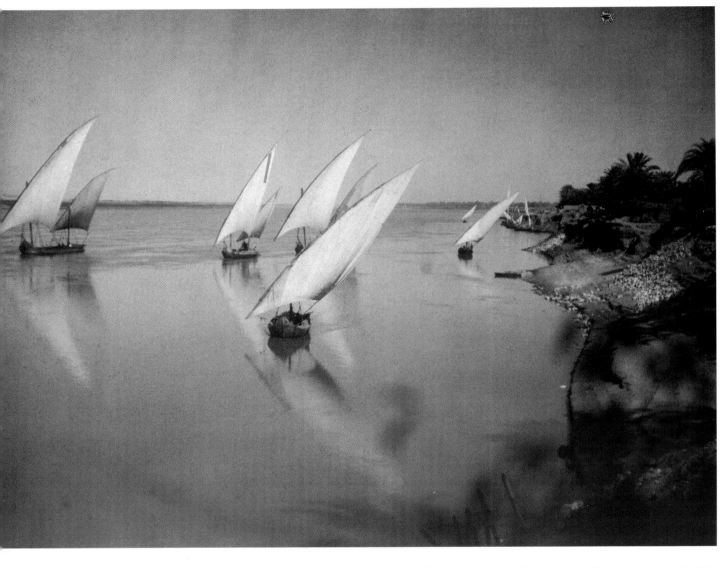

LEFT In January 1914, Helen Messinger Murdoch wrote of this image: "These are the Nile boats Every afternoon the bridges are opened at Cairo and they come sailing up like great white birds. It was great good-fortune to get boats in motion with a time exposure." Murdoch was able to develop her autochromes in hot weather by using a large covered tin box filled with ice as a table top, thus keeping her developing trays and chemicals chilled.

ever seeing her father without two bulky boxes hanging from his shoulders – one carrying his camera and lenses, the other his boxes of autochrome plates. While the majority of Paneth's autochromes are of family life and events, holidays, landscapes and architecture, he also used them in a didactic sense in his teaching, giving illustrated lecture trips in Europe as well as in class, as shown in the two images on page 47.

Because the autochrome could be projected from a lantern slide projector with very strong light, it gave a rather more dramatic rendition than the previous monochrome or hand-coloured lantern slides. Hitting the lecture circuit during the winter months, when not out photographing, became a useful source of income for autochromists as well as a popular event with audiences, with attendances of up to 3,000 in major US cities. In February 1909, Coburn was in Detroit to autochrome the collections of Oriental art and pottery and James Abbott McNeill Whistler's paintings owned by Charles Lang Freer, the railroad-car magnate. The art critic Charles H. Caffin then used slides made from the 100-plus autochromes to give a well-received lecture at the Detroit Museum of Art on April 23, greeted with "spontaneous bursts of applause". This same rapturous response greeted the Boston photographer Helen Messinger Murdoch when she embarked on a round the world tour from 1913 to 1915, notably the first woman photographer to make such a journey, photographing on both autochrome plates and black and white negatives. Her travels took her first to Lyon to buy the plates, then down to Marseilles from where she sailed to

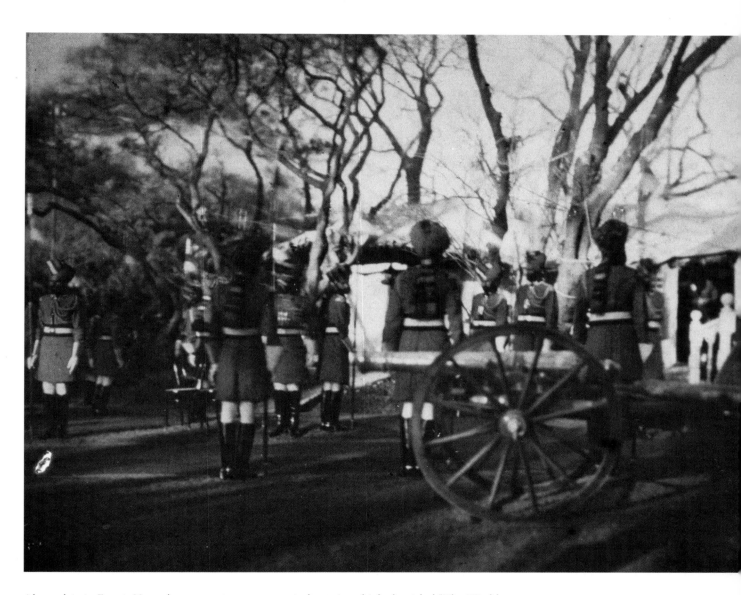

Alexandria in Egypt. Her subsequent stops en route in her trip, which she titled "The World in its True Colours" in her lectures, were in Cairo, Luxor, Palestine, India, Burma, Ceylon, Hong Kong, China, Japan, the Philippines, Hawaii, Honolulu, San Francisco, San Diego and then back overland to Boston via Chicago, arriving home in 1915, lecturing all the way and inserting new material as it was photographed.

Her observations, in her diary, her letters home to her sisters and the notes from the lectures she made along the way, make fascinating reading, giving a vivid picture of the experiences of a lone Western woman traveller in the early twentieth-century Middle East and Asia at a time of war. But there is also great photographic detail, both artistic and technical, given the exigencies of getting successful results from the autochrome process – which was frequently frustratingly temperamental under the baking heat of an Indian sun and in countries where fresh water was scarce – or of photographing in the mountains and having to melt snow to wash her plates. Murdoch discusses exposure problems in a variety of climates as well as the difficulty with the supply of the plates themselves. She also fulminates against the customs duties she repeatedly had to pay on all her equipment and chemicals at a variety of foreign borders because most countries she passed through had never seen this technology before and were suspicious, so charged her anyway.

Some of Murdoch's Indian and Ceylonese autochromes were eventually reproduced in an eight-page full-colour spread in *National Geographic* magazine of March 1921. This was

ABOVE Murdoch tried to take pictures at the garden party given for the Viceroy, Lord Hardinge, and Lady Hardinge at the Summer Residency, Malabar Hill, Mumbai. "I was only able to get the Guard of Honor, the Sikh regiment, as they were obliged to stand perfectly still, lined up either side of the red carpet, leading to the receiving line…. I noticed that their well-kept beards were kept in place by hair-nets." This autochrome of March 1914 was one of those later reproduced in *National Geographic*.

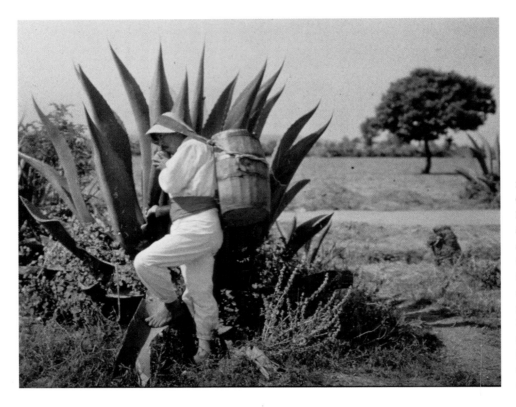

LEFT For many years, Fred Payne Clatworthy was one of the best-known American photographers as, like Murdoch, he travelled around taking autochromes then projecting them in popular illustrated lectures. His Mexican autochromes were the first colour photographs of that country. This 1919 agave farmer harvests the sap of the maguey (or agave) plant to produce pulque which, when distilled, produced the stronger spirit tequila.

RIGHT Clatworthy had previously photographed the American South West in black and white but retraced his steps to rephotograph it in colour, here to glorious effect in the sand dunes of Palm Springs, California in 1921. Eighty years later, Clatworthy's work might still be largely unknown beyond the pages of *National Geographic* had it not been assiduously and tirelessly collected by the American aficionado Mark Jacobs.

seven years after she had taken them, but nevertheless it made her the first woman to have her autochromes printed by the magazine. Begun in 1888 as a journal for about a thousand geographers, *National Geographic* reinvented itself and captured an audience of millions by incorporating photographs into its pages. By 1907, half of its pages were devoted to exotic images from around the world with well-written explanatory captions. Between 1914 and 1938, the magazine reproduced 2,355 autochromes (and later Finlaycolor) images on its pages, making it the most prolific user and distributor of colour images. After 1938, the magazine switched to Kodachrome full time. *National Geographic* still retains a collection of more than 14,000 autochromes and examples of other early colour processes in its archives. In April 1916, it featured a spread of 23 autochromes by Franklin Price Knott (1854–1930) but it was not until 1927 that colour was featured in every issue, including the first underwater autochromes taken in 1926 by flashlight by Charles Martin (1877–1977) with William H. Longley.

Murdoch's American colleague and friend, Fred Payne Clatworthy, had a rather more successful career than she did with *National Geographic*, his work being frequently reproduced in its pages from 1916 to 1934. A successful monochrome photographer, Clatworthy was introduced to autochromes in 1914 by the splendidly named Clark Blickensderfer. Clatworthy had a photographic studio in the Rocky Mountain National Park and worked mostly in the American South West – in Colorado, California and Mexico – although he also travelled further afield to Hawaii and New Zealand in 1926. During his

LEFT Hans Hildenbrand was based in Stuttgart, Germany, and had over 150 autochromes reproduced in *National Geographic*. The magazine owns another 700 of his autochromes, but the rest of his output seems to have been destroyed in the Allied bombing of Stuttgart in 1944.

career, he produced an estimated 10,000 autochromes, a satisfying number of which have survived. In 1923, he was paid just $160 for the 16 pages of images he supplied, despite supposedly being the favourite contributor of Franklin Fisher, *National Geographic*'s illustrations editor; if this was the top rate, one wonders what Fisher's other less-favoured contributors were paid. In 1928, Clatworthy made a triumphant return, this time being paid $1,000 for 16 pages of images which, after the costs of travel, transport, plates, living expenses and so on, still left him with no profit.

Hans Hildenbrand (1870–1956) had photographed German troops on autochrome during World War I. He ran his own photographic studio in Stuttgart and was court photographer to the royal family. He travelled widely with them and was able to photograph in the Middle East, the Balkans and North Africa.

Although they never met but sent their material to the Washington office from wherever they were working, several of Clatworthy's freelance colleagues at *National Geographic* – including Jules Gervais-Courtellement and Stéphane Passet (1875–1942) – also worked

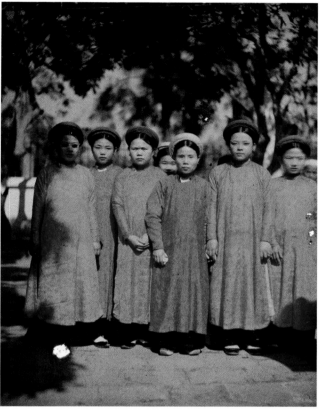

for the magnificent Archives de la Planète collection created by Albert Kahn (1860–1940). Seemingly one of the most philanthropic bankers in the industry's history, Kahn, born in Marmoutier, Alsace, and of Jewish descent, came to Paris as a junior employee at Goudchoux Bank in 1879. While moving up the banking ladder, he also studied with the philosopher Henri Bergson (1859–1941), who remained a friend and whose ideas deeply influenced him. By 1892, Kahn was the director of Goudchoux and by 1898, he had made a fortune speculating in South African diamond and gold mines, especially De Beers.

In 1893 Kahn had bought land at Boulogne-Billancourt on the outskirts of Paris, where he was able to concentrate on his various passions. He created four hectares of beautiful and varied gardens, and set up several utopian institutions and an intellectual salon to encourage debate.[8] Honorary members included Anatole France (1844–1924), Auguste Rodin (1840–1917) and Bergson. Kahn also financed students to travel and broaden their minds. After business trips to Japan and China in 1909, where his chauffeur took some preliminary black and white photographs, the notoriously camera-shy banker established the Archives de la Planète, a methodological visual survey "to put into effect a sort of photographic inventory of the surface of the globe as inhabited and developed by Man at the beginning of the twentieth century".[9]

Thus, a couple of years before the carnage of World War I and more than three decades before the United Nations was created, the pacifist Kahn believed that an increased knowledge of international cultural differences would lead the world to better understanding and peace between nations. It is a truly glorious idea that colour photography could save the world. While Kahn did not achieve international peace, he did construct an amazing archive of material. As well as 72,000 autochrome plates, there are 4,000 stereographs and 183,000 metres of film. Without Kahn's impressive dedication to documenting the world in glorious colour, it is unlikely that the autochrome would have survived for 25 years. Given, at the very

ABOVE LEFT Frédéric Gadmer's first posting for Kahn's Archives de la Planète was to Syria, Libya and Palestine in 1919. He photographed these Bedouin weavers in Marran, Syria, obviously attracted by the strips of cloth dyed a deep red and strewn to dry picturesquely along the walls of the interestingly shaped stone dwellings.

ABOVE RIGHT Léon Busy was already an old Tonkin (Vietnam) hand when he photographed there for Albert Kahn between 1915 and 1920, producing more than 1,700 autochromes of the country. These young girls in their vibrantly dyed saffron and pink frocks are participating as pawns in a game of living chess, a speciality at festival time. The girl on the far left in dark glasses is probably blind.

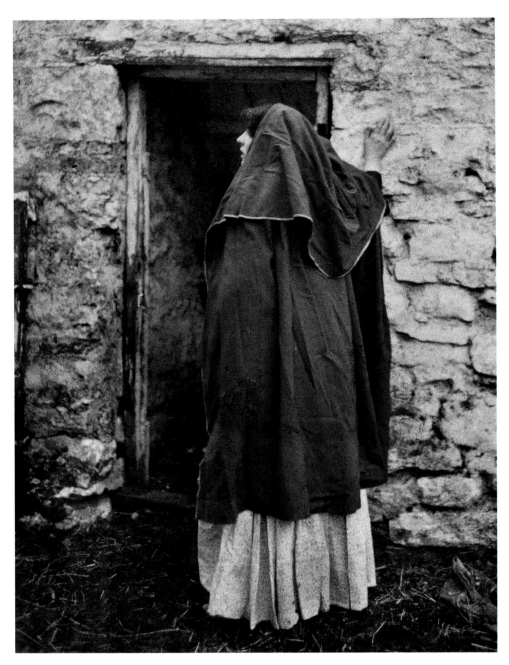

least, a 50 per cent failure rate through imperfect technique, deterioration, breakage and loss, it seems that Kahn himself must have accounted for around 1 per cent, and possibly more, of the autochrome's 20 million sales.

To achieve his end, and under the directorship of the geographer Jean Brunhes (1869–1932) – the instigator of the new discipline of "human geography" at the Collège de France in Paris – Kahn employed an ever-changing team of photographers, many of whom had previously worked for the Lumières, as roving autochromers and cinematographers. They covered 50 countries and most continents, except for Oceania and North and South America. As the balance of power was fragmenting, shifting and realigning throughout Europe, the Middle East and Africa and the former Austro-Hungarian Empire was splintering, Kahn's timing was particularly pertinent. At a time of widespread colonialist expansion, the growth of capitalism, the rise of Communism and Fascism, Kahn's photographers were recording a disappearing world.

Under specific instructions from Brunhes, the photographers involved concentrated on the human environment and habitat, architecture, traditions, crafts, dress, groups and everyday activities. Amongst them were Léon Busy (1874–1951), Paul Castelnau, Georges Chevalier (1882–1967), Fernand Cuville, Jules Gervais Courtellement, Roger Dumas (1891–1972), Frédéric Gadmer (1878–1954), Auguste Léon, Marguerite Mespoulet (1880–1965), Madeleine Mignon (1882–1976) and Stéphane Passet. Some of Kahn's photographers remained in the countries they primarily

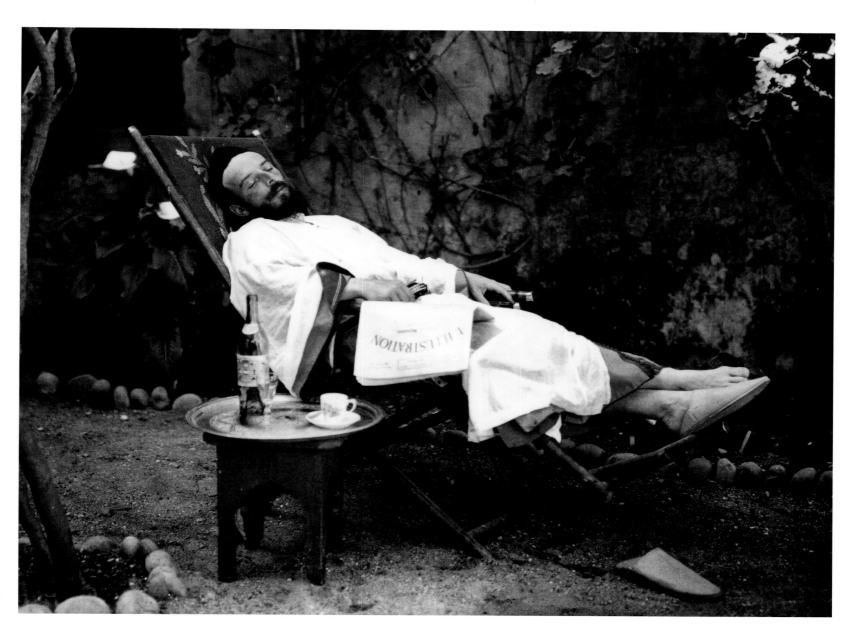

ABOVE Gabriel Veyre was a cinematographer who worked for the Lumières around the world. From 1901 to 1908 he was ensconced at the court of Sultan Moulay Abd el Aziz of Morocco in Marrakesh, as resident photographer and cinematographer, and added autochromes to his accomplishments. This wonderfully raffish self-portrait of 1908 in Casablanca shows Veyre, languidly holding a copy of *L'Illustration*, for whom he was Moroccan correspondent.

photographed for long periods of time. Others went on to work for the film industry. The resulting autochromes and films were used to illustrate Brunhes's lectures at the Collège as well as to enlighten and entertain Kahn's various educational institutions and intellectual salons.

During the 1920s, as the Depression set in, Kahn's finances began to suffer and after the Stock Market crash of 1929, he lost practically everything. On his death in 1940, his vast collection of colour documentary material was valued at only 500 francs, the same estimate as was put on his luggage and suitcases. Luckily, the collection was taken over by the local département of Hauts-de-Seine and both gardens and photographic archives can now be seen at the Musée Albert Kahn.

Primarily a cinematographer for the Lumières, Gabriel Veyre (1871–1936) worked with the autochrome until the bitter end, his last project being a survey of Morocco in 1935. He spent the last three decades of his life in Casablanca.

In 1932 the Lumière factory switched the autochrome emulsion to a sheet-film base, Filmcolor (in production until the 1950s), and then to roll film, Lumicolor. However, by this stage colour photography had moved on, and Kodachrome 35mm colour transparency on roll film was released on to the market in 1936. After almost 30 glorious years, autochrome technology declined but – as the first commercially successful colour process – its influence on twentieth-century colour vision was incalculable.

3 ALTERNATIVES TO THE AUTOCHROME
1900–1930

The invention of photography in the 1820s and 1830s shows that, although they were operating in isolation and knew nothing of each other's research, pioneers in the field were thinking along much the same lines. Joseph Nicéphore-Niépce (1765–1833) and Louis Jacques Mandé Daguerre (1787–1851), working in partnership in France, and William Henry Fox Talbot (1800–1877) in England reached broadly similar conclusions in their ideas and results, about how to register an image by harnessing the action of light on specific light-sensitive silver-based chemicals.

Where Daguerre and Talbot differed widely, however, was in the physical support medium used for their images. Daguerre worked on metal and produced a unique positive image from which copies could be made only with great difficulty. Talbot worked on paper and produced a negative from which an infinite number of paper positives could be made. It was this process that became the standard for all later photography, the paper negative being largely replaced by glass in the 1850s and then by film in the late nineteenth and early twentieth century. The daguerreotype, initially the more popular process of the two for around 15 years from 1839, disappeared into obscurity in the mid-1850s, although it endured for rather longer in the USA.

Seventy years later the situation in colour photography was not dissimilar. For the 25 years following its commercial launch in 1907 the autochrome, a single, positive, additive screen image, was the most widely available and wildly successful colour process on the market. However, because it was made from a single exposure on glass rather than on paper, it was not infinitely reproducible; like the daguerreotype, therefore, it had no future or role to play in the further evolution of photography.

In contrast, monochrome photography, now often using flexible roll-film negatives in easily portable handheld cameras, was becoming quicker, cheaper, simpler and easier to process and print at home, and the desire for speed, ease and flexibility came to replace the desire for slow autochrome colour. The rapid growth of cinematography, which provided a new way of recording both reality and unreality, the change in both photographic and artistic aesthetics during this period and the aftermath of World War I meant an end to the autochrome's heyday of languid pictorialism and golden summers. With aeroplanes, cars, telephones, radio and electricity now becoming more commonplace, life was speeding up and art and photography had to speed up too, to deal with the harsher new world order.

RIGHT This Samarkand fabric merchant, surrounded by bales of richly patterned cloth, is one of Sergei Prokudin-Gorskii's stunning experimental colour images from 1909 to 1915, taken using three plates rapidly exposed behind coloured filters. His photographs were acquired by the US Library of Congress from descendants in 1948 and in 2004 were digitally scanned and reconstructed as full-colour images by Blaise Agüera y Arcas.

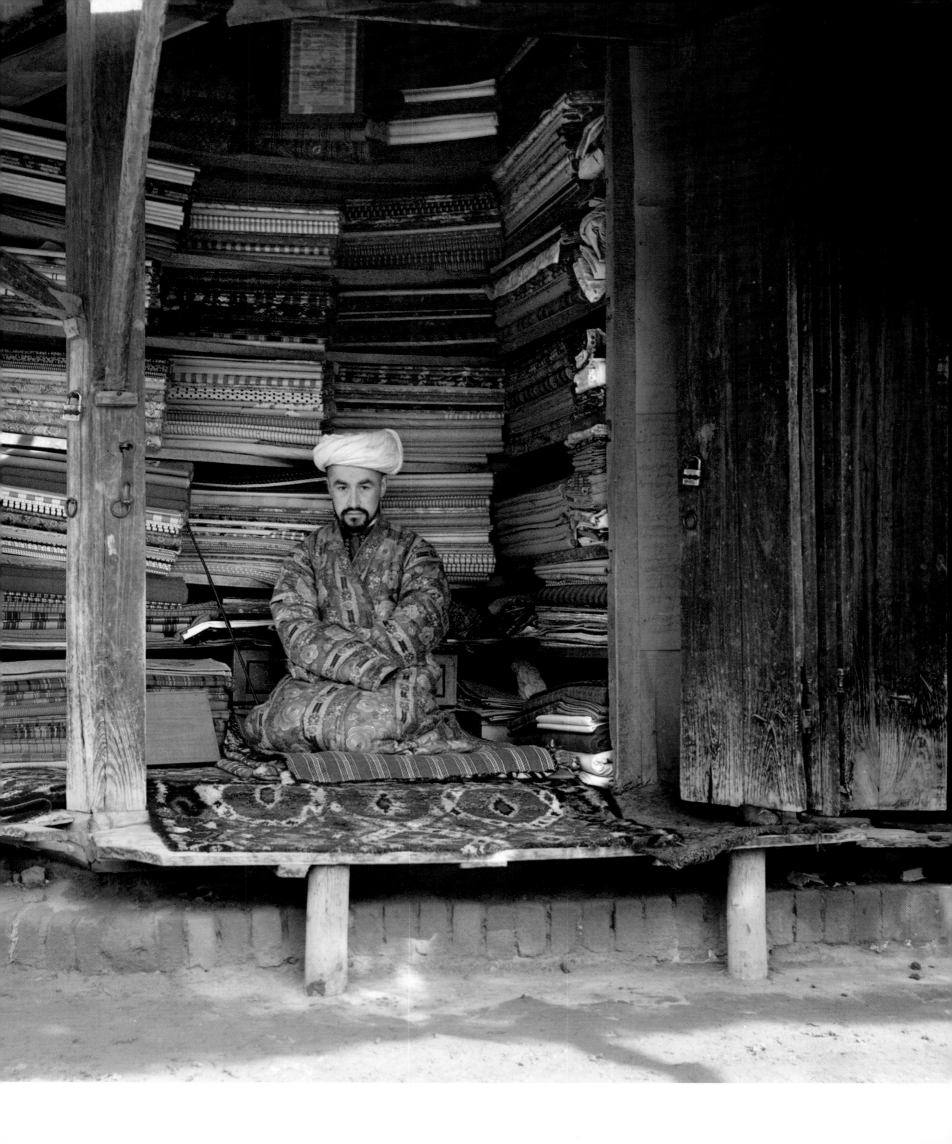

During the first three decades of the twentieth century, the search was on for a commercially viable, popular and simple colour photographic process which, like monochrome, could produce a negative on flexible roll film, be manufactured in a variety of sizes to be used in any camera, and allow an infinite number of colour positives to be printed on paper. This did not finally happen until the introduction of Kodacolor to the general public in 1942 – an advance heralded by Kodachrome in 1935. As with the autochrome, funded by the mighty Lumière Co., the research and production costs of such an enterprise could only properly be met by a major manufacturing organization. Nevertheless, from 1900 to the 1930s both amateur and professional photographers in Europe and the USA were simultaneously undertaking research and experimentation in this area; if few of their inventions ever passed into the mainstream, they were – like those of Ducos du Hauron – based on principles that did, and were all-important milestones along the way to the easier achievement of colour on paper.[1]

Thus three streams of colour photography were being actively researched and used from 1900 to 1930: additive screen-plate colour on glass, the relatively simple autochrome and other similar processes which were difficult to reproduce successfully on paper and eventually became obsolete; tricolour subtractive processes which could be reproduced on either glass or paper, but were painstaking, time-consuming, used bulky equipment and needed patience and dedication, although once simplified, became the future of colour photography; and the attempt, largely by nonprofessional pictorial and artist-photographers such as those who had briefly experimented with the autochrome, to introduce colour into their images on paper by other means.

This latter group had an imperative to exhibit framed works on paper and did so in an explosion of exhibitions which they organized of their own and each other's work, initially

ABOVE Edward Steichen's wonderfully atmospheric and moody green gum bichromate over platinum print of the iconic Flatiron Building in New York, the negative made in 1904, the print in 1909, is perhaps his best-known image. He printed it in several different sizes and by different processes to change the feel. Built in 1902 by the Chicago architect Daniel Burnham, the 285ft (85m), 21-storey triangular steel-framed building, clad with an ornate terracotta and limestone relief, occupied a site at the intersection of Broadway, 5th Avenue and 23rd Street and could at that time be seen from as far away as Central Park.

experimenting with printing from the autochrome and tricolour separation negatives on paper, while also finding many other ingenious ways to introduce colour into their photographs. To do this, they referred back to nineteenth-century processes, such as gum and carbon printing, hand-colouring of images and the early cyanotype process, putting a new twentieth-century spin on them by merging processes together. Often involving laborious preparation, hand-coating fine-art paper or Japanese tissue, followed by complex registration and assembly, these processes were time-consuming and expensive both to make and for the collector to buy, but they did give the photographer ultimate control of every step of the proceedings and established the finished product as a true work of art.

Among others, Edward Steichen – photography's colour barometer for the next four decades – experimented with every "new" colour process available, and even invented a few of his own. In 1904 he bought apparatus designed by Professor Adolf Miethe, built and marketed by W. Bermpohl of Berlin. This made three separation negatives quickly one after the other and all on one plate, through red, green and blue filters. From these three negatives, three positives could be made on glass, to be projected in a magic lantern through three more filters as a superimposed image or as colour prints on paper. A variation of this camera was used by Sergei Prokudin-Gorskii (see pp.57, 68–69) and by Miethe himself to very impressive effect. Since 1899, Miethe had continued to improve on Hermann Wilhelm Vogel's (1834–98) research into increasing the sensitivity of panchromatic emulsions which contributed to the success of the autochrome. Steichen made several beautiful tricolour prints using Miethe's technology, which were much admired when exhibited between 1904 and 1910 and were reproduced in *Camera Work* 15 and the *Camera Work Steichen Supplement* in 1906.

ABOVE Adolf Miethe's years of research were vital to the evolution of colour photography. He was one of the few photographers able to achieve good representative colour on paper. This image of the east side of the temples of Luxor was reproduced in a book of Egyptian archaeological views, *Unter der Sonne Ober-Ägyptens*, published in Berlin by Dietrich Reimer in 1909.

Both Alvin Langdon Coburn and Steichen used the gum-platinum process in which the initial platinum photograph was re-exposed under one or more layers of pigment suspended in a light-sensitive solution of gum arabic and potassium dichromate. Brown, blue and green were the most frequently chosen colours, although Coburn also used a yellow gum layer in his London and Mediterranean images to suggest sunlight. The gum created glossy shadows and matt highlights while allowing more manipulative control over density, contrast and tone. Its raised-relief edges gave a three-dimensional depth to the image, the choice of colour chosen suggesting mood. The gum layer, containing only pigment and no silver, was also impervious to fading and thus gave photographs much-desired longevity. This was in contrast to the autochrome, which had exhibited a precarious and fugitive impermanency with an image that could fade, seated on a support that could be smashed.

Gum bichromate was a derivative of the carbon process, the first permanent nineteenth-century pigment process. From 1866, commercially available carbon tissues were marketed by the Autotype Company of Ealing, London, which printed many of the photographs taken by Julia Margaret Cameron (1815–79), in brown or pink carbon. After 1919, the Autotype Company marketed Carbro in more than 50 colours. This consisted of a *car*bon tissue that was used with a silver *bro*mide print to make Trichrome (or tricolour) Carbro prints, and

ABOVE Alvin Langdon Coburn made this image, *The Rudder*, in Liverpool Docks in April 1906 and exhibited it at Liverpool Amateur Photographic Association in his one-man exhibition the same month. He had perfected the technique of printing with a coloured gum layer over platinum, here a moody blue, to such an extent that the British photographic press rechristened the process "Coburnesque".

was in use until the late 1940s. Minna Keene (1861–1943) used the carbon process almost exclusively in her work, usually on a large scale and in a wide variety of colours depending on the required mood. Rudolf Dührkoop (1848–1918) utilized the complexities of multiple-carbon printing for his astonishingly coloured portrait of 1915 (see p.62), while Robert Demachy (1859–1936) preferred to add colour to his photographs on textured fine art paper by hand-colouring with pastel crayons (see p.63).

All these processes used the painterly aesthetics and presentation of colour, whereas cyanotype was a rather simpler, but equally striking process. With its rich Prussian blue tones, it appealed to both graphic artists and artist-photographers and also became popular as a quick and easy way to document industrial and domestic scenes. The cyanotype process (ferro-prussiate or blueprint) invented by Sir John Herschel in 1842 and used with such skill by many then – among them Anna Atkins and Hippolyte Bayard (see Chapter 1, p.12) – blossomed again in the late nineteenth and early twentieth century.

Bertha Evelyn Clausen Jaques (1863–1941), a respected printmaker, founder of the Chicago Society of Etchers in 1910 and active member of the Wildflower Preservation Society, produced more than 1,000 cyanotype photograms of botanical specimens in much the same way as Atkins 70 years previously. An enthusiastic world traveller, she made camera-less

ABOVE The London-based Autotype Company supplied pigment papers in 50 different shades to early colour photographers worldwide and had a tint for every mood, as seen in this advertising image. Although printing with carbon tissues was immensely fiddly and time-consuming, the company's products were used by both amateur and professional alike with much success and the company still exists today.

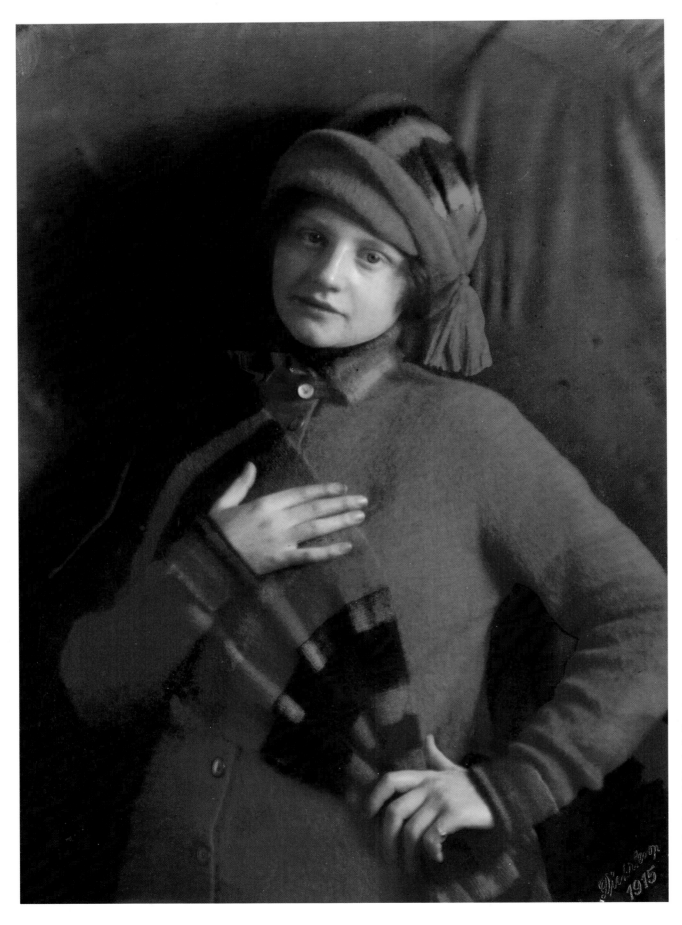

LEFT Rudolf Dührkoop, with his daughter Minya Diez-Dührkoop, was a successful portrait photographer in Hamburg, Germany and often used colour carbon processes in his work. This untitled portrait of 1915 was obviously taken to explore the full colour spectrum with its strong purples, blues and vivid greens. The identity of this colourfully dressed girl is, alas, unknown.

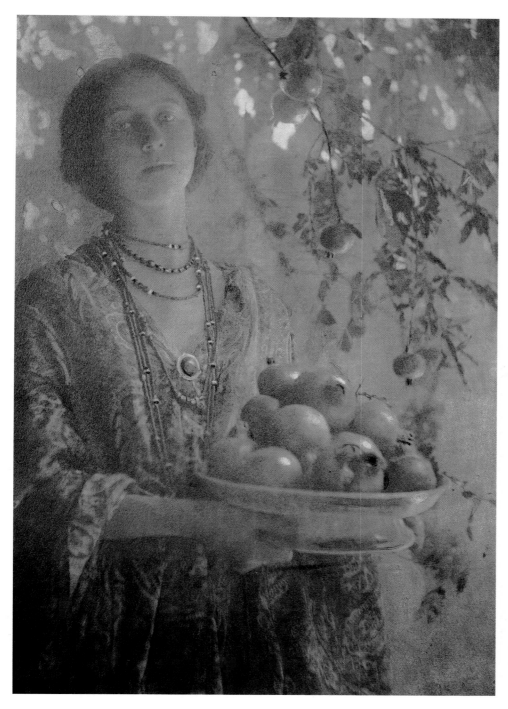

ABOVE Minna Keene always preferred to work with coloured carbon processes and used a bright blue/green for this 1910 portrait, which may be of her daughter Violet, also a photographer. Born Minna Bergman in Germany, Keene and her family travelled widely, living in South Africa for 10 years, then in Britain, before settling in Canada in 1913.

ABOVE Robert Demachy was, in effect, utilizing free-form hand-colouring when he added colour from pastel oil crayons to his photographs, as here in 1906, always striving for a unique work of art. He was not concerned with the faithful reproduction of detail and reworked his images, using the negative as a mere starting point, etching and scratching at the emulsion to obliterate any background.

LEFT AND BELOW Bertha Jaques was a consummate graphic artist who worked in etching, drypoint and latterly, to introduce some colour into her work, cyanotype. For the latter she used botanical specimens gleaned on her travels, here elderberry blossoms (left) and the blossom of the chandelier plant (below). She had a reverence for the often overlooked commonplace elements of nature and produced exquisite and beautifully crafted objects which have a pure and pleasant simplicity.

RIGHT Florence Peterson was around 17 when she posed for this gorgeous cyanotype. Paul Burty Haviland made a series of about 20 cyanotypes of her either nude or, as here, wearing a kimono, in Clarence White's studio and his own apartment during 1909/10. Haviland's French/American family owned the famous Haviland Porcelain Company and he operated as the company's representative in New York before returning to Paris in 1914. His archives are at the Musée d'Orsay in Paris.

images using specimens she collected on her journeys, placing them directly on to sensitized paper which was then exposed to light. Jaques's work reflects the simplicity and purity of the cyanotype process just as Atkins' work did in the nineteenth century.

Paul Burty Haviland (1880–1950) made a series of autochromes, platinum prints and cyanotypes of Florence Peterson in Clarence White's New York studio in 1909 that are possibly the most sensual cyanotypes ever made. Some years later in 1920, Edward Steichen who – since fleeing his home in France during World War I and returning to New York – had discarded soft-focus pictorialism for a sharper, straighter photography, used a combination of palladium and cyanotype to make a series of abstract Modernist images. His work in aerial photography in the Photographic Section of the Army Air Service from 1917 had changed his photographic vision and he reasoned that "if it was possible to photograph objects in a way that makes them suggest something else entirely, perhaps it would be possible to give abstract meaning to very literal photographs".[2]

LEFT After World War I, Steichen began to construct images using simple everyday objects to try to represent volume, scale and weight, often with a one- or two-day exposure. His photograph *Time-Space Continuum* is intended to be a visual representation of Einstein's Theory of Relativity, using objects including a locksmith's pattern sheet as symbols to create abstract images and experimenting with photographic chemistry to achieve a mix of monochrome and colour.

Initially, in the first decade of the twentieth century, many other additive colour screen-plate processes came on the market in an attempt to tap into the autochrome's lucrative sales. However, despite various innovations, few could realistically compete with the Pointillist charms of the autochrome which made every photographer an artist. In June 1907, Ducos du Hauron himself and his nephew Raymond de Bercegol released the Omnicolore plate which Steichen tried and quickly dismissed, finding its colour quality inferior to that of the autochrome, although it had a more rapid exposure time. By 1911, Omnicolore had been taken over, absorbed and then discontinued by the Lumière Co.

Another process, the Mantechrome, has only come to light in the last two decades and seems never to have been sold commercially but only used by its inventor. Indistinguishable from the autochrome, it was supposedly invented by Louis Amédée Mante (1826–1913) in the 1890s, thus predating the Lumières' work by at least a decade. How it functioned before the introduction of the all-important panchromatic emulsions is not clear.[3]

In 1909 the Thames Colour Plate, initially patented by Clare L. Finlay (?–1936) in 1906, offered a British autochrome alternative using a screen of precise coloured circles rather than the autochrome's randomly stippled blobs. However, this was discontinued before World War I, only to re-emerge as the much re-worked Finlaycolor in 1929. It was used briefly by *National Geographic* magazine after it had abandoned the autochrome.

LEFT AND BELOW Never let it be said that early colour processes cannot be fun! The Finlaycolor process used a black and white negative exposed through a separate colour screen and then, after development, the resulting positive was viewed through a similar colour screen to register a full-colour image. If the registration was not correct or a different screen was used, the colour balance, here the pink and green, would be reversed. This is demonstrated in the colour charts with information about exposure and development temperature, and also in the reversed flowers and leaves pattern on the dress that both the woman and the man are gamely wearing.

Other additive screen processes included the Paget Colour Plate released in April 1913 by Geoffrey S. Whitfield (dates unknown). This had a much more rapid exposure time than the autochrome – 1/25th second at f4.5 – but the colours were paler and not so seductive, and it was discontinued in the early 1920s when it became too expensive. The German Agfa Process of 1916 only became available outside Germany in 1923 and came rather late to the marketplace, being replaced by Agfacolor roll film and cut sheet film in 1932.

The only true early competitor with the autochrome was the Dioptichrome Plate of 1909–14, invented by Louis Dufay (1874–1936), which sold a respectable 40,000 units in 1911. Renamed Dufaycolor, it was introduced as ciné film in 1932 and as roll-and-cut film for the still photography market in 1935. The last "additive" colour process to be marketed, Dufaycolor consisted of a very fine, regular filter screen made up of red, green and blue cross-hatched lines printed on a film base. With increased sensitivity and more colour accuracy than Lumière roll film, it achieved exposures of 1/50th second at f8 on a sunny day and was popular with both amateur and professional photographers. Much used by British photographers during the 1930s and 1940s, it was only discontinued in the 1950s.

There is one final remarkable name in the rolls of inspired additive colour inventors. As Albert Kahn was sending his photographers around the world to record it on autochrome and ciné film for his Archives de la Planète, Sergei Mikhailovich Prokudin-Gorskii (1863–1944),

a Russian photographer from Murom in Vladimir Oblast, east of Moscow, had the same idea, if on a slightly less grandiose scale. He had studied science at the Russian Institute of Applied Technology, then colour reproduction with the influential Professor Adolf Miethe in Berlin in the 1890s, and become interested in the possibilities of colour photography for projection and reproduction purposes, working with Miethe again in 1902. He had already made his own tricolour plates and used them for lectures and as illustrations in the Russian photography journal he edited, entitled *Fotograf Liubitel* (*Amateur Photographer*). Now he wanted to use the new tricolour glass negative technology to assemble a vast realistic visual document of the massive multicultural Russian Empire while it was still in existence, and then use the resulting images for lectures and books to inform and educate people about the past, present and future of the Russian Empire. Growing social unrest threatened revolution and the impending dissolution of the old order: Prokudin-Gorskii's timing, like Kahn's, was critical.

From 1909 to 1912 and again in 1915, using a camera with a repeating back of the type designed by Miethe and made by Bermpohl in Berlin, Prokudin-Gorskii travelled ceaselessly

ABOVE LEFT The square format of Prokudin-Gorskii's images gives them a very modern feel. For this 1909 image of bright blue cornflowers and white daisies in a very green field of rye, he must have been lying flat in the field to fill every bit of the frame with colour and detail.

ABOVE RIGHT This 1910 image of the joining shop for the production of scabbards at the Zlatoust plant must be one of the earliest industrial images in colour, its drama increased by the raking window light. At this time Zlatoust's major industry was the production of cannons, sabres and swords made from Russian steel which would be much in demand over the next few stormy decades of the country's history.

through 11 separate areas of the Russian Empire and produced over 3,500 sets of negatives. His black and white negatives, three to a plate on 9 x 24cm Ilford "Red Label" glass plates, hypersensitized by his own (and Miethe's) process, were exposed consecutively at one-second intervals through red, green and blue filters. He funded the whole project himself; however, after a well-received presentation to the Imperial family, he was also granted sponsorship from Tsar Nicholas II in the form of a Pullman railway carriage fully equipped for photographic use, a steamship, a motorized boat and a Ford motor car for access to areas of the country without railway connections. More pertinently, he had Imperial orders for all officials to cooperate rather than obstruct, enabling him to access otherwise prohibited areas and photograph the old and the new – people, buildings, landscapes, customs and religion, as well as factories, construction and industrialization.

Prokudin-Gorskii's initial intention was to take 10,000 photographs over a 10-year period but the cost of the project – equipment, photographic products, paying assistants, living expenses and so on – meant that each photograph cost a mighty 10 roubles. Thus

ABOVE Prokudin-Gorskii's calm and peaceful self-portrait on the banks of the Karolitskhali River in the Caucasus Mountains, probably taken around 1915, shows a man who tried to make a difference and who, like Albert Kahn and his Archives de la Planète, believed that colour photography had an important role in the future of education and a more tolerant global understanding.

economics, and then the Russian Revolution, hampered the realization of the full-scale project. For his lectures, including several to the Tsar to report on progress, positive plates made from the three black and white separation negatives were projected simultaneously, and in register, through the corresponding red, green and blue filters of a projector of his own making (this may possibly have been based on a modified Ives projection Chromoscope – a form of "magic lantern" projector). The three images were then superimposed to produce a full-colour image, in the same way as James Clerk Maxwell had done 50 years previously.

Prokudin-Gorskii also made a set of monochrome contact prints from the negatives, which he kept in annotated albums as a record of his journeys. After the 1917 revolution, he and his family left Russia, their money and property lost, and lived, with just over half of the photographs that they had been allowed to export, in Norway, England and Paris until his death in 1944. The Library of Congress in Washington acquired the remaining photographic archive of 1,902 negatives and 14 albums from his descendants in 1948. Using digital technology, the explicatory albums and the tricolour negatives have now been amalgamated into a full presentation of Prokudin-Gorskii's achievements. The negatives, now rendered as glorious full-colour images, can also be seen in their three component parts. A century since these images were taken, technology has finally caught up and come full circle. Once again, these additive images can be seen online in full colour on a screen, but can also now be printed out on paper at the touch of a button.

ABOVE The Lumières achieved stunning results with every colour process they researched and devised, but only the autochrome was commercially viable and went into long-term production. The bichromated gelatin glue process yielded bright jewel colours and seems to glow with an inner light. It was fitting that they experimented with it in the colourful *salle à manger* of the Château de Chantilly in 1898, when it was first opened to the public as the Musée Condé.

By the early 1930s, the days of the additive method, with more than 300 different processes patented, were largely over and new photographic technology would be based on the subtractive process. Since first outlined by Ducos du Hauron in various patents from the 1860s onwards (see Chapter 1, pp.16–19), there had been furious experimentation with subtractive colour processes using tricolour glass negatives and heavy experimental cameras – a time of startling full-colour images sandwiched between sheets of glass and of hazily grainy pastel-tinted images on paper. Many attempts were made to find subtractive alternatives to the autochrome which could be marketed as successfully, not least by the Lumière brothers themselves. From 1893 to 1935 (see Chapter 1, p.19), they experimented with the (nonsubtractive) Lippmann Process of 1891 but realized it was too difficult to manufacture on a commercial basis. They also had excellent results with the bichromated gelatin glue process which they exhibited as stereos under glass to much praise at the Exposition Universelle Internationale in Paris in 1900. Although the colour is startlingly rich and luminous, each image took 12 hours to expose, print, register and assemble in a glass sandwich, and thus the method could never appeal to the amateur market. E. Sanger Shepherd's (1869–1927) Process involved a similarly complex assembly and the images produced had a tendency to yellow. It was used by Sarah Angelina Acland, who experimented with practically every form of early colour as it became available on the market.

Another determined experimenter was Otto Pfenninger (dates unknown) whose public row with Frederic Eugene Ives (see p.18) enlivened the pages of the *British Journal of Photography* in 1910, in which both men claimed to have invented the single-reflector three-colour

ABOVE LEFT Because the slowness of early colour processes meant that subjects had to be motionless, still lifes and flowers were ideal, being both static and colourful. The Lumières frequently photographed arranged still lifes of equipment in their laboratories or artfully arranged flowers, as here in this 1900 stereo of orange/yellow parrot tulips against a background of deep turquoise silk.

ABOVE RIGHT The daughter of Henry Wentworth Acland, who was Regius Professor of Medicine at the University of Oxford and President of the General Medical Council, Sarah Angelina Acland took this Sanger Shepherd process lantern slide during her winter holidays in Madeira in 1905. She switched to the easier autochrome process in 1908. Her substantial archives using a variety of monochrome and colour processes are now in the Museum of the History of Science and at the Bodleian Library in Oxford.

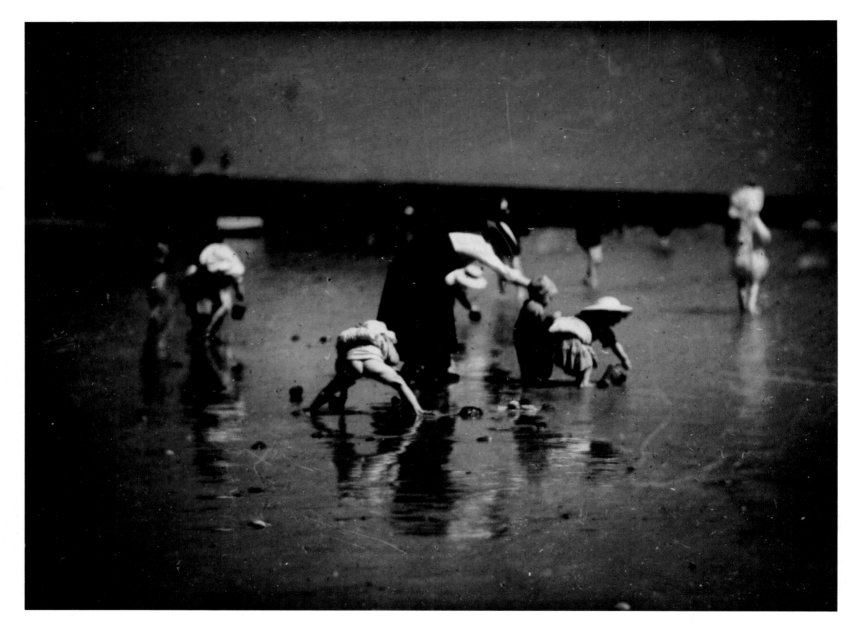

camera. The Dover Street Portrait Studios in London used Pfenninger's camera from 1911, but he also put its various prototypes to good use by taking a series of charming photographs on Brighton beach during the summer of 1906. Ives went on experimenting with new methods. His twentieth-century inventions, such as the Hicro and Hichrome processes, were ingenious but monumentally complex, although they were used to great effect by Steichen.

Tricolour printing processes on paper in the 1920s were not for the faint-hearted, being complex, fiddly and largely unautomated. Although there was a flourishing trade in colour in portrait studios for those who could afford it, colour generally was expensive and the public was largely disinclined to pay for it when a hand-coloured monochrome portrait was cheaper. Professional photographers usually stuck to monochrome rather than master a multiple-exposure camera, involving two or three black and white negatives shot through different-coloured filters which then had to be printed or laminated together to form an assembled colour image. The various processes often involved more than 80 precise and exact steps, none of which could be omitted, and it could take up to 10 hours to make a single print. Apart from the complex technology of the tricolour processes, there was also the expense

ABOVE Early colour photography was particularly responsive to the quality of bright daylight found at the seaside. Despite their air of the Venetian Lido, Otto Pfenninger's photographs of Edwardian families at play were taken on summer weekends in Brighton, on England's south coast – this one on June 16, 1906. The strong blue dye of the two- and three-colour processes with which he was experimenting and the fact that he printed on a transparent base as well as paper, give his images a captivating translucency.

RIGHT The beach also inspired Agnes Warburg in this *c.*1910 tricolour Carbro image of bathing machines, bathing huts and winding gear. As Warburg has mounted the image as an exhibition print, we can assume that she liked the strange colour effect achieved by the three colours being printed slightly out of register to achieve green tones around the ghosted wheel spokes.

of equipping a darkroom and training staff. Therefore it was left to enthusiastic individuals and "amateurs" who had the time, money and sufficient grasp of both technology and colour aesthetics to master the new techniques.

The history of amateur colour photography is a very under-researched subject. Many members of the Royal Photographic Society (RPS) in London (established in 1853) were keen to practise colour photography and there is much early experimental colour material, both images and equipment, in the Society's Collection and Archives.[4] Although sometimes having more experimental and technological import than visual and aesthetic appeal, this colour material suggests that an alternative history of early amateur colour photography – beyond the commercial, professional and research worlds – needs to be written.

In 1927, Agnes Beatrice Warburg (1872–1953) and Violet Katharine Blaiklock (1879–1961) established the RPS's Colour Group, which is still extant. The younger sister of John Cimon Warburg, the former enjoyed the luxury and time afforded by private funding. Like Acland before her, she had mastered a variety of complex photographic processes – platinum, gum, carbon, autochrome and bromoil – before tackling colour on paper. She produced her first

LEFT Warburg later used the commercial Raydex colour process, a variation of tricolour Carbro, which could be bought as packs of pre-dyed sheets and, relatively speaking, was simpler to use than many other early colour processes on paper. This strong and subtle image is a Raydex print made from Wratten panchromatic negatives on May 19, 1912. The thick textured art paper on which the image is printed emphasizes its painterly aspects.

RIGHT Fred Judge's landscapes are a Turneresque distillation of atmosphere, smudged and diffused lights and colours, so ephemerally present that they have been likened to ectoplasm. Taken in 1918, only a decade and a few miles down the beach from Otto Pfenninger's sunny blue Brighton photographs, Judge's images seem to depict another more transitory world.

tricolour Carbro print in 1908: a simple, charming still life of spring flowers in a vase.

From 1907 to 1934, along with her brother, Warburg was a frequent contributor to the *Colour Supplement* of the *British Journal of Photography* published by Henry Greenwood in London, and a founder member, in 1907, of the Colour Photographers' Group. For the next three decades, she experimented with a variety of colour processes including Dufaycolor and Kodachrome, but most often with the tricolour paper processes, eventually introducing her own variation, the Warburytype, and never returning to monochrome. Her prints have much the same appeal as autochromes in that they are full of unreal plangent light, strangely comforting and accessible in their muted colours printed on textured art paper.

One of Warburg's RPS colleagues was Fred Judge (1872–1950). Originally an engineer from Wakefield, Yorkshire, in the north of England, Judge had turned his all-consuming hobby of photography into a career after a photographic trip to Sussex in 1902. With his brother, he bought an existing photographic company in Hastings and set up a successful postcard business that is still thriving today. Initially Judge took all the photographs for

ABOVE A sunnier mood prevails in Judge's 1920 darkroom still life, where the stuff of image-making – the funnel, the pestle and mortar to grind the pigments, the corked bottles – becomes the image itself. Judge's preferred bromoil transfer process profited considerably from his skill at introducing colour, but its complexities were mostly beyond his contemporaries.

RIGHT AND BELOW RIGHT
Although many of S. I. Rainforth's 132 stereoscopic photolithographs in this 1914 series (copyright 1910) by the New York Medical Art Publishing Company are fundamentally too gruesome for popular reproduction, their stereoscopic nature, simple presentation and heightened colour give them a direct and contemporary feel. Of the two reproduced here, the rather beautiful no.122 *Urticaria (Dermographica)* shows the extreme sensitivity of the woman's skin in that a finger tracing her name brings up wheals and no. 19 *Eczema Erythematosum Faciei* shows how the identification of the visual traits of dermatological diseases could benefit from colour photo-reproduction. A full explanation of the causes, symptoms and treatment of the particular disease was given on the reverse.

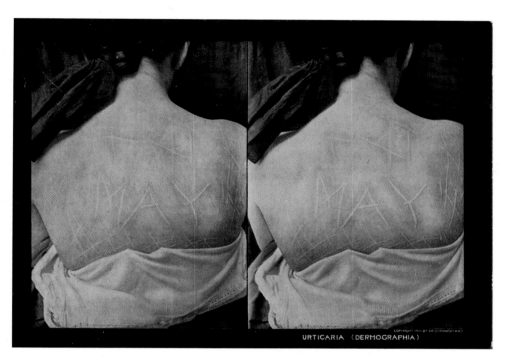

URTICARIA (DERMOGRAPHIA)

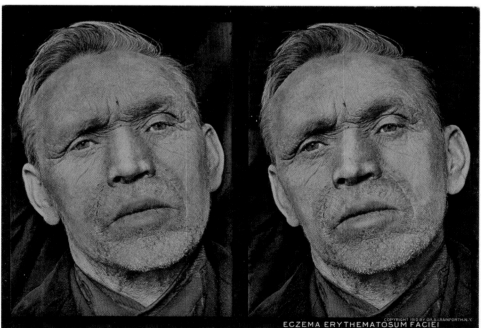

ECZEMA ERYTHEMATOSUM FACIEI

the postcards himself but, after the company's success, he had time to concentrate on his own pictorial work. He worked on a bromoil transfer process to which he was able to add multiple colours, achieving, like Warburg, something very near the atmosphere of the autochrome. Their photographs give no hint that World War I ever happened, nor do they anticipate the many dynamic changes that colour photography was to experience in the next decade.

One of these was the continued advance of colour photography and its use in medical diagnosis and teaching. Sets of stereoscopic cards boxed with a stereoscopic viewer and text in the form of clinical lectures were produced for the use of medical practitioners and students. Dr S. I. Rainforth's *Stereoscopic Skin Clinic* of 1910 went into several published editions and stereoscopic sets of this nature were in production until the early 1950s.

4 COLOUR FOR ALL
1930–1939

With the luxury of hindsight, the 1930s can be seen as perhaps the most formative and dynamic decade in a century of colour photography, even though the long-term effects and the detailed knowledge of just how formative and dynamic a time it was were not realized for several years because of the interruption of World War II. It was the decade when the autochrome and all other screen processes on glass became obsolete (apart from those produced by individuals who, like Fritz Paneth, had zealously hoarded the plates against this expected calamitous day); when the various tricolour printing processes finally were commercialized for those who could afford to use these services and tricolour negatives could be routinely, if expensively, sent to the lab for reliable processing and printing, rather than painstakingly tackled at home by the photographer; when the 35mm camera, first introduced by Leica in 1925, began to go more mainstream; and when Kodak launched the Kodachrome 35mm slide transparency on to the market.

In the world of the arts and the artist-photographer, the period between the two world wars was a dynamic one, with an avant-garde backlash against everything that had gone before. New ways of looking at the world – Realism, Modernism, Constructivism, Expressionism, Precisionism, Surrealism – that had been honed to razor sharpness by the futile reality of the bloody debacle of World War I, meant the death of soft, romantic pre-war Pictorialism. Gone were the languid out-of-focus women in long white dresses moodily clutching globes. Life took on a new immediacy: bold and radical experimentation was all, and there was a new predilection for exploring the sexual, the psychological, the abstract, the fanciful and allowing the unconscious imagination to run riot.

For 1930s colour photography, the major influence was European Surrealism. The influence of émigré artists and photographers from decimated Europe and elsewhere was paramount. Those photographers who chose to use colour in this decade were a brave and dedicated coterie. After a century of brown, then black and white photographs, the general public initially saw the full glare of 1930s colour as rather crass, frivolous and vulgar. "Serious" photographers stuck with "realistic" black and white. Colour was also far more expensive and was far too complex for most amateur photographers, but was taken up by the experimental avant-garde, among them Man Ray (1890–1976), László Moholy-Nagy (1895–1946), Paul Outerbridge (1896–1958), Nickolas Muray (1892–1965), Madame Yevonde (1893–1975) and Walter Bird (1903–69).

RIGHT Initially wary of Kodachrome, Edward Steichen wrote in his 1963 autobiography that it was "more of a liability than an asset for it brought forth an orgy of color. Instead of colorful pictures we had coloriferous images." He changed his mind during a two-month trip to Mexico in 1938 after using the film in a 35mm Contax camera given to him by Zeiss. This beautifully composed study of two Mayan women in Yucatan, their profiles the same as those carved in ancient frescoes, was one of a series that edged his work ever closer to photojournalism.

In 1920s Paris and Berlin, Paul Outerbridge was mixing with the avant-garde élite and took those influences back to New York with him in the 1930s where he worked in advertising photography and produced still-lifes and nudes. His nude studies are complex and often obsessional, and examine the female body as idealized form, as fetish and as theatre. Much of this same uneasily probing and questioning attitude may be seen in his still-lifes too. Outerbridge devised his own methods of printing full colour from three separate negatives – a laborious and technically demanding feat but one he mastered to the highest degree of perfection. Not only was he a disturbing and brilliant photographer, he was also a consummate technician and craftsman.

The same may be said of Nickolas Muray who emigrated to the USA from his native Hungary in 1913 and had a hugely successful career over four decades as a freelance photographer working in fashion, society, advertising and the commercial sphere. His photographs of models in beachwear were the first colour images to appear in the popular American magazine the *Ladies' Home Journal*, in 1931. In his advertising photography Muray became adept at depicting an idealized American way of life.

Technological advances in photography meant that, within a couple of decades, many families would possess a projector and screen and could fill their Sunday evenings with

RIGHT Arthur Traube
(1878–1948), a student of Adolf
Miethe's in Berlin, worked with
him in 1902 on the discovery of
isocyanine dyes, which improved
the sensitivity of panchromatic
emulsions to yellow/orange,
making the autochrome and
other colour processes possible.
In 1931 Traube invented a dye
transfer process, the Uvatype, and
used it to print this Modernist
photograph of a plate of mixed
biscuits including a Zugspitz
biscuit – named after Germany's
highest mountain.

BELOW This charming 1938
Vivex print by Photographic
Advertising Ltd of London is
most likely an advertising shot
for (unseen) cheese, given the
route of the mouse scampering up
the tablecloth. Closer inspection
reveals that, alas, the mouse's
front and back right paws have
been forcibly stuck through the
tablecloth to hold him there,
suggesting that he was no longer
able to scamper or eat cheese.

endless slide shows reliving high days and holidays photographed by a family member
– usually Father – in glowing and embarrassing colour. As with the stereoscope in the
nineteenth century, the 35mm colour slide returned photography to the heart of the family
with this shared viewing experience. This decade of photographic progress was not so
obviously apparent at the time because of the intervention of World War II, which slowed
down the proliferation of the new 35mm technology across the amateur market. However,
from the mid-1930s, slowly but surely colour photography began to open up to a wider
audience – if it was not colour for all, then at least it meant colour for more. (The full impact
of Kodachrome, a 1930s invention which only gained widespread use over the next two
decades, will be more fully considered in Chapter 5, pp. 102–104).

The push for colour in the 1930s was stimulated by three different industries, all of which
were growing at a phenomenal rate: the film industry, most especially in Hollywood; the
advertising industry; and the growing "lifestyle" and news publishing industry which fed off
the previous two, its content defined by an increased number of reproduced photographs as
well as text. Early models of the modern picture magazine, such as *Berliner Illustrierte Zeitung*
and *Münchner Illustrierte Presse*, were published in Germany in the 1920s, while *National
Geographic* was an even earlier example.

From the 1930s, photographic research and processes were largely geared to meet the demands of the commercial cinema which, as it converted to colour from monochrome, increased the amateur interest in using colour. Demand grew for a quick, cheap, easily mastered home colour system and photographic processes were hastily perfected to respond to the demands, and the finances, of this new market. Initially they took the form of 16mm film for home movies. Then, as the new "miniature" 35mm cameras became more popular, 35mm slide film became available. Thus, as colour began to enter into people's lives via the movie screen, it also found its way into their own photography.

Perhaps the most influential use of colour, however, and one that became ever-present, was in the advertising industry. Advertising had been around for decades of course, as had advertising in colour. But, if photographically based, the colour was usually added by the hand of an illustrator to a reproduced monochrome print. From 1900, magazines had been able to make colour separations and print colour reproductions of drawings and paintings. But reproducing colour photographs accurately was more problematic and also expensive and the cost could only be justified if sales were high, as with the reproduction of autochromes in *L'Illustration* during World War I and in *National Geographic*. Between 1925 and 1936 a new species of one-shot colour-separation cameras began to appear on the market that made the transition from photograph to printed page a marginally less cumbersome exercise.

After the effects of the 1929 Crash percolated down through society during the 1930s Depression, advertising began to turn more aggressive: with a tighter economy, the wiles used to get consumers to spend what little cash they had became ever more inventive. The new rash of "lifestyle" magazines, largely aimed at a female audience, found that their sales rocketed when they used colour photography on their editorial and advertising pages. The June 1931 issue of *Ladies' Home Journal* – the first popular American magazine to print reproductions made from an original colour photograph – featured two of Nickolas Muray's tricolour carbro prints of models in beachwear. Muray, who had been a successful New York-based celebrity portraitist since the 1920s, and who worked for the Condé Nast stable of *Vogue* and *Vanity Fair* as well as *Harper's Bazaar*, the *New York Times* and *McCall's Magazine* until the 1960s, was to become the most successful advertising and celebrity portraitist over the next three decades. By 1934, his photographs had been used by such "premium" brands as Coca-Cola, Dodge and Lucky Strike cigarettes.

The barometer of colour photography, Edward Steichen – who had been working for Condé Nast and the advertising agency J. Walter Thompson in New York since 1923 – used colour with growing frequency throughout the 1930s, in both his commercial and his private work, achieving an especially resolute colour palette of deep glowing blues. After leaving Condé Nast in 1937 and closing down his New York studio on January 1, 1938, he retired to his estate in Umpawaug, Connecticut. Here his colour technician from the New York studio, Noel H. Deeks, set up a darkroom and studio for Steichen where he worked and further experimented with colour photography for the next quarter of a century. In 1938, on a retirement vacation in Mexico, he also used a 35mm Contax camera to achieve more instantaneous photographs in both black and white and colour, including a set of rarely seen but beautiful images of

LEFT Rich cerulean blue was a favourite colour of Steichen's. He painted with it, bred it in his delphiniums and used it often in his colour photography. Here the lithe-torsoed and silver-bangled model "Miss Hill" triumphantly brandishes a phallic head of sweetcorn. The armlets and collar suggest slavery. The pose suggests freedom. The whole suggests kitsch. Perhaps the title – *Ripe Corn* – is a giveaway? From 1935 to 1947 Steichen had a major role in the production of *US Camera Annual*, for which this image was apparently taken on December 12, 1934.

OPPOSITE H. I. Williams and Fiestaware pottery were made for each other as shown in this sophisticated *c.*1938 Modernist diagonal shot. The range was launched in 1936 with the slogan "Color! That's the trend today." Williams regarded his work as entirely commercial rather than artistic, saying in *The Commercial Photographer* magazine in October 1931 that, "in order to be a commercial photographer, you've got to be a dramatist and an inventor and an engineer."

LEFT Williams was well known for his gloriously vivid food photography as here in this *c.*1930 tricolour Carbro image of fresh and bottled red and green peppers. He was also no mean cook, even going so far as to write recipes to accompany his photographs. His recipe for Caesar Salad can still be found on the US *Astray Recipes* website (astray.com).

Mexican street scenes, most especially featuring Mexican women (see p.79). These scenes reflect Steichen's growing interest in photojournalism during the late 1930s and the 1940s, which was to culminate in his seminal 1955 "Family of Man" exhibition at the Museum of Modern Art (MOMA) which then travelled worldwide. Steichen's third wife and widow Joanna recalls boxes and boxes of tricolour and small-format negatives, remarking that Steichen "wanted results as rich and subtle as those he had achieved in his earliest private experiments with multiple color processes".[1]

In the world of advertising, colour grabbed and engaged attention, represented the product more accurately and, most importantly, sold more goods. As the Western world increasingly plunged into economic depression during the 1930s, so advertising was used to sell nationalistic and domestic values and engender a sense of pride in both home produce and design. A prime example of this is the work of H. I. (Harney Isham) Williams (1886–1965), who specialized in gloriously composed and shockingly colourful food photography. He was also commissioned by Fiestaware. Designed by the British designer Frederick Hurten Rhead, the art director of the Homer Laughlin Pottery Company in Newell, West Virginia, the innovative new Fiestaware crockery took the USA by storm when it was launched in 1936, its multiple bright colours making it a natural for colour reproduction. After a successful run of 24 years, the range was restyled in 1959, withdrawn in 1972 and relaunched in 1986 – and, of course, is now a collector's item on the auction website eBay and elsewhere. In 1948

LEFT Presages of war pervade Madame Yevonde's surreal 1939 advertising image for Glyco-Thymaline, an alkaline cleansing solution for oral and personal hygiene. The gas mask box, helmet, fire bucket, bandages and stuffed owl of wisdom, the latter one of her favourite and often-used props, are arranged in a jaunty composition. It is the tin of anti-gas ointment, to be rubbed into the hands and containing Chloramine-T as a prophylactic against the chemical weapons mustard gas and lewisite, that is strangely chilling.

alone,10,129,449 pieces were sold: this must surely be at least in part due to the fabulously rich colour of Williams's and others' photographs of the products.

After the shock of the International Surrealist Exhibition held at the New Burlington Galleries in London between June 11 and July 4, 1936, European advertising in the 1930s took on a rather more Surrealist slant, especially in the UK. The exhibition attracted 1,000 visitors a day, among them Madame Yevonde whose studio was around the corner at 28 Berkeley Square in Mayfair. A successful but increasingly bored monochrome portrait photographer since the 1920s, Yevonde embraced colour photography with an absolute passion. In 1932 she hired the Albany Gallery in London for the first-ever solo exhibition of colour portraiture in Britain when she showed 36 examples of her recent colour work. Throughout the 1930s, she took thousands of tricolour negatives on her one-shot camera, which weighed more than five kilos (11 pounds), and exhibited her work. She also lectured and wrote on colour photography at every opportunity, noting that, "Photographers have little or no sense of colour and if they ever possessed such a quality it has become warped or nonexistent through years of disuse."[2]

Yevonde's dedication to colour was facilitated by the establishment of the company Colour Photographs Ltd, the first professional colour printing service. Using the Vivex process – yet another variation of the tricolour Carbro process – the company produced vivid colour photographs from tricolour negatives, in a meticulous and standardized factory

LEFT Cunard was reluctant to cooperate with Yevonde during her 1936 photo-essay on the final fitting-out stages of its liner *RMS Queen Mary*. She also experienced difficulties in lugging all her equipment on board ship and with an uncertain power supply for the lighting, but despite that the whole shoot went surprisingly well and she was able to illustrate the massive size and moneyed splendour of the vessel. A delighted *Fortune* magazine printed 12 Yevonde images instead of the planned four.

environment, thus sparing the photographer the drudgery. The factory could turn around prints from negatives in eight hours, although five to ten days was the norm. The end result was an absolutely archivally permanent colour photograph. However, Vivex was an expensive process: a 15 x 12in print cost £2.12s. 6d, so photographers compensated by charging anything up to 20 guineas for a portrait sitting, making seven or eight sets of negatives and then only having prints made from the very best. Most photographers seemed to think the end product worth the expense, and 90 per cent of all colour prints produced by more than 200 photographic studios in the United Kingdom during the 1930s were made by the Vivex process. One of the great advantages of the process was its capacity for infinite retouching which enabled blemishes to be removed, as well as overly fleshy areas to be discreetly bleached away. In 1939, when most of the printers enlisted in World War II, the factory closed: with the advent of Kodachrome, post-war photography would become a very different proposition.

Colour photography enabled Yevonde and other members of the Colour Photographers' Association (among them Walter Bird and Photographic Advertising Ltd) to expand their lucrative editorial and advertising work. Yevonde's first major editorial commission was to photograph the fitting out of the Cunard liner, the *Queen Mary*, at the shipyards of John Brown & Co. at Clydebank in Scotland, before the ship made her maiden voyage in 1936. The resulting photographs were reproduced in a 12-page colour spread in *Fortune* magazine in June 1936. By

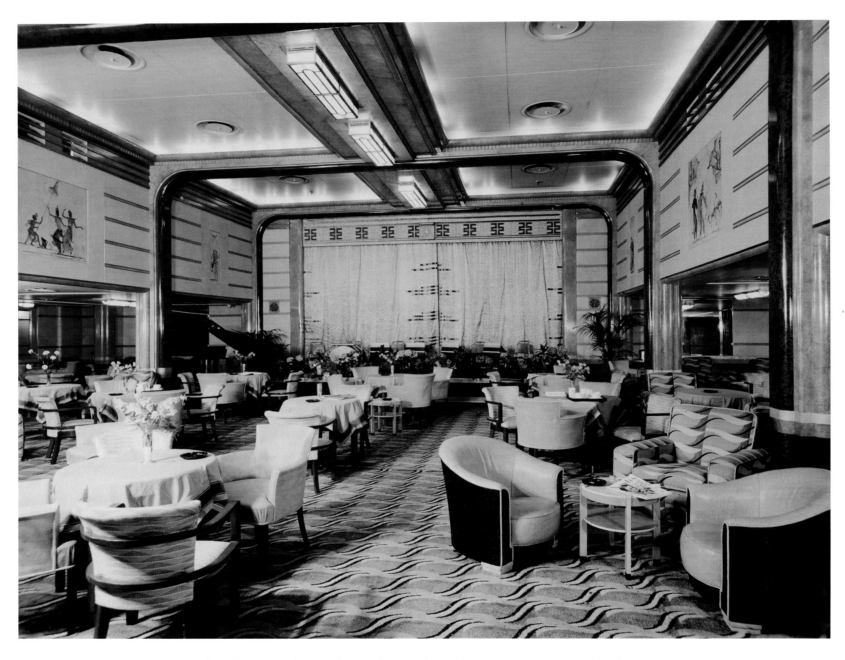

this date, *Fortune* was frequently reproducing colour photography on its pages; others, however, were slower to follow suit. *Time* magazine – which had begun publication in 1923 but was reinvented and newly launched as a weekly photojournalism magazine by Henry Robinson Luce on November 23, 1936 – did not fully feature colour until later in the 1940s and 1950s. *Picture Post*, which began publication in 1938, remained resolutely black and white.

Subsequently in 1937, in one of the first showings of colour photography in a museum or art gallery context, two of Yevonde's *Queen Mary* photographs were exhibited at the MOMA, New York, in Beaumont Newhall's seminal exhibition "Photography 1839–1937" (Newhall was then curator of the newly formed Department of Photographs). Also on display was new colour work by Nickolas Muray, Edward Steichen and Paul Outerbridge. The latter seems to have been an important influence on Yevonde's later commercial work.

The glorious Art Deco interiors of the new breed of ocean liners were also extensively photographed by the Stewart Bale Co. of Liverpool (operating 1911–80). Building luxury

ABOVE Cunard decided to make second-class accommodation on the *Queen Mary* better than that of their rivals. The main lounge on M deck had Wilton carpets, amboyna and macassar ebony furniture and upholstery in the favourite Art Deco colours of pale green, ivory and black. The walls were Thuya burr, birch and maple with appliquéd green, ivory and silver leather and murals of dancing through the ages by Margot Gilbert.

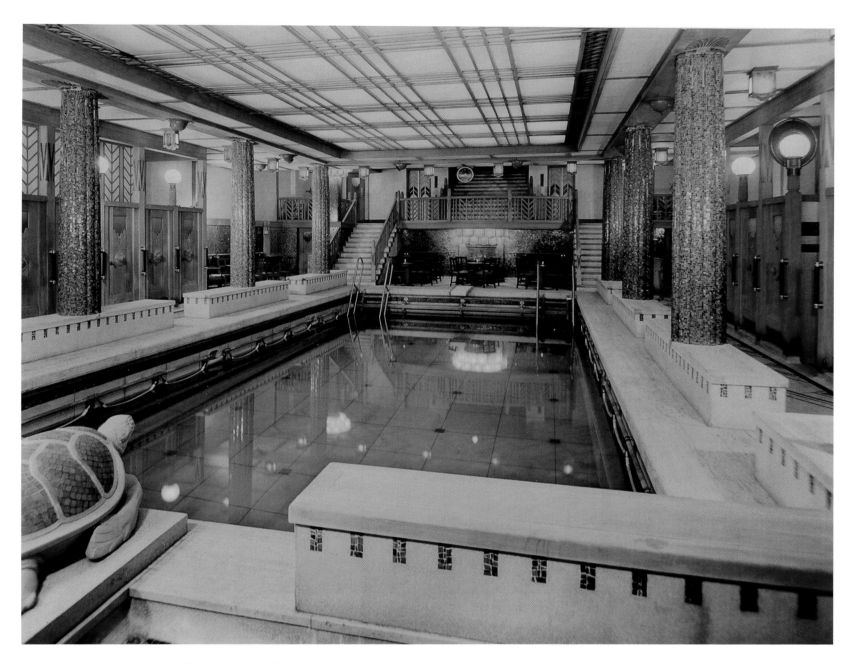

liners seemed to be endemic in the 1930s at a time when the Depression was causing growing economic hardship and the rumblings of an imminent war grew ever louder. However, none of this is apparent in the luxurious insouciance of the internal fittings and the lavish Vivex prints. The charming image by F. W. Westley (dates unknown) of the calm, stone-lined, Olympic-sized swimming pool on the *Empress of Britain* – in 1931 the largest, fastest and most luxurious ship of her day, sailing between England and Canada – truly depicts a world that would be gone forever within a couple of years. During World War II, both the *Queen Mary* and the *Empress of Britain* would be fitted out as troop transport ships. While the *Queen Mary* survived the war and has, since 1967, served as a hotel at Long Beach, California, the *Empress of Britain* was torpedoed and sunk by a German U-32 on October 28, 1940.

Portrait photographers found it difficult to persuade their daily bread-and-butter clients to sit for a colour portrait as people resented the expense and what they perceived to be the

ABOVE F. W. Westley used three separation negatives, a long exposure and a whole-plate field camera with a wide-angle lens to photograph the indoor pool on the *Empress of Britain* in 1937. The image was then printed by Colour Photographs Ltd as a vivid Vivex print. Dr D. A. Spencer, Director of Colour Photographs Ltd, used the left half as an illustration in the influential 1938 book *Colour Photography in Practice.*

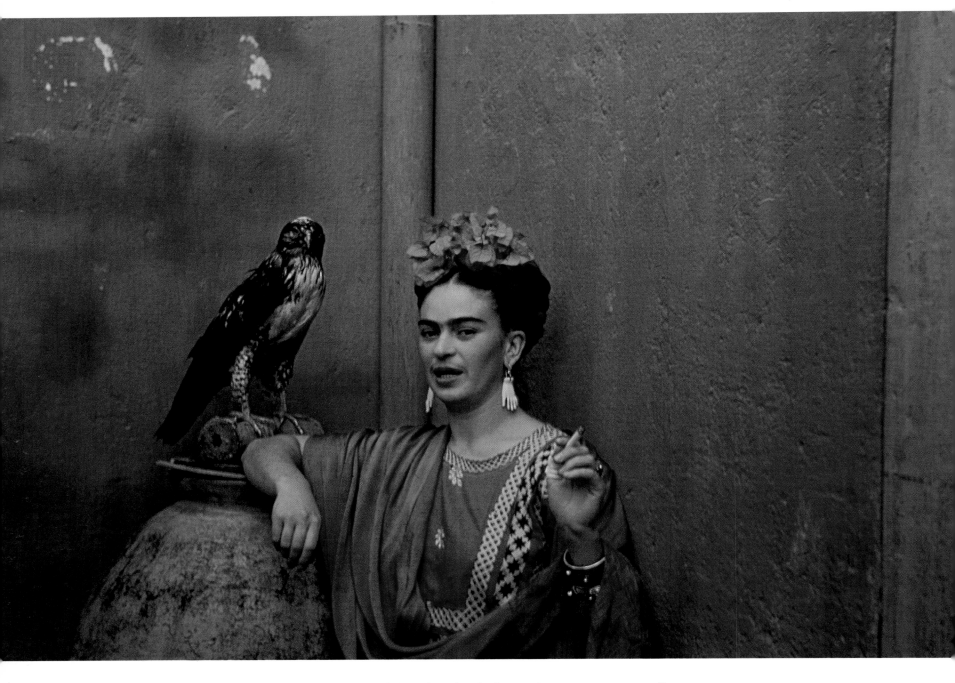

"chocolate box" garishness of the end result. The famous, however, were more willing to experiment with colour and it is significant that most of the portraits here are of artists, who were the celebrities of the day (before their celebrity status was overtaken by that of film stars), and who also knew about colour. Nickolas Muray was the lover and confidant of Frida Kahlo (1907–54) from 1931 to 1941 during her two explosive marriages to her fellow artist Diego Rivera (1886–1957), and the two remained friends after their affair ended. As Kahlo's reputation as an artist has deservedly grown, Muray's stunning series of portraits of her striking features, brutally beautiful and majestically in control, become ever more significant. Muray seemingly took no bad photographs of Kahlo, especially in colour. Both Kahlo's and Muray's acute colour, compositional and spatial awareness, added to her ferocious self-presentation and his urge to represent her in an iconic fashion, combine to make a memorable body of work.

The portraits of the Parisian artistic and intellectual milieu taken by Gisèle Freund (1908–2000) are seemingly calmer and quieter, but equally involve an agreement about implicit control between subject and photographer. Freund, of Jewish descent and an active socialist, left Germany for Paris in 1933, negatives strapped around her body, when neither her race nor her politics augured a prosperous future – if any future at all – in her country of birth. At the Sorbonne in Paris, she continued her research on how photography had

ABOVE Nickolas Muray photographed Frida Kahlo in the summer of 1939 at her home Casa Azul in Coyoacán, a suburb of Mexico City. It was built by her father Guillermo a year after her birth, and Kahlo lived there most of her life; the building is now the Frida Kahlo Museum, complete with her ashes. Muray's Kodachrome, printed as a lush dye transfer, shows Kahlo as she wished to be seen in Tehuana costume and pre-Columbian jewellery, with constant cigarette and pet hawk.

BELOW Margaret Sweeny, no less mythical a creature than Helen herself, poses as a blue-tinged, marble-hued Helen of Troy for Yevonde's 1935 *Goddesses* series. Already divorced from American golfer Charles Sweeny in 1947, her second marriage to the 11th Duke of Argyll ended in divorce in 1963 when he accused her of infidelity with 88 men, producing Polaroids of her wearing only her trademark three-strand pearl necklace, fellating a naked man, headless in the photographs, as proof. Her voracious nymphomaniac tendencies were supposedly the consequence of falling down a 40-foot lift shaft at her chiropodist's in Bond St.

RIGHT Marcel Duchamp introduced Gisèle Freund to Peggy Guggenheim, the American multimillionaire Surrealist art collector then living in Paris. Guggenheim informed Freund, "I'm not photogenic, my legs are the only good thing about me. Photograph them with Herbert Read's head." The art critic Read was Guggenheim's adviser. Freund aimed to photograph the great figures of the interwar years, making her camera the witness of the times. She used 35mm colour film, establishing a strange muted colour palette that is instantly recognizable as her own.

influenced the portrait while photographing the Parisian avant-garde on the new C-type colour negative film. Freund's photographs, from 1939, have a very different and more muted colour cast than the ebullient Vivex prints of the 1930s which makes them seem acutely modern and undateable, as does her severe cropping and the obvious lack of a studio setting and artificial lighting. Freund later remarked, "In those days [1939] colour film was still so weak that you could not take any indoor shots."[3]

While fantasy was never a neglected subject in monochrome photography, colour enabled a wider and more lubricious visual vocabulary. Madame Yevonde's most famous work was her well-received series of *Goddesses and Others* – around 30 costume portraits taken in 1935, reconstructing the extravagantly glamorous fancy-dress outfits worn by a whole host of outrageous society ladies who had attended an Olympian theme party at Claridge's Hotel in Mayfair, London, in aid of the Greater London Fund for the Blind. After three years of experimenting with what the Vivex printers could get from her negatives, Yevonde was now confidently covering her studio lights with blue or green cellophane to achieve either a blue marble-like or green underwater caste in the flesh tones. Despite the Vivex printers kindly correcting what they perceived as reprehensible colour balance on her part, Yevonde eventually got the surreal blues and greens she wanted in her flesh tones.

LEFT Walter Bird's wonderful image of a red-lipped, arch-browed, widow's-peaked vamp makes the best use of the vibrant reds that the Vivex colour Carbro process could achieve. He gives the image a few Oriental touches with the model's red silk Chinese jacket, pearl earrings and hanging foliage, but its strength derives from his brave use of red on red.

RIGHT A cigarette was a fashion statement in the 1930s; a cigarette in a holder showed one had class. Otherwise, this very modern-looking model from 1935 could be from any decade from the 1960s onwards. Bird's colour photography emphasizes his confident use of decorative patterned fabrics, light-reflecting silks and satins and strong studio lighting.

LEFT Bird's love of crimson gives a powerful punch to group compositions such as this 1938 *Roman Bath*, which evokes the classical *tableaux* paintings of nineteenth-century artists such as Sir Lawrence Alma-Tadema. Trained as a painter, Bird had a sure grasp of chromatic balance. During World War II, his London studio was bombed, his negatives destroyed and the Vivex factory closed down. Post-war, Bird turned to the new colour processes of Kodacolor and Kodachrome.

But most photographers who used the Vivex process were happy that they could finally get a decent strong red into their images. Walter Bird ran a successful London studio which specialized in serious monochrome portraits of both major and minor celebrities, as well as "glamour" shots of artistically arranged and strategically airbrushed, perm-haired nudes, seductively draped over metal curves, scrunched-up cellophane or furry rugs. This was the norm of course. When Bird started to work in colour with Vivex, he adopted a totally different aesthetic and revealed a very different vision. To the twenty-first-century eye, kitsch is never far from the surface, but it is powerful kitsch with nothing wishy-washy about it.

British colour photography of the nude during this period has an embarrassed and staged playfulness to it that, perversely, also has its own nostalgic attractions. Bird's *Roman Bath* shows a group of terminally bored-looking models enacting a staged *tableau*

LEFT Yevonde's playful 1937 *Machine Worker in Summer*, featuring the model Joan Richards, may have been a speculative proposal for a Singer sewing machine advertisement, as scrawled on the envelope containing the three separation negatives. More likely it is Yevonde following her own advice to other photographers to look to historical art masterpieces (in this case Vermeer, Boucher and Fragonard) for inspiration.

vivant for the photographer, such as could be seen in London's red-light area any night. While it definitely fails as an arousing image, it succeeds as a staged one because of Bird's use of rich colour, light, composition, skin tones and other elements, which are strong and complicitly engage the viewer. Yevonde's *Machine Worker in Summer* falls halfway between being a Surrealist image and a silly one. Had it been by Man Ray, it would doubtless be perceived as the former.

The hugely attractive and evocative hesitancy implicit in colour nude photography in Britain in the 1930s was not echoed in the USA. Paul Outerbridge's nudes are all about the ripe and fecund female body, which had rarely been photographed in this way before, apart from as pornography. Perhaps because of crude 1930s hair dyes and perms and calloused soles, Outerbridge often cropped the heads and feet off his models, concentrating on their anonymous torsos. With their thrusting, aureoled, torpedo-like breasts, bruises, pubic hair

ABOVE Outerbridge's *Nude with Towel, c.1938*, shows the influence of Surrealist theories of woman as myth and as an object of obsession and has a powerful erotic content. Outerbridge believed that the nude should be "relatively impersonal", and that it was "a fatal error… to have a model establish too personal or intimate contact with the person viewing the picture".

RIGHT Agnes Warburg's
delight, beyond her
photography, was her garden
at her home in Porchester
Terrace, west London, which
is probably where the old-
fashioned roses for this *c*.1935
image were grown. Warburg's
compositional and printing
talents seemed only to increase
with age, as did her deft and
consummate handling of colour.

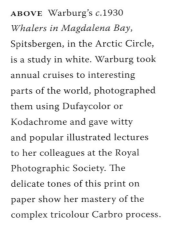

ABOVE Warburg's *c*.1930
Whalers in Magdalena Bay,
Spitsbergen, in the Arctic Circle,
is a study in white. Warburg took
annual cruises to interesting
parts of the world, photographed
them using Dufaycolor or
Kodachrome and gave witty
and popular illustrated lectures
to her colleagues at the Royal
Photographic Society. The
delicate tones of this print on
paper show her mastery of the
complex tricolour Carbro process.

and no airbrushing, Outerbridge's nudes are real womanly flesh and blood: there is rarely
anything easy about them. Like Muray, Outerbridge was a master printer of the Trichrome
Carbro process and, in the 1940s, the dye transfer process and could control the colour
palette of the most complex chemistry.

Outerbridge's preferred Trichrome Carbro process was used to rather different effect by
Agnes Warburg and Violet Blaiklock. While they continued to photograph and exhibit for
some years beyond the 1930s, their pastel-hued images of the interiors of British middle-class
homes, all chintz, blue-and-white Willow Pattern and drooping old-fashioned roses, would
come to seem anachronistically out of place by 1945, after the end of World War II – as out
of place as the autochromes of sunny-faced, golden-haired children in sailor suits had seemed
in 1918, after the end of World War I. But Warburg's and Blaiklock's later colour-bleached
and minimal images seem far more difficult to place in a specific decade than those of the far
more densely colour-assertive advertising images of their photographic colleagues.

Some of the most provoking colour photography of the 1930s was that by artists who were
often self-taught photographers and who mixed media, using paint, pencil, sculpture, collage,
assemblage and hand-colouring in their images. Their work showed that colour was not only
the preferred medium of the film and advertising industries, used to sell celebrity and shift
products; it could also be employed by the avant-garde as an innovative form of expression
and be aligned with progressive Modernism and the various art movements of the day,
Surrealism being the most attuned.

ABOVE Violet Blaiklock, Warburg's colleague in the Royal Photographic Society's Colour Group, also worked as a professional portrait and commercial photographer but this *c.*1930 print of Otterburn woollen mills in Northumberland is her signed personal work intended for exhibition. The image shows the progress from "raw" wool at the left-hand side, through bright skeins of dyed hanging wool to finished tweeds, rugs and blankets at the bottom right of the picture.

RIGHT Frozen in time, this genteel British sitting room of 1932 oozes the wistful period charm of chintz and china in the pale pastel colours of nostalgia. Was this Blaiklock's own sitting room in her London home or perhaps that of her friend Agnes Warburg?

man Ray 1930

Like Steichen in the 1920s, émigré artists such as Man Ray (Emmanuel Rudnitzky) and László Moholy-Nagy were intrigued as to whether colour in photography could create a new kind of fictional or metaphorical visual language, or if the very reality of colour made photography even more of a documentary recording tool than previously. Born in Philadelphia, Man Ray initially taught himself photography in 1915 as a way to make records of his own paintings and, after meeting the painters Marcel Duchamp (1887–1968) and Francis Picabia (1879–1953) in New York, became a committed Dadaist. After moving to Paris in 1921, where he set up a professional studio for portrait and fashion photography, he mixed in Dadaist then Surrealist circles working on collaborative projects and publications with Surrealist artists and poets and avant-garde film-makers. His own photography became increasingly experimental and his work was shown in the influential "Film und Foto" exhibition in Stuttgart in 1929, one of whose organizers and contributors was Moholy-Nagy. Man Ray's experiments with colour photography in the 1930s, used either alone or with other media, make full use of the rich possibilities of the new processes.

RIGHT Hans Bellmer's book *Les Jeux de la Poupée* (*Games of the Doll*) with 15 tipped-in hand-coloured gelatin-silver prints and poems by Paul Eluard was finally published in an edition of 136 by Les Editions Premières in Paris in 1949, although Bellmer had been working on the images since 1934. Bellmer liked to emphasize the doll's "pink pleats", his poetic metaphor for female genitals.

Hans Bellmer (1902–75), a draughtsman running his own advertising company, again taps into Surrealist doctrines with his fascination for automata and the sexualization of the pubescent, and infinitely manipulable, female form. During the 1930s, Bellmer built life-sized dolls from wood, plaster and glue, which he took apart, reassembled in grotesque anatomical positions, and then photographed. He later moved on to dolls that were ball-jointed, round-bellied, often many-breasted and -buttocked and with underdeveloped genitalia, and placed them in a sinister narrative tableau suggesting the aftermath of some previous sexually disturbing event. In these arrangements the doll becomes the implied victim in a constructed drama that has taken place just prior to the photograph being taken. Bellmer's stated aim was "to construct an artificial girl with anatomical possibilities... capable of re-creating the heights of passion even to inventing new desires".[4] His hand-coloured gelatin-silver images, in often lurid shades of pink and green juxtaposed with pale flesh tints, return to the nineteenth-century practice of hand-colouring photographs, as the chemistry of 1930s colour photography could not have produced the unreal pastel and almost neon colours that Bellmer needed.

LEFT It is likely that this image was made in London, where László Moholy-Nagy was living from 1935 to 1937 before he moved to Chicago, and where he learnt colour photography, using tricolour separation negatives, for his commercial work. The Vivex print was made for him by Colour Photographs Ltd. During the London years, he became more interested in working with transparent plastics, using them to create shading, texture and reflection.

Traumatized by World War I, in which he served in the Austro-Hungarian army and was wounded at the Russian front, László Moholy-Nagy abandoned his law studies to train as an artist and photographer. After working at the Bauhaus in Weimar for Walter Gropius (1883–1969) from 1923 to 1928 as head of the metal workshops, and also teaching photography, he set up his own commercial design practice in Berlin. Then, in 1934, he left Germany for the Netherlands, moved to London in 1935 and finally arrived in Chicago in 1937 to set up the New Bauhaus, which became the Institute of Design in 1944. Throughout his life, Moholy-Nagy propounded the doctrine of "New Vision" to look at the modern world in different ways from the traditional past. He constantly experimented with photography's unrealized possibilities, working with his first wife Lucia Moholy (1894–1989) producing photograms (camera-less photographs), negative prints, collages and montages. His interests in pattern and light, transparency, reflection

RIGHT Willy Zielke's 1934 *Still life – Colours in chemistry* is a four-colour bromoil transfer print made from three separation negatives, a descendant of the artist-photographer processes used in the early 1900s. The process gives a soft painterly feel to an image, here also emphasized by the paper grain. Zielke is perhaps better known as a German film-maker who worked with Leni Riefenstahl, most infamously on the 1938 *Olympia*.

and distortion are all apparent in the still-life shown here, in which the superficially simple is rendered strange by an unusual Constructivist perspective. From 1937 and into the 1940s, he began to use 35mm for both his colour and monochrome photography.

The "Film und Foto" exhibition held in Stuttgart in 1929 was the ultimate showcase for the New Vision in photography and film. Among those whose work was exhibited, including Steichen, Outerbridge, Man Ray and Moholy-Nagy, was Willy Zielke (1902–89). Zielke was known for his carefully composed Modernist still lifes of everyday objects exquisitely printed in monochrome as well as tricolour Carbro and bromoil, processes which would not survive in the mainstream in the 1940s. The New Vision gradually became acceptable to and absorbed by the international mainstream as many German and Eastern European practitioners moved elsewhere in Europe and even to the USA as another war approached.

5 DOCUMENTARY IN COLOUR

1940–1949

Colour photography finally came out of the studio, into the pocket and on to the road in the 1940s. The new 35mm cameras that began to proliferate during the late 1930s and early 1940s, along with the introduction of 35mm Kodachrome colour transparency roll film in 1936, enabled amateur photographers to capture the world in its true colours for the first time, defining a new way of seeing. Kodachrome was the first integral tripack film using the subtractive process and colour formers in its development. The film base is coated with three very thin emulsion layers (with inbuilt red, green and blue filter layers) on top of each other, but is black and white until processed. At the processing stage – a 28-step procedure taking three and a half hours – each layer is dyed the relevant colour and the silver content bleached out.

Compared with previous colour processes that used three glass or film negatives in a complex and cumbersome one-shot camera, Kodachrome was almost shockingly quick, easy and portable. In good light it had an exposure time of 1/30th of a second at f8 and anyone could use it, even to achieve action shots. Images were sharper and, by 1938, the dyes were very stable. More importantly, it was a relatively cheap deal, selling at 12s. 6d. for an 18-exposure film including processing, a price that compared well with the cost of developing and making prints from a roll of black and white negative film, always the manufacturers' benchmark.

The advantage of colour transparencies is that, although they are unique objects in the same way as daguerreotypes and autochromes, unlike those processes they did become relatively easy to duplicate, even if with some resulting loss of colour and sharpness. Also, prints could be made from them and they were easy to reproduce on magazine pages. But there were drawbacks too. Like the autochrome, they are "objective" and relatively unmanipulable in the camera, and even more so at the processing stage, which was rigorously standardized by Kodak chemists. Viewing them also required a light source – either a projector and screen, a hand-held viewer or a lightbox (although Kodak offered a printing service from Kodachrome transparencies for a few years from 1941). Despite these supposed disadvantages, however, colour slides remained the darlings of the lecture circuit for 60 years, superseded only in the early twenty-first century by the advent of PowerPoint presentations but still used by many and lamented by more.

All film manufacturers had long understood that the provision of cheap colour roll film would allow them to tap into the huge, lucrative and as yet untouched amateur market that would ensure their future prosperity, as had monochrome roll film previously. Kodachrome became the first commercially successful amateur colour film. Much research had been done worldwide on integrated tripack film and, as ever, the far-sighted Ducos du Hauron had foreseen the possibilities, proposing such a system in a French patent of 1895. Rudolf Fischer (1881–1957) and H. Siegrist (dates unknown) had also patented a proposal for a tripack film in Germany in 1912, although their ideas, anticipating as yet unavailable chemistry, largely remained theoretical.

RIGHT Russell Lee's strong Kodachrome portrait for the Farm Security Administration (FSA) of the resilient and resourceful Mrs Bill Stagg, holding up the State Quilt she made from ripped-up tobacco sacks, was taken in Pie Town, New Mexico, in October 1940. After helping her husband in the fields with farming work – corn and pinto beans were the main crop – Mrs Stagg then spent her noon rest hour quilting. After the late summer harvest, the quilting parties began.

In 1915 the first Kodachrome Process invented by John G. Capstaff (1879–1960), a British portrait photographer who went to work for the Eastman Kodak Research Laboratory in Rochester, USA, went on the market for a few years. It was a two- rather than three-colour process and worked well for the skin tones of portraiture as the missing colour was blue, which was not vital for flesh tones, but it was unsuitable for other subject matter.

The Kodachrome name was revived for a new process invented by Leopold Godowsky Jr (1900–83) and Leopold Mannes (1899–1964). A violinist and pianist respectively, these two classically trained musicians came from musical families and had been friends since schooldays. They were also avid amateur photographers and, since 1917, had been determined to work together to invent a more practicable system of colour photography, despite spending their university days on opposite sides of the continent at UCLA and Harvard. After attracting funding for their research, they finally joined Kodak in 1930 and the first Kodachrome continuous-tone colour film – 16mm movie film – came on to the market in 1935, followed by 8mm movie film and 35mm slide film in 1936. Larger-format sheet film in a variety of sizes for the professional market became available in 1938. Kodacolor, the first colour-negative roll film from which colour prints could be made, was launched in 1942, and Kodak Ektachrome, the first colour film that could be developed by the photographer rather than returned to the factory for processing, in 1946.

Initially, after processing at the Kodak factory, films were returned in a roll that the customers then had to cut up and mount as slides themselves. However, in 1939 Kodak perceptively offered a cardboard slide-mounting service so that transparencies could be projected as soon as they were received. Kodachrome was in production for longer than any other photographic product even though, in this digital age, its day is now over.

At around the same time, Agfacolor in Germany introduced a similar line of products, based on Fischer and Siegrist's 1912 research, although these were not widely available outside Germany until after World War II. After this date, a variety of similar processes came on to the market – Gevacolor, Ferraniacolor, Sakuracolor and Fujicolor – with the film's tonal palettes adjusted to complement the skin tones of its principal consumers, for example, Kodak's to Caucasian colouring, Fuji to Asian.

One of the first and historically most significant bodies of work to be photographed on Kodachrome in the USA was that taken by members of the Farm Security Administration (FSA), many of whom were subsequently absorbed into the Office of War Information (OWI) to document America's mobilization for World War II. Originally established as the Resettlement Administration in 1935, the FSA was part of President Franklin D. Roosevelt's New Deal programme designed to help the American economy recover during the decade of the Great Depression after the 1929 stockmarket crash. Roy Emerson Stryker (1893–1975) was head of the FSA/OWI's Information Division and director of photographic projects. From 1935 to 1943, he deployed a team of more than 20 photographers – among them Walker Evans (1903–75), Dorothea Lange (1895–1965), Gordon Parks (1912–2006), Arthur Rothstein (1915–85) and Ben Shahn (1898–1969) – to document the "spirit of America at a time of great trial". Eventually, the combined FSA/OWI archive comprised 164,000 black and white negatives and 1,610 Kodachrome transparencies on both 35mm and larger format dating from 1939.

Struggling rural communities living in harsh conditions of abject poverty and ravaged by the dual effects of the Depression and the Dust Bowl – in which the drought-stricken areas of land turned to dust and literally blew away – were relocated to large government-run collective farms and homestead communities. Here they received educational aid and

RIGHT Taken at the FSA's migratory farm labour camp of 5,000 participants in Robstown, South Texas in January 1942, this Arthur Rothstein Kodachrome shows the son of a Hispanic farm worker during the harvest of the community centre's cabbage crop. One fears that the child's life was not always so sunny.

government loans to spend on new machinery, livestock, trucks and other items to enable them to operate in a more efficient and cost-effective manner; they were also encouraged to grow crops that were marketable. From 1936 to 1943, educational aid was given to almost half a million farm families, and economic aid (in the form of 1 per cent interest loans) to a million of them.

The initial aims of the FSA were not achieved because farmers wanted individual farm ownership rather than something perceived to be akin to the Russian Communist collective farm system. The programme was then changed to help them buy farms. From 1942 onwards, as the USA mobilized for war, there was a migration shift to the cities for factory jobs and the economy began to improve. Many farms were abandoned and the FSA was eventually replaced by other agencies.

The resulting FSA photographs – more than 77,000 taken between 1935 and 1942, of which 644 were in colour – were reproduced as photo essays in a wide variety of publications, posters and travelling exhibitions. However, the colour images were never widely known as they were rarely reproduced at the time because of the difficulty and expense of using them in newsprint, which still lagged behind the illustrated magazines' colour reproduction vanguard. The purpose of these forceful images was both to educate unaware urban Americans about rural deprivation and to influence and pressurize Congress to allocate more money to these devastated areas. Eventually the archive of images became a broad national record of a past life that was housed in the Library of

ABOVE One of more than 100 photographs that Lee took of Faro and Doris Caudill and their family in Pie Town, this Kodachrome of October 1940 shows them in their dugout eating a basic diet of green beans, fat pork stew and biscuits. In later interviews Doris Caudill said that her years in Pie Town were the happiest of her life. Her story was turned into a book, *Pie Town Woman* (2001), by photographer Joan Myers.

Congress in Washington in 1944. The FSA colour images only began to reach a wider audience during the last three decades of the twentieth century.

Arthur Rothstein was the first photographer Stryker employed. He took more than 5,000 images for the FSA including, most famously, a series of the devastating dust storms in Cimarron County, Oklahoma, in April 1936. Later, using both black and white and colour film, he documented life in the FSA migratory farm labour camp in Robstown, South Texas.

Russell Lee (1903–86), a successful chemical engineer who had retrained as an artist in 1929, initially used photography to make studies for his paintings but then joined the FSA in 1936. Lee visited Pie Town, New Mexico, on several occasions between 1940 and 1942, initially because the name of the place caught his fancy. So called because a prospector's wife once sold pies there, Pie Town was a community settled by around 200 migrant Texans and Oklahomans who had filed homestead claims and excavated their own dirt-floored, naturally lit dugout accommodation, the construction of which took 10 days and cost 30 cents in nails. There was little if any electricity; the nearest doctor was 97 kilometres (60 miles) away and the nearest town, Albuquerque, a 290-kilometre (180-mile) trip. Despite this, the enterprising Pie-Towners occasionally managed a treat of ice cream, the ice brought from 64 kilometres (40 miles) away and stored in ice-storage huts made of thick wood blocks.

On his travels to Pie Town, Lee was accompanied by his second wife Jean Smith, who wrote captions for his images. Photographing in both black and white and colour, Lee had a humane and unsentimental eye and imbued his subjects with a simple grace and dignity.

ABOVE Despite a hand to mouth existence, this occasion – the barbecue dinner at the annual Pie Town Fair – demands that Sunday best be worn. Lee's always sympathetic camera captures a group of Pie-Towners saying grace in October 1940 before tucking in to their much-anticipated feast.

LEFT AND ABOVE Luke Swank's photographs of steel mills are taken in Pittsburgh, PA. The image on the left is of a a 20-ton capacity oven being emptied out after the coking of the coal has been completed. The glowing mass is coke that has been refined (heated in a reduction atmosphere for 18 to 24 hours at temperatures in excess of 1800°F), falling into a transport car to be taken to the quenching station. The image above shows steam released by coke that is being extinguished.

The homesteaders were nothing if not inventive: there are several shots of a Mrs Bill Stagg holding up a variety of quilts she had sewn in a very brief period, some made from ripped up tobacco sacks (see p.103).

The advent of Kodachrome enabled documentation of a more industrial nature. The main body of work of Luke Hartzell Swank (1890–1944) focused on the Pittsburgh steel industry which he photographed from 1927 until just before his death, quickly rejecting his earlier romantic Pictorialism for straight photography and exhibiting an astounding Modernism and even an Abstract Expressionism. From 1938, he explored the colour, the flames and the drama of the steel industry in ultra-realistic Kodachrome.[1] Long after other similar

LEFT The small white springhouse (used to keep food cold in the days before refrigeration) in this *c.*1940 Kodachrome is possibly on Reiff Farm, Oley Valley, in East Pennsylvania. It appears in a black and white version, framed slightly differently and titled *Old Springhouse*, in the book *The Story of Food Preservation* by Edith Elliott Swank, with illustrations by her husband Luke, which was published in a limited edition by the H. J. Heinz Company. Swank often paired up similar monochrome and colour shots as he experimented with Kodachrome.

ABOVE The Californian photographer Alfred T. Palmer's Kodachrome shows one of the female workforce drafted in to work in American aircraft factories and was taken at North American Aviation, Inc. in California in June 1942. His 15-year-old friend Ansel Adams gave the 11-year-old Palmer his first camera so that they could spend their summers exploring Yosemite together. After the war, Palmer turned more to commercial and documentary film-making.

colour films came on the market, droves of photographers continued to use Kodachrome because they loved it so, cherished its quality of "aloofness", treasured its permanence and respected its truthfulness. Given these inestimable qualities and its portability, it became the favourite film of travel photographers.

More photographers were drafted in by the OWI between 1942 and 1944 to record American life during mobilization for war after the Japanese attack on Pearl Harbor in December 1941. One example is Alfred T. Palmer (1906–93), who toured the aircraft factories in California and Kansas in 1942 compiling a strong series of images showing women in the workplace preparing for war.

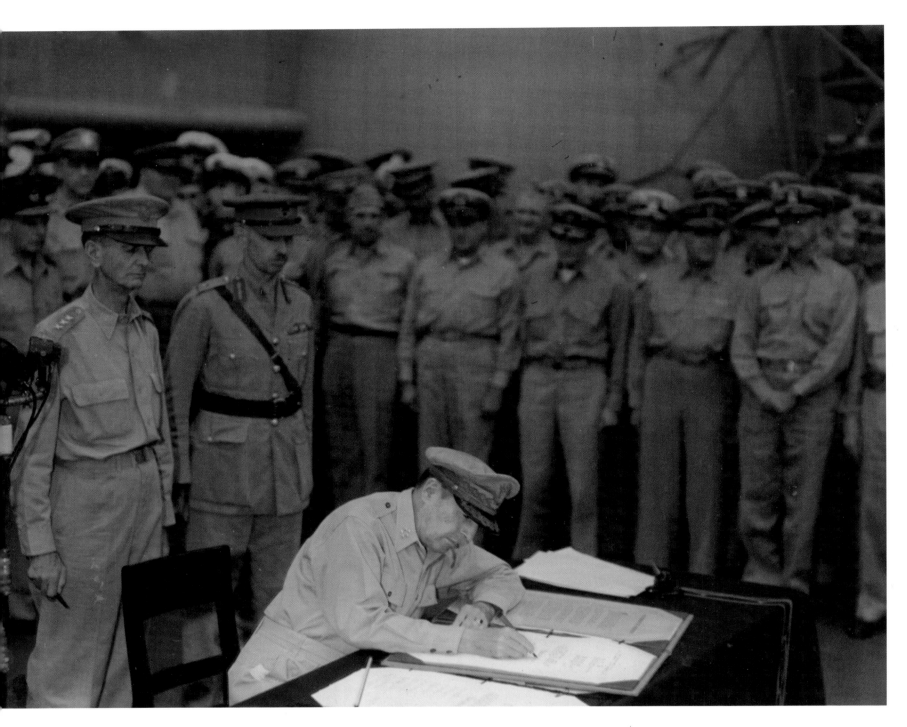

ABOVE The two skeletally thin men standing behind General Douglas MacArthur are Lt Gen. Jonathan Mayhew Wainwright IV, US Army, and Lt Gen. Sir Arthur Ernest Percival, British Army, who had just been released from Japanese prison camps. This whole remarkable scene was photographed by Major F. P. Muto, US Army Signal Corps, using a one-shot National Color Camera.

Six million women worked in US manufacturing plants during World War II, producing armaments and munitions as well as everyday necessities. The government created the mythical figure of "Rosie the Riveter" to spearhead a propaganda campaign to get more women into the workforce: in 1940, only 10 per cent of all employed women worked in factories; by 1944, the figure had risen to 30 per cent. Women also trained as pilots, to ferry aircraft to military bases and to test planes. Between 1942 and 1944, over 1,000 women qualified as WASPs (Women Airforce Service Pilots), but they were not allowed to fly in active combat – it was an all-male crew who, on August 6 and 9 dropped atomic bombs on Hiroshima and Nagasaki, leading to Japan's surrender. The photograph of US General MacArthur signing the surrender documents on board the USS *Missouri* on September 2, 1945, which captures a profoundly serious and historic occasion, would be

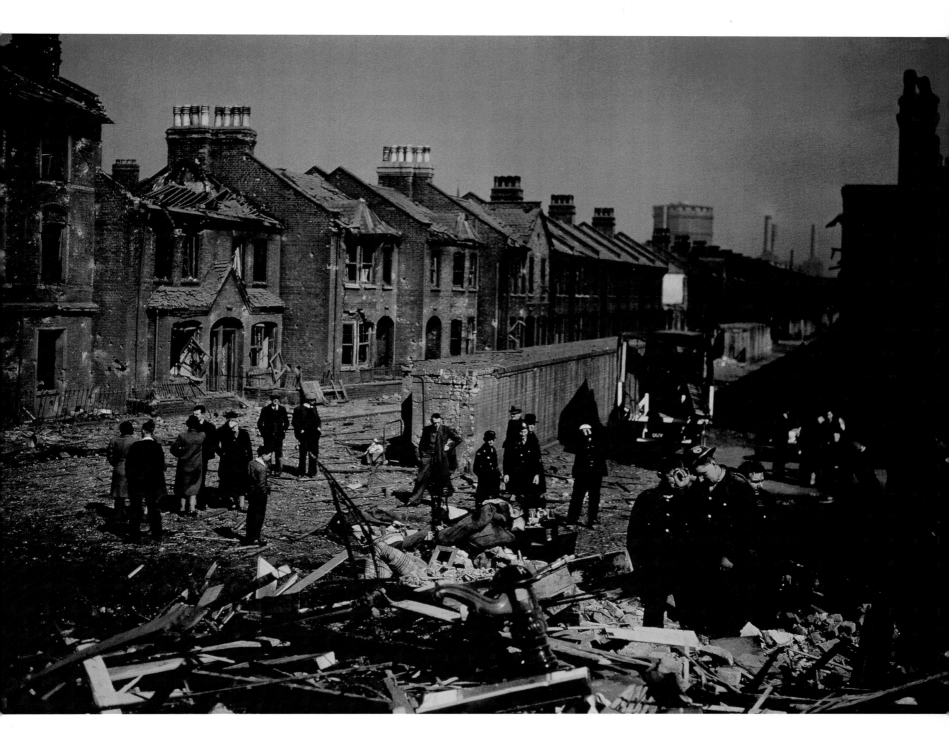

quite unexceptional in monochrome, but it is rendered quite extraordinary by the powerful and permanent colours of the dye transfer process used to print it from three separation negatives. Much of World War II was photographed in colour by all countries involved, but to see the surreal quality of this image makes the event seem absurdly and almost uncomfortably unreal.

While FSA and OWI photographers were routinely documenting American life in fast 35mm Kodachrome film, those in the UK had to be content with recording World War II with the rather less sharp and clear Dufaycolor, on cut-sheet film and occasionally even glass. The London Blitz began in earnest on September 7, 1940 and continued on an almost daily – and nightly – basis until May 11, 1941, with sporadic bombing after that. Around

ABOVE Like Otto Pfenninger's Brighton beach images of 1906 in Chapter 3, this 1943 image taken on Dufaycolor film has a sunny blue colour cast to it, belying the scene of damage and devastation. It almost has the look of a film set, but this dramatic aftermath of an air raid in London is for real.

BELOW Clark Gable joined the US Army Air Force in August 1942 after the death of his wife Carole Lombard in a plane crash in January that year, although he was already beyond draft age. Stationed at RAF Polebrook in Northamptonshire from February to September 1943, he was primarily in the UK to make an air gunnery training film but also flew five combat missions in B17s as an observer and returned to the USA with the rank of Major.

43,000 people were killed and more than one million homes were damaged and destroyed in London, including the street shown on p.111, which was probably in Pimlico or Lambeth. Battersea Power Station can be seen top right; the third of its eventual four chimneys was not completed until 1943, the fourth in 1955.

Kodachrome film was available in Britain during the war – but only to those with the right contacts. John Cyril Alfred Redhead (1886–1954) was head of Kodak's Photo-Finishing Laboratory in Harrow. His position gave him access to Kodachrome Professional sheet film, which he used to photograph Captain Clark Gable when he visited the Kodak factory in Harrow in 1943 while stationed in Britain. Redhead's team used the precious Kodachrome film to document other aspects of British life, emphasizing the enduring nature of rural farming landscapes and British manufacturing despite the war.

The most striking series of images graphically depicting, in glorious colour, the effects of the war on the British was captured by one exceptional individual, John Wilfrid

ABOVE Every inch of land in the UK was used for growing crops during the war as importing food was almost impossible. John Redhead seems to have operated almost as a one-man British equivalent to the American FSA/OWI photographers. His photographs of royalty, politicians, high-ranking military personnel, celebrities and "ordinary" people stressed that life went on as near to normal as possible.

RIGHT This *c.*1945 anonymous shot of an operative at a paint-mixing machine in a factory was probably intended to illustrate the fine colour balance of the Kodachrome process as well as to show ordinary everyday working life during the war effort.

Hinde (1916–97). Hinde, a member of the Quaker shoe-manufacturing family Clark's, precociously made his first experimental colour print in 1933 when he was 17. He later learnt the tricolour carbro process from Frank Newens at the Reimann School in London (a private school of German origin set up to teach practical design and commercial art in Britain) in 1937. For the next 10 years he stuck with this complex process pretty religiously, although he was also able to use quarter-plate Kodachrome sheet film in 1942–43.

In keeping with his Quakerism Hinde was a conscientious objector during World War II, but he was also a colour zealot, and set up a company called Freedom Productions Ltd to use colour photography to support the war effort in beneficial and constructive ways. In this, he had something of Albert Kahn's humanist faith in the redemptive communicative power of colour documentary photographs showing the strength of ordinary people in their natural environment.

LEFT John Hinde's evocative photograph was taken at dawn after an air raid on Grimsby. The eye is immediately caught by the awkward curve of the woman's body, the colourful games' boards, the child's doll perched on the wall and the fluttering Union Jack. Stephen Spender's caption reads: "Joan's sister and her father save what goods they can from their home. The local authority arrange for a van to take them and their belongings to the house of a relative in another part of town."

RIGHT Spender's informative, and chilling, caption to Hinde's photograph reads: "People soon lost all fear of fire-bombs. They would pour sand on them from sacks or buckets, beat them with spades, and even stamp on them with their feet. In some poor districts, children used to kick incendiaries around the streets like footballs. They formed their own street fire-fighting gangs. Later the Nazis put delayed-action explosives into fire-bombs, which made them more tricky to deal with."

Hinde was commissioned by the Ministry of Information to work on a series of projects, among them a co-production with the poet and writer Stephen Spender (1909–85), who was seeing out the war serving in the London Fire Service. The resulting publication, *Citizens in War – and After*, the "after" of course being important to keep up morale, was published in 1945.

Citizens in War – and After follows the everyday lives of the Civil Defence Forces and ordinary civilians during wartime and asks the question: "can all this experience give citizens as wide a survey of social responsibility in peace as they have learned in war?" Notified by the Home Office, and with special security clearance, Hinde would rush to the scene of the latest bombing, usually in London but as far afield as Grimsby in the north of England, to capture yet another episode revealing the nation's suffering and stoical fortitude. He regarded his work for this book as "the most important and the most successful single assignment I ever undertook during my career as a photographer". His close partnership with Spender, whose social ideals he shared, meant that the text and

ABOVE Although post-war food rationing ended in 1954, this type of dessert was still frequently served up into the late 1960s in countless British school dinner canteens: the dried fruit, especially prunes, to keep one "regular"; the pink swirled blancmange to add a colourful touch of supposed eye appeal.

illustrations were very closely interwoven. Spender's prose is cool, lucid and informative. Hinde's photographs, with their deep saturated colour, are almost surreally real, especially the portraits. The particular qualities inherent in the Carbro process – matt highlights, lustrous shadows with the darker areas of the print standing out in low relief – survived even the stringencies of wartime reproduction, which Hinde also supervised.

For these photographs, Hinde used the American Devin 3.5 x 4.5in one-shot single-exposure camera (the 5 x 7in Devin was the favourite studio camera of Nickolas Muray and H. I. Williams). With this he could achieve exposures of 1/50th of a second in bright sunlight and thus capture a fair degree of action and decent depth of field, although some of the interior shots have a long-exposure "posed" look about them.

Throughout his long career in colour photography, Hinde worked with his own distinctive and inimitable colour palette, which is equally apparent in his many paintings. It can be seen in his advertising work; in more than 30 books that he illustrated with his photographs; and in the colour cast of the postcards printed by the successful company he later founded, which is still in operation. It is interesting to compare his food photography with Luke Swank's taken around roughly the same date, Hinde's using tricolour Carbro, Swank's Kodachrome.

In one example, Hinde shows an archetypal plate of British wartime food from 1941 (rationing remaining in place until 1954): a pink and white striped and dense-looking

cornflour-based blancmange, in a syrupy moat of stewed dried apricots and prunes, along with tinned grapefruit segments (considered rather glamorous in austerity Britain), are all arranged on a stolid Denby ware plate (Britain's rather more austere answer to Fiestaware). The food may be vile but the photograph is fabulous, the strange colour balance giving it a surreal green edge. It could be nothing but British, produced as an advertising shot for the Empire Tea Bureau in an attempt to encourage – as if any encouragement were needed – tea drinking during the war. The lack of any suggestion of tea in the photograph is odd, but perhaps the dried fruit had been steeped in a fragrant tannic brew to rehydrate it.

In contrast, Swank's glorious summery cornucopia of bottled, dried and fresh fruits and vegetables, photographed in Kodachrome's glowing primary colours, could only be American, and recalls the food photography of H. I. Williams a few years earlier (see Chapter 4, pp.84–85). Swank worked on several commercial projects for the food company H. J. Heinz from 1936 to 1943 and several of his Heinz food shots were reproduced in *National Geographic* magazine in March 1942. It would be hard to find two more dissimilar images illustrating either food availability and preference or the differences in colour photography technologies on either side of the Atlantic in the early 1940s.

While Europe and its photographers slowly came to terms with the new order and ensuing reconstruction of postwar life, most of which was filmed in grainy monochrome, the USA's

ABOVE Before the days of obesity, junk food, fast food, McDonald's and wall-to-wall Coca-Cola there was Heinz, founded in 1869. America had a healthy diet of slow food, inundated with a rich abundance of seasonal produce that, without endemic refrigeration, needed to be bottled, pickled, dried, tinned and otherwise preserved. Luke Swank's photographs were used to illustrate an article in *National Geographic* in March 1942 on "Flavor and Savor in American Foods".

ABOVE LEFT After her divorce from Rivera in 1940, Frida Kahlo cut her hair and abandoned her traditional Mexican dress, only to re-embrace it with even more flamboyant vigour when they remarried in 1941. By 1946, when Nickolas Muray photographed her on a New York rooftop, she was increasingly ill and reliant on painkillers and alcohol to ease the pain. This print is a modern colour Carbro made from Muray's original Kodachrome transparency.

ABOVE RIGHT Lejaren à Hiller was widely credited with creating the medium of photographic illustration in 1915, using monochrome photographs for magazine illustrations. It is not surprising that he moved easily into colour photography, constructing dramatic *tableaux*. This studio reconstruction of Naval men watching a battle cruiser against a painted backdrop is the 1940s version of CGI.

advertising and celebrity industry, now using even more glorious colour, swung back into action with renewed vigour. Dramatic improvements were made in colour printing techniques in magazines and in the quality and reliability of colour film, and the late 1940s and 1950s saw a huge growth in magazines in the Condé Nast empire (see Chapter 6, pp.126–33).

Nickolas Muray was the busiest and most successful commercial photographer of the 1940s, photographing the new breed of film divas, as well as his favourite subject Frida Kahlo, in the glamour of exaggerated colour. Judy Garland, Marlene Dietrich, Elizabeth Taylor, Ingrid Bergman, Carole Lombard and a young Marilyn Monroe were among the many who sat for him as did their leading men, including Clark Gable, Tyrone Power and Robert Young. Muray used Kodachrome film but for studio work he still preferred his one-shot Devin camera and his trusted tricolour Carbro assembly process with its saturated colour palette and its almost three-dimensional definition, which lends a strange and intense colour balance to his pictures, especially his advertising work for food companies (as with John Hinde's food photography using the same process).

Much of 1940s advertising now looks entertainingly kitsch and Muray, of Hungarian birth, was not afraid to embrace all-American kitschsness as exemplified by his picture of a gap-toothed Shirley Temple lookalike. The astonishingly unreal colour and the three-dimensionality of this image exemplify everything that was unique about the colour assembly processes available in the 1940s. In 1945, Kodak's Dye Transfer Process was launched, a descendant of the earlier Kodak Wash-off Relief Process of 1935 (which is the colour printing process used in this photograph) but simplified and standardized so that a print could be made in a mere 30 minutes. It used stable mineral-based pigments and its resulting faithfulness of colour and archival permanence means it is still used by photographers today.

In the flashy flamboyancy stakes, however, Muray was vastly outdone by Lejaren à Hiller (1880–1969) who specialized in photographing constructed narratives with an unabashed brashness that is quite breathtaking, and owes much to Hollywood. From 1927 until the 1950s, Hiller made a series of photographs (sadly in monochrome) for Davis & Geck, manufacturers of hospital supplies, entitled "Surgery through the Ages". The brief was to

LEFT Early 1940 found Edward Steichen experimenting with colour printing from older negatives. This colourful vase of flowers dated January 8, 1940 appears in many different colour combinations – green tulips and roses in a pink and purple vase being one – in Steichen's archives at George Eastman House. Steichen probably grew the flowers in this image and the ones opposite on his plant-breeding farm at Umpawaug.

create "dramatic photographs representing the lives and careers of the great men who have made surgical history from the earliest Egyptian records down to the present day". The resulting wildly exaggerated images largely show naked or scantily-draped females in abandoned ecstatic poses, while fully-clothed men purposefully get on with making surgical history. The extreme silliness of these images almost transcends their obviously sexist content. They were apparently very popular with doctors and framed series of them were hung in hospital corridors in the USA in the 1930s, doubtless much to the chagrin of female patients. Hiller was no less riotously imaginative in his 1940s colour work, and his dramatic sets and theatrical lighting are almost indistinguishable from B-movie stills. His skills were not so much photographic as scene-settingly dramatic. Sadly, his work is little known now, although long overdue for a comeback.

Meanwhile Edward Steichen – photography's great colour barometer – had retired from the hurly burly and daily grind of studio work in New York for Condé Nast and J. Walter Thompson. Although still accepting frequent freelance work, he had time to experiment

with colour. A large body of this experimental work, bequeathed to George Eastman House in Rochester, New York, would suggest that he had much quirky enjoyment and fascination in doing so. Meticulous detailed technical information about development, amplification and so on is added to the verso of each print. Steichen printed on different papers using a variety of processes with fascinating results, playing with colour and seeing how the whole meaning of an image could be changed depending on the order in which the three negatives were printed – thus offering us a view into a colour photographer's active creative mind.

Semi-retirement from the commercial world also allowed Steichen to devote more time to growing, breeding and photographing delphiniums, his passion since 1910 and his Pictorialist days in Voulangis, France. This pursuit also fulfilled his passion for blue, a colour that appears in much of his work. In 1936 he had exhibited his hybrid delphiniums and photographs of them at the Museum of Modern Art (MOMA) in New York, later curating several thematic exhibitions for the museum during World War II. In yet another astonishing career twist in 1947, at the age of 67 he (rather than MOMA's first photography

ABOVE More experimentation in May 1940, from left to right: in natural colours; using the Sabatier effect to solarize the print and throw it into partial negative; and using colour posterization. The latter was a trick used by the advertising industry to make an image grab attention by employing brilliant colour and an abrupt change from one tone to another to achieve flattening of the pictorial space, as in a poster.

ABOVE László Moholy-Nagy bought a 35mm Leica camera in London before emigrating to Chicago; he used this and Kodachrome film throughout the rest of his life. Few of the several hundred transparencies made remain; even fewer were reproduced at the time because of his dissatisfaction with reproduction quality. His beautiful 1940s' abstracts, like this *Pink Traffic Stream*, are about tracings of light and pure colour. They have recently been retrospectively printed on Fuji Crystal paper.

curator Beaumont Newhall) became the first director of the museum's Department of Photographs, a post in which he remained until 1962.

By the late 1940s, advertising photography had become brasher, louder, stronger and ever more colourful. The glossy magazines were enjoying a post-war heyday featuring increased use of colour on their pages. The amateur 35mm colour photography market was beginning to boom and would continue to mushroom over the next half-century, and there was always some new improvement with which camera and film producers could tempt and seduce the amateur market. These changes were less obvious outside the USA, however, where colour sheet film in larger sizes was still in short supply and expensive and not everyone had a 35mm camera.

So, if the "new" colour photography in the 1940s was for advertising and amateurs, where was the serious photographer to turn but back to monochrome? Monochrome had never gone away, of course, and was still the preferred medium of the majority, being faster, cheaper, easier and more predictable. Images of World War II were mostly shot in monochrome with some limited use of colour stills and colour movie film. With the formation of the Magnum agency in 1947, gritty, grainy, rapidly shot black and white

became the photojournalist's medium of choice, largely because almost all editorial photographs published in news magazines were monochrome. Not until the early 1960s did colour become more usual. If black and white was good enough for Magnum's founders – Henri Cartier-Bresson (1908-2004), Robert Capa (André Erno Friedmann: 1913–54), David "Chim" Seymour (David Szymin: 1911–56) and George Rodger (1908–95) – then colour could be left to the applied and amateur practitioners. Cartier-Bresson was known to be immune to colour's charms, but Capa famously did shoot colour film during World War II and even had colour images reproduced in the then avowedly monochrome *Life* magazine in 1938.

But did all serious photographers reject colour photography in the 1940s? Not at all. While many photographers developed a marked aesthetic prejudice against it some, like Moholy-Nagy, now teaching at the Institute of Design in Chicago, embraced it. Writing in an essay entitled "Paths to the Unleashed Colour Camera" in the *Penrose Annual* of 1937, he predicted that the new single-exposure cameras would give photographers a different colour vision and set them free to make colour snapshots and experimental images equally as abstract as anything in monochrome. He appointed both Arthur Siegel (1913–78)

ABOVE Arthur Siegel was a scholarship student of Moholy-Nagy's at the New Bauhaus in Chicago (which subsequently became the Institute of Design, Illinois Institute of Technology) and his later teaching career at the Institute over three decades influenced many generations of students. He also worked for the FSA and OWI as well as freelance for *Life, Fortune* and others. His 1946 *Dry Cleaners* creates a wonderful abstract documentary image, using words and colours in graphic blocks.

and Harry Morey Callahan (1912–99) to teach the pioneering photography course, New Visions in Photography, at the Institute in 1945–46. Siegel, a former student in 1937–38, produced experimental monochrome work and began to use Kodachrome 35mm film in 1946. Callahan began making colour photographs in 1941. Despite Moholy-Nagy's early death in 1946, his experimental and minimalist eye and exuberant use of Kodachrome remained influential as they were disseminated down through his staff and students.

Edward Weston (1886–1958) used 8 x 10in Kodachrome and Ektachrome briefly when commissioned to do so in 1946 by Dr George L. Waters of Kodak. Weston explored colour's specific attributes by revisiting some of his previous black and white subjects and viewing them afresh. He eventually sent 13 transparencies that "met his standard" to Kodak and some of these were then printed as dye transfers. His increasing illness with Parkinson's disease prevented his pursuing colour more vigorously, even though he declared himself "really interested for the first time" and wrote an essay called "Color as Form" in 1953.[2] In this he stated that many of the subjects he had photographed in colour "would be meaningless in black-and-white; the separation of forms is possible only because of the juxtaposition of colors".

Weston's brief photographic career in colour showed how photographers could work with colour beyond the commercial remits of photojournalism, fashion and advertising. This example was to be taken up increasingly by serious photographers in the 1950s, despite that decade's emphasis on colour in commercial photography.

Towards the end of the 1940s, a new technology was introduced into the market: in 1947 Edwin Land's Polaroid camera was launched. This could take and print a black and white peel-apart photograph in one minute, and within 20 years, 14 million of these cameras would be sold. However, it was not until the 1960s that "instantaneous" colour Polaroid technology became available.

LEFT Edward Weston's 1947 *Nautilus Shells* explores a familiar subject matter but examines it afresh, emphasizing the visual richness and textural detail of both the shells and the background pebbles by using flat lighting. Kodak paid Weston $250 for each transparency accepted – 7 of the 13 he sent – and paid him $1,750, the largest single order of his career. Kodak used some of the images in advertising campaigns for Kodachrome and Ektachrome film.

6 THE COLOUR BOOM

1950–1959

In 1951 Alexander Liberman (1912–99), then art director of Condé Nast Publications, wrote: "the driving spirit... is the magazine, the phenomenon of our age. It is the meeting place of all talents, a new salon where the whole world is on exhibition. Through their success magazines have become the patrons of the new art, and material means have been put at the disposal of the photographers to develop and search and create."[1] What gave the Condé Nast stable of magazines – among them *Vogue, House & Garden, Gourmet, Vanity Fair* and *Glamour* – such a bold, modern new look in the late 1940s and early 1950s was Liberman's generous use of colour photography, which he saw as the precocious new art of the future, on their pages.

Since Condé Montrose Nast (1873–1942) began to buy his stable of titles, starting with *Vogue* in 1909, the company had established an early manifestation of niche lifestyle publishing. It had always employed the foremost photographers of the day, such as Baron de Meyer, Edward Steichen and Man Ray, and given them a fair amount of freedom to follow their artistic bent. *Vogue* had first used a full-colour photograph on its front cover in 1932 and had determinedly set publishing trends before and after that date. From 1941, however, under Liberman's direction, its rate of innovation went up several notches. He is generally credited with shifting the sensibilities of American women by featuring fashion that allowed them to move freely in their clothing, and with influencing the cultural tastes of millions.

Large-format colour photography in a magazine was expensive to produce, print and publish and the initial outlay had to be recouped through increasing circulation and selling larger amounts of advertising space. *Vogue*'s sales had rocketed throughout the gloom of the Great Depression and World War II, its weekly dose of heady glitz and glamour bringing comfort to those whose life currently contained neither. Now Liberman was looking to the future and to the new generation of post-war baby boomers who would have more affluence and disposable income than their predecessors. He threw out the old formal, staged and artificial fashion shots and many of the Hollywood influences that had crept in over the war years. Keeping a few safe pairs of hands in the studio, such as the older Cecil Beaton (1904–80) and Horst P. Horst (Horst Paul Albert Bohrmann: 1906–99), he encouraged the wayward talents of a whole new breed of photographic mavericks – among them Richard Avedon (1923–2004), Erwin Blumenfeld (1897–1969), Clifford Coffin (1913–72), William Klein (b.1928), Herbert Matter (1907–84), Gjon Mili (1904–84), Norman Parkinson (1913–90), Irving Penn (b. 1917) and John Rawlings (1912–70) – and allowed them to work across the

RIGHT Not yet a fully-fledged sex goddess – *Niagara, Gentlemen Prefer Blondes* and *How to Marry a Millionaire* were still a year away – Marilyn Monroe seems bemused by the rather obvious sexual connotations of the ornate and overflowing bowl of lush, ripe fruit that Nickolas Muray made her straddle in this unpublished portrait of 1952. Warily apprehensive and wide-eyed, Monroe is still lustrous. Or is she trying not to laugh? Muray has reversed the image when printing, as Monroe's beauty spot is usually on her left cheek.

LEFT Horst P. Horst's iconic *Figure with color planes* shows a model dressed in a black Schiaparelli dress, trimmed with a bow in her trademark screaming shocking pink, silhouetted against a background of various coloured paper shapes tacked on to the walls. The image was used in *Vogue* on February 15, 1947.

ABOVE After a previous career in architecture, training under Le Corbusier in Paris, Horst's photography was first published in French *Vogue* in November 1931. He joined Condé Nast in New York in 1932 and remained there, intermittently, for half a century. This cover shot for *Vogue*'s "Summer Beauty" issue of May 15, 1941 – a study in mute shades of white and grey punctuated by red – has a timeless appeal.

LEFT The brilliant and wayward Clifford Coffin preferred to use colour as a "single splash, a sharp stab of brilliance", as here in his bathing-suit shot on a Los Angeles beach of *Figures on a dune*, published in American *Vogue* on June 1, 1949. Coffin wrote that the most interesting assignment he could be given would be "photographing an ash blonde in a white dress in an empty white room".

BELOW This image by John Rawlings was used in *Vogue* on June 1, 1952. Rawlings worked for Condé Nast for 30 years and had more than 200 *Vogue* and *Glamour* covers to his credit, as well as 11,000 pages of editorial fashion features and advertising campaigns, and television commercials. His archive was donated to New York's Fashion Institute of Technology.

LEFT Swiss-born Herbert Matter studied with Fernand Léger in Paris and was a master of photomontage in commercial art. He moved to the USA in 1936 and began to work as a freelance photographer for Condé Nast and as a design consultant for Knoll Associates. His Escher-like *House Painters* initially existed as two separate images which were then stripped together into a photomontage at the printing stage, *c.*1950.

BELOW Matter's supreme grasp of colour composition is apparent in this 1951 shot for *House & Garden* of a grey-suited model among 24 balloons in the magazine's new signature colours. He later became a professor of photography and graphic design at Yale University and worked as a design consultant with both the Guggenheim Museum in New York and the Museum of Fine Arts in Houston. His archives are now held by Yale and Stanford Universities.

Condé Nast stable of titles photographing fashion, houses, gardens, food, people and travel. They were encouraged to think the unthinkable, photograph the impossible and make magic on the page. Some of them also made mayhem in the studio.

Between them, his young-gun photographers let rip and kicked over the traces, replacing stuffy formalism with the more artistic influences of Abstraction, Surrealism, Minimalism, Naturalism and Modernism in their work – and, in some cases, a more louche hothouse homosexuality than had previously been either admitted or tolerated. They found new ways to capture images, experimenting with lighting, location, backdrops, lenses, cameras and films and truly revelled in the colour they could achieve. "With what voluptuous and rapturous delight the heart responds to colour!"[2] wrote the influential art and architecture critic Aline B. Louchheim (1914–72). "They have made a new palette popular for fabrics and furniture, for fashion and make up. The shocking pinks, the mustardy yellows, the sage greens, and frosty blues... are peculiar to our time, as the fervent blues and blazing reds were for the Middle Ages and the crimson of velvets and gold of damask were for the Renaissance."[3] Louchheim, with a confident finger on the decade's colour pulse, also noticed "a piercing purplish-blue which seems to be unique to colour photography".[4] These colours defined the era.

ABOVE Albanian-born Gjon Mili, a self-taught photographer who had trained as an electrical engineer, worked with Professor Harold Edgerton's (see Chapter 7) electronic flash and stroboscopic light technology to capture movement. This triple exposure of Pablo Picasso drawing with a flashlight at his home in Vallauris on the French Riviera was one of a series Mili made in 1949 and illustrated Picasso's belief that "To draw, you must close your eyes and sing."

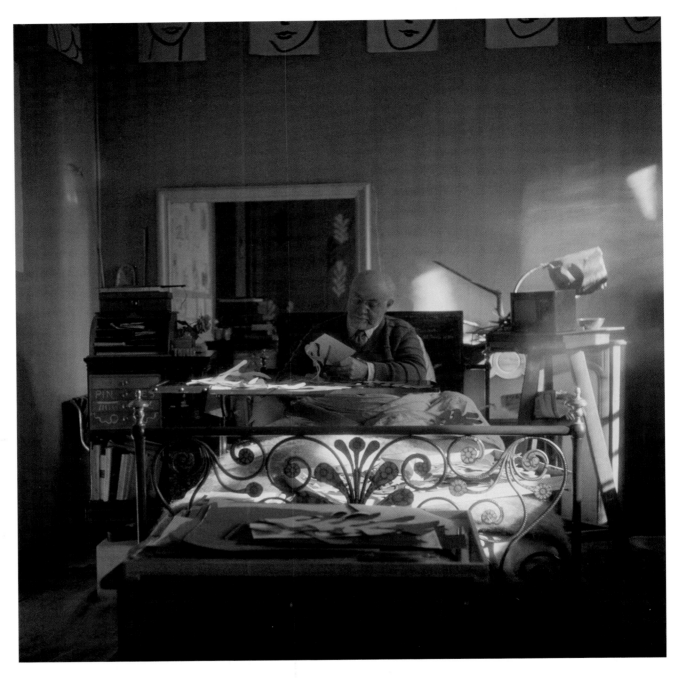

Liberman wanted *Vogue* to adopt a forward-looking cultural stance. He was concerned to introduce avant-garde art to its pages and established an intellectual position for the magazine in current artistic debate, relocating fashion in the art world and proving that the two could comfortably coexist. He profiled living artists in pieces he wrote and illustrated himself, using both black and white and colour photography. He also audaciously used exhibitions of artists' work as backdrops for his fashion shoots with high-maintenance debutantes modelling evening gowns and clutching gloves in front of Matisse's paper cutouts and, in March 1951, bad-boy Jackson Pollock's controversial "drip" paintings at the Betty Parsons Gallery in New York. Many of his photographers had previously been painters and brought a different vision and colour awareness to the photographic experience, as painters had done with the autochrome four decades earlier.

Given the virtuosity, innovation and sheer exuberant skill with which the Condé Nast photographers addressed their work, it seems perverse that black and white images increasingly continued to set the artistic standard; a certain snobbery seems to have set

ABOVE Coffin was working for French *Vogue* in 1948 when he photographed the 79-year-old, bedridden Henri Matisse at his home in Vence, Nice. Matisse was working on designs and paper cutouts for the Dominican nuns at the Chapelle du Rosaire in Vence. Published in American *Vogue* on February 15, 1949 and in British *Vogue* in June 1949, this image was one of those Coffin took with the aim of bringing French culture into British and American homes.

LEFT Cecil Beaton posed two
models dressed in designer Ceil
Chapman's rayon taffeta coats
against an exhibition of Matisse's
Jazz cutouts for the *Vogue* April 1,
1949 issue. Jean Patchett wears a
wine-coloured coat over a floral-
print Swiss organdie dress; her
colleague wears grey taffeta with
a grey net Pierrot collar over a
matching taffeta and net dinner
dress with yellow Delman opera
pumps. Both models wear red
Coty lipstick. Of course.

in around this time about the purity of monochrome vision as opposed to the commercial
crassness of colour. But there were those who embraced colour photography for its own sake.

Edward Steichen – our colour barometer – who was now director of the Department of
Photography at MOMA, showed an exhibition of colour photographs in 1950, including work
by Edward Weston. In 1953, in a group show entitled "Always the Young Stranger", he included
photographs by Saul Leiter (b. 1923). Leiter's work, and that of other "serious" photographers
who worked, privately and commercially, in both black and white and colour has been largely
ignored for the last four decades.[5]

Leiter's New York photographs find a delicate urban romance in the gritty realism of
the mean streets. He coaxes warm, soft, almost autochrome-like, muted colours from his
transparency film with, here and there, a flash of vibrant red or yellow, bending the film's
colour capacity in unfeasible and glorious directions. This is entirely fitting for a man who has
painted all his life, embraced Abstract Expressionism and the Japanese print aesthetic and is a
great admirer of the work of Pierre Bonnard (1867–1947) and Edouard Vuillard (1868–1940).

ABOVE A model dressed
in designer Henri Bendel's
asymmetrical hooped-skirt silk
paper taffeta short ball gown
shows "The New Soft Look" for
Beaton's *Vogue* cover of March
1, 1951. Posing before Jackson
Pollock's painting *Autumn
Rhythm*, one of 32 on show at the
Betty Parsons Gallery in New York
in 1951, the model's aloof and
detached appearance is pointedly
at odds with the vigorous physical
energy of the painting.

ABOVE LEFT Originally from Pittsburgh, Saul Leiter, son of the distinguished Talmudic scholar and rabbi Wolf Leiter, left his rabbinical studies at Cleveland Theological College in 1946 to pursue the life of an artist in New York. Here he was introduced to photography's potential by the Abstract Expressionist artist Richard Poussette-Dart. Leiter continued to paint, but photography became his passion.

ABOVE RIGHT The asymmetrical and graphic qualities of Leiter's work appear natural and contemporary now but were radical for their day, as was his rapid espousal of colour in the late 1940s after initially working in black and white. Although Leiter later worked commercially for magazines such as *Esquire* and *Harper's Bazaar*, his daily photography, about randomly glimpsed moments of life on the streets as here in 1957, and above left in 1958, was for himself.

Colour is as much the subject of Leiter's photographs as are the streets of New York. The enigmatic colour cast of his images was achieved by using out-of-date film stock or cheaper, more unpredictable film from obscure companies, the price of the more established manufactured colour film such as Kodachrome being beyond his impecunious reach. Leiter's streets are places of misted windows and reflections, of evanescent captured moments, of lights gone fuzzy in the rain, of barely glimpsed transitory presences. It is hardly possible to imagine that a camera intervened between his eye and the captured image. His intriguing compositional graphics, with parallels, verticals, horizontals and diagonals dissected by planes of colour, give his photographs a timeless quality, dated only by the headgear and the cars. Leiter's fascination with inclement weather and its effect on street life is matched by his delight in the cosy warmth of his interiors. These are places to which we want to go – he has taken the "mean" out of the streets.

In true 1950s style, Leiter only showed his colour slides to friends in projected film shows and at the Artists' Club in New York, but they have recently been printed as dye transfers for exhibition and sale. In 1957 he was engaged by Henry Wolf (1925–2005), art director of *Esquire* magazine, and for the next 20 years he worked as a fashion photographer for *Esquire*, *Harper's Bazaar* and others.

LEFT Rarely has a photographer loved city weather conditions as much as Leiter. The harsh summer sunlight gives him dramatic shadow detail, as opposite; the winter snow, as in this 1960 shot framed through a window, yields atmospheric condensation on glass and a chilly, almost monochrome, colour palette blasted through with the yellow of the truck in the background.

ABOVE On the Boulevard Saint Germain in Paris in 1959, seated in the Café Les Deux Magots looking out at the nearby Café de Flore, Leiter captures a small, warm and intimate corner of French café culture. Here, compared with the manic bustle of the New York streets, the colours are softer, the mood more relaxed, the moment timeless, the photographer happy.

Not to be left behind in the race for colour, *Life* magazine published their biggest colour spreads yet on September 14 and 21, 1953 – 24 pages of colour photographs of New York entitled "Images of a magic city". It had commissioned the talented young Austrian émigré Ernst Haas (1921–86) who had arrived in the USA two years previously, escaping from a bleak existence in war-torn Austria. He had acquired his first camera, a Rolleiflex, on the black market in 1946, having traded it for 10kg of margarine which he had received as a twenty-fifth birthday present. By 1949, he had switched to a Leica and 35mm colour film. Wilson Hicks, picture editor of *Life*, had used Haas's photo essay of the homecoming of Viennese prisoners first published in *Heute* magazine and now fruitlessly tried to persuade him to accept a post as a full-time staff photographer – then widely seen to be one of the most desirable photographic jobs going. Haas refused, writing, "What I want is to stay free, [so] that I can carry out my ideas.... I don't think there are many editors who could give me the assignments I give myself."[6]

Haas and the Swiss photographer Werner Bischof (1916–54) became the fifth and sixth photographers signed up by the Magnum quorum in 1949; Haas was to play a significant

ABOVE Ernst Haas's love affairs with his adopted city New York, and with colour photography, were inextricably linked and he photographed the city throughout his life. His 1952 *Billboard Painter* on Broadway shows a very different eye and colour palette to that of his contemporary Saul Leiter. Haas described himself as "a painter in a hurry". This image and *Reflections* (opposite) were reproduced in *Life* magazine in "Images of a magic city" in 1953.

number of roles within the agency over the next two decades. The Magnum philosophy addressed the conflict between editors and photojournalists head on. Magnum photographers created their own stories rather than accepting the dictates of editors and the market, and Robert Capa, one of the agency's founder members, encouraged Haas to pursue his own vision. This attitude appealed to Haas far more than a future as a *Life* staffer, although he subsequently produced some of his best work for the magazine in the next decade.

For the next 30 years, he worked for a wide variety of publications, including *Vogue*, *Look*, *Stern* and *Geo*, as well as publishing many influential books of his photographs and working for the film industry. Haas's wish was "to be remembered much more for a total vision than for a few perfect single pictures".[7] His many photo stories for *Life* in the 1950s raised his profile to one of the 10 greatest photographers in the world, as voted for by readers of *Popular Photography* magazine in 1958. His photo essays in colour for *Life* included: "Africa, land of tranquility" (August 16, 1954); "A great event repeats itself in Egypt" (September 20, 1954); "The glow of Paris: it evokes a city's many moods" (August 1, 1955); "The mirror of Venice: a camera catches

ABOVE *Reflections – Third Avenue* (1952) is taken from an unusual angle to render the image abstract. Haas's photographs were a realization of Henry Luce's stated aims for *Life* magazine when he relaunched it in 1936: "To see life; to see the world; to eyewitness great events; ...to see man's work – his paintings, towers and discoveries; ...to see and to take pleasure in seeing; to see and be amazed; to see and be instructed."

the enchantment of the city's shadows and shimmer" (June 25, 1956); "Violent and pictorial sweep of warfare in Spain: *The Pride and the Passion* is about guerrillas and a monster gun" (July 8, 1957); "In a brutal art beauty: a great cameraman shows bullfight's 'perfect flow of motion'" (July 29, 1957); "The magic of color in motion: a famous photographer explores new dimensions", Part I, and "Adventure in new camera realm: a famous photographer records 'Magic of color in motion' on land", Part II (August 11 and 18, 1958 respectively). Note how during these five years, Haas's byline description at *Life* changed from "a great cameraman" to "a famous photographer".

Haas pioneered new techniques in his late 1950s colour work, panning with the camera to create action shots and mixing colours by using a slow shutter speed. He loved colour with an unmitigated joy and passion after his previous life of bleak greyness in war-decimated Austria, and wrote in its defence frequently and with vehemence: "There have never been conflicting thoughts within me about black and white versus color photography. The change came quite naturally. I was longing for it, I needed it, I was ready for it, and there was a film available to work with. The year was 1949, and the film was Kodak I, rated at 12 ASA. I wanted to celebrate in color the new times, filled with new hope."[8] Haas wrote much about the exuberance of colour: "Color is joy. One does not think joy. One is carried by it. Learn by doing or even better unlearn by doing."[9]

Colour photography gave Haas a brand-new life. "Everything was connected with the new coverage for color," he stated. "Fashion, food, travel, cars, flying – everything changed and took on a new brightness."[10] He was also one of the first to try refreshingly to delineate the problems that other "serious" photographers had with colour: "I still do not understand all these problematic discussions about color versus black and white. I love both, but they do speak a different language within the same frame. Both are fascinating.... Color does not mean black and white plus color. Nor is black and white a picture without color. Each needs a different awareness in seeing and, because of this, a different discipline.... There are black and white snobs as well as color snobs. Because of their inability to use both well, they act on the defensive and create camps. We should never judge a photographer by what film he uses – only by how he uses it."[11]

During the 1950s, Haas went on to become the vice-president of Magnum's American operations and in 1954, on the deaths of Capa and Bischof, a member of Magnum's board of directors. He served on the agency's executive committee from 1957 and then as Magnum president from 1959, also editing and designing the exhibition "The World as Seen by Magnum Photographers" that same year. Like many of his colleagues, he worked as a stills photographer on film sets – *Land of the Pharaohs* (1954), *Moby Dick* and *The Pride and the Passion* (both 1956). His overwhelmingly successful career as a colour photographer, which continued throughout the 1960s and 1970s, is one of the first examples of a photographer choosing and preferring to work solely in colour. Haas frequently spoke about this decision with great eloquence. "I have worked for 35 years as a photographer. At least a third of this time was in black and white, as there was nothing else. The rest has been in color, with a few unhappy years when we were asked to work in both styles."[12]

One of Haas's colleagues at *Life* was Eliot Elisofon (1911–73) who, in a prolific and lively career, had been the first staff photographer at MOMA from 1939, president of the Photo League from 1940 and a freelance photographer for *Life* and other magazines prior to 1942, after which he joined *Life* as a full-time staff photographer. *Life*'s first full-colour cover on July 7, 1941 was Elisofon's portrait of Major General George S. Patton Jr. He embraced colour in 1938 and it gradually replaced black and white in his work. "I've never believed color in

LEFT Haas's Spanish bullfight photographs of 1956, including *La Suerte de Capa, Pamplona* marked the first time he used a panning camera to slur and stagger motion and a slow shutter speed on Kodachrome ASA 10 film to drag and mix colours. Haas was also working in cinematography at the same time and his experiments with colour and motion were buoyed by, and fed into, his film work.

LEFT Eliot Elisofon's 1958 photograph of Japanese lanterns looks like a contemporary lighting display in Ikea or Habitat. Only much better. This proves what we all already know; that Oriental design is best. The tiny female figure adjusting a huge light would suggest that this image is a photomontage. Elisofon uses subtly nuanced light to emphasise the sculptural shapes of the lanterns.

pictures ought to be a facsimile of the real thing," he wrote. "Good artists take what they like from reality and discard the rest."[13] Elisofon reckoned that he travelled over two million miles criss-crossing the globe on photographic assignments throughout his life. His later colour work concentrated almost obsessively on Africa, a continent and peoples he loved and which cried out for the use of colour (see Chapter 8, p.182).

The 1950s was the time when colour photography began to come out of the woodwork as it became cheaper as well as quicker and easier to work with. Thanks to some of the photographers mentioned above, its proliferation in the illustrated press, the cinema, advertising and fashion made it an increasingly familiar part of people's daily lives and one with which they became progressively more comfortable. The contribution of the unsung heroes of colour photography – the millions of amateurs who chose to use each colour process as it evolved throughout the twentieth century – has never been properly assessed (nor, as yet, much researched), apart from by the amateur camera clubs and publications that catered to this vast market.

In the UK amateur photographers did their best with meagre post-war resources and showed 35mm colour transparencies and colour prints at photographic societies' exhibitions. They rarely met with the judges' approval, drawing such comments as, "It must be granted that the scarcity and cost of the material militates against experiment, but this cannot be allowed as an extenuating circumstance in judging results."[14] Or, "Another very noticeable thing was the number of slides of branches of blossom against very blue skies and of water lilies on viscous-looking ponds" and "the conclusion to be drawn from the rejected entries seems to be that colour prints are too difficult to make and colour transparencies too easy to make!"[15] Despite this, the prognosis for the future of colour photography was deemed to be good.

Haas and Elisofon were professional photojournalists who chose colour over black and white and an increasing number of magazines were willing, and increasingly able, to publish in colour. But black and white photography, with some exceptions, continued to set the artistic standard for museum, gallery and exhibition display, although the momentum there too was changing. Haas and other colour enthusiasts had to fight their colleagues' prejudices against the medium but colour aesthetics were slowly beginning to shift and exhibitions of colour photography would increasingly move into the museums in the 1960s. During the

ABOVE It would be difficult to recognise this 1950 image – *Gas station Mexico* – as a Paul Outerbridge photograph, as it is so different from his previous studio-based work. And yet the confident use of a minimal but vibrant colour palette (here red, white, green, brown), the foreground figure with shadow, the graphic placement of vertical pillars and horizontally divided spaces show that Outerbridge still photographed with a graphic designer's precision.

1940s and even more so in the 1950s, all the directions that modern colour photography would take beyond advertising, fashion and illustrated magazines were in evidence: photojournalism, photographing the everyday and ordinary, and nature.

Paul Outerbridge had a successful career as a commercial colour photographer in New York for two decades, often charging $750 for one of his meticulously printed tricolour Carbro prints – but then he was one of the best colour photographers and printers around, as a glance at his 1940 book *Photographing in Color* reveals.[16] Once he "retired" to California in the 1940s, Outerbridge operated a portrait studio but continued to make photo essays throughout the area. In 1950 he picked up a 35mm camera and photographed ordinary life in Mexico, as Steichen had done in 1938, but with a very different aesthetic. His seemingly casual images of subject matter previously deemed unphotographic, charting the growing urbanization of Mexico in everyday imagery, blaze with gloriously clashing colours in the bright sunlight, rendering the ordinary extraordinary and thereby anticipating one of the radical directions in which colour photography was to develop over the next 20 years.

LEFT Like an illustration to a Grimm fairy tale, Eliot Porter's scudding skies and sliver of crescent moon have a spooky and mysterious atmospheric presence. Porter photographed cloud studies just before and immediately after sunset near his home in New Mexico. This *Cloud formation and moon after sunset* was taken in Tesuque, New Mexico, in July 1958.

BELOW Curators love photographers who put dates on their photographs. Porter took this close-cropped image of green bottles and Millbrook Club beverage crates on Matinicus Island in Maine on August 24, 1954. Life on Matinicus, two miles long and one mile wide, moves at a pace set by wind, weather and tides. Porter offset the textures of the dark green and grey salt-lashed and weathered shed boards, daubed with a splash of red paint, with the shiny green glass bottles and sinuous coil of rope.

One of photography's main themes – nature and landscape – had until now been infrequently addressed by photographers with a strong colour aesthetic. Eliot Porter (1901–90) was to change all that. The brother of the Abstract Expressionist Fairfield Porter (1907–75), he trained as a biochemist. With a strong interest in botany, Porter began to experiment with colour photography in 1939, almost immediately after his first solo black and white exhibition at Alfred Steiglitz's An American Place gallery in New York in 1938. A keen ornithologist, Porter initially used colour to make more accurate records of birds, but the revelations that colour photography made in this study encouraged him to experiment with it in other areas.

Porter's interest did not lie in the grand, majestic sweep of nature but in its fascinating, intrinsic detail – not for him the grandiose landscapes that his contemporary Ansel Adams (1902–84) was recording in black and white (although Adams also occasionally used colour), but instead intimate and intense portraits of rock formations, lichen, flowering plants, cloud patterns, water and light effects on woodlands. Over the next few years Porter taught himself the intricacies of tricolour Carbro, Kodak wash-off relief and then finally

RIGHT Shimmering autumn shades of flaming gold, chestnut and azure form an image of molten lava-like colour in Porter's *Pool in a brook, Pond Brook, New New Hampshire* taken on October 4, 1953, and later reproduced in his book *In Wildness* (see Chapter 7). The golden-red autumn leaves act as a coda to place an otherwise abstract image in reality.

Kodak dye transfer printing. He remained committed to the latter for the rest of his life as it gave him the depth of colour and the archival permanence he required. Working from 4 x 5in colour transparency film, he made three separation negatives through coloured filters and printed from those (or had others print for him) through a variety of detailed and precisely measured steps, much as Agnes Warburg and Fred Judge had done 30 years before (see Chapters 3 and 4) with earlier processes. Meticulous in the extreme (and a curator's dream), he recorded the exposure details of each image he shot and how it was printed. Through watching and waiting, he knew what effects he could capture: "A film of water on a rock surface... may reflect the light of the day after absorbing the longer wavelengths and be as blue as the surface of the sea, or it might reflect the color of a sunlit sandstone cliff and become a band of gold."[17]

Like Haas and Elisofon, Porter's photographic journey continues through the next three chapters when the small trickle of "serious" photographers using colour becomes an almighty rush.

7 WE ARE ALL COLOUR PHOTOGRAPHERS NOW
1960–1969

The 1960s was the decade in which the many strands of colour photography finally came together. Everything that black and white photography could achieve was now possible in colour: nature, landscape, portraiture, fashion, advertising, war, social documentary, street photography, scientific photography, and by the end of the decade, the "new" vernacular photography – something that amateur colour photographers had naturally been practising for years, blithely unaware that they were creating "new colour". It was also the decade when the work of colour photographers, already widely used in upmarket and wide-circulation magazines, began to be published in handsome monographs. There were still very few venues for exhibiting photographs or otherwise getting them seen beyond a scattering of museums and galleries in major cities, so books and magazines were an increasingly important means of dissemination. Weekly newspaper colour supplements which first appeared in the 1960s, usually as part of a Sunday newspaper, and which provided many photographers – especially photojournalists and advertising and fashion photographers – with steady work were another significant outlet. The first British colour supplement was launched by *The Sunday Times* on February 4, 1962, followed by the *Observer* on September 6, 1964.

In a natural progression from Alexander Liberman's Condé Nast photographic mavericks of the 1950s, photographers became the hip young gunslingers of 1960s pop culture, and were now on a par with pop and film stars, fashion designers and anyone vaguely creative and under 30. The Italian art-house film director, Michelangelo Antonioni (b. 1912) made a photographer – sexually predatory but seemingly also sexually irresistible – the star of his first English-language film, the über-cool *Blow-Up* (1966). Although it was always denied by its star David Hemmings, the central character was supposedly based on an amalgam of the photographers David Bailey (b. 1938), Terence Donovan (1936–96) and Brian Duffy (b. 1936). Shot in the Holland Park studio of John Cowan (1929–79), the film was a huge critical success, combining as it did a lot of sex and nudity with this newly glamorous occupation.

Bailey's own take on photography was that the first half of the twentieth century belonged to Picasso and the second half to photography: he may well be right. Photography courses, both practical and theoretical, were now taught in steadily increasing numbers of schools, colleges and universities, especially in the USA, and a whole new breed of photographers with educational qualifications would shortly emerge to give the medium more institutional clout and backbone and an increasingly enhanced profile.

RIGHT How many of us have felt the urge to shoot a banana? This microsecond exposure of a .30 calibre bullet travelling at 2,800 feet per second through a banana was taken in 1964, when Harold Edgerton seemed intent on puréeing fruit with ammunition. He used a more widely published image from the same year – a bullet's trajectory through a red apple – to illustrate a lecture entitled "How to Make Apple Sauce". Printed as a rich dye transfer print, the yellow on blue/green of the exploding banana makes for a powerful image.

As in previous decades, the uses to which colour – or any – photography could be put depended on advances in technology. Dr Harold Eugene Edgerton (1903–90) was Professor of Electrical Engineering at Massachusetts Institute of Technology, a committed teacher and communicator, and inventor of the electronic stroboscope in 1932. This effectively froze motion, emitting 60 10-microsecond flashes of light per second, but could also capture subject matter that was too slow, too bright or too dim to be seen by the naked eye or by other traditional photographic means, thus making the invisible visible. Allied with a camera, the stroboscope had many applications and was used in night aerial photography during World War II, to capture nuclear explosions and for underwater photography and exploration.

Providentially, Edgerton was a scientist with an acute visual aesthetic and knew that strong and striking photographic images, especially in arresting colour, were the best means of communicating the stroboscope's multiple possibilities. He also had a wry humour that adds another level to his work. From 1937, he worked with the Condé Nast photographer Gjon Mili, who used an Edgerton multiflash strobe light, most famously in his photographs of Pablo Picasso "painting" with light (see Chapter 6, p.131). Edgerton also produced series of black and white photographs of his own, often with an exposure of less than 1/10,000th of a second – most famously bullets being shot through playing cards and apples, the cartwheel arc of a golf swing, feet kicking footballs and the perfectly symmetrical coronet formed as a drop of milk hit a hard surface. Colour photography gave Edgerton's already stunning images a startling immediacy and modernity, making them classics of modern art and reductive science. He preferred the dye transfer process for its depth of pure glowing colour and archival permanence and this, along with their compositional simplicity, gives his colour photographs that rare attribute of timelessness.

Although Edgerton used the dye transfer process, an important new colour printing process became available in the 1960s. In 1963 the first exhibition of Cibachrome prints was shown at the Photokina photo fair in Cologne and was in widespread use by the end of the decade, a home printing version being introduced in the 1970s. Designed for making prints from colour transparencies, Cibachrome is noted for its stability, longevity, image clarity and rich colour saturation and is still in use today, now named Ilfochrome.

That same year, Kodak launched the Instamatic 126 camera. Cheap, easy to load and easy to use, the Instamatic used foolproof Kodacolor negative cartridge films, all ASA 64, thus enabling anyone to get good results under a wide range of conditions. Polaroid launched the first instant colour film, Polacolor, a "peel-apart" negative/positive system that could be used in most existing Polaroid cameras. The whole process took a couple of minutes, was especially good at capturing skin tones, and became hugely successful. By the mid-1960s, Polaroid was the second largest photographic company in the world after Kodak.

In 1962 Eliot Porter's first book *In Wildness is the Preservation of the World*, published by the influential conservation group the Sierra Club (founded in 1892 to preserve and conserve the world's environment and ecosystems), matched his evocative photographs of the changing seasons in New England with the plangent words of the nineteenth-century Transcendentalist writer Henry David Thoreau (1817–62). Beautifully designed and printed at the unusually large size of 14 x 11in (35 x 23cm), the book was published on the centenary of Thoreau's death. Although selling for the high price for the time of $32.50, and on a relatively obscure subject, it was an unexpectedly huge success, selling out even before publication. It sold 59,000 in hardback and many more copies in a variety of later editions. Its distribution gave the Sierra Club a powerful international voice in the conservation movement and tapped into the *zeitgeist*

OPPOSITE Eliot Porter made 11 trips to Glen Canyon in southeast Utah between 1960 and 1965, producing more than 1,000 images of rock faces, water and canyon plants, before a dam was built and the canyon flooded. Porter celebrates the geological monumentality of this little-visited place by creating a set of intimate portraits concentrating on the details, as in the striated rock formation of these sheer cliffs photographed in September 1961.

LEFT Porter took this image of a starfish resting on volcanic sheet lava in shallow water on San Cristobal Island in the Galápagos, on May 23, 1966. He and his Sierra Club colleagues toured the islands by sailboat for four months to document their endangered and extraordinary ecology. The image, using Porter's preferred square format, is all about texture and light, as the water seems almost to ripple on the page across the patterned rock.

of growing environmental and ecological awareness, and all in glorious full colour. Porter, using his scientist's knowledge to enhance his artist's eye, was able to get increased colour brilliance, contrast and saturation from his Kodachrome film before printing dye transfers from it. He also printed differently from the same negatives, eager to explore all colour possibilities.

Buoyed with success and with financial equilibrium, Porter's subsequent photographic career was to follow this established pattern of photographing ecologically and environmentally significant places worldwide, pairing them with relevant text, often by nineteenth- and twentieth-century seers, then producing an exquisitely printed, visually challenging and thought-provoking book. In the course of more than 50 years in photography, Porter produced 26 books. During the 1960s, all his publications were with the Sierra Club, on whose board of directors he served from 1965 to 1971.

In 1960 Porter accompanied the Santa Fe poet "Spud" (Walter Willard) Johnson (1897–1968) on a rafting trip down the Colorado River through Glen Canyon in southeast Utah. The canyon was about to be flooded to create a dam and although Porter's second Sierra Club book, *The*

RIGHT This image of sunset in James Bay Santiago in the Galápagos Islands, taken on April 11, 1966, captures the strange otherworldliness of the place with its black sand beaches, dark and oily, inky-green seas, lowering skies and the light from a full moon juddering through the water.

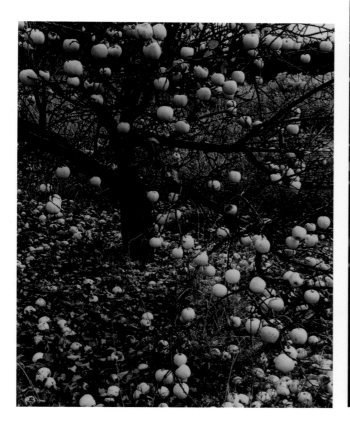

ABOVE Porter moved to Tesuque, New Mexico, in 1946 and photographed these frostbitten apples there on November 21, 1966. His words, taken from the 2003 publication *Eliot Porter: Color of Wildness* sum up all his work: "I try, not always with success, to photograph only what stimulates a recognition of beauty, either that which is intrinsic in the objects of nature or is a manifestation of the wonderful relationships of things in the natural world."

Place No One Knew, Glen Canyon on the Colorado, published in 1963, came too late to stop this particular dam, it was effective in having future schemes halted or re-evaluated.

Porter became interested in the Galápagos Islands after reading the 1961 book *Galápagos: the Noah's Ark of the Pacific* by the eminent Austrian biologist Irenaus Eibl-Eibesfeldt and he spent four months photographing there in 1966. In 1968 the Sierra Club published the two-volume *Galápagos: the Flow of Wildness*. Porter's photography has exceptional harmonious and lyrical qualities and invests unknown places with a sense of calm familiarity. We recognize the objects he photographs but see them anew through his unique interpretation (although his photographs unleashed a bevy of similar material). He photographed nature's intricate and detailed complexity in thorough scientific detail while rendering the whole as a simple and beautiful piece of abstract art. Pulling the camera back, he took longer and wider general views to establish scale, but his most successful photographs are those in which he moves in to concentrate, with a scrupulous forensic intensity, on the very personality of the subject matter, be it a frozen apple, a starfish or a cleft in the rock.

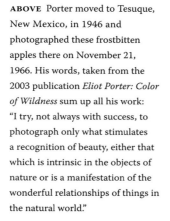

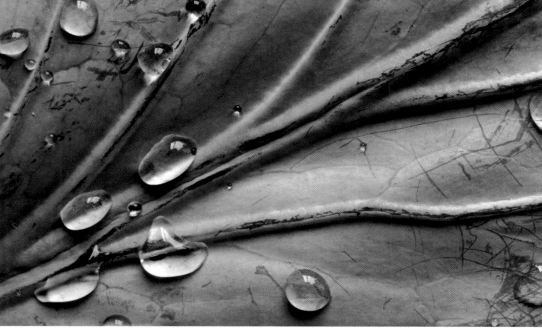

ABOVE LEFT In a varied career, Heinz Hajek-Halke was in the vanguard of German experimental photography in the 1920s and again during its spiritual revival in the 1950s and '60s, after World War II. Exploring colour photography, he used the techniques he had learnt in his previous camera-less photograms and photographic abstractions utilizing shards of glass, glue, varnish, soot, wire and fish bones, as well as darkroom techniques of montage and double exposure, to achieve images that looked like macrophotographs.

ABOVE RIGHT This subtle and beautifully composed close-up by Erna Lendvai-Dircksen of a just-washed cabbage leaf is dated 1962, the year she died aged 79. With its purple-pink spine, delicate tracery of abrasions on the grey/green bloom of the leaves and crystal drops of clinging water, it resembles magnified human arteries and veins.

Porter was not alone in his exploration of how colour could render the objective subjective, the definite abstract. In Germany the experimental photographer Heinz Hajek-Halke (1898–1983) incorporated photomontage, camera-less projection, *Lichtgrafiken* (light graphics) and chemical reworkings of previously exposed negatives into his work to achieve the desired abstract end. He started to experiment with colour in the late 1950s.

Also in Germany, Erna Lendvai-Dircksen (1883–1962) changed photographic directions in 1945 from her previous close-up portrait photography exploring race, with some commissions from the Third Reich, to the altogether healthier pursuit of colour landscape and nature photography.

Horst Baumann (b.1934), like Ernst Haas, was an expert at photographing motion and speed in colour. He later went on to work in illustration, video and laser and digital light installations.

There was great hope for reinvention and starting again in the 1960s, the hypothetical decade of peace and love and youthful exuberance. After 15 years of depressing post-war austerity, everything had to be "up to date". In the USA, John F. Kennedy's brief 1,000-day

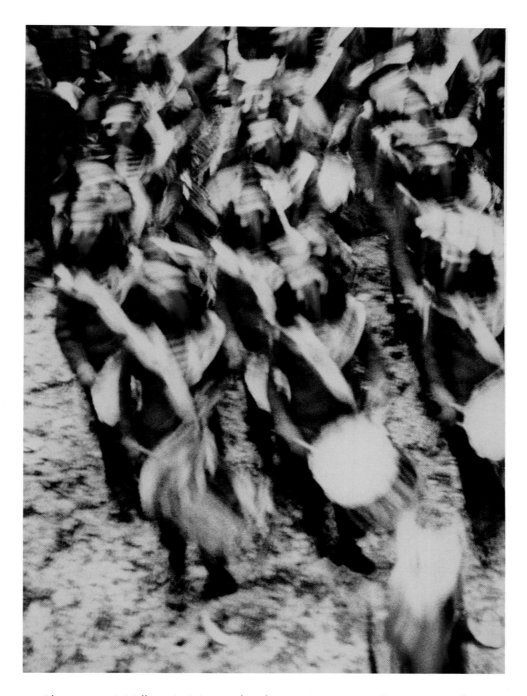

presidency set an initially optimistic tone, but the attention swung to Europe, especially London, which was seen to be the absolute in hip and cool or, in 1960s-speak, fab and groovy. Photographers now had a new range of subject matter: "swinging" London, pop music, Pop Art, mini-skirts and the inexorable rise of fashion, models and hairdressers, homegrown TV and film celebrities (British TV would eventually lurch into colour for the favoured few in 1967), and – in the footsteps of *Picture Post*, which folded in 1957 – the exploration of domestic social conditions and the rapid changes in the British urban environment. Later in the decade there would be hippy culture and psychedelia to be addressed, as well as race relations, student riots and the war in Vietnam.

But there was little mainstream British colour photography prior to this date and so photographers had to adjust quickly. Influenced by the work of Henri Cartier-Bresson and Bill Brandt (1904–83) in Europe and by American photographers such as Walker Evans, W. Eugene Smith (1918–78) and Robert Frank (b. 1924), some photojournalists, notably Don McCullin

ABOVE Horst Baumann's series of photographs of the Basel Carnival in 1961 capture the movement of the three-day festival, celebrated for exactly 72 hours from 4am on the Monday following Ash Wednesday to 4am on the Thursday of the same week. Here the colourfully costumed and masked drumming bands merge into a carnival swirl of colour.

LEFT London in the 1960s was not always "swinging" for recent Afro-Caribbean immigrants, who had mostly settled in the North Kensington/Notting Hill area of London. In August 1965, in an attempt to bind the old and new communities in the area together, the first Notting Hill outdoor carnival was held and attracted around 1,000 people. By 1976 the carnival had become predominantly Afro-Caribbean; today it regularly attracts crowds of over one million.

BELOW By the mid-1960s, 40 per cent of the British population were aged under 25. Fashion magazines like *Vogue* needed to cater to a younger, streetwise clientele that was becoming increasingly prosperous after the dire post-war years: a clientele that wanted to wear informal clothes that allowed movement, rather than formal ones that restricted it. Norman Parkinson pans his camera, keeping the model and her clothes static and in focus but filling the image with the red blur of the London Routemaster bus behind her.

(b. 1935) and Philip Jones Griffiths (b. 1936) stuck resolutely to gritty, contrasty black and white. Others, including John Bulmer (b. 1936?), Roger Mayne (b. 1929), Eve Arnold (b. 1912) and Anthony Armstrong-Jones (later Lord Snowdon, b. 1930) adapted to colour easily.

In 1960 Keystone Press photographers documented the new wave of Afro-Caribbean immigrants who had settled in the (then dilapidated) Notting Hill area of London in the 1950s. After the 1958 race riots there, the bright colours of these images give an unnaturally jaunty and positive air to what was in fact a fairly desperate and intolerant situation.

Fashion photographers naturally embraced colour. In a career lasting seven decades, Norman Parkinson (Ronald William Parkinson Smith, 1913–90) was considered by *Photography* magazine in 1964 to be "the greatest living English photographer". Parkinson – who believed that "colour photography is largely magic" – worked on and off for *Vogue* from 1941 to 1978 but was contracted to *Queen* magazine in London during its 1960s revitalization prior to its being taken over by *Harper's Bazaar*. He was famous for getting models out of the studio and posing them on the streets, and his photographs from this decade, shot with a Widelux camera that gave him a 180-degree range of coverage, emphasize their London location by featuring

LEFT Courrèges, the "Le Corbusier of fashion", was about as cool as it was possible to be in the mid- to late-1960s with his Space Age, Gladiator and Egyptian designs. He put women into mini-skirts, white and silver boots, metal clothing and nylon wigs. The American photographer Bert Stern (b. 1929) was not far behind in the cool stakes. Although now best known for his work with Marilyn Monroe, Stern was a major name in fashion photography in the 1960s and '70s. This image by these two icons of the fashion world is of the 1967 Courrèges Paris collections, from *Vogue*.

BELOW In the 1930s Angus McBean merged two of his many skills (those of photographer and theatrical props maker) and established his reputation when he began to arrange his sitters in specially constructed Surrealist landscapes and sets of his own devising in the studio. It was a style he made his own and with which he continued, with quirky variations, until the 1960s, as in this portrait of Spike Milligan.

iconographic British symbols such as bright red telephone boxes and double-decker buses.

Along with the phenomenal rise of pop music, album covers became a platform that provided photographers with a whole new blank canvas and their design became hugely competitive during this decade and beyond. Angus McBean (1904–90) created a Surrealist assembled portrait of "Spike" (Terence Alan) Milligan (1918–2002) in 1961 for the album cover of *Milligan Preserved*. Largely responsible for the writing and production of the first "modern" comedy, *The Goon Show*, which ran on BBC radio from 1951 to 1960 with 26 shows a year, Milligan was one of the most famous people in the UK at the time and McBean's Surrealist-lite style perfectly suited Milligan's eccentric and disturbed personality. His colour palette refers back to the 1930s – all Art Deco eau-de-nil and pistachio greens and deep claret reds, with echoes of Madame Yevonde. Two years later, in 1963, McBean photographed the Beatles in Manchester in colour for the cover shot of their *Please Please Me* album. Resisting the urge to bury them up to their necks in sand, he described them then as "a gangling group of four young men in mole-coloured velveteen performing suits of a terrible cut".

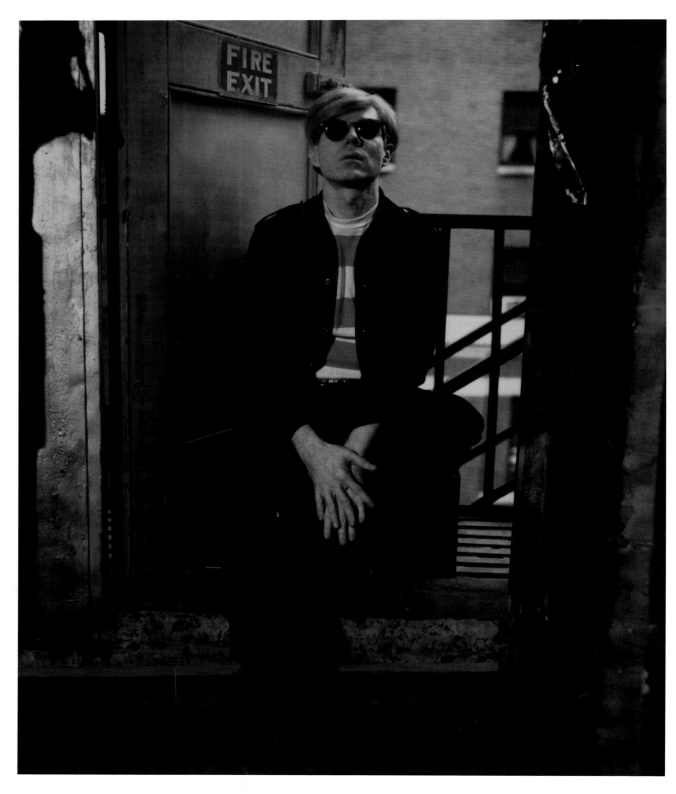

The photographer Marie Cosindas (b. 1925) and her sitter Andy Warhol enjoyed rather
more fame than Warhol predicted in 1968 when he made the famous statement: "In the future,
everyone will be world-famous for 15 minutes." Cosindas started to use colour photography in
1962 at the recommendation of Ansel Adams and soon moved on to Polacolor in 1963. By 1966,
she was probably as famous in her world as Warhol was in his, with a one-woman exhibition
at MOMA and a reputation for achieving intimate revelations of her sitters' inner lives by her
innovative use of rich Polaroid colours and personal props.

Bob Dylan (Robert Allen Zimmerman, b. 1941), arguably the most important American artist
of the 1960s was photographed by Daniel Kramer (birthdate unknown) on an almost daily basis
during 1964–65 in both black and white and colour. The cover shot used on the *Bringing It All
Back Home* album of 1965 was Kramer's first album cover and Dylan's first folk-rock album – an
album that dramatically upset some of his more folk-oriented devotees. The decision to use
colour was because "we are leaving where we were, and we are going some place new... color
would also add to the dimension, the layering in the picture".[1] Thus the use of colour rather than

ABOVE Daniel Kramer's album cover and its contents have been much scrutinized and theorized over by Bob Dylan obsessives. Kramer wryly observes, "A lot of mysterious concepts and ideas have come about looking at this picture… and they're all true." Items gathered together to put in the picture include albums by Robert Johnson, Eric von Schmidt, Lotte Lenya and the Impressions. The back cover of the magazine that Dylan is holding bears an advertisement for Louella Parsons' biography of Jean Harlow, reissued in 1964. Sally Grossman claims never to have worn the red jersey culottes-dress again.

black and white in the image reflects, and is analogous with, the change in Dylan's music from acoustic to electric. Kramer encircles Dylan, Lord Growing (the house cat, who is sitting on his knee) and Sally Grossman (wife of Dylan's manager Albert Grossman, who is deliberately wearing red to ensure her prominence in the composition) with a haloed ring-flash effect, but it is the mean, moody-eyed stare of Dylan that captures the attention.

Back in New York, musicians were also coming under the lens of Lee Friedlander (b. 1934), now better known for his black and white photography of the American social landscape – street scenes, shop fronts, images from TV screens and esoterically glimpsed self-portraits. A lifelong lover of jazz, R & B and soul, Friedlander started photographing jazz musicians in Los Angeles in the early 1950s. From the middle of that decade, he photographed Atlantic Records' stable of musicians for album covers. His bold and harshly lit exploratory close-ups in colour at the beginning of his career are seemingly a world away from the main body of his work.

War had been photographed in colour before – World War I by Tournassoud and a corps of autochromists, World War II by Hinde and others – but it had never seemed so immediate as in the work that *Life* photographer Larry Burrows (1926–71) did in Vietnam. His photographs

ABOVE LEFT Aretha Franklin moved from Columbia to Atlantic Records in 1967, after which her career went into the stratosphere for almost two decades. Rejecting a composed studio portrait, Lee Friedlander captures her performing at the piano in 1968, belting out a number, filling the cropped frame with her head. Not a flattering photograph, but one that explodes with energy.

ABOVE RIGHT Friedlander's square-format portraits were shot with album covers in mind. This 1969 shot of Miles Davis comes from a session that provided the cover for the first of Davis's jazz/electric rock fusion albums *In a Silent Way*. Light bounces off the planes of Davis's face, emphasizing the wariness in his eyes and his cool demeanour.

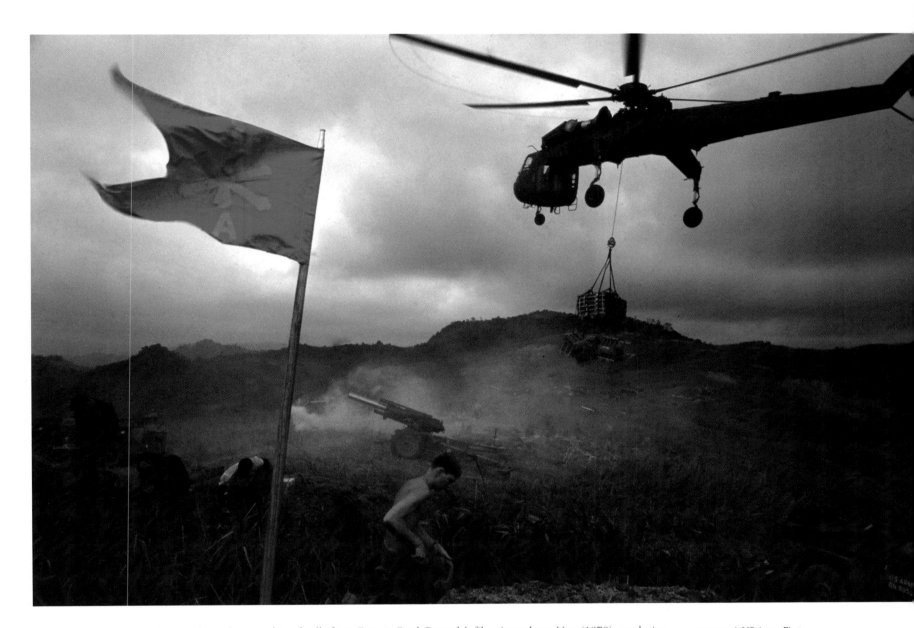

have the unreality of stills from Francis Ford Coppola's film *Apocalypse Now* (1979), rendering scenes of unremitting violence and horror strangely beautiful. This is perhaps not surprising given that the journalist Michael Herr (b. 1940), a friend of Burrows' in Vietnam, worked with Coppola on the screenplay, based on his 1977 Vietnam memoirs *Dispatches*.

Burrows worked for *Life* in its London offices as a lab boy from 1942 when he was 16 years old, printing from thousands of World War II negatives by Robert Capa and the like, and itching to be photographing at the Front with them. He served his colour apprenticeship under *Life* photographer Dmitri Kessel (1902–95), copying great works of art to be reproduced in colour in the magazine and came to understand the requirements of colour better than most. "He understood... that when the conditions were right, color cast a special glow around the core of a photo, and created its own living ambience. Color, done right, was mood; mood, done right, became art."[2] Rather than have separate cameras loaded with black and white and colour film and use them consecutively for the same scenes, Burrows decided which film was needed for particular situations and lighting. "The others tended to take the same photo twice, and the second time, instead of black and white film they used color—so the same people turned up in

ABOVE A US Army First Air Cavalry helicopter airlifts ammunition into a Marine outpost which is under attack while attempting to break the 77-day North Vietnamese siege of Khe Sanh in April 1968. During the siege, codenamed Operation Scotland, several thousand North Vietnamese soldiers and almost 2,000 US personnel were killed or injured in one of the bloodiest battles of the war. A tactical victory for the Marines, Khe Sanh was abandoned soon after.

both photographs. Color was very different for Larry. He understood what it could do the way a great artist understands it and he used it like an artist – as if he were one of the Impressionists."[3]

Burrows also had the freedom of creating his own photo essays rather than working to deadlines and was able to tell eloquent and moving stories in colour. *Life*, faced with falling sales caused by the incursions of colour TV reporting, featured more and more colour photography during the 1960s. Burrows loved the country and the people of Vietnam but never achieved his wish of photographing it when war was over. His helicopter was shot down by North Vietnamese anti-aircraft fire over the Ho Chi Minh trail on February 10, 1971: he was one of the 135 photographers from all nations killed during the war. *Life* ceased publication as a weekly magazine on December 29, 1972.

In 1962 the Museum of Modern Art (MOMA) chose Ernst Haas's work for its first solo exhibition of colour prints, one of the last exhibitions planned by Edward Steichen who retired that year as director of the Department of Photographs (aged 83). Steichen's personally chosen replacement as director, John Szarkowski (b. 1925), wrote of Haas's work, "The color in color photography has often seemed an irrelevant decorative screen between the viewer and the fact of the picture. Ernst Haas has resolved this conflict by making the color sensation itself the subject matter of his world. No photographer has worked more successfully to express the sheer physical joy of seeing."[4]

By this date, Haas's work had begun to move in a new direction, away from the formalism of photojournalism and reportage and towards natural observation and the exploration of the

ABOVE It seems that every photographer turns to flowers at some stage in his or her life and Ernst Haas was no exception. This 1967 image of parachute flowers shows the delicate gossamer-like threads and inverted parachute-like structure of these wild meadow flowers. Haas's reaction to flowers was instinctive: "If the beauty was not in us, how would we ever recognize it?"

metaphorical potential inherent in the photographic image. He had a further solo exhibition at George Eastman House in 1963 and increased his film work, directing the Creation sequences based on the Book of Genesis in John Huston's meaty 1964 epic *The Bible*. He travelled, taught and made educational TV programmes entitled *The Art of Seeing* in 1963, prints from which were then sent out and exhibited worldwide by Kodak. Like Porter, he was to produce several books over the next two decades, starting in 1963 with *Elements*, with a highpoint being the publication of the hugely influential *Creation* in 1971. Thirteen years in the making, in an unusual oblong 9¼ x 13⅝in (23.5 x 34.5cm) format, it became the most successful colour photography book of its time. Published in several languages, it sold over 350,000 copies.

During the 1970s, Haas produced several more successful books – *In America* (1975), *In Germany* (1977) and *Himalayan Pilgrimage* (1978) – reflecting his increasing interest in matters of the spirit.

By the late 1960s, colour photography was beginning to be more widely shown in travelling exhibitions, especially on university campuses, where it reached a whole new enthusiastic audience. It was also increasingly being shown in museums by enlightened directors and curators; for example, Beaumont Newhall (1908–93) at George Eastman House, Rochester, New York, and Roy Strong (b. 1935), first at the National Portrait Gallery and then at the Victoria and Albert Museum, both in London. Even the Royal Photographic Society in London showed colour photography at its small in-house exhibitions from 1907 onwards, but there were still negligibly few dedicated photography galleries – a situation that was to change radically in the 1970s.

ABOVE Haas's famous shot of traffic in the streets of Albuquerque, New Mexico, printed as a punchy dye transfer, was taken after a heavy downpour in 1969. It is a daytime shot, the skies darkened from rain and thunderclouds at the junction of the old Route 66 at Central Avenue and Carlisle. Almost 40 years later, the People's Flower Shop and motel signs on the right, the bank building and the Aztec motel sign on the left are all still there. Even the street lighting is the same.

LEFT This giant tube of Lifesavers (similar to Polos in the UK) shows the bold colour and striking composition of Pete Turner's work. For five decades, Turner has been printing with this intense and colour-drenched palette for advertising, magazines and album covers.

BELOW LEFT William Eggleston photographed for his *Los Alamos* series around the American south and southwest between 1965 and 1974. This project was much interrupted and only rediscovered recently. Shot on colour negative film rather than transparency, the *Los Alamos* pictures represent Eggleston's first experimentation in colour photography. This back view of a beehive hairstyle in a small-town green-boothed diner juxtaposes the softly ladylike pink gingham dress and double-stranded pearl necklace with the harshness of the backcombed and hairsprayed beehive.

OPPOSITE Edgerton continued to produce astounding images, this one with J. Kim Vandiver in 1973, again printed as a radiant dye-transfer print. This microsecond exposure of a .22 calibre bullet passing through the hot air rising above a candle flame is a stroboscopic colour *Schlieren*, or shadow, picture taken with a one-third microsecond exposure. *Schlieren* pictures make visible the variation in density of gases, shockwaves, vapour and heat – things usually invisible to the naked eye.

Pete Turner (b. 1934), who started to experiment with colour photography in 1948, has stuck with it ever since for both commercial and personal work, producing extraordinarily saturated images of a highly individual nature, seemingly impossible in a pre-digital world. And he was not alone in preferring to use colour over black and white. Therefore it is erroneous to think that when, in 1967, William Eggleston (b. 1939) a photographer from Memphis, Tennessee, took a suitcase full of his work into MOMA to show to John Szarkowski, colour photography as an art form was invented there and then on the spot. Inspired by Cartier-Bresson and Walker Evans, Eggleston had been working as a freelance photographer in the Mississippi and Tennessee areas using black and white, but had begun to experiment with colour in 1965. Championed and supported by the dynamic, charismatic and increasingly influential Szarkowski, Eggleston became – and possibly still is – the most important name in modern colour photography. What is inescapable about his colour vision, although widely copied since, is that it was his and his alone, and heralded a quite different way of seeing.

8 EXPERIMENTS IN COLOUR

1970–1979

During the 1970s, a number of American photographers, often from an art background, turned increasingly to colour. Many made the switch permanently, finding in colour something that fulfilled their artistic objectives more satisfyingly than black and white. For some, like the British photographer Tony Ray-Jones (1941–72), the change was sadly short-lived. Born Holroyd Anthony Ray-Jones, he began his photographic career in the 1960s but mostly worked in black and white until the end of that decade, then briefly bloomed into colour before dying tragically early of leukaemia. Ray-Jones's photographic vision was a rich mix of five years' wide experience in the USA in the early 1960s, wedded to European influences and his own quirky British social sensibility. After gaining his Master of Fine Arts diploma in graphic design from Yale University School of Art in 1964 and working as art director for a record company, he studied at the volatile Design Laboratory of Alexey Brodovitch (1898–1971), alongside Irving Penn, Robert Frank and Garry Winogrand (1928–84), photographing on the New York streets with Joel Meyerowitz (b. 1938) and Ryszard Horowitz (b. 1939).

Returning to Britain in 1966, Ray-Jones intended to follow in the footsteps of Sir Benjamin Stone (1838–1914) and Bill Brandt before him and document British life before it became too urbanized and too Americanized. However, he was shocked at the British lack of interest in noncommercial photography compared with its growing appreciation in the USA: "Photography to me is an exciting and personal way of reacting to and commenting on one's environment and I feel that it is perhaps a great pity that people don't consider it as a medium of self-expression instead of selling themselves to the commercial world of journalism and advertising."[1]

Ray-Jones packed a lot into the late 1960s, touring around Britain casting his sardonic and surreal eye, levelled with a whimsical and idiosyncratic sense of humour, over the British at work and play. There was still a great rift between the new affluence of London, now with its emphasis on youth culture, and life in the more impoverished provinces where post-war economic depression was slower to dissipate. He photographed seaside resorts, country festivals, crafts and customs, low-key everyday pleasures, looking for "the quiet madness in us all". Much of his colour work was done for *The Sunday Times* colour supplement, especially the *Happy Extremists* series for which he found and photographed some of Britain's great eccentrics and animal lovers, using strong concentrations of bright primary colours. Although the Institute of Contemporary Arts (ICA) in London did include his black and white work in its first photography exhibition (a group show in 1969), Ray-Jones grew increasingly frustrated by his attempts to get his work widely shown in Britain. In 1971, shortly before his death, he moved back to the USA and worked on several colour projects, hoping to satisfy his love of colour by eventually working in cinematography.

But things were slowly changing for photography in Britain in the early 1970s, albeit too late for Ray-Jones. In London, Bill Jay was appointed Director of Photography at the ICA in 1970;

RIGHT Even when on vacation, Walker Evans could not resist photographing examples of the typography and graphic design of the local culture, using his new Polaroid camera, as here on the island of St Martin in the French Caribbean in 1974. The shoemaking shopkeeper advertises his wares – Coca-Cola, cigarettes, batteries and Chiclets chewing gum – in a display of commercial graphics such as always fascinated Evans.

Sue Davies, previously of the ICA, founded The Photographer's Gallery in 1971; and Barry Lane was appointed the first photography officer at the Arts Council in 1973 with a brief to fund photography exhibitions and publications. The first major photography auction, organized by Philippe Garner, was held at Sotheby's in London in 1971 and the number of photography collectors and dealers accelerated sharply. The fact that photographs now had a rising monetary value led to a spate of launches of commercial photography galleries in New York, among them the Witkin Gallery in 1969 and the Light Gallery in 1971, followed by a dozen others before the end of the decade. To support themselves, many photographers also taught on an increasing number of photography courses and influenced a growing number of students. More museums worldwide were showing photography exhibitions.

In 1976 John Szarkowski, in his introduction to *William Eggleston's Guide*,[2] wrote of the new wave of colour photography in the USA:

"In the past decade a number of photographers have begun to work in color in a more confident, more natural, and yet more ambitious spirit, working not as though color were a separate issue, a problem to be solved in isolation (not thinking of color as photographers seventy years ago thought of composition), but rather as though the world itself existed in color, as though the blue and the sky were one thing. The best of Eliot Porter's landscapes, like the best of the color street pictures of Helen Levitt, Joel Meyerowitz, Stephen Shore, and others, accept color as existential and descriptive; these pictures are not photographs of color, any more than they are photographs of shapes, textures, objects, symbols, or events, but rather photographs of experience, as it has been ordered and clarified within the structures imposed by the camera."

ABOVE LEFT This symphony in green, a topiary garden of sixteen Scottie dogs, two cats and a rat, belongs to Cyril Clifft (who can be seen peeking through the gate far left) and is near Wolverhampton in the Midlands. It was one of Ray-Jones's *Happy Extremities* stories for *The Sunday Times* and, really, could only be British and only Ray-Jones, showing "poignancy and sharpness… with humour on top".

One name absent from the list was that of Walker Evans who famously thought, and frequently said, that colour was vulgar. After the death of Edward Steichen on March 25, 1973, Paul Strand (1890–1976) and Evans were left as the two grand old men of American photography. Remarkably, Evans began to use colour in earnest a couple of years before his death. During his 20-year stint working for *Fortune* magazine from 1946, Evans had used colour transparency film intensively and amassed thousands of images, but they were never printed. In 1973 he was recovering from his second divorce and near-fatal stomach surgery when, during a visit to a dentist friend in Atlanta, Georgia, he bought a new Polaroid SX-70. Launched in 1972, this was unlike the previous peel-apart negative/positive Polaroid processes in that it used an absolute one-step integral system, whereby a grey positive image was ejected after two seconds and developed into full, bright colour in ordinary light. The lens and exposure systems were specially calibrated for portraiture and the whole apparatus conveniently folded up to slip into a jacket pocket.

Evans used the camera, with film donated by Polaroid, for a brief, intense period from September 1973 to November 1974, producing 2,500 images. He became enamoured of its direct and intimate abilities and its self-containment, which made the darkroom redundant. He concentrated on photographing his usual leitmotifs and quintessentially American subjects – small town façades, architecture, weathered signs, typography, street markings and nostalgic Americana. He had great fun with this new toy and liked the neat and compact intimacy of the 3⅛ x 3⅛in image size, but warned that "nobody should touch a Polaroid until he's over 60",[3] as the camera's instantaneous capabilities could only be fully exploited after a lifetime of photographic experience.

Evans's transmuted influence can be clearly seen in the work of photographers throughout this period who concentrated on the American vernacular, especially William Christenberry

ABOVE RIGHT How could Evans resist photographing this sidewalk ice-dispenser, the shape of a giant ice-cube itself, on a sunny day with the sun beating down directly on to the façade and casting dramatic angular shadows? The vending machine's shape perfectly fits the square format of the Polaroid SX-70, which Evans used with great delight between 1973 and 1974.

LEFT William Christenberry has known this corrugated green warehouse in Newbern, Alabama, since childhood and has photographed it annually since 1973 (here in 1978). In 1996 he also made a mixed media scale model of it, measuring 16 x 32 x 16in (40.5 x 81 x 40.5cm). Christenberry's interest in this beautiful vernacular building has helped to preserve it: its former owner, now deceased, left instructions that the building should be kept up and it is reassuring that one person's dedication can achieve this quiet triumph.

(b. 1936) and Stephen Shore (b. 1947). The 1970s and beyond were the decades when photographers used colour to shun conventional subjective themes and concentrate on less traditional subject matter. They redefined the mythical, heroic landscape as a contemporary reality, emphasizing the objectivity of a location. They showed the man-altered human environment, usually without any humans, developing a preference for social landscape that depicted everyday features of industrial and vernacular culture. This style, derived from a tradition of documentary photography, showed things as they actually were in a coolly observational and nonjudgmental fashion, presenting the ordinary and the banal – the life that surrounds us daily – as subjects worthy of interest.

Also working in paint, sculpture and collage, often incorporating found objects, Christenberry initially started to use photographs as aides-memoires for his paintings. His interest focuses more or less exclusively on Hale County, Alabama, and was influenced by his acquisition in 1960 of the book *Let Us Now Praise Famous Men*, published in 1941, which paired the photographs Walker Evans took in Hale County during the 1930s Great Depression with the prose of James Agee (1909–55). Encouraged by meeting Evans and their ensuing friendship, Christenberry set about photographing rural structures – churches, farmhouses, warehouses

LEFT Stephen Shore's photographs are balanced, harmonious and rhythmic; he uses light and shadow and juxtaposition of strong colours as an essential part of the composition. This clapperboard-style house, specifically documented as *Kimball's Lane, Moody, Maine* on July 17, 1974, draws its appeal from the graphic elements of symmetrical vertical and horizontal lines, offset by the diagonals of the leaning fence in the foreground.

and abandoned barns – returning again and again to document changes, decay, rust and patina. The work he initially showed Evans was made using a Kodak Brownie box camera. He moved on to 35mm Kodachrome, then in 1977, at the suggestion of Lee Friedlander, began to use an 8 x 10in Deardorff view camera, which enabled him to capture enhanced detail. Interested in beauty and the passage of time, the tension between past and present, Christenberry imbues his images with a great timelessness, their own intrinsic beauty and his own emotional history.

Stephen Shore received a copy of Evans's influential *American Photographs* (1938) in 1957. The precocious Shore had been given a camera when he was eight and took his first colour photographs in 1956. While still in his teens and using black and white, he worked with Andy Warhol and the Factory in the 1960s, and had the first solo photography exhibition by a living artist at the Metropolitan Museum of Art (MOMA) in New York in 1971. In the 1970s he began to make road trips driving around the USA and Canada, photographing in colour – first on 35mm, then on 4 x 5in and finally with an 8 x 10in view camera – and making contact prints from his large-format negatives. His photographs are formally composed, serious and considered portraits of contemporary America's social landscapes, altered by urban sprawl and other forms of human intervention in the environment. His work was included in the hugely

influential group show and catalogue, "New Topographics: Photographs of a Man-Altered Landscape", curated by William Jenkins at George Eastman House in 1975.

However, it is Eggleston's 1976 monographic show at MOMA, "Photographs by William Eggleston", which is generally regarded as the moment when colour photography was first warmly embraced by the art photography and museum world: this is in spite of the fact that MOMA had shown colour slides by Helen Levitt two years previously; and, as we have also seen, colour work by Saul Leiter, Ernst Haas, Eliot Porter and others had travelled and been shown worldwide over the previous decade.

There are many reasons for the dominance of this exhibition, not the least of them being the wonderfully eclectic and untoward eye of the photographer and his astonishing use of colour and composition. The 75 photographs on show were selected from a cohesive body of around 400 slides made between 1969 and 1971 and showed everyday images as if compiled for an album. Writing in the catalogue introduction, Szarkowski – with the resigned air of a man who had been made to sit through one too many family "film-shows" – stated:

"Those of us with a limited appetite for the color slides made by our own friends, pictures showing people and places that we cherish, may be puzzled by experiencing a deeper and more patient interest in the pictures of unfamiliar people and places that are reproduced here. These subjects appear to be no more overtly interesting or exotic than those in our own family albums, nor do they identify themselves as representatives of a general human

ABOVE Very few photographers make use of just one colour to account for the whole image. Before William Eggleston made this technique his own, it was probably last used in the 1930s by Edward Steichen and Madame Yevonde. The traffic-light palette of this double-page spread of yellow, red and green depends totally on colour and light – which is its magic – and the fabulous dye transfer process. Never has a sink and washing-up drainer looked so good as in this sun-drenched kitchen on Saint Simon's Island, Georgia, in 1978.

RIGHT The epitome of green and green-ness, the clever cropping of this 1973 image *Green shower, Memphis*, married with the gorgeous colour, makes this a precise and unforgettable image despite the soap scale on the tiles and the dirty grout between them. Eggleston said of the dye transfer print, "By the time you get into all those dyes, it doesn't look at all like the scene, which in some cases is what you want."

condition. They are simply present: clearly realized, precisely fixed, themselves, in the service of no extraneous roles. Or so the photographs would have us believe. In truth the people and places described here are not so sovereign as they seem, for they serve the role of subject matter. They serve Eggleston's interests."[4]

With its lively and provoking introduction by Szarkowski, *William Eggleston's Guide* was the first colour catalogue of a one-man show ever produced – and it should not be forgotten that the reproduction of colour photography was still a hugely expensive procedure and that this catalogue was a milestone. The exhibition later travelled widely throughout the USA and, perhaps most importantly, received a whole welter of publicity, much of it negative, which kept it in the public eye. The remarks made by the *New York Times* art critic Hilton Kramer upon reading Szarkowski's comments on Eggleston's "perfect composition" – "Perfect? Perfectly bland, perhaps. Perfectly boring, certainly" – have acquired the delicious status of modern myth.[5]

Eggleston was a natural and obsessive observer who used a colour cast which always seems vaguely threatening, unsettling, Hitchcockian. He had worked with colour transparency film from 1965, then colour negative from 1967. In 1973 he had begun to print his images as dye-transfer prints with glorious saturated colour and heightened contrast and in 1974, the photographic dealer Harry Lunn published 14 of Eggleston's dye-transfer photographs in a slickly-produced, limited-edition portfolio. He used a snapshot-style aesthetic of seemingly unreal colour and worked with a moderate wide-angle lens to exaggerate perspective.

ABOVE LEFT Eggleston said of his 1973 dye transfer print, *Greenwood, Mississippi: the red ceiling*: "[It] is so powerful that, in fact, I've never seen it reproduced on the page to my satisfaction. When you look at a dye-transfer print it's like it's red blood that is wet on the wall. The photograph was like a Bach exercise for me because I knew that red was the most difficult color to work with. A little red is usually enough, but to work with an entire surface was a challenge. It was hard to do. I don't know of any totally red pictures, except in advertising. The photograph is still powerful. It shocks you every time."

LEFT The dye transfer process was equally adept at introducing subtle gradations of tone and texture into an almost monochrome image, as here in Eliot Porter's *Victorian house, Lexington, Missouri*. During the late 1970s Porter travelled through Kansas, Indiana, Michigan and Missouri collecting images for a book published in 1981 called *American Places*, its title perhaps a homage to Alfred Stieglitz's An American Place gallery, which had given Porter his first break in 1938.

Overexposing his film by changing Kodak's recommended ASA ratings, he was able to intensify, monumentalize and enlarge the banality of the everyday colour snapshot until it reached a level where it elicited an emotional and aesthetic response from the viewer and began to look like art rather than snapshot. Eggleston had a remarkable ability to find beauty, and striking displays of colour, in ordinary mundane reality.

A quite different eye for colour was shown in later work by Eliot Porter who, by the end of the 1970s, was exhibiting regularly in a variety of commercial galleries and had become interested in photographing architecture, applying the same detailed scrutiny as in his previous work but in a more minimalistic way.

Where Porter is on the outside looking in, standing back, observationally, from his decaying Victorian doorway and noting eroded paintwork and unswept detritus on the front step, Joel Meyerowitz is familiarly ensconced in the house, on the inside looking out, a participant rather than an observer. Meyerowitz studied painting and medical illustration and worked

ABOVE This interior in the *Hartwig House, Truro*, near the tip of Cape Cod in Massachusetts, was among the first photographs Joel Meyerowitz took with his new large-format Deardorff view camera in 1976. He returned to the house again on future occasions, photographing from a slightly different vantage point. Flooded with light, the door half-opened (or half-closed?), the house beckons with its hint of mysteries and possibilities.

for four years in advertising as an art director and designer before concentrating full time on photography. Encouraged by Robert Frank, and captivated by the subtly poignant romance of the photographs of Eugene Atget (1857–1927), the "Balzac of the camera", he realized that he needed to be down on the street and involved in its life rather than observing it remotely from his office window, so he left his job for a life in photography. From 1962 to 1965, he photographed almost exclusively on New York's streets with Garry Winogrand, Lee Friedlander and Tony Ray-Jones, working rapidly in colour slide film, then black and white with a 35mm camera, relentlessly snatching transitory moments.

Although preferring colour, printing from colour transparencies was still a hassle; however, he returned to colour in 1973 and began to print his own. Finding 35mm colour film too grainy, like Christenberry and Shore, he invested in an 8 x 10in Deardorff view camera that weighed 20kg (44lb). This necessarily slowed down his work, replacing the rapid immediacy of a 35mm hand-held camera with the considered reflection and composition required by

LEFT Meyerowitz's Cape Cod photographs are very much about weather, the inter-relationship between sea, sun, sky and wind and nostalgia for a place that was home to long-time residents, itinerants and the photographer himself. *Laundry, Provincetown* (1977) fills half the frame with blustery sky, the rest with billowing washing. The stripes of the sheets echo the lines of the clapperboard house and the orange/blue-grey juxtaposition is a favourite Meyerowitz colour balance.

BELOW For Meyerowitz dusk is a favourite time of day, when colours change and a limpid calm descends; a time the French call *"entre chien et loup"* (between dog and wolf). And pools are a preferred Meyerowitz subject. After the hubbub of activity in the harsh sunlight of the day, the empty pool at dusk – as here in 1977's *Pool/Palm, Late Gate, Fort Lauderdale, Florida* – becomes a different, magical world; a contemplative study in tranquil tones and unruffled reflections, shot through with the soothing rose-violet glow of sunset.

a large-format tripod camera (although he never stopped using 35mm). Meyerowitz would wait for days for that perfect combination of light and colour values. "Photography is about description," he said. "I really mean the description of sensations I get from things – color, surface, texture – and by extension, my memory of them under other conditions, as well as their connotative qualities."[6]

Family vacations to Cape Cod, the haunt of artists, writers and fishermen, provided Meyerowitz with endless vast flat vistas of sea and sky. In response, his colour palette calms right down to one of sunny pastels, reflected light and a thousand shades of blue, while his images reveal a fascination with the ever-changing seas and scudding clouds. His book *Cape Light* (1978), which has sold more than 100,000 copies, evokes the special light and atmosphere of the place – this is not so much a landscape altered by man as a landscape in harmony with man, the two in equivalence. Even in interior shots, or those that do not show the sea, its elemental presence can be sensed, heard and felt.

ABOVE The sky is the star of *Cold Storage Beach, Truro*, occupying almost 90 per cent of the image. The bottom strip of beach, lifeguard station, sea and horizon, occupied by almost 100 tiny people dwarfed by the vault of the sky, seems to stretch into infinity. Those complementary colours that Meyerowitz uses so well are here toned down to a pale peachy orange and a hazy blue-grey.

Meyerowitz returned to his New York roots, and an earthier New York colour chart, for his *Empire State Building* series of 1978, in which the building puts in a cameo appearance in each image in some form or other – as a shadow, a reflection, a partially glimpsed sliver down a canyon between high-rise buildings. With hindsight, this documentation of a particular building, its location and effect on the human environment, eerily presages Meyerowitz's post-9/11 work at Ground Zero in New York (see Chapter 10, p.214).

John Pfahl (b. 1939) and Richard Misrach (b. 1949) both came to colour photography in the 1970s, their work concerned with man-altered landscapes and the human imprint on nature, using an

ABOVE John Pfahl's *Kaanapali Coast, Maui, Hawaii*, has the unreal quality of an image projected on a wall rather than a real view seen through a window. The rest of the room is in darkness, suggesting a *camera obscura*, and the yellow-gold curtains add to this reading.

unsettlingly artificial colour palette. Pfahl's early work is largely concerned with formal structure and geometric shapes. His *Picture Windows* series (1978–81), in which the internal room is like a gigantic camera eternally focused on the external view, shows nature seen and neatly interpreted, rather than experienced, through a window frame acting as an architectural viewfinder and compositional device. Misrach does the very opposite, filling the frame with a chaos of complex abstract and impenetrable forms that we can interpret as we will. His use of artificial strobe lighting at night distorts the colour balance and renders the whole scene disturbingly unreal. After working with colour on his *Hawaii Portfolio* in 1978, Misrach never worked in black and white again.

LEFT Richard Misrach's intense night-time strobe lighting and large-format negative highlights the detailed abstract patterns created by dense tropical vegetation and depicts them in intense and hyper-real colours, which are further emphasized when printed as dye transfers. It is as if he is experiencing a different, unknown side of nature at a time when it expects to be unseen and undisturbed.

BELOW Jan Groover's series of kitchen still lifes are largely untitled, just numbered. This one, no. 78.4 from 1978, shows her trademark dense and tightly bound composition, the dulled, smooth sheen of the Japanese stainless steel cutlery highlighting the succulent juicy roundness of the orange/gold Conference pear with its coarsely textured skin.

When photography first began, there was still life, *nature morte*; this has been a salient theme throughout the medium's history and has remained a favourite subject for colour photography, not least in Jan Groover's reworking of the genre. Trained as a printer, Groover (b. 1943) was an abstract artist teaching painting in the 1970s when she exchanged her paintbrush initially for a 35mm camera, then a large-format plate version. She constructed her complex kitchen-sink dramas with everyday insignificant household items – fruit, vegetables, plants, cutlery, cooking tins and moulds – then arranged them in kaleidoscopic density with glass, stainless steel, aluminium foil, water and mirrors to produce multiple reflective and refractive surfaces to intrigue, confuse and seduce the eye.

Her work makes visual references to Edward Steichen's advertising photography and Edward Weston's intense studies of form, with an element of 1930s' Constructivist geometry and Formalist volume. Groover also acknowledges a debt to Cézanne. But these images are wholly her own and unique in inspiration, construction and realization. The effect of juxtaposing cold,

ABOVE The leaves of favourite household plants – spikes of mottled-green striped sansevieria and dramatically patterned coleus and caladium in pinks, dark greens and whites – are merged with the silvery reflective glow of cutlery, background glass and water. Groover creates images that are as abstract as they are concrete, as natural as they are unreal, as authentic as they are illusory.

pressed steel, sinuous pronged forks and jagged edges with soft organic and lushly sensual plant forms, curved spoons and glass bowls is further enhanced by the strong variations in colour rendered through the myriad reflections in her tightly controlled and composed constructions. Printed as larger-than-life 16 x 20in (40.5 x 51cm) C-type prints, these images illustrate Groover's consummate craftsmanship and supreme colour dexterity.

As with still life, exploration of the self was not a new photographic genre but was to assume growing importance in the 1970s, becoming one of the dominant themes of photography over the next 30 years, especially in the work of Cindy Sherman (b. 1954, see Chapter 9, pp.188–89). The launch of the Polaroid SX-70 in 1972 meant not only that Walker Evans could, in his sere days, use it very happily for its "straight" immediacy, but that Lucas Samaras (b. 1936) could use its manipulability, seemingly rather less happily, to further his obsessive exploration of his own psyche, the subject and core of all his work.

Samaras was already a successful sculptor, painter and performance and multimedia assemblage artist when he started to use peel-apart negative/positive Polaroid 360 in 1969

RIGHT A disturbing image from July 6, 1976, in which Samaras seems to be in the act of beheading, or has already beheaded, himself. Energy and violence are suggested by the diamond shapes that spring from his body, emphasizing the frenzy of the attack. The domestic setting of the image renders the violence especially incongruous.

for his multiple exposure *Autopolaroids.* These mostly concentrated on his anatomy, bodily functions, disguise and sexual transformations. The malleable wet dyes of the new SX-70 prints allowed time for manipulation as the ejected positive image developed in available light. Samaras worked on the surface with erasers, pins, paint and other tools. By these means, and using double exposures, he could create distorted, mutilated, frequently funny and often grotesque and shocking images that he called *Photo-Transformations,* with himself as the human chameleon or Proteus who could seemingly change shape, colour and form at will; this was perhaps not the use Polaroid had envisaged for their product but it was one that the company embraced. Psychologically fraught, these images show the internal struggle between conflicting aspects of Samaras's personality: self-loathing and self-love, youth and age, birth and death. Transforming the Polaroid technology mirrors the transformation of self; both medium and subject have undergone a metamorphosis.

Samaras's unpretentious New York apartment was also his studio; the very mundane domesticity of the kitchen setting, with refrigerator, cooker, radiator, pots and pans in the

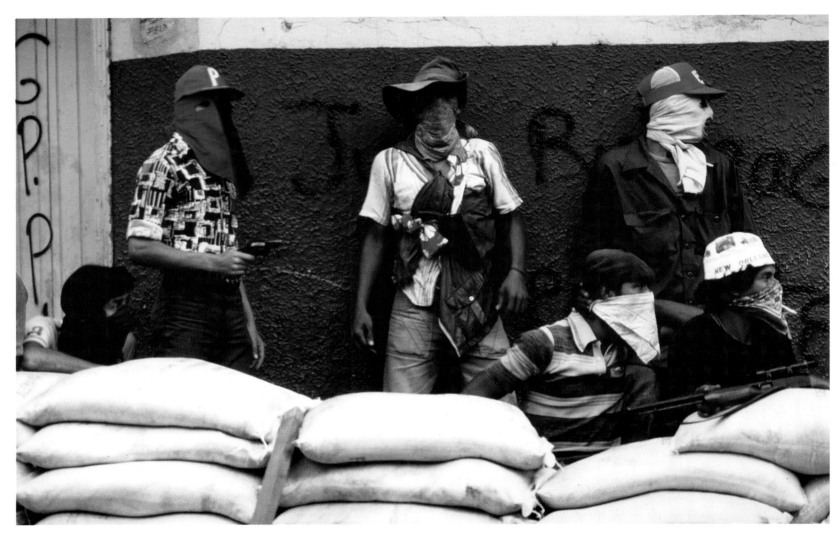

background and black and white vinyl tiles on the floor, somehow intensifies the strangeness of his vision, as do the bright boiled-sweet/traffic-light hues that Samaras achieved with coloured lights. All tightly framed and contained in the just over 3 x 3in square of jewel-like Polaroid, the content rages to escape from its confines.

Samaras's *Photo-Transformations* are more immediate, more communicative than his black and white *Autopolaroids* because their eclectic use of colour gives them humanity. Colour, specifically, puts us in closer touch with people in the photographs and makes them more real than their black and white counterparts. Although some of Magnum's earliest members – George Rodger, Werner Bischof and Eve Arnold – had worked in colour since the 1940s and early 1950s, the 1960s had been largely the decade of black and white in photo-reportage. It was not until the 1970s that an increasing number of photojournalists began to use colour in their documentary work in such a way that they took its remit beyond documentary.

In her coverage of the Sandinista uprising against the repressive government of President Somoza in Nicaragua from June 1978 to July 1979, Susan Meiselas (b. 1948) – who joined Magnum in 1976 – used both black and white and colour; but it is the colour images that stay with us. There is a tough balancing act between the horror of the situation and the beauty of

ABOVE Susan Meiselas's 1978 photograph shows the Sandinista "Muchachos" awaiting counterattack by the Guard in Matagalpa. Her sympathetic photographs of the insurrection and political struggle in Nicaragua, previously ignored by most of the world's press, helped to bring the conflict to public attention. The middle figure, who faces the photographer directly while the others look to their left, seems to be bracing himself for the click of a gun rather than a shutter.

the colours in the memorable composition of Meiselas's photographs, as there was in Larry Burrows' a decade earlier – can anyone so colourfully dressed really be intent on killing?

Eve Arnold's five-decade career in photography with Magnum sent her around the world several times as well as in and out of Marilyn Monroe's orbit. The photographs in her book *In China* (1980), taken after Mao and the Cultural Revolution had gone but before McDonald's and China's booming economic miracle had arrived, show the country and its people at a turning point in their history. As she was one of the first Western photographers allowed into the country, her colour landscapes and portraits – which represent some of her most lyrical, tender and sympathetic work – helped spread a new awareness of China in the West.

Despite working as a colour consultant in Hollywood in the 1950s and 1960s on films such as *The Greatest Story Ever Told* (1963–65) and as director of the prologue of *Khartoum* (1966), Eliot Elisofon continued to visit Africa on nine separate and exhaustive photographic assignments. There is a particular joy and sense of belonging in Elisofon's African colour work that truly comes from the heart. With his background in painting, he knew how to use colour to create intensity, emotion and meaning. He eventually bequeathed his African art collection and his photographic archive of 80,000 black and white prints and 30,000 colour slides to the

ABOVE Eve Arnold photographed these children in the nursery of a cotton mill in Beijing, China, in 1979. They appear to be intently watching something and, apart from the little girl third from the right, they seem unaware of Arnold's presence. Although not a particularly happy-looking group, their linear formation and brightly-coloured clothing make for a charming image.

LEFT The plastics section of an African market will always be a colourful one, as here in Ibadan, Nigeria. Eliot Elisofon contrasts the bright oranges, greens, blues and pinks of the gaudy plastics with the subtler colours of the girl's dress and the drab brown of the earth and buildings.

RIGHT In Elisofon's archives, held at the National Museum of African Art in the Smithsonian, there are many versions of this image from March 1972; they mostly focus on the colourful stripes of the sleeping woman's dress, as she lies among the coils of rope and bunches of plantains on the deck of a steamer heading to Kinshasa in the Democratic Republic of Congo. In this particular shot, one child makes eye contact with the photographer.

RIGHT Raghubir Singh's photograph of a pilgrim resting against Singh's red Ambassador car during the 1977 Kumbh Mela festival in Uttar Pradesh in northern India is a well-known image, but still exemplifies the fact that red is the colour that photographs best, especially when illuminated, as here, by bright sunlight. The pilgrim has found a moment of peace and calm during a festival that was attended that year by ten million visitors.

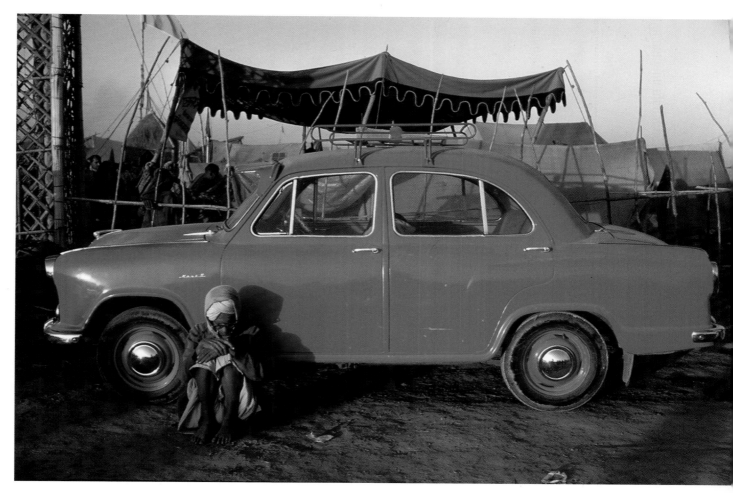

Smithsonian Institution.[7] Browsing through his images online and watching his photostories unfold (both the images reproduced here are part of much larger surveys of African markets, a subject he particularly loved) is a richly rewarding experience in two senses. Elisofon's archives teach us a lot about Africa and its peoples and also about how to use colour cogently to convey heart and soul. He wrote:

> "For me color film is neither reality nor romanticism. It is far from ideal.... Color in still photography and the motion pictures has simply been accepted because it was there, without control. I can't understand why.... Color, just as any visual aspect of photography, must be consonant with the subject. This is of key import."[8]

These are sentiments that are also dear to the heart of Raghubir Singh (1942–99). Despite his love of Cartier-Bresson's black and white work – they had met in 1966 when the latter was working in India – Singh knew that India *must* be photographed in colour to reflect its remarkable resilience and vitality. From somewhere he obtained Kodachrome film, then neither sold nor processed in India. Born in Rajasthan, where colour was a way of life – "the eyes of India only see in colour" – Singh, in his all too brief career, produced a vast body of work that has a filmic quality; the vibrant colour and the organization and division of pictorial space in his photographs have taken them out of the realm of documentary photography.

Travelling around the country in a gloriously retro-styled Ambassador car (first produced in 1957 and for many years the only mass-produced car available in the country), he made the car the star, the leitmotif, in his unsentimental and dramatic images, using splashes of exotic and pulsating colour juxtaposed with the muted tones of the country's baked earth. He used the physical aspects of the car – the doors, the rear-view mirror and the windshield – to fragment and divide the space in his images, using the car like a focusing device.

Colour photography could, and would, now be used for everything and, over the next two decades, it would explore avenues undreamed of by black and white.

9 COLOUR IS THE NEW BLACK (AND WHITE)

1980–1989

In the 1980s the arts world took on a Postmodern cast and the importance of photographic practice gave way to modern theory and critical debate – a hotly and often painfully intellectualized academic debate rather than a readily appreciated or understood populist one. The most important Postmodernist themes and issues were appropriation, identity politics, startling inventiveness, gender representation and self-absorption, and in the decade of increased AIDS awareness, exploration of sexuality, straight, gay and permutations thereof. There was a growing emphasis on artists *choosing* to use photography – as they could choose to use paint, stone, textiles – rather than submit to the straitjacket of nomenclature and declare themselves photographers. An increasing number of women, radicalized, energized and freed by the concepts of feminism, and given ownership over their own bodies and sexuality by two decades of the Pill, began to explore these same bodies, using them as catalysts for cultural commentary or as an element in constructed narratives.

Colour photography was now as much about representing the future direction of photography as it was about colour per se. This was an interesting dichotomy in the decade that, in 1989, saw the 150th anniversary of the invention of photography, an event that was celebrated in museums worldwide. Very few of the major retrospective exhibitions and accompanying weighty catalogues featured much colour photography, placing full retrospective emphasis on monochrome. There were a few early autochromes here and there, a little recent colour from the 1970s and 1980s, but nothing from the mass of colour photographs made in the eight intervening decades. And this given that colour had been around for well over half of the 150 years being celebrated.

Many museums with tight acquisition budgets were tardy in collecting colour photographs as they presented a whole new set of collection management, preservation and storage problems. Knowledge of photographic conservation and preservation was still in its infancy at the time, with perhaps fewer than a couple of dozen photographic conservators practising worldwide. Most colour prints and transparencies, with the exception of the archivally permanent tricolour carbros and dye transfers of the 1930s and 1940s and later processes derived from them, were an inherently unstable chemical cocktail that faded and yellowed at normal temperatures and humidity, even if kept in the dark and away from pollutants. The need to preserve colour material by housing it in cold storage or freezer units created extra pressures on cash-strapped, space-poor collections.

RIGHT There is a great exuberant love of colour, its purity and its visual triumph in John Batho's work. Colour provides the subject, substance and structure of his images. In its abstraction, Batho's work resonates more with the work of the European avant-garde of the 1930s and '40s, such as that of László Moholy-Nagy, than it does with the subjective documentaries and gender politics of the post-industrial climate of the 1980s.

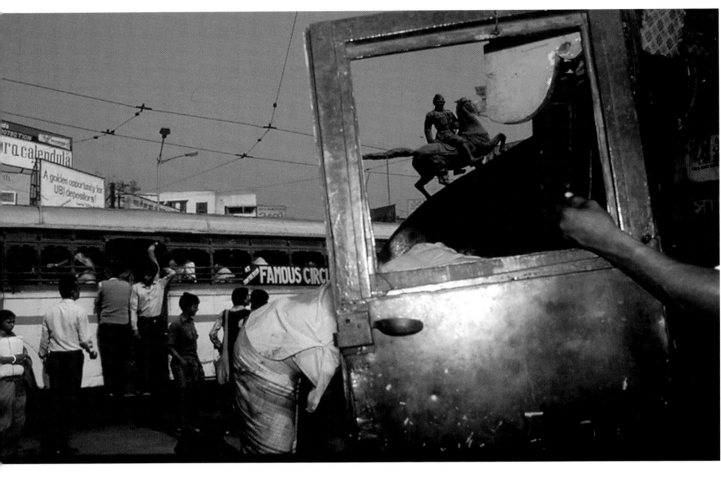

From 1983, the advent of electrostatic, inkjet and later dye-sublimation prints, with variable and often unknown but generally poor light-fastness, only increased the problems. The fear of hanging colour photographs in an exhibition, only to see them fade later, was one that gave many curators sleepless nights. Although the new Cibachrome II (later renamed Ilfochrome) print and transparency materials, launched in 1980 and incorporating new chemistry and a silver masking layer, promised greater permanence and were used by many photographers, dye-transfer prints were often specifically made at the request of curators for museum collections.[1]

If the museums were failing to collect and show colour photography as rapidly as they might wish, or were able, an ever-increasing number of galleries were filling the void and Europe was beginning to catch up with the USA. The first one-man exhibition of the photographs of John Batho (b. 1939) was held at the Paris branch of New York's Zabriskie Gallery in 1978. Batho's work is joyous and revels in pure rich colour and its representation, with a passion. This is especially true of the gloriously giddy movement of whirling, riotously coloured fairground rides of his series *Les Manèges* (1978–82). Refreshingly, autochromes and Ernst Haas's work are mentioned as influences. Batho often used the exquisitely beautiful Fresson process – a charcoal and pigment-based method giving dense saturated colour, great luminosity and real permanence. Primarily interested in the sensation of colour and considering it part of the very being of things, Batho has famously quoted Cézanne: "*Quand la couleur est à sa richesse, la forme est à sa plénitude.*" ("When colour is at its richest, form is at its fullest.")[2]

Batho is interested in form and colour, Raghubir Singh in people, environment and colour. In his photographs people have a benign and apposite presence and contribute their own beauty, their own sense of belonging and interacting with the dense urban cityscape. One of the main focuses of photography in the 1980s was to be the search for a definition of human effect, by presence, by interpretation, by fiction, by comparison or by absence.

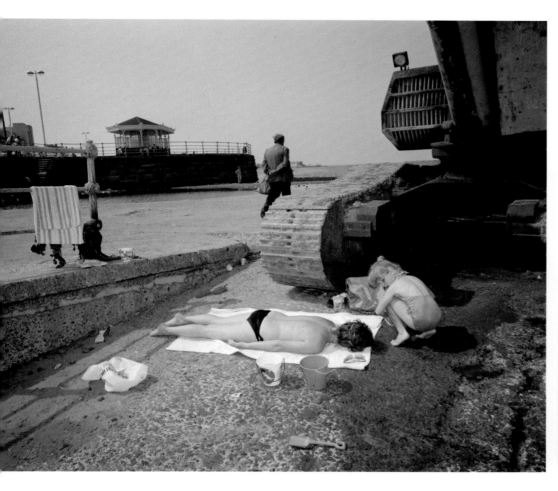

Martin Parr (b. 1952), seemingly the "love-child" of John Hinde, Tony Ray-Jones and William Eggleston, and also described, in rather overblown fashion, as the direct British satirical descendant of Hogarth, Gilray and Rowlandson, developed a visual language all his own, intrinsically like none of the above but yet with elements of all. Over the past 20 years, through his exhibitions, publications, TV appearances and teaching, Parr has had more influence than any other British photographer since Bill Brandt. And, unlike Brandt, Parr is a homegrown species. His teaching at West Surrey College of Art and Design in Farnham and at the University of Wales over the past two decades has led to a proliferation in the use of colour photography in the UK, as has his full membership of Magnum since 1994. Parr achieves his high colour saturation by using ordinary amateur film: Fuji 400 Superior for a 6 x 7cm camera and Agfa Ultra or Fuji 100 ASA film for use with a macro lens and ring flash.

Whether one loves, hates or is indifferent to his work, Parr's profound influence is undeniable. His earlier 1970s black and white documentary work in the north of England and Ireland now seems charmingly and romantically nostalgic in an almost *Picture Post* tradition compared with the radical difference in his work since he switched to colour full time in 1982. Parr himself freely admits:

> "The practice of colour and the practice of black and white evolved separately up until the eighties. Today the two are merged.... Why regard photographers working in colour in isolation? There is no longer any reason to see any kind of difference whatsoever.... What is odd is that, when you see a black and white photograph, it doesn't look like the real world; it is an interpretation. In this sense, black and white is unusual whereas colour is quite simply normal."[3]

Thatcher's Britain in the 1980s – with its "Me" generation whose main concerns were for class, consumerism, materialism and social fragmentation, resulting in a spiritual vacuum rather than any sort of integrated attempt at creating a more equal and caring society – was the perfect hotbed for Parr and his "New Documentarist" contemporaries, Peter Fraser (b. 1953), Paul

ABOVE LEFT Martin Parr's "breakthrough" exhibition "The Last Resort" was shown at the Serpentine Gallery in London in 1986. Parr had emphatically adopted colour photography when he returned to Thatcher's Britain after two years of a more rural monochrome dalliance in Ireland. He bought a Plaubel medium-format German camera with high definition and, wearing his middle-classness like invisible armour, began a series of colour projects driven by his intense curiosity.

ABOVE RIGHT Parr, the perennial outsider, is always watching. Like Eliot Porter, he comes from a family of amateur ornithologists and close forensic observation is second nature to him. He has always been fascinated with what people eat and this hot-dog shop from "The Last Resort" demonstrates a peculiarly British unease with food: it is seen as something to be consumed without obvious enjoyment and by stealth. There is not a single smile in the whole picture.

Untitled # 96 of 1981 from the *Centrefolds* series shows a young freckle-faced and flat-chested teenager clutching a torn-out bit of newsprint from the Personal Ads columns. Is she in a state of shock or bliss? In her orange gingham skirt and T-shirt, she almost blends into the similarly coloured vinyl kitchen floor. Even her face is orange in this tightly composed and restraining composition in which she seems imprisoned.

Graham (b. 1956), Paul Reas (b. 1955), Chris Steele-Perkins (b. 1947) and Chris Killip (b. 1946). Using medium-format cameras, wide-angle lenses, electronic fill-in flash, tilt-framing and, most importantly, colour film (for most of them), they explored British class prejudices and vanishing social values with disarming realism. The harsh, brash flashlit colour palette echoed that of the brightly coloured postcards produced by John Hinde's company (Hinde was last seen in Chapter 5 photographing World War II in colour), which Parr avidly collected.

Parr's first published body of colour work *The Last Resort* (1986), shot over three years in the worn-out and rundown working-class northern seaside resort of New Brighton near Liverpool, seemed shocking at the time and his taste for the commonplace was variously described as cynical, cruel and exploitative of his subjects' lives; or conversely, realistic, reflective and sympathetic to his subjects' lives. Its depiction of a sun-starved population throwing itself with near-naked abandon at a distinctly unglamorous seaside experience with all its trashy, tawdry trappings would appear, perhaps, faintly amusing and "quaint" if shot in the more objective black and white. Colour, concentrating subjectively as it does here on expanses of almost obese lobster-pink, overexposed flesh courting melanoma, conveys the giddy holiday excitement and the occasional quiet and tragic desperation, boredom and malaise inherent in the attempt to try to experience "a good time" in such an environment. In retrospect, it becomes a strangely touching body of work because it seems, despite everything, "a good time" is being had by the majority.

During the late 1970s, many conceptual artists picked up a camera for the first time and turned it upon themselves, not in the accepted format of self-portraiture but as a vehicle for performance art. There are probably more photographs of Cindy Sherman (b. 1954) than of any other artist in photography collections worldwide, but none of them is an actual portrait of *her*. From 1977, using wigs, make-up, clothing and relevant backgrounds, she featured

Untitled # 123 from the 1983 *Fashion* series, in which Sherman wears Dorothée Bis, she seems ready to climb out of the frame with her coiled coquettish pose and suggestively leering come-hither smile. The dramatic raking light contributes to the disturbing quality of the image.

herself, acting as director, photographer, actor and model in a series of *Untitled Film Stills* in black and white. Appropriating, recreating and responding to stereotypical and clichéd female characters from TV and B-movies with whom the viewer/voyeur could identify and on whom they could project their own narratives and fantasies, she renders her own persona nonexistent in the creative process. Sherman creates private performances for herself. She becomes a fictional someone else, photographs the transformation and then ceases to be that person. Her photographs do not have titles to render them subjective, but are merely objectively numbered within each specific series.

Moving on to colour in the 1980s, Sherman was commissioned (although the images were never published) by *ArtForum* magazine to explore and explode the conventions of the double-page centrefold pin-up. She also worked on fashion advertisements for Issey Miyake, Dorothée Bis and other designers, using the clothes for the advertisements and then in her personal work. Later series of work, the grotesque *Disasters/Fairy Tales* (1985–89), *History Portraits* (1988–90), and *Sex Pictures* (1992), the latter using prosthetic body parts and dolls, would suggest a nod back to Hans Bellmer in the 1930s. Her work inhabits an uneasy place, acknowledging as it does the necessary inter-relationship between the voyeur and the viewed.

Ellen Carey (b. 1952) and Helen Chadwick (1953–96) explore the revelation, or obfuscation, of the self in different ways. Carey's many variations on self-portraiture over two decades are fascinating. Initially, she applied swirled acrylic and ink to black and white gelatin silver photographs, relying on colour and abstraction to convey her symbolism while also obscuring and concealing her face. She also uses optical distortion to flatten the facial planes. Mondrian and Man Ray seem likely influences. Later work uses Polaroid film, multiple exposure, a fragmented face/body image and an overlay of fractal geometric patterns recalling 1960s psychedelia to communicate an alienated identity. Carey, a picture-maker rather than

ABOVE Ellen Carey's physical intervention in the mechanics of image-making as well as her visual presence can be seen in her work, interested as she is in "chaos theory, fractal geometry… symmetry and asymmetry as found in art, nature, science and mathematics". She uses physical manipulation – the hands-on materials, tools and techniques of photography – as primary agents, thus the malleable Polaroid is a natural medium for her.

a picture-taker, seems to present herself as the Queen in a pack of geometric playing cards in her 1986 Mannerist Polaroid self-portrait. Recent work on large-format Polaroid and as cameraless photograms has become completely nonfigurative, relying on colour alone (see Chapter 10, p. 247).

Helen Chadwick frequently used her own naked body, its functions and fluids, both as subject and as object in her original and intensely personal work. She questioned and confronted conventionally held ideas and debates about the place of the human, especially the female, body in society but broke this down into often interlocking explorations of flesh, gender and sexuality. Always embracing new technology with fervour, a supple imagination and enthusiastic immediacy, she used the new colour photocopiers, large-size Polaroids, computers and electron microscopes almost before they were unpacked from the box. For her series of *Meat Abstracts* (1989), she allied the acknowledged and accepted beauty of fine leather, deep-pile velvet and rich, lustrous silk in jewel colours with the unacknowledged beauty of vital internal animal organs – offal such as tripe, kidneys, hearts, livers, tongues. These compositions of a glowing light source and animal innards – the heaven-seeking light of the soul and the earth-grounded meat of the flesh – are simultaneously beautiful and unsettling. And how much of their challenge and message would be lost in black and white.

Personal representation and reinvention came in many forms in the 1980s, a decade in photography that often took itself far too seriously, and with far too much tedious political infighting. What was needed was humour and, luckily, there were photographers who were

ABOVE Helen Chadwick's early death robbed the art world of a boundary-smasher, a shibboleth-breaker, a woman unconscious of risk and deeply aware of beauty. She established harmony and balance in unlikely combinations, found colour and texture in surprising places and created splendour in unexpected juxtapositions in order to convey her thoughts on art and life.

LEFT Bernard Faucon's memorable work made 1980s photography more fun with its blend of witty irreverence, elegant style and vivid colour. Working with an eventual supporting cast of 83 mannequins, just a few of which are seen here in 1980's *Diabolo Menthe* (*Peppermint Soda*), he achieved a cult following in Japan but gave up photography in 1995: "because I was convinced that it was over, that the period of the history of photography I had belonged to, 'staged photography', was the swan-song of photography, the last stage before the reign of pure image, digital, commercial".

BELOW Calum Colvin's Old Masters' classics reclaimed for the twentieth century included works by Botticelli, Bosch, Rubens, Titian and here Ingres' *Turkish Bath* in 1986. Painstakingly produced with chemistry, sculpture and paint in an era before digital photography, Colvin's photographs have been described as "a Babel of iconography" where the bitter realism of Surrealism is merged with the legacy of the "pop" generation.

able to show wit and absurdity in their work by fabricating fictions and constructing narratives. Bernard Faucon (b. 1950), Calum Colvin (b. 1961) and William Wegman (b. 1943) seemed to have no malevolent axes to grind. Working on the series *Les Grandes Vacances* from 1976 to 1981, Faucon would load up his Citroën open-top sports' car with a selection of blonde, blue-eyed shop-window dummies and drive around the Luberon area of Provence positioning them, alongside live boys, in natural settings and remembered convivial scenes from his idyllic childhood. Faucon's images, about the nostalgia of desires and the perfection of a recollected moment, cover many themes from classical to surreal. They are printed as exquisitely beautiful Fresson prints, which emphasizes their appeal. The photograph above may be the last taken in the *Les Grandes Vacances* series, anticipating the start of Faucon's next series, *Évolution Probable du Temps* (1981–84), which involved explosions and flames. Faucon eventually presented his dummies to the Nanasai Company mannequin collection in Kyoto, Japan where, it is rumoured, they are very happy.

Calum Colvin, initially a sculptor who went on to embrace painting, photography and now digital imaging in his work was, like Martin Parr, one of the young British turks in the 1980s, and is now Professor of Fine Art Photography at Dundee University. His work uses complex installation and surrealism to explore ideas of national identity, sexuality and aspects of contemporary culture. He built kitschy 3D room sets, extremely time-consuming and intricate constructions, initially recreating images from the history of art, but later from mythology, the Bible, ornithology and Scottish history. Filled with everyday items and found objects, living-

LEFT William Wegman's 1981 Polaroid of *Ray and Mrs Lubner in bed watching TV* is a reconstruction (with dogs of course) of a scene in a sketch from the cult American comedy programme "Saturday Night Live". Wegman used his dogs as Faucon used his mannequins, and Colvin his three-dimensional objects and two-dimensional painting, to create a Surreal world but one still rooted in a non-digital reality.

room sofas, Formica-topped tables and standard lamps, and quite often infiltrating an Action Man wearing a kilt into the composition (a Colvin signature), he would paint a two-dimensional image in anamorphic distortion across the installation so that the room became part of the image, the image part of the room. The whole lot would then be photographed and printed at large size on glossy, jewel-bright Cibachrome.

The 1980s was the time when photographs began to be printed at ever larger sizes, becoming "wall art", or were presented as diptychs and triptychs to occupy the maximum amount of wall space. In 1977 Polaroid built their first 20 x 24in camera which produced 50 x 60cm (20 x 24in) prints, stood 1.5m (5ft) tall and weighed 106kg (48lb). It was used by many photographers, but perhaps none so successfully, so lucratively, nor so amusingly as William Wegman. A conceptual and fine artist who began to use photography and video for his work, Wegman bought his first Weimaraner dog, Man Ray, in the early 1970s while teaching in Long Beach. The rest, as they say, is history. After Man Ray's demise following a 12-year collaboration, in 1986 Wegman acquired the female Fay Ray whose puppies and grandpuppies also romped delightfully through his work. The infinite quizzical patience, extreme elegance and smooth, silky beauty of the dogs, draped in a dizzying array

ABOVE LEFT Robyn Beeche was introduced to India, where she now lives, by the artist, sculptor and designer Andrew Logan. Logan's amazing and desirable jewellery using broken mirror glass, holographic eyes and sumptuous settings, is here modelled by Scarlett, a well-known model in the 1980s, who has replaced her trademark chicken's feet earrings with examples from Logan's Burma range. Beeche's image shows a strong and confident grasp of colour dynamics, yellow against yellow, allied with the effect of the jewellery's texture and sparkle.

ABOVE Beeche also photographed fellow Australian, performance artist and exhibitionist Leigh Bowery, but it was Fergus Greer who photographed Bowery and his many extravagant personas regularly from 1988 until his AIDS-related death in 1994. Bowery's stated aim, "to be the Andy Warhol of London", was aided by Greer's chronicling of his reworkings and mutilations of his body and obsessive self-representation. Bowery was also a frequent nude model for Lucian Freud, whose paintings show him in a gentler light.

of costumes enacting fantasies and surreal naratives, is juxtaposed with Wegman's dramatic and confident use of bold Polaroid colour, the whole shot through with wonderfully benign humour.

Wegman became expert at using the tropes of fashion and beauty photography to reveal character and narrative, making his Weimaraners into four-legged performance artists; in London, with the evolution of the New Wave/New Romantic fashion, club and music scene, anyone could be their own performance artist. Robyn Beeche (b. 1945) moved from life as a fashion, beauty and celebrity photographer in the mechanistic London of the 1980s, working with Zandra Rhodes and Vivienne Westwood, to a more spiritually fulfilling life documenting yearly rituals and festivals in Vrindaban in India, which she had first visited in 1982. Her bold and confident use of colour, honed in the fashion world, was put to a worthier purpose in her later work. Fergus Greer seems to have photographed everyone from Vivienne Westwood to Bill Gates, Imelda Marcos to Margaret Thatcher; there is no doubt that colour was mostly a necessity when photographing the exotic and esoteric costume creations of Leigh Bowery.

In sharp contrast to the hedonism of the London club, music and fashion scene, the exploration of fractured self and the ensuing oxygen of crazy publicity, two European

photographers – Franco Fontana (b. 1933) and Keld Helmer-Petersen (b. 1920) – used colour photography in an altogether quieter fashion. Although Fontana has photographed around the world, and has turned his camera on urban landscapes in the USA, swimming pools and nudes and most recently a series (*Asfalti*) in which he has concentrated on small markings on road surfaces, he is best known for his natural landscapes. Fascinated by form and colour, he rarely lets people invade his images, unless they fulfil a particular colour or compositional function.

Keld Helmer-Petersen kept people out of his images altogether as he photographed the industrial areas around Copenhagen in Denmark. His work is abstract, modern, clean and formal. In the late 1940s, he briefly studied at the Institute of Design in Chicago and abosorbed the spare and minimalist aesthetic taught by Moholy-Nagy and Siegel. In 1948, he produced his first book of colour photographs, *122 Farvefotografier* (*122 Colour Photographs*), which showed his sharp eye for colour and form; on November 28, 1949, his "camera abstractions" were reproduced in *Life* magazine.

ABOVE Franco Fontana pares his landscape images down to their spare core, using abstract blocks of colour to tell his story and eliminating everything that could cause a visual disturbance in the harmonious whole he seeks. He photographs Mediterranean and Adriatic horizons in their many moods, isolated in space and time. This 1983 *Mediterraneo* shows an inky sea with a glowing, almost nuclear, sky.

ABOVE Seen through Fontana's lens in 1982, Morocco becomes a grid of planes of sweeping colour and texture, punctuated by random olive trees. His photographs capture a world imbued with a profound romantic lyricism, a sense of belonging and being at one with nature. So strong is their appeal to the Italian psyche that he was awarded the signal honour of having his landscape photographs reproduced on a limited designer edition of Illy coffee cups in 1993.

RIGHT Since he started to use colour in 1948, the Danish photographer Keld Helmer-Petersen has aimed to make pictures that would work *only* in colour, and not in black and white. His spare and modernist images concentrate on the mundane and the everyday, as here in this 1982 electrical installation in blue and white which is reproduced in his book *Danish Beauty, 1972–1995.*

RIGHT Alex Harris, who studied with Walker Evans, began to photograph his neighbours' homes in New Mexico in 1980, switching to colour film and a view camera. He published a book of these portraits without people, *Red White Blue and God Bless You*, in 1992. The title comes from an inscription over carpenter Amadeo Sandoval's kitchen doorway, "I love my God, I love the Red, White and Blue and You. Red White Blue and God Bless You."

BELOW Eliot Porter's importance in the appreciation and popularization of colour photography since the 1950s cannot be overstated. For his Macau trips in the early 1980s, as well as his 4 x 5in camera, he also used 35mm, which, with its rapidity and flexibility, extended his vision, allowing him the spontaneity to photograph more immediate street scenes and people. Porter's immense archives are at the Amon Carter Museum, Fort Worth, Texas

The representation of human presence by its very absence became an increasingly strong theme in the 1980s. In old age, Eliot Porter first visited Macau in 1980 with his son Jonathan, a scholar of Chinese history, and on two later occasions, a trip which resulted in a book, *All Under Heaven: The Chinese World* (1983). Fascinated by the culture and history of the Portuguese colony and its people, Porter photographed landscapes, historic monuments, schoolchildren and street life but, from the almost 600 resulting images, it is his close-ups of the everyday, the accoutrements and ephemeral trappings of humanity and the jaunty use of colour, that are most striking. Alex Harris's (b. 1949) series of interiors of the homes of his Hispanic neighbours in northern New Mexico tell a similar story with innate dignity and a sense of sadness that the room is empty. Amadeo Sandoval is absent from his living room in Río Lucio but we know a great deal about the way he chooses to live his life, and his devotion to his adobe home, from the religious icons, the family photographs, the American flag and the colour schemes with which he embellishes and beautifies his living space. Harris captures

LEFT Robert Polidori's 1985 *Cabinet des Beautées* shows just four of the plump court lovelies, densely hung on a busily patterned wall in Versailles, while the right-hand side of his photograph shows a vista of endless rooms. Acres of polished parquet flooring and veined marble stretch into the distance, to a blank closed door at the end of the corridor.

BELOW Polidori's altogether starker and less richly coloured image of the ancient vestibule of Madame Adelaide's apartment at Versailles highlights her absence. One of the 10 children of Louis XV and Marie Leszczynska, Madame Adelaide lived at Versailles from her birth in 1732 until her rapid flight during the French Revolution of 1789.

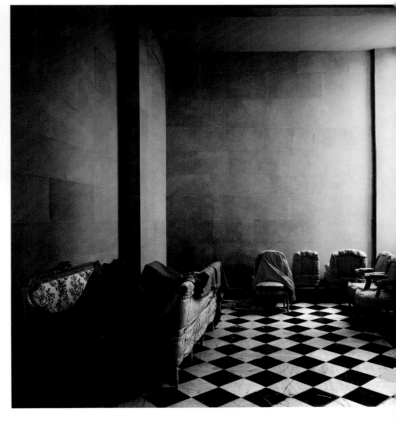

the true essence of the place, its inner life and memories, with his sympathetic and balanced colour palette.

Even such a glorious architectural creation as Versailles, steeped in history and intrigue, ritual and grandeur, cannot escape the melancholy of neglect, of long-silenced voices and hushed untrodden corridors. Robert Polidori (b. 1951) aims to find the true essence of a place, its inner life and memories: the emblematic moment when past and present coalesce. Describing his photographs as "metaphors and catalysts for states of being", he photographed the faded aristocratic elegance of Versailles during its restoration from 1983 to 1988. His subtly modulated colour palette with, here and there, flashes of exuberant red, gold and bright blue and raking sidelight, eschews nostalgia and suggests the seductive historical context of the place, the remnants and traces of magnificent ostentation, despite its current dusty disarray. He photographs hallways, back corridors, antechambers and unexpected glimpses through doorways, Vermeer-like in their photorealism and balanced composition.

ABOVE John Pfahl's mirror image of Three-Mile Island, shot in the weak springtime sun, conjures up a romantic pictorial Arcadia before debunking it. Pfahl's website gives interesting testimony to this. "I have frequently noticed that the electric power companies have chosen the most picturesque locations in America in which to situate their enormous plants... it sometimes seems that there is an almost transcendental connection between power and the natural landscape."

Man's physical absence but the dire effects of his interference and development is also a theme of two of John Pfahl's (b. 1939) series of work in the 1980s, *Power Places* and *Smoke*. His idyllic landscape on the Susquehanna River (above) adopts a pictorial aesthetic, with trees reflected in the placid water lit by pastel sunlight, to frame the seemingly insignificant cooling towers in the distance. In fact, the towers are those of Three-Mile Island nuclear power plant, just three years after the most serious partial meltdown to date in 1979. The message that industrial waste and pollution can be seductively beautiful is further emphasized by the glorious orange plume of smoke in the picture opposite, like a particularly magnificent sunset lighting a low cloud. Only the inclusion of the top of a chimney stack in the bottom left of the picture reveals that the glorious colour has a truly noxious source.

ABOVE Of *Smoke, Bethlehem #16, Lackawanna, New York, 1988,* Pfahl wrote: "By the simplest act of looking through the enormous telephoto lens of my Hasselblad, I thrust myself into a phantasmagoria of light and color. Simultaneously attracted and repelled, I feel myself engulfed in a truly awesome spectacle of nature…. Occasionally… the clouds come right at me and I become immersed in a lung-searing atmosphere of toxicity. I grab at my equipment and stumble back to the car, trying all the while not to inhale too deeply… this particular plant is first in statewide rankings of highly toxic emissions, discharging 1.4 million tons of benzene alone into the air each year."

ABOVE Ernst Haas's later close-up work is photographed "with the eye of a poet". The joy is in the detail and in the interconnection between the parts and proportions of the one wondrous whole that is the universe. His many studies of reflections in abalone shells, as in this 1980 shot, capture the glorious colours of nature, unadulterated by man.

LEFT A close-up of Californian hydrangeas is saved from the chocolate-box school of art by the bright red geranium petals that punctuate the soft pink, blue and mauve of the hydrangeas. Although it is Haas's flower photographs that seem to be most published by calendar producers these days, their undoubted pictorial appeal is balanced by their forensic detail.

Ernst Haas continued to work until his death in 1986, as a stills photographer on films such as *Heaven's Gate* (1981), photographing flowers and producing limited edition portfolios of dye transfers (1983) and travelling and working extensively in Japan. His lifetime's work on the theme of creation was never far from his mind and he continued to explore the natural world. In 1985, sponsored by the New Zealand Centre for Photography and by the Brooks Institute in Santa Barbara, he travelled to New Zealand where, working in colour, he achieved an almost black and white image of chalky hot bubbling mud at Waimangu Thermal Valley in Rotorua. It seems a rather pertinent full stop at the end of a life lived in colour.

ABOVE Haas's final book, *Focus on New Zealand,* edited by Magnum photographer Brian Brake, was published by Collins in Auckland in 1986, shortly before his death. It perfectly illustrates his belief in a natural spiritual ecology and a universe in which even the smallest thing has its destined place.

10 DIGITAL DIRECTIONS

1990–TODAY

Colour photography, like history, does not divide itself into neat, orderly decades, (even though for the purposes of this book an attempt has been made to do just that); nor do photographers produce a precise and finite body of work per decade, then change their style or subject matter when the year ends with a zero, although Edward Steichen perhaps came closest to this as he pursued ever-changing directions over half a century. Generally a famously long-lived bunch, photographers such as Ernst Haas, Eliot Porter, Madame Yevonde, Norman Parkinson, Eve Arnold and Steichen often have a 40-, 50- or even 60-year career. Some, like Tony Ray-Jones and Raghubir Singh, were around all too briefly. New photographic technologies evolved to enable ease and speed of use, cheapness, better lenses, ever-smaller cameras and the possibility of more manipulation. New colour photographic technologies each brought their own colour palette – the romantic pastel shades of the autochrome, the bright and vivid clarity of Kodachrome, the rich saturated strength of dye transfers, the vibrant jewel-like hues of Polaroid, the glossy intensity of Cibachrome.

Whether photographers aim to produce documentary, create art, explore the scientific or natural worlds or just use the camera, as we all do, to commemorate meaningful or random moments, they are all, to a greater or lesser extent, recording something that actually exists and is real. However, all photographs are a personal interpretation, a simulacrum of reality, and photographers have found ways to subvert and modify the medium's apparent but often questioned inherent truthfulness. By manipulating the colour chemically, adding paint or pencil, working on the emulsion and the negative, using double and multiple exposure, employing collage, constructing narratives, or with special effects of lighting, lenses and exposure, photography can be made to tell a multitude of stories. The expectations and challenges of the limits of available technology were constantly defied and overturned by inspirational, enterprising and inventive practitioners who found ways to wrench implicit meaning out of light, film and paper.

But if those limits were fully removed, if new technology enabled realization as vast as or vaster than one's imagination, in what directions would photography go then? It is estimated that by 2008, 82 million digital cameras will have been sold worldwide, outstripping film camera sales, and this figure does not include camera phones. Although digital cameras have been available since the 1980s, it is only in the past decade that the marriage of digital computer technology, image-manipulation software and desktop printers have evolved to replace film cameras and photography on paper with images made up of a string of digits, using information as its raw material. These can be viewed on a screen, sent around the world on the Internet or by phone or simply printed out in an ever-increasing variety of formats and at the touch of a "print" button. We can store thousands of images on a laptop the size of a magazine and unless we hit the "delete" button or lose the laptop, we have them forever. They will not fade, we will not lose the negatives, they can be viewed on the screen or printed out as fresh and bright as the

RIGHT Ruud van Empel's staggeringly emphatic Cibachrome images from his 2005 *World* series (this one is no.12) position a race of dramatically striking digital progeny in a tropical forest of Rousseauesque fecundity and surround them with the menace of rampant green digital vegetation.

day they were taken. With image-manipulation software we can seamlessly create assemblages of realities to produce unrealities that never existed. The boundaries have collapsed and now photography's basic objective veracities and descriptive authenticities have been replaced by subjective fictions and make-believe.

Before the 1990s, most photographers began their careers working in black and white; now colour is the medium of choice, black and white uncommon. It has actually taken colour photography just less than a century to reverse the positions. Colour is now the choice of most present-day media output – TV, cinema, newspapers, magazines, books and the Internet. So will digital photography eventually replace film camera photography totally? Is black and white antiquated and dead? Of course not. Despite dire predictions, TV did not replace radio, nor computers books. Videos and DVDs have not replaced cinema, e-mails and phone text messages have not (quite) replaced the gentler art of letter writing. In a hundred years time, someone may write a book on a century of "new" black and white photography.

Faced with the confusion of unlimited choice, some photographers have gone totally digital while others have preferred to stick with film cameras or combine the best of film and digital. The slick possibilities of the photographic technology of the future have, paradoxically, increased our interest in the complex techniques of the photography of the past. The huge growth in degree courses in photography in the 1990s, now teaching the history of photography that was deemed so drearily outdated, inappropriate and irrelevant in the Postmodernist 1980s, has encouraged long-overdue research into photography's first century as well as the rediscovery of hands-on nineteenth-century processes such as cyanotypes, platinum printing, gum bichromate and hand-colouring (see Chapters 1 and 3).

While there is a history of artists using photography, and photographers producing art, photography has increasingly been appropriated as a tool in the kit of contemporary artists, and is ever more frequently seen on the walls of major international art museums and sleek gallery spaces, and reproduced in high-quality books and dedicated magazines. As more people and institutions collect photography, and its market value increases in the limited edition art market and auction houses, its economic significance mirrors its growing cultural importance and acceptance as a vehicle for ideas. Photography fairs such as those organized by AIPAD (Association of International Photography Art Dealers, founded in 1979 with fewer than 20

ABOVE In his three-decade career, Martin Parr has produced over 50 books and catalogues of his work including limited editions. These practically human seagulls take pride of place in Parr's homage to one of his favourite and most rewarding subjects – the British seaside. The sleepy seaside town of West Bay in Dorset, southwest England, is immortalized in his limited edition (of 250) artists' book *West Bay*, published in 1997.

members and now with over 130), Paris Photo (1997) and Photo London (2004) are attracting ever-bigger attendances and that all-important quotient of celebrity practitioners and collectors as photography morphs into art. After years of struggling to try and prove itself an art form, photography has finally become one. What failed to appeal or sell as photography has now been prettied up and given new and more understandable accoutrements of art and is selling like hot cakes. After all, if it's presented like art, framed like art, hung like art, marketed like art and, most importantly, priced like art, then it *must be* art! There are many who think that photography was art all along.

Better than any other medium, photography has always dealt with the everyday human condition, our place in the environment and relationship with it and there has certainly been much subject matter in the first few inglorious years of the twenty-first century. These ways of recording and understanding our world are founded on our social interrelations, the association between nature and culture, the cost of human consumption – globalization, global warming – and our nostalgic and confused relationship with the land. Their focus may be at the intimate everyday level shown in an agglomeration of touching vernacular visual and domestic records, such as the work of Adam Bartos (b. 1953) and Mike Smith (b. 1951), or on acute moments of world history when what we have created technologically, culturally and socially comes back with a vengeance to destroy us. Robert Polidori's photographs of Chernobyl and Joel Meyerowitz's Ground Zero series, both taken in that *annus horribilis* of 2001, eloquently demonstrate humankind's capacity to annihilate itself and its world.

Martin Parr's beady and idiosyncratic eye for symbols and icons, clichés and trivia is as much at home at the British seaside as it is in a Japanese department store. His chip-eating seagulls, shot with the harshest of heightened colour, have taken on squabbling anthropomorphic qualities. The Union Jack billowing out from the boat flagpole is an adroit "Little Britain" touch. The most democratic of photographers, Parr gives exactly the same unflinching close-up treatment to the "artistic" arrangement of Spam tins and artificial cherry blossom in 2000. The proliferation of foodstuffs across the world – Spam in Tokyo, sushi in Sunderland – suggests how individual national characteristics are disappearing and the world is getting smaller.

ABOVE Parr has now reached "national treasure" status in the UK and has become a resident cultural commentator and satirist. The Deutsche-Börse website refers to the "Parr cosmos", meaning that he has created a world of his own in his imagery that makes it instantly recognizable. The company, which funds an annual photography prize and collects Parr's work, defines it thus: "A Martin Parr photograph is like a painting by [J. M. W.] Turner, a sentence written by Thomas Mann, the voice of Frank Sinatra or the scent of Chanel No.5."

A quite different approach is taken by Raghubir Singh. Singh's India could only be India, with its river of colour flowing along the streets. Using a wide-angle lens to capture the varying theatre of these multiepisodic scenes, he marries a decisive street moment with a complex composition, the eye pulled to the low centre by the red mirror. Singh had become fascinated with light, glass, reflections and translucency, expertly employed here to fracture the image into complex planes and angles. He even managed to include his reflected self with camera to eye in the act of capturing the image.

There is no visual inclusion of self in the elegiac work of the three American photographers, William Eggleston, Adam Bartos and Mike Smith, which concentrates with intensity on a small ephemeral and insignificant area of their immediate world. They make something complex, intriguing and thought-provoking out of the seemingly limited subject matter found in their own backyard. Eggleston, the photographer's photographer, was a native Southerner raised on a cotton plantation in the Mississippi Delta. Working around Scott, Mississippi, near his home, he

ABOVE Raghubir Singh's 1991 *Pavement mirror shop* in Howrah, West Bengal, shows the multifaceted street life of India in microcosm. Singh published his first book in colour in 1974 and a further 14 during his lifetime, revealing the reality of Indian life rather than its interpretation through Western eyes: "Indian photography stands on the Ganges side of Modernism rather than the Seine or East River side of it," he wrote.

BELOW One of the best books on colour, written by Paul Outerbridge in 1940, *Photographing in Color* seems to apply particularly well to William Eggleston's work: "In black and white you suggest; in color you state. Much can be implied by suggestion but statement demands certainty – absolute – certainty. Happy accidents do not occur in color – you get nothing for nothing." Eggleston's colour statements, as here in 1992, are always made with absolute certainty.

RIGHT Adam Bartos admits the influence of Eggleston as well as that of the dramatic nineteenth-century landscape work of Timothy O'Sullivan and Carleton Watkins in his work, which follows the tradition of American vernacular and landscape photography. His colour palette is subtle and there is a sense of uncanny stillness in his images. The *Hither Hills* series was reproduced in the magazine *Double Take* in spring 1997 and subsequently won Bartos two Alfred Eisenstadt awards in 1998.

was later commissioned by the Delta and Pine Land Company, specialists in the breeding and production of cotton and soybean seed, whose headquarters were located there. His window in an unremarkable corrugated metal building glows with an eerie green light. It is beautiful but threatening and suggests a menace best avoided and passed by.

Where Eggleston implies unease, Adam Bartos is all reassurance. His still life composition of well-used, dented and corroded pans, neatly arranged with a scorched candleholder and a burnished coffee pot, has an air of quiet, reliable domestic familiarity. It is an intimate portrait of unremarkable tools, set off by the jaunty yolk-yellow of the dimpled candleholder and the greenish reflections in the coffee pot. He monumentalizes their ordinariness and imbues them with a formal serenity, even a touch of elegance. Bartos visited the recreational camping grounds in Hither Hills State Park in Montauk, Long Island, in the late afternoon over several years from 1991 to 1994, observing the comforting familiarity of the annual vacation ritual, complete with battered cooking utensils.

Mike Smith's subject matter is in an area just 10 miles from his home in America and, like Bartos, he is interested in the passage of time. He explores remote parts of the rural mountain culture of Southern Appalachia in East Tennessee, looking at the interrelationship between the isolated landscape and its inhabitants. Although largely unpopulated, his images are not pure landscape as each shows traces of human presence; nor is his work specifically documentary in that it also reflects on his own insider/outsider status as a respectful stranger in the neighbourhood. He looks at the lack of change in a community that resists homogenization, shopping malls, agribusiness and all the other accoutrements of "progress" and relies on small family farms, local skills and sharing to supply all needs. Smith's images show a hard and often solitary life but a dignified one. Finding modern colour negative film too saturated for his needs, he uses portrait film with its less intense emulsion and shoots in diffuse light – rain, fog and clouds. Avoiding the bright sunny blues and greens of spring and summer, and using a 6 x 7cm camera, he works when the landscape has mellowed to autumnal earthen colours, to muted browns and greens. Despite living in the area since 1981, Smith has titled his book of these photographs *You're Not from Around Here* (2004), the question invariably asked of him by any born-and-bred locals he met.

The encroachment of urban architectural spaces into areas of natural beauty is at the heart of the work of John Riddy (b. 1959). In his series of layered compositions, *Views from Shin-Fuji* (2005), he explores the relationship between the old and the new in Japan, traditional and modern landscapes, the natural and the artificial. The small and unspectacular town of Shin-Fuji with its power cables, pylons and unremarkable buildings coexists with the tranquil, iconic natural beauty of Mount Fuji, always placed as a precise point of reference in the background. His view is not pessimistic (the stark red placed against the bright blue sky and dramatic cloud ensures this) but examines the relationship

ラーメンショップ

LEFT John Riddy's intriguing series of digital C-type prints of Mount Fuji gives us a new interpretation of an icon as we glimpse this astounding creation of nature afresh through the messy and banal filter of human creation. Just as Joel Meyerowitz's *Empire State Building* series made us look at that New York icon in new ways, the unexpected viewpoints Riddy presents provide several new levels of interpretation of this timeless symbol of Japan's mystery.

RIGHT Naoya Hatakeyama's intriguing premise with his *Lime Works* series is that as much limestone is quarried from under the ground in Japan as is used to create cement and concrete to build cities above it. If the cities were subsequently ground to dust, the quarries could be refilled, the land restored, the scars healed. His work often explores the intriguing duality of the under- and above-ground aspects of cities.

evolving over time between town and mountain, people and nature, architectural and natural environments, with some similarities to the work of Smith and Bartos. Is Shin-Fuji living in the shadow of Mount Fuji or is the town blighting the iconic mountain?

The photographs of Naoya Hatakeyama (b. 1958) look at how the Japanese interact with the earth's surface and at the duality of what is above, and what is below, that surface. In his *Lime Works* series, it is the limestone provided by the earth, which is quarried to make cement and concrete, that provides the major building source for Japan's urbanization and its paving over of nature. "When I learned that Japan was a land of limestone, my appreciation of its cityscape underwent a subtle change. Japan is dependent on imports for most of the minerals it uses, but when it comes to limestone it is totally self-sufficient. Every year some 200 million tons of limestone are cut from the quarries scattered about the country, half being used to make cement.... The quarries and the cities are like negative and positive images of a single photograph".[1] The red and white painted chimney, like a giant jaunty barber's pole, the bright blue sky and the linear graphic qualities give the image above a surreal pictorial effect that is at odds with its formal compositional elements.

ABOVE The concept of producing planned and cogent series of images began in the 1970s, gained increasing popularity during the 1980s and became mainstream in the 1990s. A series allowed the photographer to explore a subject in depth and was an especially practical initiative for gallery exhibitions, catalogues and sales of limited editions. John Pfahl tends to concentrate on a subject for two to four years, as in the *Piles* series to which this 1994 image *Holley Lime Quarry, LeRoy, New York* belongs.

That same otherworldly effect is apparent in John Pfahl's work from his *Piles* series, shot between 1994 and 1998. In these images he explores piles of raw and recycled materials created by man but seemingly, at least in the two examples here, belonging perfectly naturally, and hugely dramatically, in the landscape. Waiting for moments of spectacular epic lighting and atmospheric effects, Pfahl transforms the battered lime quarry into a Babylonian ziggurat; the sand piles of the city ship canal await the incursion of a camel-riding Lawrence of Arabia.

ABOVE Pfahl found his dramatic subject matter near his home in Buffalo for this September 1994 *Sand piles, City Ship Canal, Buffalo, New York.* He makes these man-made dunes as monumental as the mountain ranges he visited on summer vacations. Both this image and the previous *Holley Lime Quarry* gain their drama from their spectacular skies.

Robert Polidori's more recent work reflects his continual fascination with interpreting the interrupted urban landscape. His large-format 1996 image of Amman in Jordan fills practically every centimetre of the frame with crazily stacked grey concrete boxes, piled in a seemingly random and haphazard fashion into a heap that somehow functions as a cogent, working city where people exist. Although built by man to be lived in by man, here man is invisible, lurking somewhere in this confusing heap of human containers. Polidori's restrained blue/grey colour palette is given a few vivid scatterings of red that act like visual magnets and pull the eye into the core of the image. His work is not so much about architecture as about human habitats.

In May 2001 Polidori photographed the aftermath of the Chernobyl nuclear disaster in the Ukraine, working for three days at Chernobyl and in Pripyat, a dormitory town built in

ABOVE Robert Polidori's unruly mass of a city (Amman) seems to contain few humans, but signs of human habitation are everywhere: in the splashes of shady green roof gardens, the occasional car or truck, but mostly in the lines of colourful washing hanging from windows and across rooftops. Framing the city so tightly gives it a feeling of boisterous exuberance.

ABOVE Polidori is always looking for "the emblematic moment" in his work. His images must have a serious subject matter and be about something of psychological and historical substance. He sees himself as an anthropologist, an archaeologist, a sociologist, a "muse of remembrance", which is why he seeks out places such as Chernobyl where interiors, as in this burnt-out *Control room for Reactor 4*, have suffered what he calls "habitat violation" and "room rape".

RIGHT Polidori's unpeopled architectural interiors for his *Zones of Exclusion* photographs of Pripyat and Chernobyl act as character studies for their previous occupants, be that absent Russian schoolchildren – as here in *Classrooms in Kindergarten no. 7, "Golden Key"* – or members of the Bourbon royal family haunting the corridors of Versailles. Polidori is always "looking for a sense of belonging" in his work, which makes it poignant and sympathetic rather than nostalgic.

1970 to house the nuclear plant's workers. Over 116,000 people were evacuated from the immediate area after the meltdown in Reactor 4 on April 26–28, 1986. Polidori's photograph of the burnt-out control room of Reactor 4, with its lilac and pale green colour scheme, barely hints at the utter devastation caused and has a powerful beauty as light from windows on the left rakes across the scene. More disturbing is the cheerful colour in the utterly trashed Pripyat schoolroom – the tomato-red board, the peeling, blistered pistachio-green walls and clear early summer light streaming in and unnaturally illuminating the space. On the board, in white Cyrillic letters, are written the words: "No return. Farewell. Pripyat. August 28, 1986". While these photographs may seem to have little in common with Polidori's earlier work, these are rooms whose original occupants, like those of his Versailles interiors, will never return unless as ghostly presences.

Devastation comes in many forms – nuclear explosions, acts of terrorism and wars – all leaving people dead, dislocated, displaced, traumatized, the future changed. The dignified eloquence of Joel Meyerowitz's *Images from Ground Zero* series of photographs after the 9/11 terrorist attacks on the Twin Towers of New York's World Trade Center are a sober reminder of an event that shocked most, delighted some. Working with a large-format wooden camera over a nine-month period, employing his trademark calm colour palette, Meyerowitz reveals much more than just the chaotic twisted metal and skeletal wreckage of the crime scene to which he was initially denied access. There is almost too much visual information in the images, too much to comprehend, the colours too subtle to signify that this is real life, not Hollywood, and that real life has changed forever. For those of us who lost

ABOVE How can it be that an image that captures such terrible destruction and loss should be so beautiful? Joel Meyerowitz's photograph of the South Tower of the World Trade Center, taken on September 25, 2001, bathes the scene with the poignant beauty of pure atmosphere in the deepening dusk.

LEFT Admas Habteslasie, an Eritrean living in the UK, travelled around Eritrea in the summer of 2005. For the first time he was without his family, travelling alone or with friends and photographing what captured his imagination, such as this man taking a lunchtime nap on the floor of the Massawa mosque. As he marvels at the beauty of his country, its architecture, the grace and affability of its people, his images reflect the warmth of his reawakened feelings.

BELOW Habteslasie's photographs show Africa through the eyes of an African, albeit one working out the relationship between his British and Eritrean identities. Although new houses, roads and infrastructures are being built, refugee camps like this one at Senafe, a market town on the edge of the Ethiopian highlands, are home to too many displaced Eritreans.

friends and relatives that day, these photographs capture the terrible architectural beauty of a mass graveyard, a charnel house. Meyerowitz's intention was to collect evidence in his photographs, not make art. He did both.

No less moving are the still, quiet and sadly reflective images of Admas Habteslasie (b. 1982) taken in Eritrea, a country caught like a fly in amber in a limbo between war and peace. After a 30-year war with Ethiopia to achieve independence and then a further conflict from 1998 to 2000, Eritrea has found that the end of war does not necessarily signify the start of peace. The soft colours of Habteslasie's largely empty images show a country retreating into itself, its people displaced in refugee camps, its economy in tatters, its pace of life slowing down, its search for a future weary and confused.

LEFT Samuel Fosso's 1997
portrait of himself as the chief
who sold Africa to the colonialists
was made as part of a series
for the fiftieth anniversary
of *Tati*, the chain of French
discount clothing stores among
whose customers are many
underprivileged immigrants.
Fosso's chief has surrendered his
independence and principles for
a wealth of gaudy gold jewellery
and a pair of flashy red leather
loafers, all set against a backdrop
of wonderfully flamboyant
African textiles.

War and displacement were also the driving forces behind the photographic career of Samuel
Fosso (b. 1962) when he left Nigeria at the end of the Biafran War, after two years on the
run, to relocate to Bangui in the Central African Republic with his brother. Running his own
photographic passport and portrait studio aged 13, he initially began to make self-portraits,
using up exposures on his films, to send to his grandmother in a refugee camp back in Nigeria.
After working in black and white in the 1970s and 1980s, Fosso's later self-portraits in colour
became more complex and inventive as he explored archetypal stereotypes of sexuality and
identity, questioning the continent's history of colonialism and oppression and collective
African identity. Like Cindy Sherman, he delights in role-playing in an evermore experimental
and outlandish fashion, dissecting and reconstructing the self in increasingly ironic guises.
Fosso has not denied the Narcissus element in his work, admitting that for 30 years he has been
obsessed with one subject – himself.

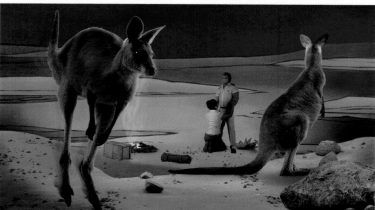

ABOVE Using comic-book colours and layout, Tracey Moffatt's *Adventure Series* of 2004 mixes a clutch of stereotypes and archetypes, layers them with science fiction, fantasy, adventure stories and romantic biopics and produces a world of constructed narratives. It is a B-movie world populated by giant mutant kangaroos and eagles, impossibly square-jawed hunks and passive, high-maintenance beauties.

RIGHT Moffatt's *Adventure Series* was shot while she was artist in residence at the Institute of Modern Art in her hometown of Brisbane, Australia, over the summer of 2003; the images were digitally assembled back in New York, where she now lives. Superficially amusing (and Moffatt's account of how the series was made is highly entertaining), her images deal with the issues of sexism, racism and colonialism.

Australian Tracey Moffatt (b. 1960) also features herself in her constructed alternative realities. Like Fosso, she tackles themes pertinent to her country's indigent population and its colonial past. Half Aboriginal herself, Moffatt addresses race relations between Aborigines and white immigrants and settlers: themes of gender, sexuality, identity and family are overlaid with a sociohistorical perspective. Moffatt uses Aboriginal and Caucasian actors to create series of work which have the momentum of TV soap operas. Her work is much influenced by memories of childhood and deals with universal issues and concerns. All of this is done with a remarkable awareness of fantasy, a hectically kitsch colour palette and the humour to make her photographs both approachable and instantly communicative.

A rather more coolly detached aesthetic in portraiture has become prevalent in recent years, questioning racial identity, history and memory. There is an increasing concentration on childhood and adolescence. There is also a concentration on external surface and circumstance

LEFT Loretta Lux's more recent photographs have tended towards an implied narrative, although the story behind *The Fish* of 2003 is open to interpretation. Her colour palette is one of modern, washed-out minimalist pastels such as are currently beloved of interior designers. Lux was born and brought up in Dresden in the former East Germany and visits to art museums to see Old Masters were important events in her visual and artistic development.

OPPOSITE Achim Lippoth achieves a look of impromptu spontaneity in his photographs by meticulous forward planning and storyboarding as in *Together, no. 3, South Africa*, 2004. While his children appear to have more blood in their veins than Lux's, they still have a slightly creepy air of perfection about them.

BELOW Works by the Italian Mannerist Bronzino, by Velázquez (reproductions of whose Infantas Margarita and Maria Teresa Lux owned) and Caspar David Friedrich are cited as influences on Lux's work, as are the fairy tales and cherubic children of Philipp Otto Runge and the adolescent girls of Balthus. *Isabella*, from 2000, even has a glorious Tiepolo sky in the background.

rather than any attempt to reach an inner life that remains unknown or ambiguous. Digital tools are used to place the sitter in unusual and unexpected settings.

Loretta Lux (b. 1969) is concerned with the state of childhood rather than with portraits of individual children, using her composite creations as metaphors for a lost paradise. Her otherworldly, shadowless images, disquieting and disconcerting, strangely and nostalgically appealing in equal measures, catch children at a blank and frozen moment in a story with no apparent before or after in a fictitious tableau. Trained as a painter, Lux began to use a camera and digital imaging instead of paint and brushes in 1999. Friends' children are photographed dressed in vintage retro 1970s clothing (some of it saved from her own childhood), then digitally situated on-screen in front of a painted or photographed backdrop.

These are solitary subjects, isolated and lonely, set in a quiet and surreal landscape in their own world – but a world often not far removed from the queasy anxieties of a modern-day Grimm's fairy tale. The children never represent themselves, never wear their own clothes, but become one of a tribe of Lux-lets, reminiscent of the nonhuman golden-eyed children in John Wyndham's 1957 science fiction classic *The Midwich Cuckoos*. Their eyes, heads and limbs are subtly distended, their skin made flawless and translucently pale; they have a bleached, milky, pastel tone. After two or three months of this digital manipulation on each image, Lux prints her work as small-format Ilfochromes, their small scale suggesting family photos to be held in the hand, rather than artworks to be hung on walls.

The children in the photographs of Achim Lippoth (b. 1968) are quite the opposite as they run, jump, dance, hurl themselves through the air and pull faces at the camera. Lippoth, a freelance commercial photographer since 1992, founded his own progressive children's fashion magazine *Kid's Wear* in 1995, a trend and lifestyle journal for children's fashion, and specializes in photographing children, often in athletic pursuits or dressed in uniforms and costumes,

frequently situated in unreal settings. His South African girls' sports team are here tossing and catching some very digitally suspect balls.

The husband-and-wife partnership of Shao Yinong (b. 1961) and Mu Chen (b. 1970) explore the various functions of memory and its relationship to particular spaces and to China's history in their work *Childhood Memory*. Their large-format (61 x 122cm/24 x 48in) panoramas digitally situate worried-looking naked young children in front of buildings of historical significance and tourist interest where their juxtaposition disconcerts in a very surreal way. These images have many connotations with the tensions between China's political past and present in a time of transition – Tiananmen Square is used as the backdrop in one of these

ABOVE In this image by Shao Yinong and Mu Chen, the little girl looks fearful as she apparently stands naked in front of the saccharinely hand-coloured ruins of Yuan Ming Yuan – the Emperor's old summer palace, which was destroyed by the British during the Second Opium War in 1860 – in Beijing. With only her red parasol for comfort and cover, her red shoes placed neatly by her side, she evokes both our sympathy and our curiosity.

works – about the country's transformation from a rural agricultural nation to an urban economic powerhouse and about the potent mix of nostalgia and provocation.

Like those who appear in Lux's work, these children have been put into situations over which they have no control, seemingly (in these fictitious images) made to pose naked in a public space. It is the photographers who are using the child's body for their art rather than the child wishing to participate. Thus the childhood memories of the title cannot be those of the children, as they were never there. The hand-painted colours are reminiscent of tinted postcards of a century earlier and, with an emphasis on the politically significant revolutionary red, they soften the message and add an evocative wistful beauty to the image, rendering the

ABOVE Posed as standing before the 10-storey Monument of the People's Heroes in Tiananmen Square, Beijing, this young naked boy, without even the protection of a parasol, is alone in a place that seethes with Chinese history; most recently with the protests and deaths of June 1989. The eerie green hand-colouring and the vehemently pink flags make us fearful for the boy's safety.

children's nakedness innocent rather than prurient. And yet there is a disturbing edge: the children don't look happy.

The photographs taken by Brigitte Carnochan (b. 1947) in China have far more of a documentary nature in that she pictures her young boy, still a touch wary around the eyes, against his natural background in Guizhou in the south west. Like Shao Yinong and Mu Chen, Carnochan often hand-paints her gelatin silver photographs (although the added colour here is digital). Conversely, Ruud van Empel (b. 1958) conjures up his own fantastic paradise from his arresting visual imagination and skill with digital collage, creating his own race of striking black children and locating them in situations of his choosing. Printed in brilliant greens, his large-scale Cibachrome prints – 150 x 107cm (59 x 42in) – place impossibly tall, slender, Bambi-eyed children in a Rousseauesque tropical Eden, as exotic as they are surreal. Always alone, stock-still and unsmiling amid lush vegetation, often wearing their best Sunday clothes, they become the apogée of nature's interest as dew-flecked leaves form sun-dappled canopies around them, perfect waterlily pads part to allow them access, doves and orchids peek through the magical undergrowth. But there are threats in van Empel's paradise too: phallus-shaped growths and

ABOVE Brigitte Carnochan's digital image *Landscape eye, Guizhou* of 2005 shows the mountainous landscape of southwest China. The series of horizontal terraces climbing up the hillside look unreal, like a painted studio backdrop or the painted layers of a Hiroshige woodcut.

ABOVE Where Lux's digital children are pale, ethereal and printed small, Ruud van Empel's digitally-created race are tall, strong and printed large. Where Lux's colour palette is pastel, constrained and restrained, van Empel's is lush and saturated; similar subject matter, but hugely different interpretation and digital treatment. The confrontational staring eyes of the child in *World no.7* are distinctly unsettling.

carnivorous pitcher plants threaten the children's digital innocence and remind us that nature can also be menacing, primal, wild and rampant, even when created on a computer screen.

Influences on contemporary photography for creating staged and choreographed narratives can come from many directions and references – from film, art, modern myths, literature and theory – and the work of the photographers who follow takes inspiration from all these areas. Creating staged narratives was an area in which Nickolas Muray and Lejaren à Hiller excelled in the 1940s (see Chapter 5), largely for advertising purposes and with a rather more kitsch intent. There is always something uncanny and unnatural in the work of Gregory Crewdson (b. 1962), showing suburban Hopperesque small-town America where decayed body parts lie in the undergrowth and strange beams of light fall from an off-camera source – a police helicopter or an extraterrestrial spaceship? It would be surprising if cinema, especially the films of David Lynch, Steven Spielberg and the master of menace Alfred Hitchcock, were not also a major

ABOVE Gregory Crewdson's *Natural Wonder* series (1992–97) explores the unknown and unnoticed secret rituals performed by wildlife – birds, insects, worms – in our own backyards, under our very noses. Four stuffed birds formally arranged in a group in a fertile flower garden peer perplexed at some unfathomable object (a dead bird?) carved with the word HOME. The object seems to be punctured (caused by exploratory pecking?), and perhaps bleeding.

influence on his psychological dramas, which are part documentary, part fantasy creations, frozen in time, never to have a resolution.

Often working with a production crew of up to 60 people, building stage sets or on location in ordinary small American towns in rural New England, Crewdson uses all the production values of cinema to stage pictures and photograph them on large-format 8 x 10in negative. Rather than creating momentary film stills, his images have to contain and convey a whole depth of composite meanings, the whole story with prequels and sequels. Using a mixture of ambient and artificial light, mist, fog, twilight or dim interior lighting, he creates a world of anxiety, isolation and fear with which we are already apprehensively and uneasily familiar through TV and cinema. We know about the murky secrets of the paranoid and claustrophobic world of small-town America, so we bring our own experience to the reading of these images while waiting for the axe to fall. Aiming to reveal a complicated beauty rather than a seductive

ABOVE Crewdson is particularly fascinated by twilight: "My photographs are about the moment of transition between before and after. Twilight is evocative of that. There's something magical about the condition…. There's really only a five-minute span where everything lines up. It's the witching hour. The wind dies down and everything becomes still." *Ray of Light* (2001) is from the *Twilight* series of 1998–2002.

or elegant one, Crewdson's digital prints are often 7ft (2.1m) across to further enhance the impression that we can walk right into them and become part of this unsettling world.

Sandy Skoglund (b. 1946) similarly presents staged environments of a world in which normality gets seriously out of kilter when packs of wild or domesticated animals, in abnormal numbers, invade a familiar human situation and run amok. It is the stuff of nightmares or extreme Surrealist dreams. Her storytelling installations take months to build and combine human beings and sculpted animals, often using a vivid and unnatural colour palette, as here. Her gang of sculpted epoxy resin squirrels, massing in numbers enough to be worrying, seem intent on something more threatening than burying autumnal nuts and looking cute. Her subliminal message, beyond the humour, is that humans have created a Frankenstein world that is mutating, out of control and turning on them.

The photography of Karen Knorr (b. 1954) also puts animals in unlikely settings, here real victims of taxidermy from the Natural History Museum in London rather than sculptures, to explore debates concerning the confrontation of nature and culture. In a series of work examining institutions, she introduces an anarchic element by locating wild and domestic animals seemingly roaming freely in a museum or art gallery space, here the Wallace Collection in London, to disturb and question the expected order. As in her previous work looking at

BELOW Skoglund and Crewdson make no attempt to render their animal installations lifelike, but the opposite is true of Karen Knorr. In *Painting after Nature* (2004) from the *Life Class* series, the monkey seems to have momentarily jumped on to the chair, and to be considering the next brushstroke to add to the canvas on the easel. Knorr's image borrows an eighteenth-century trope of the monkey-as-painter used by, amongst others, Chardin.

RIGHT Knorr's *Sanctuary* series of images made in the Wallace Collection was the first contemporary exhibition held there in 2001 and site specific to the Wallace's galleries and collections. *When Will You Ever Learn?* seemingly depicts a sorry fable in which a disobedient lamb comes to a sticky end, or is overcome by Art, after wandering through the galleries of Canalettos and Bouchers (as seen on the walls here).

the British class system, she examines the precepts that support heritage and patrimony in the formation of national identity and looks at the effects of increasing materialism and consumerism by juxtaposing unlikely combinations. Using dramatic lighting and a palette of relevant colours from the historical period exhibited by the particular institution where she is working, she produces an observational fable that weaves together a conceptual and allegorical approach with wit, humour and irony.

Like Knorr and his fellow Chinese photographers Shao Yinong and Mu Chen, Wang Qingsong (b. 1966) is concerned with the ravages of global consumerism, the loss of tradition and the rollercoaster speed of China's economic miracle. Like Crewdson and Skoglund, he meticulously assembles a cast of characters in a studio to enact his ideas, using digital elements for montage work, and also appears in the image overleaf himself, playing the pedlar. Basing his compositions on appropriated material from China's ancient artistic tradition, in this case the Song Dynasty scroll painting *Packman* by Li Song (1166–1243) which shows a pedlar selling his wares to countrywomen, he reinterprets them for twenty-first-century China. In jewel-bright colours and printed at the large size of 120 x 400cm, his scroll photograph compares the worship of available global foreign merchandise – Western brand names like McDonald's and Coca-Cola – with the more traditional, cultural values of China's own past now being lost in the gallop towards

ABOVE Wang Qingsong's humour and irony allow him to embed a serious message about consumerism, globalization and loss of cultural identity in a kitsch and staged parodic image, *Knickknack Pedlar* (2002), that is nonetheless hugely visually appealing with its episodic narrative structure. Yet again it is children who will be the inheritors of this new, drastically changed world when traditions and culture wane.

modernization. With irony and humour he examines the conflicts that ensue from these two contradictory cultures and his own place, and that of his family and newborn son, in this world.

Work by avant-garde Beijing artist Chi Peng (b. 1981) also speaks of displacement, alienation and physical and mental oppression in China's brave new world. Using his own body in his digitally made performance art, he explores sexuality and gender, the fluidity and mutability of personal identity in an increasingly impersonal world. Here multiple Chi Pengs run naked through the Beijing cityscape pursued by red – always revolutionary red – aircraft and buses. There is confusion about self-representation in this new fast-moving place, the pace of change leading to a sense of rootlessness, loss of family and increased reliance on oneself, disharmony caused by the sudden rush of extreme contrasts.

The *Lucky Family* series by Shanghai-based Yang Zhengzhong (b. 1968) challenges conventional notions of acceptable social behaviour with wit and irony. He examines outdated family patterns by looking at the traditional concept of formally posed family groups, replacing the expected humans with chickens, all in a riot of Day-glo colour. Digitally anthropomorphized with human facial expressions, the proud parents stand happily behind their offspring who wears the bad-tempered and peeved expression of a grouchy teenager.

ABOVE Digital manipulations of his own body give Chi Peng enough diverse tools to create a varied series of images such as this ironically Surrealist *Sprinting Forward 2* of 2004. Running figures, flying figures – tiny Chi Pengs with huge dragonfly wings appear in his most recent work – beleaguered, oppressed and escaping figures dominate his photographs.

Other photographs in the series show an entire brood of chicks, lined up in serried ranks like a school photograph or a sports' team, older chicks standing at the back with parents, younger ones squatting at the front.

Zhengzhong's work and other recent photography emerging from China prove that there is always new life in the medium and that a mix of personal ideas, imagination and exploration, new technology and changing environments, communications and national characteristics will result in new visions. Recently, photography has exploded in many directions that cannot always be classified or categorized according to the standard genres of portraiture, landscape, documentary and so forth, but which herald a more liberated and inclusive approach to image-making. Previously unconsidered subject matter, regarded as oblique, unrewarding, unworthy or not even noticed at all, has been made extraordinary and beautiful and significant by the fact that it has been photographed and given an artistic meaning beyond its usual everyday function. The unspecial has been made special. Conversely, there have been attempts to look at age-old subjects – flowers, still lifes, architecture, fashion, water, transparency and reflections – in new ways, using digital or traditional technologies. Rediscovered and reworked historical processes such as the photogram, hand-colouring and Fresson prints have made

ABOVE Shanghai artist Yang Zhengzhong works in a variety of media – video, installation and film – as well as still photography. His 1995 series *Lucky Family* parodies traditional family life in a series of clever visual parables substituting chickens for humans. These were the images that signified his "breakthrough".

contemporary photography a vital and reflective medium, exploring its own history and using the photographic process as an integral part of the image.

No one offers a better example of this than Adam Fuss (b. 1961) who has worked with nineteenth-century processes such as daguerreotypes, platinum printing and photograms. The latter is a camera-less image used experimentally by Thomas Wedgwood in the late eighteenth century and by William Henry Fox Talbot in the mid-1830s and signifies the start of photography on paper. In Talbot's case, nonopaque objects – lace, flowers, feathers, ferns – were laid on paper coated with light-sensitive chemicals and exposed to the sun. The paper darkened where the light reacted with the chemicals, but there was no reaction where the object blocked the light. Talbot called these images photogenic drawings, the term photogram coming into use later. They were in fact negatives that could then be printed as a positive if desired.

Fuss's work updates and intensifies the basic simplicity of this process by letting the object/ subject itself interact with colour photographic paper, over hours or days, either by movement, as in his images of an undulating snake or a baby moving over the paper in water, or by the

ABOVE Like Edward Steichen before her, Brigitte Carnochan is deeply involved in every step of her still-life photographs of flowers; the horticultural skill of the gardener produces products to satisfy the eye of the photographer, as in this perfect *Hyacinth* from 1999. She sows the seeds in the garden outside her studio, grows the plants and flowers, photographs them in natural light, makes black and white gelatin silver prints then delicately paints them in oils.

RIGHT Sarah Moon uses an unusual visual syntax: she tries to approximate the blurry, fuzzy look of her normal eyesight without glasses. Her colour vision uses a strong interplay between reds and greens, blues and yellows, printed in full heavy tones. *Robe à Pois* (*Polka-dot dress*) is a colour carbon print printed by the fine art company Art & Soul of Seattle, Washington, using nineteenth-century-style pigmented emulsions made by hand.

action of natural bodily fluids, as in his images of a cow liver or sperm. The created and creative process is then captured by flash exposure. Here, the bloody guts and intestinal liquids of two eviscerated rabbits react chemically with the chemistry of the paper and developer to produce unpredictable and diverse colour patterns, the outcome varying even from rabbit to rabbit. Thus the life force of the animal or living subject in question becomes part of, and indivisible from, the organic composition of the photograph.

Hand-colouring is a rather less extreme way of adding unpredictable colour to a photograph. Brigitte Carnochan is not pursuing photographic realism when she hand-paints her exquisitely formal gelatin silver images of flowers using oil paints expertly applied with cotton-wool buds, but interpreting the essence of her subject according to her imagination. Her flower studies are at once sensual and formal. The photography of Sarah Moon (b. 1940) has always shown great eclecticism and appreciation of the marriage of an often dreamlike image and a complementary historic process. This artful fashion shot of a magnificently eclectic dress, which gloriously bypasses prevailing notions of glamour, has been printed using a modern colour carbon

BELOW There is a tantalising dichotomy in Uta Barth's images between their shallow depth of field, ethereal blurriness and evanescent lightness and the solidity of the heavy wood panels on which they are mounted. And why do they seem so familiar? Do images from the *Ground* and *Field* series (1994–97) remind us of the work of the early Pictorialists like Steichen and Käsebier, or of the colour and light emanating from Turner's paintings?

RIGHT *Field #18* and *Ground (95.6)* (below) are dated 1995 and 1996 respectively. Barth worked on the two series contiguously. *Ground* concentrates more on the stillness of unoccupied foregrounds and empty space, while *Field* is more cinematic and concerned with the movement of light. The delicate blue/violet haze of colour, the scattered baubles of light and the splash of orange/pink seem to echo Erwin Blumenfeld's colour in the 1950s.

variation of the tricolour Carbro process that Agnes Warburg and Violet Blaiklock were using in the 1920s and 1930s (see Chapters 3 and 4).

The minimalist conceptual artist Uta Barth (b. 1958) is more interested in establishing an awareness in her viewers of the activity of looking per se, and experiencing the instinctive physiological and intellectual pleasure of looking and seeing, rather than in having them try to establish exactly what they are looking at. It is the looking that is all, the viewing and perception that become the subject matter. Her photographs lack focus because the camera's attention is elsewhere, and work as ambient suggestions rather than concrete descriptions so that we can fill in the space ourselves. They are visually ambiguous sensations that question the framework within which images usually work and how we generally expect them to work. And yet they look familiar: we can fill in the gaps in the image from pictures seen before and stored somewhere in our memory. It is enlightening to find that something so apparently devoid of content has as much content as we are able to find in it. Barth's soft and beautiful colours make the images nostalgically seductive. Barth herself has said:

ABOVE Barth began the transition from individual images to multipanel works in 1998 and her recent work, represented by *Untitled diptych (05.3)* from 2005, considers the phenomena of red optical afterimages – the result of staring into blinding light and then closing the eyes. The image is held somewhere in the memory of the eye and becomes about the eye's innate physiological rather than aesthetic response to colour.

"I have never been interested in making a photograph that describes what the world I live in looks like, but I am interested in what pictures [of the world] look like. I am interested in the conventions of picture-making, in the desire to picture the world and in our relationship, our continual love for and fascination with pictures. I want my work to function on two levels: to elicit the sense of familiarity of looking at an image that has the structures and conventions of a history of picture-making embedded in it, to make you aware of that, and at the same time to shift your attention to the very act of looking [at something], to your own visual perception in that particular moment, in the particular place that you are viewing the picture in. These two things are related."[2]

Barth's most recent digital work looks at the juxtaposition of positive and negative, of original scenes and inverted optical after-images, and of the organic and geometric. She does this with a domestic minimalism by photographing and rephotographing vases of flowers – a more traditional subject for her – and presenting them as multiple images. The colouring has also gone up many notches to a brilliant orange-red that cannot help but attract and thrill the eye.

LEFT Thomas Struth's *San Zaccaria, Venice* was a four-day shoot in summer 1995 with a large-format camera that produced more than 60 13 x 18cm negatives, from which this one was chosen to make the final print. The eye-level focus is on Giovanni Bellini's renowned 1505 altarpiece of the Madonna and Child with Saints Peter, Catherine, Lucy and Jerome, but Struth's interest is equally in observing the church's visitors, some of whom are there for religion, some for the art, some to get out of the fierce midday heat.

Where Barth's work has a seductive minimalist spareness, there is a mass of detail presented coolly and objectively in the photographs of Thomas Struth (b. 1954). Both artists are equally interested in the idea of investigative viewing but from opposite ends of the spectrum. A student of the avant-garde artist Gerhard Richter and photographers Bernd and Hilla Becher at the Staatliche Kunstakademie (Academy of Fine Arts) in Düsseldorf, Struth's earliest work showed deserted city streets and urban architecture in edgy monochrome and illustrated how each city has its own personality and its culture and history can be gleaned from its buildings. He is a reincarnation of the nineteenth-century history painter, with a camera. Later colour work has branched out to include landscapes, portraiture, and museum and church interiors. There are now people in his urban and public spaces and a prevailing, if detached, interest in the urban/human interaction.

His museum/church photographs are presented in rich, complex colour on Plexiglas at the same size and style, roughly 6 x 8ft (1.83 x 2.44m), and in heavy frames, as the figurative Old Master paintings depicted in them. They are made up of a series of detailed vignettes of unrelated groups of tourists, art lovers and worshippers, modern pilgrims who are yet part of a connected whole because they have come to experience the same central artwork and

atmosphere, to interact with the same historic building. Struth's flat and centrally receding compositions are edited in the camera as he works and rarely cropped or reworked digitally. They require a prolonged scrutiny to appreciate their visual exactitude, their dislocation of time and culture and their modified perspective.

Struth's German colleague Andreas Gursky (b. 1955) was also a student at the Düsseldorf Academy of Fine Arts in the early 1980s, but had previously trained in commercial and documentary photography. His work now proves a fascinating and successful distillation of all three photographic styles and he has become a photographic chameleon. His early work was of a domestic documentary nature but since the late 1980s he has worked on a large and bold scale, in terms of content, size and colour, and often from high vantage points using a viewing platform from which to photograph the hotel lobbies, airports, factory buildings and public arenas for which he is known. In a marriage of traditional and new technologies, Gursky uses a large-format 13 x 18cm camera and colour negative film for detail, then digitally refines his work by scanning and merging several exposures to give a single image.

His intention with this photograph of the Rhine was to take the most contemporary view possible – the river as metaphor – rather than allude to its picturesque or majestic qualities.

ABOVE Andreas Gursky produces large-scale work specifically to be hung in the gallery, museum or large architectural space rather than in the normal domestic interior. *Rhein II* (1999) measures 2.07 x 3.57m (81½ x 140½in). Fittingly, Gursky's studio and home is located in a former power station in Düsseldorf. Unlike many of his colleagues, Gursky does not work in consecutive series but in broad, interconnected themes, although recent work has been more concerned with the fragile balance between man and land.

LEFT Naoya Hatakeyama's nine images in the *River Series/Shadow* were created between 2001 and 2003 using 10-minute exposures at night on a 4 x 5in camera. The rivers and reflections change with the weather and with seasonal influxes of floodwater, but always have an unexpected beauty. The images appear upside down but are reflections temporarily created by the light effects of nearby buildings.

The restful colours, greys and greens, the image divided in half by the horizon and then into a further series of horizontal striped planes shows a striking view of the river that is both modern and timeless, formal and abstract – but it is a view that does not actually exist as Gursky has digitally removed a factory on the far bank, and the Rhine, rather than running with shining, silvery water as here, is badly polluted by effluent from factories such as the one that Gursky has "disappeared".

The play of light on moving water and its potential for producing disorienting images through reflection, diffraction and optical distortion is a constant photographic theme. This movement can be frozen by the quick click of a camera shutter, making the liquid momentarily solid. Or it can be slowly tracked by a long exposure as the light shifts, the water ripples, the colours change and mutate. Naoya Hatakeyama's exploration of Tokyo's rivers and underground water systems produces images of calming beauty and real nostalgia. Occasionally they evoke the memory of Ernst Haas's *Creation* work, although here the reflections come from the neon of street lights and buildings, and the rainbow effects that look like melted glass are created by mould growing on sewage and rat droppings. In a city of such frenetic energy as Tokyo, he finds unexpected natural beauty and stillness in urban spaces; in concrete channels cut through the city or in sewers five metres below street level in the district of Shibuya, where he lives. Hatakeyama's work is always concerned with the theme of man's impact on his surroundings, the foul environments and darker corners that

ABOVE LEFT Hatakeyama's ability to create beauty from ugliness is unparalleled. In his *Underground/Water* series of 1999, he produces prismatic colours from decaying detritus; pattern, colour and effect from the slightest subject matter. Here again are those three pure colours that made up the autochrome – violet-blue, green and orange-red.

ABOVE RIGHT Hatakeyama's initial thoughts for his series of pictures *Slow Glass*, created during his 2001 residency at Light Xchange in Milton Keynes, were that the images must be car-based and must feature rain – both of which were integral ingredients of the British experience. Yet again, he manages to create beautiful images from an unpromising premise.

man has created – the lime works, concrete river caverns and sewers – but from which he chooses to be largely absent.

Hatakeyama's series entitled *Slow Glass,* taken through rain-lashed car windows during a four-month residency in Milton Keynes, is pervaded by the principle that we are surrounded by all sorts of light from the past and that glass can have a memory and retain images. The camera can capture this memory as it can capture the colour produced when drops of rain act as prisms and split the light. The fascinating premise for *Slow Glass* comes from the short story "Light of Other Days" by the British writer Bob Shaw, which was published in the science fiction magazine *Analog*:

"The most important effect, in the eyes of the average individual, was that light took a long time to pass through a sheet of slow glass. A new piece was always jet black because nothing had yet come through, but one could stand the glass beside, say, a woodland lake until the scene emerged, perhaps a year later. If the glass was then removed and installed in a dismal city flat, the flat would – for that year – appear to overlook the woodland lake. During the year it wouldn't be merely a very realistic but still picture – the water would ripple in sunlight, silent animals would come to drink, birds would cross the sky, night would follow day, season would follow season. Until one day, a year later, the beauty held in the subatomic pipelines would be exhausted and the familiar grey cityscape would reappear."[3]

Hatakeyama moving his camera down into Tokyo's concrete craters to photograph a reflected world is strangely paralleled by Catherine Yass (b. 1963), who seemingly plunges down the sides of buildings at Canary Wharf in London photographing a world going by at vertiginous speed. Yass's *Descent* (yet another great body of work *not* to win the Turner Prize in 2002, the year it was entered) comprises a video taken by a camera suspended from an 800ft-high crane moving slowly down a high-rise construction site through wisps of thick fog over eight minutes; it is then shown upside-down for total dislocation and perspectival distortion. A related sequence of images taken with a stills camera from the top of an office block, tilted downwards as though falling, captures an image composed of giddying breakneck streaks of colour and light. Using different lengths of exposure from ¼ to one second, these images are visual realizations of nightmares of falling from high buildings or plummeting downwards in a spiralling plane, all realized in a glorious blue/green palette shot through with red and splashes of white light, with glimpses of disintegrating architecture.

ABOVE The tension between abstraction and representation and the overall sense of giddy disorientation gives Catherine Yass's *Descent*, taken with a ¼-second exposure with the camera at an angle of 4.7°, an almost physical energy. Its iridescent glowing colour is especially breathtaking when exhibited as a large-format colour transparency on a wall-mounted light box.

LEFT The division of planes of colours on the roughly-painted walls of the offices of the Justice of the Peace (Juez de Paz) in San Jeronimo de Tunan, Huancayo, Peru, confuses the eye about the perspective of the building, rendering it flat like a painted canvas.

RIGHT Mexico is the geographical location of some of the most colourful photographs in this book – by Edward Steichen and Nickolas Muray in the 1930s, Paul Outerbridge in the 1950s and now Jeffrey Becom in 1992. How fortuitous it is for Becom's composition that this questing pink pig's spotted rump stands out so well against the similar colour of the painted walls of Tlacotalpan, Veracruz.

Every photograph in this book is, of course, about colour as well as being in colour, but this last section expressly concentrates on the meaning and symbolism of colour, its use as a visual language and as a means of self-expression. Although these photographs are all *about* something and were taken for a serious artistic purpose, most of all they are about a true infatuation with colour as a reason, as a subject in itself, and they were taken by committed "pilgrims of colour".

Jeffrey Becom (b. 1953) has a passion for painted walls and has spent his life combining his love of architecture and painting with that of photography. He became a photographer in order to document the tradition of painted architecture on stucco, stone and wood before the culture vanished. Working in small rural villages, each with its own eccentric cultures and customs, on his travels throughout Europe, Mexico and South America, his photographs use brilliant colour and strong light to capture the geometry, texture and pattern of the painted wall and allow it to speak for itself. Many of his images are about the powerful abstract effect of juxtaposed blocks of colour.

LEFT Steve McCurry's photographs of the blue city of Jodhpur in Rajasthan, India, celebrate the importance of pigment in people's lives. In the nineteenth century British indigo factories in India, unmechanized and using cheap indigenous labour, cornered the market in production. A colour-enhanced version of this image was used by Kodak as an advertisement for Ektachrome in 1996.

BELOW Constantine Manos includes a human presence, on the left, but this image from 2000 is mostly about colour. Manos credits colour photography and Kodachrome with pulling him out of a midlife crisis and depression, but despite that he believes it is harder to make a warm human picture in colour than in black and white. His *American Color* series is shot with a Leica M8 with exposures of 1/250th of a second.

Colours have traditions, meanings and their own significant language when applied to homes, to places of worship and to dwellings for the dead. Houses are painted blue for the colour of water and the heavens, both vital to life. In Mesoamerican Mayan culture, jade-green is much used in cemeteries to show that a person is still treasured; red is symbolic of new beginnings and rebirth, yellow is for mourning. Colours, made of pigments ground from natural materials or from plants, are one of the few means of self-expression and riches that impoverished peoples have.

The photograph (right) by Magnum member Constantine Manos (b. 1934) could have been taken in the next village, but is in fact Fort Lauderdale in Florida, and is part of his *American Color* series, where he finds a beauty and vibrancy that others might miss. Fellow Magnum member Steve McCurry (b. 1950) has made more than 75 trips to India, often working for *National Geographic* magazine (whose first colour illustrations almost a century ago were autochromes). As with Raghubir Singh's work (see pp. 183, 186 and 206), India's colour, juxtaposed against the country's often parched landscape, seems all the more intensely

LEFT Jodhpur is a city with a full colour palette. During the Hindu Holi Festival that celebrates the arrival of spring, the colour largely narrows down to a vermilion red. Most of McCurry's images are grounded in the people. Colour adds complexity and another element, but it is the people who come first.

BELOW The painted walls of Beijing show a quite different colour cast to those of Mexico or India. Robert Welsh's Beijing in 1991 seems a world away from the twenty-first-century city of Chi Peng or Shao Yinong and Mu Chen a decade later and is more in keeping with Eliot Porter's Macau a decade earlier.

experienced. Colour is a way of life rather than mere pigment. The blue buildings of Jodhpur, painted with blue neel or indigo, for religious, heat-reflective or malarial mosquito-repelling reasons, contrast startlingly with the red *pagdhis* (traditional garments) of the local men, while the vermilion and other *gulal* powder colours are liberally thrown in the air and over clothing and the body during the annual Hindu Holi Festival that celebrates the arrival of spring.

Robert Welsh (b. 1953) became interested in China and involved with the Chinese community in the USA through his wife Edith Ng and her family. Welsh's thoughtful images of Chinese culture translated into an American context in the Chinatowns of San Francisco and New York are an interesting corollary to his photographs taken in China itself: his work there concentrates on the tenderness and beauty in people's everyday lives at times of great change, as ancient tradition gives way to modernity. Welsh himself also seems fond of tradition, working with a 1950s 635 Yashica twin-lens reflex camera and 2¼in square negative.

The images produced by both Scott McFarland (b. 1975) and Ruud van Empel are digital collages. McFarland uses subtle digital alteration to brighten the image which is pieced together

LEFT Certain colours come to define a decade. The past few years have seen the growth of green – not the subtle natural green of globally-warmed nature or the green of political persuasion, but greens that move from bright greeny-yellow to a calmer "heritage" greeny-grey. True twenty-first-century greens for our times. Varied greens are the crucial colours in Scott McFarland's digitally-stitched *Torn quilt with effects of sunlight* of 2003.

BELOW Ruud van Empel employs heightened jungle and forest greens in his *World* series (pp.203, 223) and a variety of vivid shades of green in his *Office* series, as here. Fittingly, his solo exhibition at TZR Galerie in Bochum, Germany, in 2004 was entitled "Study in Green".

from multiple exposures taken in sunlight at different times of the day, from early morning sunshine until sunset. Using selected areas from individual shots, he stitches them together digitally to make a final composite image, paralleling the way patchwork quilts are made. Van Empel's *Office* series of 1996–2000, his first venture into digital work after previous photocollages using scissors and glue, meticulously assembles accurate typifications of people locked into their business worlds by surrounding them with product. Angus Mill (b. 1968) painstakingly made multicoloured jellies and blancmanges at home in London, drove them to Wales, set up lighting on a Pembrokeshire beach, and floated his creations out to sea at dusk like a shoal of psychedelic jellyfish. The photograph was initially taken for a competition in the UK *Observer* newspaper's monthly food magazine, but now seems to have taken on a cult following of its own.

The photo-booth work of Liz Rideal (b. 1954) turns drapery – usually only seen as the background of the booth's more usual product, the passport photograph – into the portrait itself. The only reference to humanity in her work is the occasional hand clutching fabric or the

ABOVE Of the many intriguing elements of this image, not the least are the colour combinations that Angus Mill has chosen for the complex layers – up to nine in some creations – of jelly and blancmange; colours that seem to be a direct throwback to the dark reds, pinks, creams and pistachio-greens of the 1930s Surrealist photographers.

LEFT Liz Rideal's work revolves around issues of repetition, scale, movement and – of course – colour. An earlier version of this *Kerfuffle* of 2004, entitled *Swimming towards Christmas*, commissioned by Sculpture Urbaine and measuring 48 x 23m (160 x 77ft), was projected on to the exterior wall of a seventeenth-century French town hall at Christmas 2000. It seems eminently fitting that the town hall in question was in Lyon, home of the Lumières, home of colour photography.

back of a head shrouded by flying hair. Since 1985, she has been working with this miniature 5 x 4cm format, four frames to a strip, building up images into repetitive grids, using the play of colour and the sensuous texture of folded, draped, ruched and billowing materials. The photo-booth is an intimate and subjective space, where one can be private and hidden yet still in a public space, shielded only by another curtain.

The work of creating the photograph – the lighting, the composition, the atmosphere – must all be done in advance, as the booth has a standard fixed-focus 90mm lens and produces no negative, only a unique positive film strip with predestined chemistry so there is no opportunity for post-exposure manipulation, much like the autochrome in many ways. As with that process, Polaroid and many others, photographers will find a way to make a process their own. This particular image has a voyeuristic appeal intensified by the suggestively rich bordello red of the curtains about to be pulled apart – to reveal what? In this case, it was the BBC's Broadcasting House headquarters in London in 2004, as Rideal's original photo-booth images

RIGHT Ellen Carey's *Blinks* is a colour photogram that is projected on to a white wall for full effect; it appears there gradually, eventually reaching its full spectral range. It is a reflection on light/day and dark/night as well as colour/no colour. As natural daylight fades, the projected image "blinks" back at the viewer, its colours becoming more intense and vibrant. The blinking effect is the biological result of the eye's cones and rods trying to take in the different wavelengths of colour.

BELOW It seems fitting that the last two images in this book owe their existence to the biological and physiological aspects of seeing and the chemistry of colour. Carey's unique photograms highlight her interest in the paintings of Bridget Riley, in retinal play and in the phenomenon of painting with light and colour in photography.

were enlarged to a massive, traffic-stopping 22 x 15.4m (72ft 4in x 50ft 7in) Scanachrome to cover the building during renovation work.

The earlier work of Ellen Carey (b. 1952) explored the the notion of the self-portrait and produced many fascinating variations over two decades (see Chapter 9, pp. 189-90). Her most recent work has been totally nonfigurative and now she has pared it down even more by dispensing with the lens completely, producing camera-less photograms that incorporate her interest in the biology of seeing and in colour photographic theory. These images use just light and colour as their subject matter and as their chemistry, true colour as form. The photograms are made in the colour darkroom – multiple exposures made in a colour enlarger. A planned installation piece of a projected photogram of *Blinks* will further explore the biological result of the eye's cones and rods trying to take in the different wavelengths of colour. Thus, at the end of this book, we return to the very beginning of photography with Talbot's initial photogram process of 1834 and Thomas Young's papers on colour theory and the biology of seeing in 1807.

FOOTNOTES

Note on currency: the UK system of pounds, shillings and pence (£ s d) was replaced by decimal currency in the 1970s. 1 shilling became 5p, and 1 penny became 0.4p.

PREFACE
[1] Outerbridge, Paul. *Photographing in Color.* New York: US Camera/Random House, 1940.
[2] Barthes, Roland, translated by Richard Howard. *Camera Lucida. Reflections on photography.* Hill & Wang, 1981.

CHAPTER 1
[1] Hermann Wilhelm Vogel (1834-1898) discovered the elements that would enable the production of a panchromatic emulsion, equally sensitive to all colours of the spectrum, in 1884.
[2] Paris: A. Marion, 1869.

CHAPTER 2
[1] Before potato starch was chosen, various substances had been tried and rejected including mineral powders, pulverized enamel, rice starch and other tubers and rhizomes from around the world. Potatoes were also the main crop of the area, thus economical to use.
[2] By 1909, the price had dropped in the UK although a box of four quarter-plate autochromes sold for 4s compared with a box of a dozen quarter-plate black and white negatives for only 1s 9d so the price difference was still significant. In France, the Lumières had specifically pegged the cost of a box of four autochromes against that of a box of a dozen black and white negatives.
[3] *Photographische Rundschau* 21, 1907, p. 267.
[4] Leiden: Sijthoff, 1912–13.
[5] Leipzig: E.A. Seemann, 1912–13.
[6] Zoller's archive is now at George Eastman House in Rochester, New York.
[7] Lionel de Rothschild's photographs and equipment are in the Rothschild Archives in London.
[8] Amongst these, as well as the Archives of the Planet, were: Around the World Travel Grants (1898), Around the World Society (1906), the National Committee of Social and Political Studies (1916) and the Social Documentation Centre of the French Ecole Normale Supérieure (1920).
[9] Albert Kahn translated and quoted by Emmanuel de Margerie, letter to Jean Brunhes, January 26, 1912, reproduced in Jeanne Beausoleil et Mariel Jean-Brunhes Delamarre, "Deux témoins de leur temps: Albert Kahn et Jean Brunhes" in *Jean Brunhes: Autour du monde, regards d'un géographe/ regards de la géographie*. Boulogne: Musée Albert Kahn, 1993, p. 92.

CHAPTER 3
[1] For more detailed information on early twentieth-century photographic experimentation, see Coe, Coote, Crawford, Hirsch, Wilhelm etc. in bibliography.
[2] Steichen, Edward. *A Life in Photography.* New York: Museum of Modern Art & Doubleday, 1963.
[3] For further information on the Mantechrome, or Mantochrome, see *Louis Amédée Mante, Mantochromes and Edmond Goldschmidt, Photographer.* Vancouver: Vancouver Art Gallery, 1981.
[4] The Royal Photographic Society Collection is now located at the National Media Museum in Bradford, West Yorkshire, UK.

CHAPTER 4
[1] Steichen, Joanna. *Steichen's Legacy. Photographs, 1895-1973.* New York: Alfred A. Knopf, 2000.
[2] Yevonde, Madame. *In Camera.* London: John Gifford Ltd, 1940.
[3] Freund, Gisèle, quoted in Bauret, Gabriel. *Color Photography.* Paris: Editions Assouline, 2001.
[4] Bellmer, Hans quoted in Peter Webb and Robert Short, *Hans Bellmer.* London: Quartet Books, 1985.

CHAPTER 5
[1] See Bossen, Howard. *Luke Swank. Modernist Photographer.* Pittsburgh: University of Pittsburgh Press, 2005.

[2] Reprinted in Pitts, Terence, Ed. *Edward Weston: Color photography.* Tucson: Center for Creative Photography, 1986.

CHAPTER 6
[1] Liberman, Alexander, editor & designer. *The Art and Technique of Color Photography.* New York: Simon & Schuster, 1951.
[2] Introduction. Details as above.
[3] *ibid.*
[4] *ibid.*
[5] Leiter was "rediscovered" in the late 1980s and a recent beautiful monograph has been published of his 1950s' colour work. Harrison, Martin. *Saul Leiter, Early Color.* Göttingen: Steidl, 2006.
[6] www.ernsthaasstudio.com
[7] *ibid.*
[8] *ibid.*
[9] *ibid.*
[10] *ibid.*
[11] *ibid.*
[12] *ibid.*
[13] www.hrc.utexas.edu
[14] Pilkington, William J. "Colour Photography". From *The Year's Photography, 1950–1951.* London: Royal Photographic Society, 1950.
[15] Gresham, D.C. "Colour Photography". From *The Year's Photography, 1951–1952.* London: Royal Photographic Society, 1951.
[16] Outerbridge, Paul. *Photographing in Color.* New York: Random House, 1940.
[17] Porter, Eliot. *Intimate Landscapes.* New York: Metropolitan Museum of Art and E. P. Dutton, 1979.

CHAPTER 7
[1] Interview with Daniel Kramer on the website of the Experimental Music Project: www.emplive.org
[2] Halberstam, David. Introduction to *Larry Burrows: Vietnam.* New York: Alfred A. Knopf, 2002.
[3] Faas, Horst. Quoted in Halberstam, David; Introduction, as above.
[4] Szarkowski, John. Quoted on website: www.ernsthaasstudio.com

CHAPTER 8
[1] Quoted in Benton-Harris, John, Tony Ray-Jones obituary. *Creative Camera,* June 1972.
[2] Szarkowski, John. Introduction. *William Eggleston's Guide.* New York: Museum of Modern Art, 1976.
[3] Quoted in Ferris, Bill, *Images of the South: Visits with Eudora Welty and Walker Evans.* Memphis: Center for Southern Folklore, 1977.
[4] Szarkowski, John, Introduction. *William Eggleston's Guide.* New York: Museum of Modern Art, 1976.
[5] *New York Times,* May 28, 1976.
[6] Joel Meyerowitz quoted in Bauret, Gabriel, *Color Photography.* Paris: Editions Assouline, 2001.
[7] http://sirismm.si.edu/siris/eepatop.htm
[8] http://www.hrc.utexas.edu/exhibitions/online/elisofon/elisofon5.html

CHAPTER 9
[1] For further information on permanence of colour photographs see the very excellent: Wilhelm, Henry & Brower, Carol, *The Permanence and Care of Color Photographs: Traditional and Digital Color Prints, Color Negatives, Slides and Motion Pictures.* Iowa: Preservation Publishing Company, 1993.
[2] John Batho quoted in essay by Paolo Costantini, *John Batho.* Florence: Fratelli Allinari Editrice, 1987.
[3] Martin Parr quoted in Bauret, Gabriel, *Colour Photography.* Paris: Editions Assouline, 2001.

CHAPTER 10
[1] Text by Naoya Hatakeyama introducing "Lime Works" section in book *Naoya Hatakeyama.* Tokyo: Tankasha, 2002.
[2] Uta Barth in interview with Sheryl Conkelton, *Journal of Contemporary Art* 8, no. 1, Summer 1997.
[3] Shaw, Bob, "Light of Other Days". First published in *Analog* magazine, August 1966.

BIBLIOGRAPHY

GENERAL
Batchelor, David. *Chromophobia.* London: Reaktion Books, 2000.
Barthes, Roland. *Camera Lucida: Reflections on photography.* New York: Hill & Wang, 1981.
Bauret, Gabriel, ed. *Color Photography.* New York: Assouline, 2001.
Bouqueret, Christian *Histoire de la photographie en images.* Paris: Marval, 2001
Bunnell, Peter C., ed. *Photography at Princeton. Celebrating twenty-five years of collecting and teaching the history of photography.* Princeton: The Art Museum, Princeton University, 1998.
Coe, Brian. *Colour photography. The first hundred years, 1840-1940.* London: Ash & Grant, 1978.
Coote, Jack H. *The Illustrated History of Colour Photography.* London: Fountain Pres, 1993.
Crawford, William. *The Keepers of Light. A history and working guide to early colour processes.* New York: Morgan & Morgan, 1979.
Delamare, François & Guineau, Bernard. *Colour. Making and using dyes and pigments.* London: Thames & Hudson, 2000.
Ewing, William, *et al. The Idealizing Vision. The art of fashion photography.* New York: Aperture, 1991.
Farbe im Photo. Die Geschichte der Farbphotographie von 1861 bis 1981. Cologne: Josef-Haubrich-Kunsthalle, 1981.
Friedman, Joseph S. *History of Color Photography.* New York: American Photographic Publishing Co., 1944.
Frizot, Michel, ed. *A New History of Photography.* Cologne: Könemann, 1998.
Gage, John. *Color and Culture: Practice and Meaning from Antiquity to Abstraction.* University of California Press, 1999.
Gage, John. *Color and Meaning: Art, Science and Symbolism.* University of California Press, 1999.
Gage, John *Colour in Art.* London: Thames & Hudson, 2006.
Hannavy, John, ed. *Encyclopedia of Nineteenth-Century Photography.* New York: Routledge, 2007.
Haworth-Booth, Mark. *Photography Now.* London: Dirk Nishen Publishing in association with the Victoria & Albert Museum, 1989.
Heilbrun, Françoise & Bajac, Quentin. *Orsay. Photography.* Paris: Èditions Scala, 2000.
Hirsch, Robert. *Exploring Colour Photography. A complete guide.* London: Laurence King Publishing, 2005.
Honnef, Klaus, Sachsse, Rolf & Thomas, Karin, eds. *German Photography, 1870-1970. Power of a medium.* Cologne: Dumont, 1997.
Howarth, Sophie, ed. *Singular Images. Essays on remarkable photographs.* London: Tate Publishing, 2005.
International Museum of Photography at George Eastman House. *Color as Form. A history of color photography.* Exhibition catalogue. Rochester, New York: International Museum of Photography at George Eastman House, 1982.
Isert, Gerhard. *The Art of Colour Photography.* London: Focal Press, 1970.
Lenman, Robin, ed. *The Oxford Companion to the Photograph.* Oxford: Oxford University Press, 2005.
Mulligan, Therese & Wooters, David, eds. *Photography from 1839 to Today.* George Eastman House, Rochester, NY. Cologne: Taschen, 2000.
Naef, Weston. *The J Paul Getty Museum Handbook of the Photographs Collection.* Malibu, California: The J Paul Getty Museum, 1995.
Parr, Martin & Badger, Gerry. *The Photobook: A history. volumes I & II.* London: Phaidon, 2004 & 2006.
Pilkington, William Joseph. *Pictorial Photography in Colour.* London: Fountain Press, 1954.
Roberts, Pam. *Photogenic. From the collection of the Royal Photographic Society.* London: Scriptum Editions, 2000.
Sipley, Louis Walton. *A Half Century of Color.* New York: the Macmillan Company, 1951.
Sobieszek, Robert. *The Art of Persuasion. A history of advertising photography.* New York: Harry N Abrams, 1988.
Szarkowski, John. *Photography until Now.* New York: Museum of Modern Art, 1989.

CHAPTER 1
Bennett, Terry. *Early Japanese Images.* Rutland, Vermont: Charles E. Tuttle, 1996.
Schaaf, Larry. *Sun Gardens. Victorian photograms by Anna Atkins.* New York: Aperture/Kraus, 1985.
Sobieszek, Robert A, ed. *Early Experiments with Direct Color Printing.* Manchester, New Hampshire: Ayer Publishing, 1979.
Sobieszek, Robert A, ed. *Two Pioneers of Color Photography: Cros and Du Hauron.* Manchester, New Hampshire: Ayer Publishing, 1979.
Wilhelm, Henry & Brower, Carol. *The Permanence and Care of Color Photographs: Traditional and Digital Color Prints, Color Negatives, Slides and Motion Pictures.* Iowa: Preservation Publishing Company, 1993.

CHAPTER 2
Borge, Guy et Marjorie. *Les Lumières – Antoine, Auguste, Louis et les Autres. L'invention du cinema, les autochromes.* Lyon: Editions Lyonnaises d'art et d'histoire, 2004.
Boulouch, Nathalie. *Les Autochromes Lumière. La couleur inventée. Les collections privées de la Famille Lumière.* Paris: ScHeiBli Editions, 1999.
Enyeart, James. *Bruguière, his Photography and his Life.* New York: Knopf, 1977.
Collections Albert Kahn. *Villages et Villageois au Tonkin, 1915-1920. Autochromes réalisées par Léon Busy pour les "Archives de la Planète".* Paris: Département des Hauts-de-Seine: Collections Albert Kahn, 1986.
Collections Albert Kahn. *Irlande 1913. Cliches en couleur pris pour Monsieur Kahn par Mesdemoiselles Mespoulet et Mignon.* Paris: Département des Hauts-de-Seine: Collections Albert Kahn – Musée Départemental, 1988.
Davies, Richard. *Leonid Andreyev. Photographs by a Russian writer.* London: Thames & Hudson, 1989.
Genthe, Arnold *As I Remember.* New York: Reynal & Hitchcock, 1936.
History of Photography, volume 18, number 2, summer 1994. *Early colour & the autochrome,* pp.110–53. Various authors. London: Taylor & Francis, 1994.
McCandless, Barbara et al. *New York to Hollywood: the photography of Karl Struss.* Albuquerque/Fort Worth: University of New Mexico Press/Amon Carter Museum, 1995.
Poivert, Michel *et al. L'Utopie Photographique.* Paris: Le Point du Jour Éditeur, 2004.
Roumette, Sylvain & Frizot, Michel. *Early Color Photography.* New York: Pantheon Books, 1986.
Wood, John. *The Art of the Autochrome: the birth of color photography.* Iowa: University of Iowa Press, 1993.
Wood, John. *The Photographic Arts.* Iowa: University of Iowa Press, 1997.
Zoller, Charles C. *Rochester in Color: the Autochromes of Charles C. Zoller, 1909–1930.* Rochester, New York: George Eastman House, 1988.

CHAPTER 3
Allshouse, Robert H. *Photographs for the Tsar. The pioneering color photography of Sergei Mikhailovich Prokudin-Gorskii commissioned by Tsar Nicholas II.* New York: Dial Press, 1980.
Gernsheim, Helmut & Alison, eds. *Alvin Langdon Coburn Photographer. An autobiography.* London: Faber & Faber, 1966.
Heilbrun, Françoise & Bajac, Quentin. *Paul Burty Haviland, 1880–1950, photographe.* Paris: Réunion des Musées Nationaux, 1996.
Jay, Bill. *Robert Demachy, 1859–1936. Photographs & essays.* London: St Martin's Press, 1974.
Longwell, Dennis. *Steichen. The master prints, 1895–1914. The Symbolist period.* New York: Museum of Modern Art, 1978.
Patterson, Joby. *Bertha E Jaques and the Chicago Society of Etchers.* Madison, New Jersey: Fairleigh Dickinson University Press, 2002.
Roberts, Pam. *Alfred Stieglitz. Camera Work. The complete illustrations, 1903–1917.* Cologne: Taschen, 1997.

CHAPTER 4
Bellmer, Hans. *Little Anatomy of the Physical Unconscious, or the Anatomy of the Image.* Dominion Press, 2006.
Brown, E.H. *Rationalizing Consumption:*

Lejaren à Hiller and the Origins of American Advertising Photography. Enterprise & Society, vol. 1, no. 4, December 2000. Oxford: Oxford University Press.

De la Beaumelle, Agnes. *Hans Bellmer.* Ostfildern: Hatje-Cantz, 2006.

Freund, Gisèle. *Gisèle Freund. Photographer.* Translated from the French by John Shepley. New York: Harry N. Abrams, 1985.

Gibson, Robin & Roberts, Pam. *Madame Yevonde. Colour, fantasy and myth.* London: National Portrait Gallery Publications, 1990.

Green, Malcolm. *Hans Bellmer. The doll.* London: Atlas Press, 2005.

Johnson, Patricia. *Real Fantasies. Edward Steichen's advertising photography.* Berkeley: University of California Press, 1997.

Niven, Penelope. *Steichen. A biography.* New York: Clarkson Potter, 1997.

Krauss, Rosalind *et al. L'Amour Fou. Photography & surrealism.* New York: Abbeville Press, 1985.

Lichtenstein, Therese. *Behind Closed Doors. The art of Hans Bellmer.* University of California Press, 2001.

Man Ray. *Self Portrait.* New York: Little Brown, 1999.

Man Ray. *Photographs.* London: Thames & Hudson, 1982.

Spencer, D A. *Colour Photography in Practice.* London: Sir Isaac Pitman & Sons, 1938.

Steichen, Edward. *A Life in Photography.* New York: Doubleday & Company published in association with the Museum of Modern Art, 1963.

Steichen, Joanna. *Steichen's Legacy.* New York: Alfred A. Knopf, 2000.

Taylor, Sue. *Hans Bellmer. The anatomy of anxiety.* Cambridge, MA: MIT Press, 2002.

CHAPTER 5

Bossen, Howard. *Luke Swank. Modernist photographer.* Pittsburgh: University of Pittsburgh Press, 2005.

Brannan, Beverley & Mora, Gilles. *FSA: the American Vision.* New York: Harry N. Abrams in association with the Library of Congress, 2006-12-12.

Fiedler, Jeannine & Moholy-Nagy, Hattula, eds. *László Moholy-Nagy. Color in transparency: photographic experiments in color, 1934–1946.* Göttingen: Steidl, 2006.

Heiting, Manfred, ed. *Paul Outerbridge, 1896–1958.* Cologne: Taschen, 1999.

Grimberg, Salomon. *I Will Never Forget You: Frida Kahlo to Nickolas Muray.* San Francisco: Chronicle Books, 2006.

Henrickson, Paul. *Bound for glory: America in Color, 1939–1943.* New York: Harry N. Abrams in association with the Library of Congress, 2004.

Lee, Russell. *Russell Lee Photographer.* New York: Morgan & Morgan, 1978.

Life. The first decade. New York: Time Inc., 1979.

McGonagle, Declan & Lee, David. *Hindesight. The photographs & postcards of John Hinde, 1935–1971.* Dublin: Irish Museum of Modern Art, 1993.

Myers, Joan. *Pie Town Woman: the Hard Life & Good Times of a New Mexico Homesteader.* Albuquerque: University of New Mexico Pres, 2001.

Nickolas Muray. Exhibition catalogue. Rochester: George Eastman House, 1974.

Outerbridge, Paul. *Photographing in Color.* New York: Random House, 1940.

Peterson, Linda *et al. Russell Lee Photographs. Images from the Russell Lee photograph collection at the Center for American History.* Austin: University of Texas Press, 2007.

Pitts, Terence *et al. Edward Weston. Color photography.* Tucson: Center for Creative Photography, 1986.

Rijper, Els, ed. *Kodachrome. The American invention of our world, 1939–1959.* New York: Delano Greenridge Editions, 2002.

Rothstein, Arthur. *The Depression Years.* New York: Dover Press, 1978.

Spender, Stephen. *Citizens in War – and After. Forty-eight colour photographs by John Hinde.* London: George G. Harrap, 1945.

CHAPTER 6

Campbell, Bryn. *Ernst Haas.* London: Collins, 1983.

Elisofon, Eliot. *Colour Photography.* London: Thames & Hudson, 1962.

Elisofon, Eliot. *To Help the World to See: an Eliot Elisofon Retrospective.* Exhibition catalogue. Austin: Harry Ransom Research Center for the Humanities, University of Texas at Austin, 2000.

Garner, Philippe & Mellor, David. *Cecil Beaton. Photographs 1920–1970.* New York: Stewart, Tabori & Chang, 1996.

Haas, Ernst. *In America.* New York: Studio, 1975.

Haas, Ernst. *Color Photography.* New York: Harry N Abrams, 1989.

Haas, Ernst. *The Creation.* London: Penguin, 1976.

Head, Jeffrey. *Herbert Matter. Modernist photography and graphic design.* Stanford: Stanford University Libraries, 2005.

Horst, Horst P. *Sixty Years of Photography.* New York: Rizzoli, 1986.

Leiter, Saul. *Saul Leiter. Early color.* Göttingen: Steidl, 2006.

Liberman, Alexander, ed. *The Art and Technique of Color Photography.* New York: Simon & Schuster, 1951.

Mili, Gjon. *Photographs and Recollections.* Boston: New York Graphic Society, 1980.

Mili, Gjon. *Picasso's Third Dimension. Photographs and text by Gjon Mili.* New York: Triton Press, 1970.

Muir, Robin, ed. *Clifford Coffin. Photographs from Vogue, 1945–1955.* New York: Stewart, Tabori & Chang, 1997.

Porter, Eliot. *In Wildness Is the Preservation of the World.* San Francisco: Sierra Club, 1962.

Yohannan, Kohle. *John Rawlings. Thirty Years in Vogue.* Santa Fe: Arena Editions, 2001.

CHAPTER 7

Bruce, Roger R. *Seeing the Unseen: Dr Harold E Edgerton and the Wonders of Strobe Alley.* Cambridge, MA: MIT Press, 1994.

Burrows, Larry & Halberstam, David. *Larry Burrows: Vietnam.* New York: Knopf, 2002.

Edgerton, Dr. Harold E. *et al. Stopping Time: the Photographs of Harold Edgerton.* New York: Harry N. Abrams, 2000.

Eggleston, William. *Los Alamos.* New York: Scalo Publications, 2003.

Friedlander, Lee. *American Musicians. Photographs by Lee Friedlander.* New York: Distributed Art Publishers, 1998.

Harrison, Martin. *Young Meteors. British photojournalism: 1957–1965.* London: Jonathan Cape, 1998.

Honnef, Klaus *et al. Heinz Hajek-Halke: Artist, Anarchist.* Göttingen: Steidl, 2006.

Kramer, Daniel. *Bob Dylan. A portrait of the artist's early years.* London: Plexus, 2001.

Muir, Robin. *Norman Parkinson. Portraits in fashion.* London: Trafalgar Square Publishing, 2004.

Parkinson, Norman. *Lifework.* London: Weidenfeld & Nicolson, 1983.

Pepper, Terence. *Angus McBean Portraits.* London: National Portrait Gallery, 2006.

Porter, Eliot. *The Place No One Knew: Glen Canyon on the Colorado.* San Francisco: Sierra Club, 1963.

Porter, Eliot. *Galápagos: The Flow of Wildness.* San Francisco: Sierra Club, 1968.

Rohrbach, John *et al. The Color of Wildness: a Retrospective, 1936–1985.* New York: Aperture in association with the Amon Carter Museum, 2001.

Sobieszek, Robert A. *Bert Stern. Adventures.* New York: Bullfinch Press, 1997.

Turner, Pete. *Pete Turner – Photographs.* New York: Harry N. Abrams, 1987.

CHAPTER 8

Arnold, Eve. *In China.* New York: Alfred A. Knopf, 1980.

Christenberry, William, ed. *William Christenberry.* New York: Aperture, 2006.

Eauclaire, Sally. *The New Color Photography.* New York: Abbeville Press, 1981.

Eggleston, William. *William Eggleston's Guide.* New York: Museum of Modern Art, 2002 (facsimile edition of 1976).

Evans, Walker & Rosenheim, Jeff L. *Walker Evans: Polaroids.* New York: Scalo Publishers, 2001.

Groover, Jan & Szarkowski, John. *Jan Groover: photographs.* New York: Bulfinch, 1993.

Lifson, Ben. *Lucas Samaras.* New York: Aperture, 1988.

Meiselas, Susan. *Nicaragua.* New York: Pantheon, 1981.

Meyerowitz, Joel. *Cape Light.* Boston: New York Graphic Society/Museum of Fine Arts, 1978.

Misrach, Richard. *Richard Misrach: Chronologies.* San Francisco: Fraenkel Gallery, 2006.

Pfahl, John. *Picture Windows.* New York: Little Brown & Co, 1987.

Porter, Eliot, Stegner, Wallace & Page. *American Places.* New York: Dutton, 1981.

Roberts, Russell. *Tony Ray-Jones.* London: Chris Boot, 2005.

Singh, Raghubir. *A Way into India.* London: Phaidon, 2002.

Shore, Stephen. *Uncommon Places: the Complete Works.* New York: Aperture, 2004.

CHAPTER 9

Batho, John & Cheval, François. *John Batho: Une Rétrospective.* Paris: Marval, 2001.

Brittain, David. *Constructed Narratives. The photographs of Calum Colvin & Ron O'Donnell.* London: Photographers' Gallery, 1986.

Chadwick, Helen & Warner, Marina. *Enfleshings.* New York: Aperture, 1989.

Cruz, Amanda *et al. Cindy Sherman: Retrospective.* London: Thames & Hudson, 2000.

Eggleston, William. *William Eggleston: Ancient and Modern.* New York: Random House, 1992.

Faucon, Bernard. *Les Grandes Vacances.* Paris: Herscher, 1980.

Faucon, Bernard. *Le Plus Beau Jour de ma Jeunesse.* Paris: Les Editions de l'Imprimeur, 2000.

Fontana, Franco & Giacomelli, Mario. *Landscapes.* New York: Weatherhill, 2003.

Greer, Fergus. *Leigh Bowery Looks. Photographs by Fergus Greer, 1988–1994.* London: Violette Editions, 2002.

Haas, Ernst & Brian Brake. *Focus on New Zealand.* Auckland, New Zealand: Collins, 1986.

Harris, Alex. *Red White Blue and God Bless You: a Portrait of Northern New Mexico.* Albuquerque: University of New Mexico Press, 1992.

Helmer-Petersen, Keld. *Frameworks. Photographs 1950–1990.* Copenhagen: Museum Tusculanum Press, 1993.

Jussim, Estelle. *A Distanced Land: the Photographs of John Pfahl.* Albuquerque: University of New Mexico Press, 1990.

Kraus, Ziva, ed. *John Batho.* Firenze: Alinari, 1987.

Morris, Catherine. *The Essential Cindy Sherman.* New York: Harry N. Abrams, 2000.

Parr, Martin *Last Resort: Photographs of New Brighton.* Wallasey: Promenade Press, 1986.

Polidori, Robert & Pérouse de Montclos, Jean-Marie. *Versailles.* Paris: Place des Victoires, 1999.

Porter, Eliot & Porter, Jonathan. *All Under Heaven: the Chinese World.* New York: Pantheon, 1983.

Sladen, Mark. *Helen Chadwick.* Ostfildern: Hatje Cantz, 2004.

Wegman, William. *Wegmanology.* New York: Hyperion, 2001.

CHAPTER 10

Adams, Parveen. *Catherine Yass. Works, 1994–2000.* London: Asprey Jacques, 2000.

Bannon, Anthony. *Steve McCurry. 55 series.* London: Phaidon, 2005.

Barth, Uta & Conkelton, Sheryl. *Uta Barth. In between places.* Seattle: Henry Art Gallery, 2000.

Bartos, Adam. *Boulevard.* Göttingen: Steidl, 2006.

Becom, Jeffrey & Aberg, Sally Jean. *Maya Color. The painted villages of Mesoamerica.* New York: Abbeville Press, 1997.

Berg, Stephen *et al. Gregory Crewdson, 1985–2005.* Ostfildern: Hatje Cantz, 2005.

Blink. 100 photographers, 10 curators, 10 writers. London: Phaidon, 2002.

Bonetti, Maria Francesca & Schlinkert, Guido. *Samuel Fosso.* Milan: 5 Continents Editions, 2004.

Bright, Susan. *Art Photography Now.* New York: Aperture, 2005.

Butt, Zoë. *Wang Qingsong.* Ostfildern: Hatje Cantz, 2006.

Campany, David. *Art and Photography. Themes & movements.* London: Phaidon, 2003.

Carey, Ellen. *Photography Degree Zero. Pulls, installations & photograms, 1996–2006* and *Prima Facie: works 1975–1995* planned for 2008.

Carnochan, Brigitte. *Bella Figura, Painted Photographs by Brigitte Carnochan.* Palo Alto: Modernbook Editions, 2006.

Chi Peng. *Naked Lunch.* New York: Chambers Fine Art, 2005.

Cotton, Charlotte. *The Photograph as Contemporary Art.* London: Thames & Hudson, World of Art, 2004.

Fuss, Adam & Parry, Eugenia. *Adam Fuss.* Santa Fe: Arena Editions, 2004.

Galassi, Peter & Lowry, Glenn D. *Andreas Gursky.* New York: Museum of Modern Art, 2002.

Hatakeyama, Naoya. *Limeworks.* Tokyo: Synergy Inc., 1997.

Hatakeyama, Naoya. *Underground.* Tokyo: Media Factory, 2000.

Hatakeyama, Naoya. *River Series/Shadow.* Portland, Oregon: Nazraeli Press, 2004.

Higgs, Matthew. *Uta Barth.* London: Phaidon, 2004.

Klochko, Deborah. *Picturing Eden.* Göttingen: Steidl in association with George Eastman House, 2006.

Knorr, Karen. *Genii Loci: the Photographic Works of Karen Knorr.* London: Black Dog Publishing, 2002.

Lehmann, Ulrike & Holthuis, Gabriele. *Achim Lippoth.* Heidelberg: Kehrer, 2007.

Lipkin, Jonathan. *Photography Reborn. Image making in the digital era.* New York: Harry N. Abrams, 2005.

Lux, Loretta. *Loretta Lux.* New York: Aperture, 2005.

Maggia, Filippo. *Tracey Moffatt: between Dreams and Reality.* Milan: Skira Editions, 2006.

Manos, Constantine. *American Color.* New York: WW Norton, 1995.

McCurry, Steve. *South Southeast.* London: Phaidon, 2000.

Meyerowitz, Joel. *Aftermath: World Trade Center Archive.* London: Phaidon, 2006.

Moody, Rick. *Twilight: Photographs by Gregory Crewdson.* New York: Harry N. Abrams, 2002.

Moon, Sarah & Delpire, Robert. *Coincidences.* Santa Fe: Arena Editions, 2001.

Newton, Gael & Moffatt, Tracey. *Tracey Moffatt: Fever Pitch.* Sydney: Piper Press, 1995.

Parr, Martin. *Think of England.* London: Phaidon, 2000.

Parr, Martin. *West Bay.* London: Rocket Gallery, 1997.

Polidori, Robert. *Zones of Exclusion: Pripyat & Chernobyl.* Göttingen: Steidl, 2003.

Rexer, Lyle. *Photography's Antiquarian Avant-Garde: the New Wave in the Old Processes.* New York: Harry N. Abrams, 2002.

Rideal, Liz *Liz Rideal: new work.* Nottingham: Angel Row Gallery, 1998

Rideal, Liz. *Liz Rideal. Stills.* New York: Lucas Schoormans, 2001.

Shao Yinong & Mu Chen. *Shao Yinong & Mu Chen.* Beijing: Timezone8, 2006.

Singh, Raghubir. *River of Colour. The India of Raghubir Singh.* London: Phaidon, 2006.

Skoglund, Sandy & Muehlig, Linda. *Sandy Skoglund.* New York: Harry N. Abrams, 2002.

Smith, Elizabeth A.T. *Uta Barth. Museum of Contemporary Art catalogue.* Los Angeles: St Ann's Press, 2002,

Smith, Mike. *You're Not from Around Here.* Photographs of East Tennessee. University of Chicago Press, 2004.

Struth, Thomas. *Museum Photographs.* Munich: Schirmer/Mosel, 2005 (2nd expanded edition).

Syring, Marie Luise, ed. *Andreas Gursky. From 1984 to present.* New York: Te Neues Publishing Co., 2001.

Wang Qingsong. *Romantique.* Beijing: Timezone8, 2005.

Westerbeck, Colin. *Joel Meyerowitz.* London: Phaidon, 2005.

Williams, Val. *Martin Parr. Photoworks.* London: Phaidon, 2002.

Colour print, 1990, chromogenic development (Ektacolor) process, 70.9 x 71.1cm.

210 Holley Lime Quarry, Leroy NY, May 1994, from the series *Piles*. Colour print, chromogenic development (Ektacolor) process, 16 x 20 Ektacolor (Exhibition Prints), image 37 x 43cm, overall 40.6 x 50.8cm.

211 Sand Piles, City Ship Canal, Buffalo, NY, September 1994, from the series *Piles*. Colour print, chromogenic development (Ektacolor) process, 16 x 20 Ektacolor (Exhibition Prints), image 37 x 43cm, overall 40.6 x 50.8cm.

Otto Pfenninger
72 Children on a beach, 1906. Experimental two-colour process.

Photographic Advertising Ltd
81 Woman sitting at lunch reading a book, mouse on side of tablecloth, 1938. Colour print, assembly (Carbro) process. Image: 37.5 x 29cm.

Robert Polidori
www.flowerseast.com
www.metiviergallery.com
197tl Cabinet des Beautées, Portrait of Madame de Bourbon, Versailles, 1985.
197br Ancien Vestibule de l'Appartement de Madame Adelaide, Versailles, 1985.
212 Amman, Jordan, No. 1, 1996.
213l Control Room, Reactor 4, Chernobyl, 2001.
213r Classroom in Kindergarten #7, "Golden Key," Pripyat, 2001.

Eliot Porter
www.cartermuseum.org/collections/porter
142tl Cloud formations and moon after sunset, Tesuque, New Mexico, July 1958. Image 8½ x 8⁵⁄₁₆in.
142br Green bottles, Matinicus Island, Maine, August 24, 1954.
143 Pool in a Brook, Brook Pond, New Hampshire, October 4, 1953. Image 27.2 x 21.3cm.
146 Sheer cliffs, Glen Canyon, Utah, September 1961. Dye imbibition print.
148 Starfish in shallow water, San Cristobal Island, Galápagos Islands, May 23, 1966. Dye imbibition print.
149l Apples on tree after frost, Tesuque, New Mexico, November 21, 1966. Dye imbibition print.
149r Sunset, James Bay, Santiago, Galapagos Islands, April 11, 1966. Dye imbibition print.
170 Victorian house, Lexington, Missouri, May 15, 1978. Dye imbibition print.
196b Macau, 1980. Dye imbibition print.

Sergei Mikhailovich Prokudin-Gorskii
www.loc.gov.exhibits/empire
57 Fabric merchant, Samarkand, 1909–15. Digital image from original tricolour glass negative.
68l Cornflowers in a field of rye, 1909. Digital image from original tricolour glass negative.
68r Joining shop for the production of scabbards at the Zlatoust plant, 1910. Digital image from original tricolour glass negative.
69 On the Karolitskhali River, c.1915. Digital image from original tricolour glass negative.

Dr S. I. Rainforth
77t Urticaria (Dermographia), 1910. Stereo image of the back of young women with skin disease, image: 11 x 7.7cm.
77b Eczema Erythematosum Faciei, 1910. Offset colour lithography, image: 11.1 x 8cm.

John Rawlings
129r Model Wearing Purple Nail Polish Holding Purple Roses. Original caption: Woman holding bowl of roses to her face, 1952.

Tony Ray-Jones
www.nationalmediamuseum.org.uk/Collections/home.asp
164l "Snowy" Farr. Photograph taken for *The Sunday Times Magazine*.
164r Souvenir Ties, Nashville, 1971.
165l Cyril Clifft, 1970.

J. C. A. Redhead
www.nationalmediamuseum.org.uk/Collections/home.asp
112l Clark Gable, c.1943. Kodachrome photograph.
112r Arable Farming, Harvesting, Harvest landscape, c.1943. Kodachrome colour transparency.

John Riddy
www.frithstreetgallery.com
209t Shin-Fuji (Diner), 2005.

Liz Rideal
www.lizrideal.com
246 Kerfuffle, 2004. Original four photo-booth collaged images measured 11 x 8cm (total) enlarged to 22 x 15.4m and printed inkjet on vinyl.

Lionel de Rothschild
42tl The earliest known colour image of the Zoological Gardens in London, an autochrome plate taken c.1910. The tiger, viewed through the bars of his cage in the Lion House.

Arthur Rothstein
http://memory.loc.gov/ammem/fsachtml/fsowhome.html
104 Child of a migratory farm laborer in the field during the harvest of the community center's spinach crop, FSA labor camp, Texas, January 1942.

Lucas Samaras
www.pacewildenstein.com
178 Photo-Transformation, September 9, 1976. Polaroid SX-70, image 7.6 x 7.6cm.
179 Photo-Transformation, July 9, 1976. Polaroid SX-70, image 7.6 x 7.6cm.

Wladimir Nikolaiovich Schohin
33t Still life with egg, 1910. Autochrome.

Shao Yinong & Mu Chen
www.shanghart.com
220 Childhood Memory, Yuan Ming Yuan, 2001. Hand-dyed photograph, 120 x 240cm.
221 Childhood Memory, Monument of the People's Heroes, 2001. Hand-dyed.

George Bernard Shaw
26tr Alvin Langdon Coburn, 1907. Autochrome.

Cindy Sherman
www.moma.org
188l Untitled, 1981 (MP# 96). Colour photograph, 24 x 48in.
188r Untitled, 1983 (MP# 123). Colour photograph, 34 x 23in.

Stephen Shore
www.houkgallery.com
167 Kimballs Lane, Moody, Maine, July 17, 1974, 1974-2004. C-print, 20 x 24in.

Harry T. Shriver
39tr Rooftops of New York City After a Snowfall, c.1910. Autochrome, 4 x 5in.

Arthur Siegel
123 Dry Cleaners, 1946, from the portfolio In Chicago, with a negative date of 1946 and a print date of 1983.

Raghubir Singh
www.nationalmediamuseum.org.uk/Collections/home.asp
183 Pilgrim and Ambassador car, Kumbh Mela, Allahabad, Uttar Pradesh, India, 1977.
186 Subhas Chandra Bose statue, Calcutta, West Bengal, 1986.
206 Pavement mirror shop, Howrah, West Bengal, 1991.

Sandy Skoglund
www.sandyskoglund.com
226 Squirrels at the Drive-in, 1996.

Mike Smith
www.leemarksfineart.com
208 Unicoi County, Tennesee, 1998. Chromogenic colour print.

Emmanuel Sougez
33b Still life with lemons and siphon, 1926–28. 17.9 x 12.9cm.

Edward Steichen
27tl Mary Steichen with set of Russian nesting dolls, c.1908–10. Colour plate, screen (autochrome) process, 12.5 x 9.9cm.
27tr Emmeline Stieglitz with copper bowl, c.1910. Colour plate, screen (autochrome) process, 12.0 x 17.0cm.
58 The Flatiron, neg. 1904, print 1909. Gum bichromate over platinum print, height 18¹³⁄₁₆ x width 15⅛in (47.8 x 38.4cm).
66 Time–Space Continuum, 1920. Palladium and ferro-prussiate print, 24.5 x 19.5cm.
79 Yucatan, Mayan Women, 1938. Colour print c.1940, dye imbibition (dye transfer) process, 23.0 x 34.3cm.
82 Ripe Corn, 1934. Nude, dark-skinned female with arms outstretched, holding ear of corn. Dye transfer. Image 22.7 x 19cm.
120 Floral study, c.1940, colour print, dye imbibition process.
121l Woman in hat with bouquet of flowers, May 6, 1940. Colour print, dye imbibition (dye transfer) process, natural colour, image 24.5 x 20cm.
121m Woman in hat with bouquet of flowers, May 23, 1940. Colour print, dye imbibition (dye transfer) process, sabatier effect, image 24.5 x 20cm.
121r Woman in hat with bouquet of flowers, May 6, 1940. Colour print, dye imbibition (dye transfer) process, negative print, colour posterization, image 24.3 x 19.6cm.

Bert Stern
www.bertstern.com
153tl Courrèges, *Vogue*, Paris 1967.

Karl Struss
38br Boardwalk, Long Island, c.1910. Additive colour screen plate, 6 x 6.0625in.

Thomas Struth
www.mariangoodman.com
236 San Zaccaria, Venice, 1995. Chromogenic print, 181.9 x 230.5cm.

Luke Swank
108l #901048: Molten Steel Pour, 1940. 4 x 2⅞in. Kodachrome.
108r #90.1044: Steam Tower, 1940. 3¾ x 4¾in. Kodachrome.
109l White Outbuilding, 1940. Kodachrome.
117 Canned Foods, c.1942. Kodachrome.

Arthur Traube
81 Biscuits, c.1931. Colour print, dye imbibition (Uvatype) process, image 21.5 x 15.5cm.

Pete Turner
www.peteturner.com
160t Lifesaver, 1967. Computer-generated colour ink-jet print, printed later, image: 29 x 43.2cm.

Ruud van Empel
www.ruudvanempel.nl
203 World #12, 2005. Cibachrome, 150 x 107cm.
223 World #7, 2005. Cibachrome, 105 x 150cm.
244r The Office #34 2, 2000. Cibachrome, 112.5 x 101cm.

Gabriel Veyre
www.gabrielveyre-collection.org
55 Self-portrait in Morroco, 1908. Autochrome, 13 x 18cm.

Wang Qingsong
www.wangqingsong.com
228 Knickknack Pedlar, 2002. 120 x 400cm.

Agnes B. Warburg
www.nationalmediamuseum.org.uk/Collections
73 Bathing Machines, c.1910. Tricolour Carbro.
74 Peonies, 1912. Raydex.
96l Whalers in Magdalen Bay, Spitsbergen, c.1930. Tricolour Carbro.
96r Roses and blue china, c.1935. Tricolour Carbro.

John Cimon Warburg
www.nationalmediamuseum.org.uk/Collections
31 Cow on Saltburn Sands, c.1910. Autochrome.

William Wegman
www.wegmanworld.com
www.seniorandshopmaker.com
192 Ray and Mrs Lubner in bed watching TV, 1981. Colour polaroid, 24¼ x 20⅜in.

Robert Welsh
243 Untitled, Beijing, China, 1991. Colour print by Robert Welsh.

F. W. Westley
89 Swimming Bath, HMS *Empress of Britain*, 1937. Colour print, assembly (Carbro) process, image 28 x 36.8cm.

Edward Weston
www.edward-weston.com
124 Nautilus Shells, 1947. Kodachrome.

H. I. Williams
84 Peppers and jars of preserves, c.1930. Colour print, assembly (Carbro) process, image 38.2 x 31.7cm.
85 Still life with coloured plates, on diagonal, c.1938. Colour print, assembly (Carbro) process, image 38.5 x 32.5cm.

Catherine Mary Wood
13tl Harry Benson and crab, c.1860s. Wood Album. Hand-decorated album of *cartes-de-visite* portraits in albumen with watercolour paint, assembled c.1868.

Yang Zhenzhong
www.yangzhenzhong.com
231 Lucky Family, 1995.

Catherine Yass
www.alisonjacquesgallery.com
240 Descent: HQ5: 1/4s, 4.7ᵃ, 0 mm, 40 mph, 2002. Ifochrome transparency, lightbox, 112.5 x 141 x 12.5cm.

Madame Yevonde
www.madameyevonde.com
86 Advertisement for Glyco-Thymoline, 1939. Modern dye transfer print from original tricolour glass negatives.
87 A funnel of the RMS *Queen Mary*, 1936. Vivex.
91 Mrs Charles Sweeny (Margaret, Duchess of Argyll) as Helen of Troy from the *Goddesses* series, 1935. Modern dye-transfer print from original tricolour glass negatives.
95 The Machine Worker in Summer, model Joan Richards, 1937. Modern dye-transfer print from original tricolour glass negatives.

Willy Zielke
101 Still life – colours in chemisty, 1934. Colour bromoil transfer print.

Charles C. Zoller
www.geh.org
1 Apple on Mirror, 1907. Colour plate, screen (autochrome) process, image: 8.3 x 10.2cm.
39tl Bridge with Gandy Car on it, 1924. Colour plate, screen (autochrome) process, image 8.3 x 10.2cm.
40 Portrait of Charlie Chaplin, 1918. Colour plate, screen (autochrome) process, image 8.3 x 10.2cm.

INDEX

Note: page numbers in **bold** refer to captions.

ACKNOWLEDGEMENTS

Details of all picture credits and copyright owners can be found below, but the publishers and I would also particularly like to thank the following individuals who were extremely helpful and generous with images and information: John Batho, Bill Becker, Jeffrey Becom, Howard Bossen, Ellen Carey, Brigitte Carnochan, Shelley Dowell, Margit Erb, Bernard Faucon, Barbara Galasso, Tod Gangler, Howard Greenberg, Alan Griffiths, Laura Hajar, Naoya Hatakeyama, Robert Hirsch, Graham Howe, Ken Jacobson, Sam Johnson, Joanne King, Karen Knorr, Hans P. Kraus Jr., Jean-Marc Lamotte, Brian Liddy, Achim Lippoth, Scott McFarland, Lee Marks, Joel Meyerowitz, Angus Mill, Victor Minachin, Sarah Moon, Therese Mulligan, Mimi Muray, Alex Novak, Mark Osterman, Jennifer Parkinson, Robert Polidori, Wang Qingsong, Liz Rideal, John Rohrbach, Chris Rowlin, Alain Scheibli, Sandy Skoglund, Hugh Tifft, Nadia Valla, Bodo von Dewitz, Susannah Ward, Russ Young. And the following museums & galleries: Amon Carter Museum, Fort Worth, Texas; Eliot Elisofon Photographic Archives at the National Museum of African Art, Washington; George Eastman House, Rochester, New York; Ikona Venezia International School of Photography, Venice; J Paul Getty Museum, Los Angeles; Museum of Contemporary Art, Chicago; National Media Museum, Bradford, UK & Science & Society Picture Library, London; Alison Jacques Gallery, London; Chinese Contemporary Art, London & Beijing; Franco Fontana Studio, Modena; Hans P. Kraus Jr. - Fine Photographs, New York; Howard Greenberg Gallery, New York; Janet Borden Inc., New York; Joel Meyerowitz Photography, New York; L.A. Galerie Lothar Albrecht, Frankfurt; Luhring Augustine, New York; Nickolas Muray Photo Archives, Alta Lodge, USA; Roslyn Oxley9 Gallery, Sydney; ShanghART & H Space, Shanghai; Taka Ishii Gallery, Tokyo; William Eggleston Trust, New York.

Finally, I would like to express my personal gratitude to several people. My friends and colleagues Joe Struble and David Wooters at George Eastman House showed me much previously unpublished colour material in GEH's collections and gave their time and knowledge freely and with enthusiasm, as they always do.

The erudition, generosity and sheer passion for colour photography of Mark Jacobs were important, inspiring and invaluable elements for this book. Mark, I so hope I haven't let you down! What a very generous mine of wonderful information you are and your zeal for these lovely images is infectious.

To Penny Craig, Jenny Lord, Vicky Rankin, Zoë Dissell, Lisa Moore and colleagues at Andre Deutsch, who have worked on this publication with me, thank you so much for all your help, guidance and support. It has been fun. I think.

Finally, to Martin Roberts who is always supportive, always there for me. You enable me to be myself. This is for you.

PICTURE CREDITS

The publishers would like to thank the following sources for their kind permission to reproduce the photographs in this book. Every effort has been made to acknowledge correctly and contact the source and/or copyright holder of each picture and Carlton Publishing Group apologizes for any unintentional errors or omissions, which will be corrected in future editions of this book.

Key: t=top, b=bottom, c=centre, l=left and r=right. GEH = George Eastman House; LOC = Library of Congress; NMM/SSPL = National Media Museum/Science and Society Picture Library; RPS = Royal Photographic Society; SFP = Société Française de Photographie.

1 Courtesy George Eastman House/Gift of Mr & Mrs Lucius A. Dickerson; 2–3 © 2006 Eggleston Artistic Trust, courtesy Cheim & Read, New York, used with permission, all rights reserved/The J. Paul Getty Museum, Los Angeles, William Eggleston, c.1972 (published 1980), 16 x 20in; 4 Keld Helmer-Petersen; 6 NMM/SSPL; 9 Image Courtesy of Mark Jacobs; 11 RPS Collection at the NMM/SSPL; 12l Spencer Collection, The New York Public Library, Astor, Lenox and Tilden Foundations; 12r The J. Paul Getty Museum, Los Angeles, Hippolyte Bayard, Arrangement of Specimens, about 1842, Cyanotype (Direct Negative), Image (irregular) 27.7 x 21.6cm; 13l RPS Collection at the NMM/SSPL; 13r The J. Paul Getty Museum, Los Angeles, Unknown Maker, French, about 1852, Daguerreotype, Hand-coloured, 1/4 plate, Image 9.4 x 7.3cm; 14 RPS Collection at the NMM/SSPL; 15l NMM/SSPL; 15r © SFP. Tout Droits Réservés; 16 & 17 Courtesy GEH/Museum Purchase; 18 Image Courtesy of Mark Jacobs/Colour Reconstruction by Victor Minachin; 19l RPS Collection at the NMM/SSPL; 19r RPS Collection at the NMM/SSPL; 21 Attribué à France Lumière; 22 © Institut Lumière/Famille Lumière; 23 & 24 Image Courtesy of Mark Jacobs; 25, 26l & 26r RPS Collection at the NMM/SSPL; 27l & 27r Courtesy GEH/Bequest of Edward Steichen by Direction of Joanna T. Steichen; 28l Courtesy GEH/Museum Purchase; 28r Courtesy GEH/Gift of 3M Company, ex-collection Louis Walton Sipley; 29 & 30 Courtesy of GEH/Museum Purchase; 31 RPS Collection at the NMM/SSPL; 32 © Baron Adolph de Meyer/RPS Collection at the NMM/SSPL; 33l Hans P. Kraus, Jr and Robert Hershkowitz; 33r Amatörfotografklubben i Helsingfors r.f; 34 & 35l Image Courtesy of Mark Jacobs/Location of Original Plate Unknown; 35r © SFP. Tous Droits Réservés; 36l © Photo RMN/© Droits Réservés/© ADAGP, Paris and DACS, London 2006; 36r LOC, Prints & Photographs Division, Arnold Genthe Collection: Negatives and Transparencies, (LC-G408-CT-0031); 37 Photographs © 1989 The heirs of Vadim and Valentin Andreyev. Reproduced with the permission of the Leeds Russian Archive/Leeds University Library; 38l Wm B. Becker Collection/American Museum of Photography; 38r Karl Struss, Boardwalk, Long Island, c.1910, Additive colour screen plate, P1983.24.50 ©1983 Amon Carter Museum, Fort Worth, Texas; 39l Courtesy GEH/Gift of Mr & Mrs Lucius A. Dickerson; 39r Wm B. Becker Collection/American Museum of Photography; 40 Courtesy GEH/Gift of Mr & Mrs Lucius A. Dickerson; 41t & 41b Hans P. Kraus, Jr, New York; 42l Reproduced with the permission of The Rothschild Archive; 42r, 43l & 43r Collection Médiathèque de l'Architecture et de l'Architecture, Archives Photographiques (Centre des Monuments Nationaux, Paris; 44 © SFP. Tous Droits Réservés; 46 Courtesy GEH/Gift of 3M Company, ex-collection Louis Walton Sipley; 47l & 47r © Dr Friedrich "Fritz" Paneth/Image courtesy of the RPS Collection at the NMM/SSPL; 48 & 49 © Helen Messinger Murdoch/Image Courtesy of the RPS Collection at the NMM/SSPL; 50 & 51 Image Courtesy of Mark Jacobs; 52 Hans Hildenbrand/National Geographic Image Collection; 53l & 53r & 54 Musée Albert-Kahn – département des Hauts-de-Seine; 55 © coll. Jacquier-Veyre/adoc-photos; 57 LOC, Prints & Photographs Division, Prokudin-Gorskii Collection, (LC-DIG-prokc-21725); 58 The Metropolitan Museum of Art, Alfred Stieglitz Collection, 1933 (33.43.39) Photograph © 1998 The Metropolitan Museum of Art; 59 Image Courtesy of Mark Jacobs/Whereabouts of the Original Plate Unknown; 60 Courtesy GEH/Gift of Alvin Langdon Coburn; 61 Courtesy GEH/Gift of 3M Company, ex-collection Louis Walton Sipley; 62 Preus Museum, Norway; 63l © Minna Keene/RPS Collection at the NMM/SSPL; 63r RPS Collection at the NMM/SSPL; 64l & 64r © 2006 Smithsonian American Art Museum/Art Resource/Scala, Florence; 65 © Photo RMN/© René-Gabriel Ojéda/Droits Réservés/© ADAGP, Paris and DACS, London 2006; 66 Courtesy GEH/Bequest of Edward Steichen by Direction of Joanna T. Steichen/Reprinted With Permission of Joanna T. Steichen; 67l Courtesy GEH/Gift of 3M Company, ex-collection Louis Walton Sipley; 67r Courtesy GEH/Gift of Dr Walter Clark; 68l LOC, Prints & Photographs Division, Prokudin-Gorskii Collection, (LC-DIG-prokc-20946); 68r LOC, Prints & Photographs Division, Prokudin-Gorskii Collection, (LC-DIG-prokc-20540); 69 LOC, Prints & Photographs Division, Prokudin-Gorskii Collection, (LC-DIG-prokc-21468); 70 Image Courtesy of Mark Jacobs; 71l RPS Collection at the NMM/SSPL; 71r Museum of the History of Science, Oxford; 73 & 74 RPS Collection at the NMM/SSPL; 73 © Agnes B. Warburg/RPS Collection at the NMM/SSPL; 75 & 76 © Fred Judge/RPS Collection at the NMM/SSPL; 77t & 77b Courtesy GEH/Museum Collection; 79 Courtesy GEH/Bequest of Edward Steichen by Direction of Joanna T. Steichen/Reprinted with Permission of Joanna T. Steichen; 80 © Graham Howe, Curatorial Assistance, Inc.; 81l Courtesy GEH/Gift of the Imperial War Museum; 81r Courtesy GEH/Gift of Dr Fritz Wentzel; 82 Courtesy GEH/Bequest of Edward Steichen by direction of Joanna T. Steichen/Reprinted with Permission of Joanna T. Steichen; 84 Courtesy GEH/Extended Loan from H. I. Williams; 85 Courtesy GEH/Gift of 3M Company, ex-collection Louis Walton Sipley; 86 © Yevonde Portrait Archive/Image Courtesy RPS Collection at the NMM/SSPL; 87 © Yevonde Portrait Archive; 88 © Stewart Bale/Image Courtesy of RPS Collection at the NMM/SSPL; 89 Courtesy GEH/Gift of the Imperial War Museum, London; 90 Condé Nast Archive/Corbis Images; 91l © Yevonde Portrait Archive/Image Courtesy of RPS Collection at the NMM/SSPL; 91r © Ikona Gallery. Venezia; 92, 93 & 94 © Walter Bird/Image Courtesy of the RPS Collection at the NMM/SSPL; 95l © Yevonde Portrait Archive/Image Courtesy of RPS Collection at the NMM/SSPL; 95r Paul Outerbridge Jr © 2006 G. Ray Hawkins Gallery, Los Angeles, CA/Photo © Christie's Images/Corbis Images; 96l & 96r © Agnes Warburg/RPS Collection at the NMM/SSPL; 97t & 97b © Violet Blaiklock/Image Courtesy of the RPS Collection at the NMM/SSPL; 98 © Man Ray Trust/ADAGP, Paris and DACS, London 2006/The J. Paul Getty Museum, Los Angeles, Man Ray, Female head, blue & peach, 1930–32, (Image: 19.8 x 13.7cm); 99 Courtesy GEH/Museum Purchase: Alvin Langdon Coburn Fund; 100 © Hattula Moholy-Nagy/DACS 2006 /Courtesy GEH/Gift of Walter Clark; 101 Museum für Kunst und Gewerbe Hamburg; 103 LOC, Prints & Photographs Division, FSA-OWI Collection, (LC-DIG-fsac-1a34106); 105 LOC, Prints & Photographs Division, FSA-OWI Collection, (LC-DIG-fsac-1a34265); 106 LOC, Prints & Photographs Division, FSA-OWI Collection, (LC-DIG-fsac-1a34105); 107 LOC, Prints & Photographs Division, FSA-OWI Collection, (LC-DIG-fsac-1a34140); 108l & 108r Courtesy of Western Pennsylvania Conservancy; 109l William R. Oliver Special Collections Room, Carnegie Library of Pittsburgh; 109r LOC, Prints & Photographs Division, FSA-OWI Collection, (LC-DIG-fsac-1a35287); 110 Courtesy GEH/Gift of Dr Walter Clark; 111 RPS Collection at the NMM/SSPL; 112l & 112r Kodak Collection/NMM/SSPL; 113 Kodak Collection at the NMM/SSPL; 114, 115 & 116 © John Hinde/Image Courtesy of the RPS Collection at the NMM/SSPL; 117 William R. Oliver Special Collections Room, Carnegie Library of Pittsburgh; 118l Photo by Nickolas Muray © Nickolas Muray Photo Archives; 118r Courtesy GEH/Gift of 3M Company, ex-collection Louis Walton Sipley; 119l & 119r Photo by Nickolas Muray © Nickolas Muray Photo Archives/Courtesy GEH/Gift of Mrs Nickolas Muray; 120–21 GEH/Bequest of Edward Steichen by Direction of Joanna T. Steichen/Reprinted with Permission of Joanna T. Steichen; 122 © Hattula Moholy-Nagy/DACS 2006; 123 Image courtesy of extended loan of the Baum family Collection, Museum of Contemporary Photography, Columbia College Chicago; 124 Collection Center for Creative Photography ©1981 Arizona Board of Regents; 127 Photo by Nickolas Muray, © Nickolas Muray Photo Archives/Courtesy GEH/Gift of Mrs Nickolas Muray; 128–30 © Condé Nast Archive/Corbis; 131 Time Life Pictures/Getty Images; 132–33 © Condé Nast Archive/Corbis; 134–35 © Saul Leiter/Courtesy Howard Greenberg Gallery, New York; 136–38 © Ernst Haas Estate, courtesy of Curatorial Assistance, Inc., Pasadena; 140 Time Life Pictures/Getty Images; 141 © Graham Howe, courtesy of Curatorial Assistance, Inc., Pasadena; 142l Eliot Porter, Cloud formations and moon after sunset. Tesuque, New Mexico, July 1958. Dye imibition print (P1989-19-105) © 1990 Amon Carter Museum, Fort Worth, Texas, Bequest of the artist; 142r Eliot Porter, Green Bottles, Matinicus Island, Maine, August 24 1954. Dye imibition print (P1990.51.3034-1) © 1990 Amon Carter Museum, Fort Worth, Texas, Bequest of the artist; 143 Eliot Porter, Pool in a Brook, Brook Pond, New Hampshire, October 4, 1953, Dye imibition print (P1990.60.51) © 1990 Amon Carter Museum, Fort Worth, Texas, Bequest of the artist; 145 © Dr. Harold E. Edgerton/Courtesy GEH/Gift of the Harold and Esther Edgerton Family Foundation; 146 Eliot Porter, Sheer cliffs, Glen Canyon, Utah, September 1961. Dye Imbibition Print, © 1990 Amon Carter Museum, Fort Worth, Texas, Bequest of the artist; 148 Eliot Porter, Starfish in shallow water, San Cristobal Island, Galápagos Islands, May 23 1966. Dye Imbibition Print, © 1990 Amon Carter Museum, Fort Worth, Texas, Bequest of the artist; 149l Eliot Porter, Apples on tree after frost. Tesuque, New Mexico, November 21, 1966. Dye Imbibition Print, © 1990 Amon Carter Museum, Fort Worth, Texas, Bequest of the artist; 149r Eliot Porter, Sunset, James Bay, Santiago, Galápagos Islands, April 11, 1966. Dye Imbibition Print, © 1990 Amon Carter Museum, Fort Worth, Texas, Bequest of the artist; 150l Fotomuseum im Münchner Stadtmuseum; 150r © Museum Ludwig Cologne/Courtesy of Rheinisches Bildarchiv Cologne; 151 Fotomuseum im Münchner Stadtmuseum; 152l Getty Images; 152r Courtesy Norman Parkinson Archive; 153l Bert Stern/Courtesy Staley-Wise Gallery, New York; 153r Angus McBean/EMI Archives/Redferns; 154 © Marie Cosindas, Andy Warhol, The Dandies, The Factory, NYC, 1966. Courtesy, Robert Klein Gallery, Boston; 155 © Daniel Kramer/Courtesy Staley-Wise Gallery, New York; 156l & 156r © Lee Friedlander, courtesy Fraenkel Gallery, San Francisco; 157 Time & Life Pictures/Getty Images; 158 Stone/Getty Images; 159 Ernst Haas/Getty Images; 160t © Pete Turner/Courtesy GEH/Gift of the Photographer; 160b © 2006 Eggleston Artistic Trust, Courtesy Cheim & Read, New York. Used with Permission. All Rights Reserved; 161 © Dr. Harold E. Edgerton/Courtesy GEH/Gift of the Harold and Esther Edgerton Family Foundation; 163 The J. Paul Getty Museum, Los Angeles, Walker Evans, St Martins, 1974, Image 10.8 x 8.9cm; 164l, 164r & 165l Tony Ray-Jones/NMM/SSPL; 165r The J. Paul Getty Museum, Los Angeles, Walker Evans, Ice House, Image 10.8 x 8.9cm; 166 Image Courtesy of The Phillips Collection; 167 Courtesy 303 Gallery, New York; 168 & 169l © 2006 Eggleston Artistic trust, courtesy Cheim & Read, New York, Used with permission. All rights reserved/Image Courtesy of Christies Images/Corbis; 169r © 2006 Eggleston Artistic Trust, courtesy Cheim and Read, New York. Used with permission. All rights reserved/Image courtesy of The J. Paul Getty Museum, Los Angeles, William Eggleston, Untitled, 1973, Image 46 x 31cm, Gift of Caldecot Chubb; 170 Eliot Porter, Victorian house, Lexington, Missouri, May 15th, 1978, Dye Imbibition (P1990-51-3749) © 1990 Amon Carter Museum, Fort Worth, Texas, Bequest of the artist; 171–174 © Joel Meyerowitz/Courtesy of Edwynn Houk Gallery; 175 Courtesy GEH/Gift of the photographer/Gift of the photographer; 176l © 2006. Photo Smithsonian American Art Museum/Art Resource/Scala, Florence; 176r © Jan Groover/Courtesy GEH/Gift of the photographer/Museum Purchase: Margaret T. Morris Foundation Fund, in Memory of Dr Wesley T. 'Bunny' Hansen; with National Endowment for the Arts Funds; 177 © Jan Groover, courtesy Janet Borden, Inc.; 178 © Lucas Samaras/ Image courtesy of The J. Paul Getty Museum, Los Angeles, Lucas Samaras, Photo-Transformation, 1976, Image 7.6 x 7.6cm; 179 © Lucas Samaras/Image courtesy of The J. Paul Getty Museum, Los Angeles, Lucas Samaras, Photo-Transformation, September 9, 1976, Image 7.6 x 7.6cm; 180 © Susan Meiselas/Courtesy GEH/Gift of the photographer/Magnum Photos, Inc.; 181 Eve Arnold/Magnum Photos; 182t & 182b Eliot Elisofon Photographic Archives National Museum of African Art Smithsonian Institution; 183 © 1998 by Raghubir Singh/Succession Raghubir Singh; 185 © John Batho; 186 © 1998 by Raghubir Singh/Succession Raghubir Singh; 187l & 187r © Martin Parr/Magnum Photos; 188l & 188r Courtesy of the Artist and Metro Pictures; 189 Private Collection, Courtesy of the Artist and JHB Gallery, New York, NY; 190 © Helen Chadwick Estate/Image Courtesy of Victoria & Albert Museum; 191l © Bernard Faucon; 191r © Calum Colvin; 192 Image Courtesy of the Artist; 193l Photograph by Robyn Beeche, Jewellery by Andrew Logan 'Burma Series' 1986 model Scarlett; 193r © Fergus Greer/Courtesy of Michael Hoppen Gallery; 194 & 195l © Franco Fontana; 195b © Keld Helmer-Petersen; 196l © Alex Harris, Courtesy of The J. Paul Getty Museum, Los Angeles/Gift of Nancy & Bruce Berman; 196b Eliot Porter, Macau, 1980, Dye Imbibition Print, (P1990-51-1630) © 1990 Amon Carter Museum, Fort Worth, Texas, Bequest of the artist; 197l & 197r © Robert Polidori; 198 2006. Photo Smithsonian American Art resource/Scala, Florence; 199 © John Pfahl/Courtesy GEH/Museum Purchase; Charina Foundation Fund and Matching Funds; 200–201 Ernst Haas/Getty Images; 203 Courtesy: Flatland Gallery, Utrecht/TZR Galerie Kai Brückner, Düsseldorf; 204–205 © Martin Parr/Magnum Photos; 206 © 1998 by Raghubir Singh/Succession Raghubir Singh; 207l © 2006 Eggleston Artistic Trust, Courtesy Cheim and Read, New York. Used with permission. All rights reserved; 207r © Adam Bartos/The J. Paul Getty Museum, Los Angeles, Adam Bartos, Hither Hills State Park, Montauk, New York, 1991–94, 50.8 x 76.2cm; 208 © Mike Smith/Courtesy of Lee Marks Fine Art, Shelbyville, Indiana; 209t © John Riddy; 209b © Naoya Hatakeyama, Courtesy L.A. Galerie – Lothar Albrecht, Frankfurt; 210–11 © John Pfahl/Courtesy GEH/Extended Loan from Bonnie Gordon; 212–13 © Robert Polidori; 214 © Joel Meyerowitz/Courtesy of Edwynn Houk Gallery; 215l & 215r © Admas Habteslasie, images courtesy of Flowers, London; 216 © Samuel Fosso, Courtesy J. M. Patras/Paris/All Rights Reserved, Localisation: Paris, Musée National d'Art Moderne – Centre Georges Pompidou Photo CNAC/MNAM Cist. RMN/©; 217l & 217r Courtesy of the artist and Roslyn Oxley9 Gallery, Sydney; 218l © DACS 2007/Loretta Lux The Fish, 2003, Courtesy Yossi Milo Gallery, NYC; 218r © DACS 2007/The Cleveland Museum of Art, Gift of William S. Lipscomb in memory of his father, James S. Lipscomb 2004.99; 219 Courtesy John Stevenson Gallery, New York; 220–21 Courtesy of the Chinese Contemporary Gallery; 222 © Brigitte Carnochan; 223 Courtesy: Flatland Gallery, Utrecht/TZR Galerie Kai Brückner, Dusseldorf; 224–25 Courtesy of Gregory Crewdson and Luhring Augustine; 226 © 1996 Sandy Skoglund; 227l & 227r © Karen Knorr; 228–29 © Wang Qingsong; 230 Courtesy of Chambers Fine Art; 231 © Yang Zhenzhong, courtesy of Shanghart & H Space; 232 © Adam Fuss/Image courtesy of The Metropolitan Museum of Art, Purchase, Rogers Fund, by exchange, and Joyce & Robert Menschel Gift, 1997 (1997.195) Copy Photograph © Metropolitan Museum of Art; 233l © Brigitte Carnochan; 233r © Sarah Moon, Image courtesy of Art & Soul Gallery; 234–35 Courtesy of Alison Jacques Gallery, London, and Tanya Bonakdar Gallery, New York; 236 © Thomas Struth/The Metropolitan Museum of Art, Purchase, The Howard Gilman Foundation Gift, 1996, (1996.297). Copy Photograph © 1996 The Metropolitan Museum of Art; 237 © Andreas Gursky/Courtesy: Monika Sprueth/Philomene Magers, DACS, London 2006, Image Courtesy Matthew Marks Gallery, New York; 238 © Naoya Hatakeyama, Courtesy L.A. Galerie – Lothar Albrecht, Frankfurt; 239l & 239r Courtesy of Naoya Hatakeyama and Taka Ishii Gallery, Tokyo; 240 Courtesy of Catherine Yass and Alison Jacques Gallery, London; 241t & 241b Jeffrey Becom/Courtesy of Lee Marks Fine Art, Shelbyville, Indiana; 242t Steve McCurry/Magnum Photos; 242b © Constantine Manos/Courtesy GEH/Gift of the Photographer in honour of Alison and Anya Nordstrom; 243l Steve McCurry/Magnum Photos; 243r Courtesy of Tepper Takayama Fine Arts; 244l Courtesy of Regen Projects, Los Angeles, and Union Gallery, London; 244r Courtesy: Flatland Gallery, Utrecht/TZR Galerie Kai Brückner, Düsseldorf; 245 © Angus Mill; 246 © Liz Rideal; 247l Courtesy of the Artist, Courtesy of the Artist, JHB Gallery, New York (NY), Nina Freudenheim Fine Art, Buffalo (NY), and Katrina Traywick Art Projects, Berkeley (CA); 247r Courtesy of the Artist and JHB Gallery, New York (NY), Paesaggio Fine Art, Hartford (CT) and Nina Freudenheim Fine Art, Buffalo (NY).